OCT 28 1987

ROBERT FRANK
MOVING OUT

ROBERT

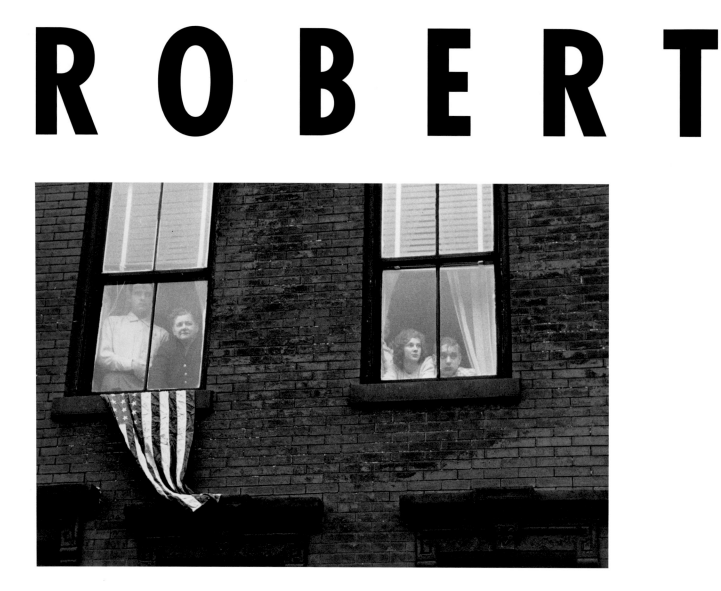

SARAH GREENOUGH • PHILIP BROOKMAN

FRANK

W. S. Di Piero

Martin Gasser

John Hanhardt

NATIONAL GALLERY OF ART, WASHINGTON • SCALO

The exhibition is made possible by
Lannan Foundation
and
Polaroid Corporation

Additional support for the exhibition and its catalogue
is provided by grants from
The Robert Mapplethorpe Foundation, Inc.,
Pro Helvetia, Arts Council of Switzerland,
and
The Circle of the National Gallery of Art

The exhibition *Robert Frank: Moving Out* is organized by
the National Gallery of Art, Washington

National Gallery of Art, Washington, D.C.
2 October–31 December 1994
Yokohama Museum of Art
11 February–9 April 1995
Kunsthaus Zurich
26 June–20 August 1995
Stedelijk Museum, Amsterdam
9 September–29 October 1995
Whitney Museum of American Art, New York
15 November 1995–11 February 1996
Lannan Foundation, Los Angeles
2 March–19 May 1996

The hardcover edition of this book is published by
SCALO, Zurich–Berlin–New York
and distributed by
D.A.P. / Distributed Art Publishers, New York.

CONTENTS

LENDERS TO THE EXHIBITION

The Art Institute of Chicago

Canadian Museum of Contemporary Photography

Fotomuseum Winterthur, Switzerland

Mary Frank

Robert Frank

Gilman Paper Company Collection

Richard and Ronay Menschel

The Museum of Fine Arts, Houston

The Museum of Modern Art, New York

National Gallery of Art, Washington

Pace/MacGill Gallery, New York

Philadelphia Museum of Art

Michal Rovner

San Francisco Museum of Modern Art

Eugene M. Schwartz Associates, Inc.

Andrew Szegedy-Maszak and Elizabeth Bobrick

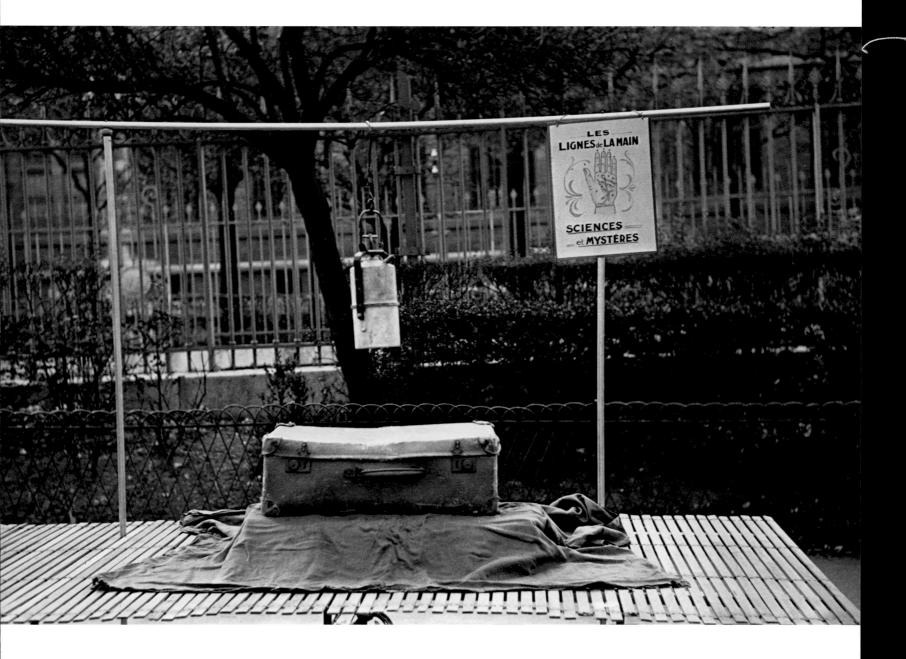

I'm always looking outside,

trying to look inside. Trying to say something that's true.

But maybe nothing is really true.

Except what's out there.

And what's out there is always changing.

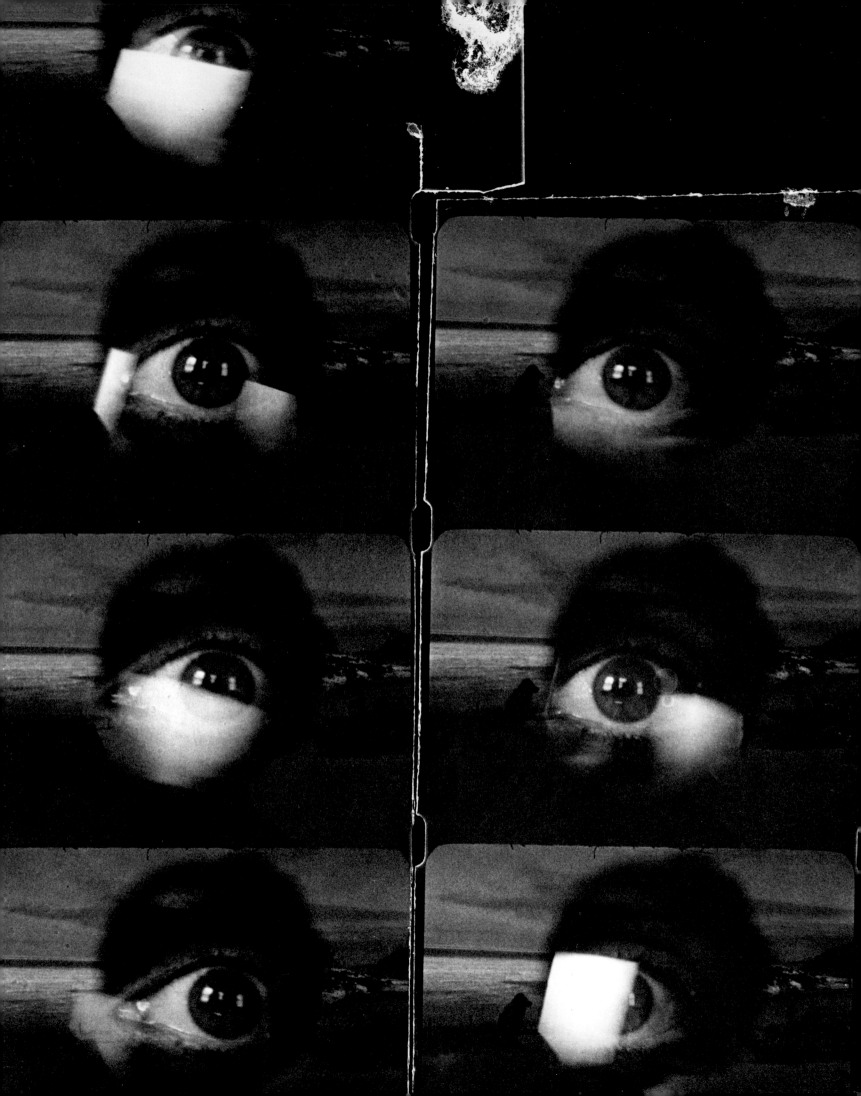

14 In Switzerland, 1944–46 —> to America, 1947
Albisgüetli, Zurich, 1945

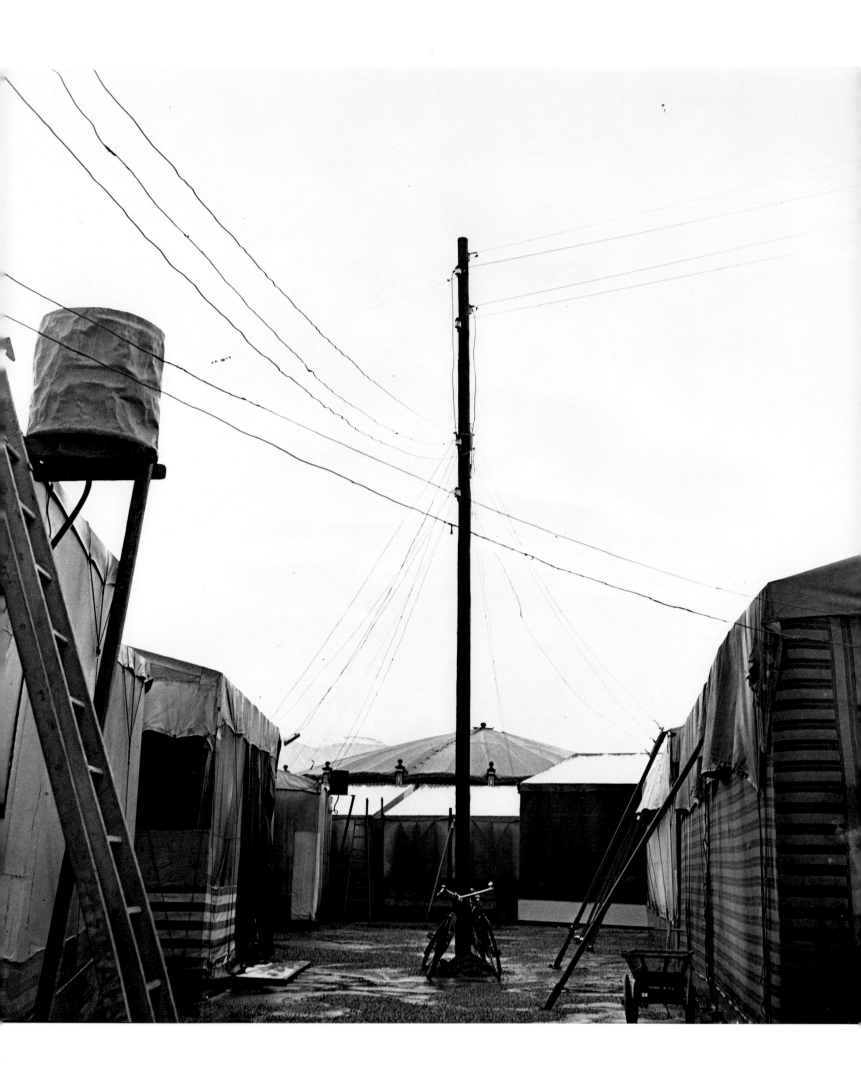

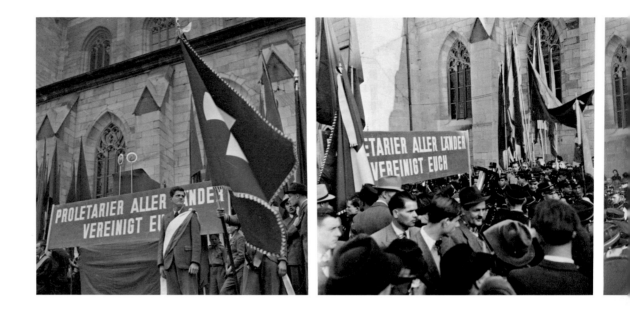

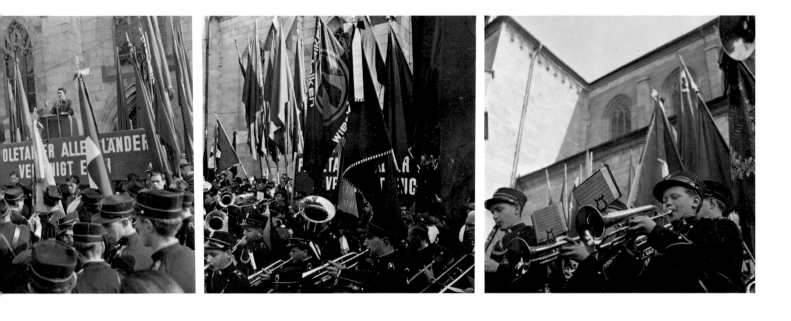

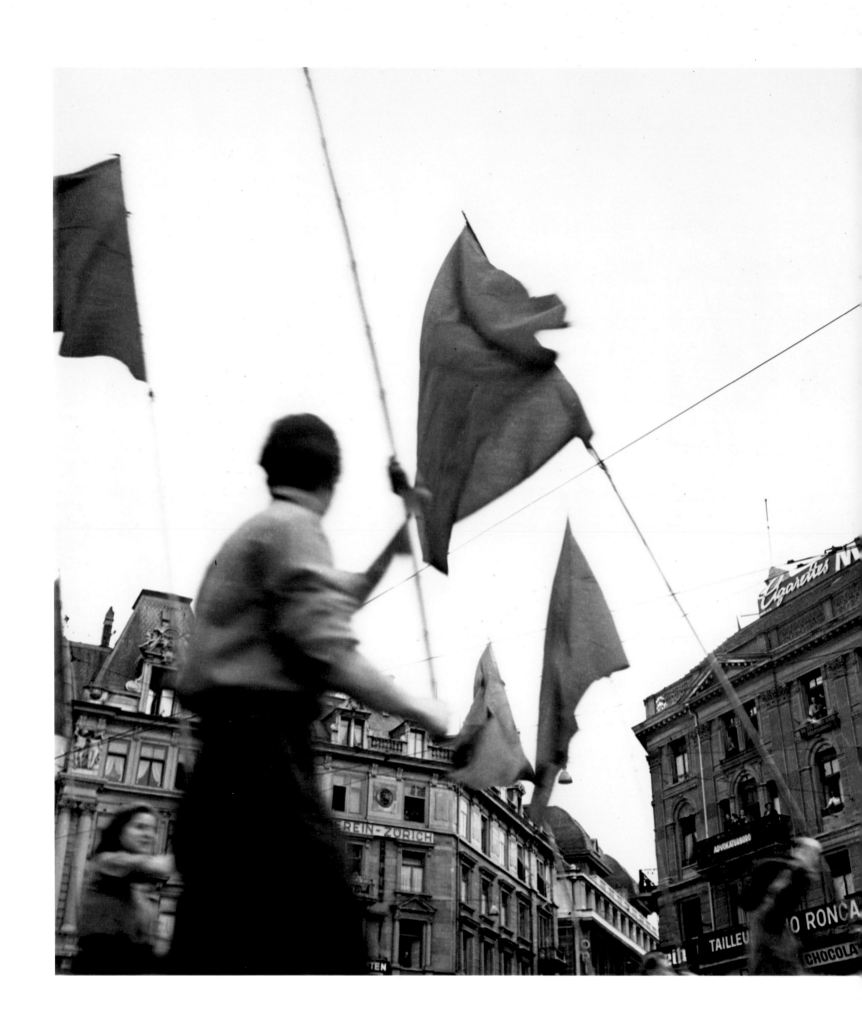

18 Zurich, 1945

In 1957 Robert Frank, nearing the end of his work on his seminal body of photographs *The Americans,* traveled to Washington, D.C., to record the inauguration of Dwight D. Eisenhower and Richard M. Nixon. Fascinated with symbols of power, he photographed national monuments such as the Capitol as well as politicians, bureaucrats, and others who populated this city's streets and corridors. And like so many other visitors, he went to the National Gallery of Art, possibly to see whether the art of this country rivaled its political, economic, and military strength. He photographed visitors seated in the galleries and a friend relaxing at the base of the fountain in the rotunda.

In the years after 1957 Frank established himself as one of the most important and influential photographers of all time. His photographs made in the United States in the 1950s cut through the clichés and sentimentality that had characterized most photography of the postwar era. With these prescient images Frank redefined the icons of America, noting that cars, juke boxes, diners, gas stations, even the road itself formed a far more truthful index of contemporary life than the majestic landscape that had once symbolized the nation. Moreover, he created an eloquent and compelling portrait of America. His intense and innovative photographs and films made in the last few decades continue to break accepted rules, expanding the expressive potential of his art. These highly autobiographical works address the artist's personal journey, his relationships with family and friends, and his connections to his physical environment.

In 1990, thirty-three years after his earlier visit, Frank returned to the National Gallery and presented it with a large gift of his work, including an important group of exhibition prints, a bound volume of original photographs titled *Black White and Things,* and a substantial archival collection of all of his negatives and accompanying contact sheets made before 1970 and more than a thousand work prints. To augment Frank's generous donation, the Gallery determined to acquire all of the photographs reproduced in the 1989 edition of his book *The Lines of My Hand,* a survey of his art from his earliest work in Switzerland during the 1940s to his work of the 1980s. In May 1994 Frank made an additional donation of exhibition prints and archival material. These gifts, along with the photographs from *The Lines of My Hand,* offer remarkable insights into his working methods and his intent and together constitute the Robert Frank Collection at the National Gallery of Art.

This exhibition *Robert Frank: Moving Out* and this book celebrate Robert Frank's magnificent donation and seek to explore the development of this American artist. The revolutionary nature of *The Americans* and the profound impact it has had on several

generations of artists, historians, and others have tended to overshadow Frank's art made before and after. By examining the work within the context of his whole oeuvre, the exhibition and book consider ideas that have invigorated his art throughout his career.

The formation of the Robert Frank Collection at the Gallery and the organization of the exhibition and publication have been complex undertakings. Both have been overseen by Sarah Greenough, curator of photographs at the National Gallery, working in close collaboration with Philip Brookman, curator of photography and media arts at the Corcoran Gallery of Art. They have selected the works in the exhibition and determined the nature, scope, and content of the essays, and they have been privileged to consult the artist himself on all aspects of the exhibition and publication. We are most grateful to Mr. Frank and to his wife, the artist June Leaf, for their willingness to devote time to this project and to lend so generously to the exhibition. Peter MacGill, of Pace/MacGill Gallery, New York, has greatly facilitated our work, and we wish to extend to him our sincere thanks.

The Gallery is extremely grateful to Lannan Foundation and its president J. Patrick Lannan and director Lisa Lyons and also to Polaroid Corporation and its vice president of corporate communications Sam Yanes for making this important exhibition possible. Their enthusiastic response and commitment to all aspects of this project have enabled us to realize fully our vision.

We wish also to thank Michael Ward Stout, Mame Kennedy, and The Robert Mapplethorpe Foundation; Rosemarie Simmen, Urs Frauchiger, and Pro Helvetia, Arts Council of Switzerland; and The Circle of the National Gallery of Art for additional support for the exhibition and this publication. We would also particularly like to thank the many individuals and foundations noted in the curators' acknowledgments who have donated funds to enable us to acquire the photographs from *The Lines of My Hand.*

Finally, it is a sign of the high regard in which Frank is held that lenders have been so generous in parting with their works for the duration of this exhibition, and all of us involved in this endeavor wish to express our deep gratitude to them.

Earl A. Powell III
Director

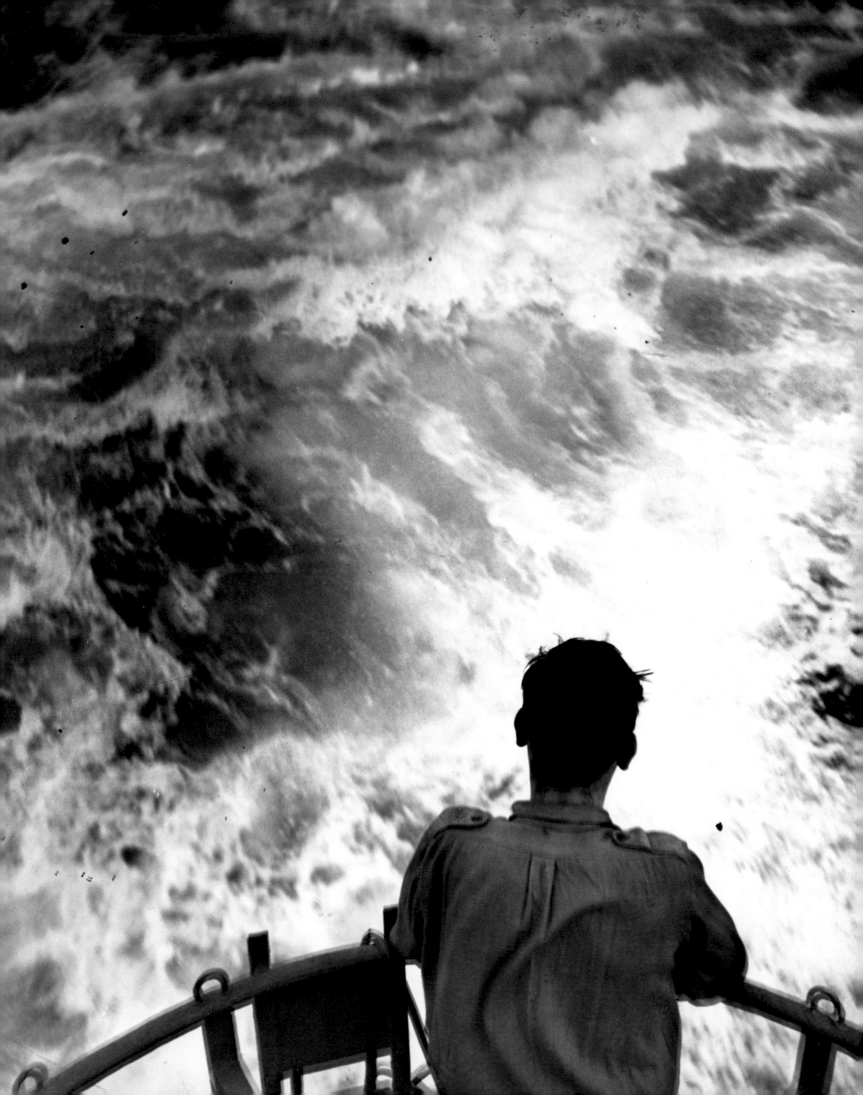

MOVING OUT: AN INTRODUCTION

In the last thirty years Robert Frank has become something of a hero to several generations of artists, for both his art and the events of his life are so compelling that they provide fertile ground for the growth of popular legend. In 1947, at the age of twenty-two, he emigrated from his native Switzerland to the United States, leaving behind a secure if constrained and predictable existence. Although he quickly achieved a certain degree of commercial success, he was never comfortable working for others and conforming to the expectations of society, and so he wandered from New York to South America to Paris, Spain, London, and Wales, in search of something more. A man of great, if quiet ambition, Frank returned to the United States in 1953 and embarked upon a project with epic proportions and far-ranging consequences: he sought no less than to document a civilization. The resulting publication, *The Americans,* was—and continues to be—a startling revelation. At a time when this country promoted a wholesome and unambiguous image of itself, Frank looked beneath the surface, scrutinizing the culture with an honest but passionate vision to reveal a profound sense of alienation, angst, and loneliness.

While *The Americans* was a clarion call to many who saw it as an affirmation of their sense that all was not well with American cultural, social, and political values, it was a mantle of fame the photographer himself did not wear easily, and he soon abandoned still photography for what he found to be the more challenging medium of filmmaking. His first film, *Pull My Daisy,* made with and about many celebrated members of the beat generation, also was highly influential. As Frank's reputation burgeoned in the late 1960s, his reluctance to be involved in the cult of celebrity and his desire to change his life radically propelled him to a remote corner of Nova Scotia, Canada. There he not only experienced the solitude of nature, but also endured a series of personal tragedies. Yet he continued to work, making some of the most innovative art of his career. These photographs and films speak less about American culture and politics and more about his own internal state; they express feelings for his family and friends, his past and present, and they address the issues of time, memory, change, and continuity.

It would be appropriate, even meritorious, to erect a monument to these accomplishments, this determination and conviction, but ultimately it would not be enough, for it would not be in keeping with the man, nor would it elucidate his art. As Frank himself has said, "Monuments are passionate statements of

hope—heroes and heaven. Life is more." This book and the exhibition it accompanies strive not simply to aggrandize the celebrated feats but to present the evolution of his art from its early manifestations in Switzerland during World War II to its mature expressions of the 1990s. The five essays in this book—on Frank's early years in Switzerland, his exploration of photographic sequences, the autobiographical nature of his art, his films and videos, and the recent work—explore not only the ideas that unite and enrich this long career, but also the innovative leaps as well as the radical and often disturbing breaks that fracture his journey.

As both the book and exhibition demonstrate, nothing about Frank's development is safe or predictable, nor is his art precise or polished. For more than fifty years he has, at times with ruthless abandon, absorbed, exploited, and rejected not only different subject matter, styles, and media, but also different objectives and ideas. The restlessness that pervades both the man and his art has consistently forced him to rebel against repetition and stasis, as well as all that threatens to confine, define, or pull him backward. Struggling to stretch the boundaries of expression, he has always actively courted tension, chaos, and a lack of control, pushing himself, both literally and metaphorically, to the edge, moving out and on. Particularly in recent years, his films and photographs have been characterized by a questioning and agitated spirit, and a need to challenge—even to destroy—as much as to create. This restless will has continually propelled him toward greater clarity and greater honesty. As he would say, he is always moving toward "less taste and more spirit...less art and more truth."

Sarah Greenough and Philip Brookman

Dear Parents,

Never have I experienced so much in one week as here.

I feel as if I'm in a film. Life here is very different than in Europe.

Only the moment counts, nobody seems to care about

what he'll do tomorrow.

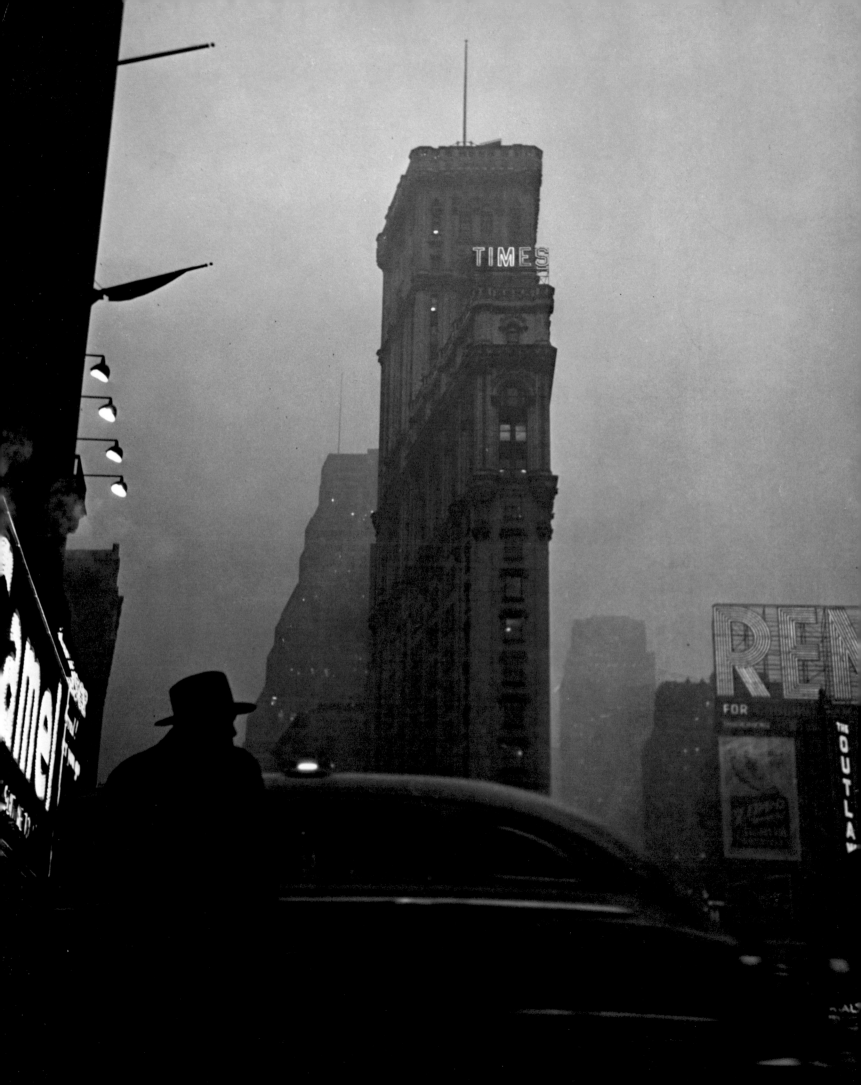

28 NYC for A.B., 1947

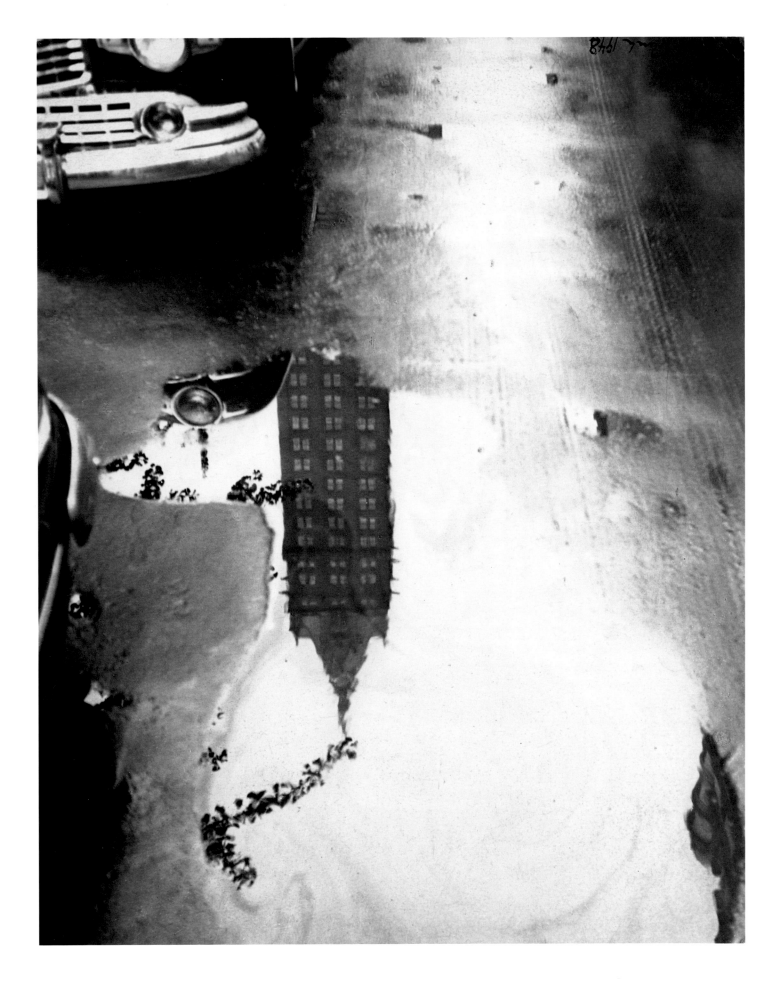

Central Park South, 1948 **29**

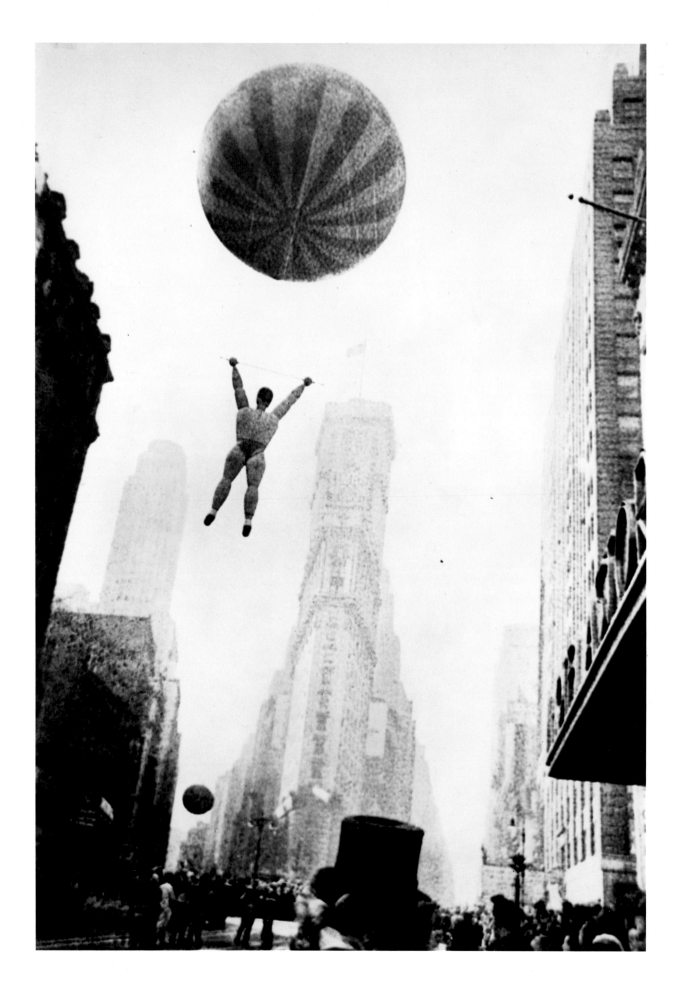

30 Men of Air, New York, 1947
Street Line, New York, 1951

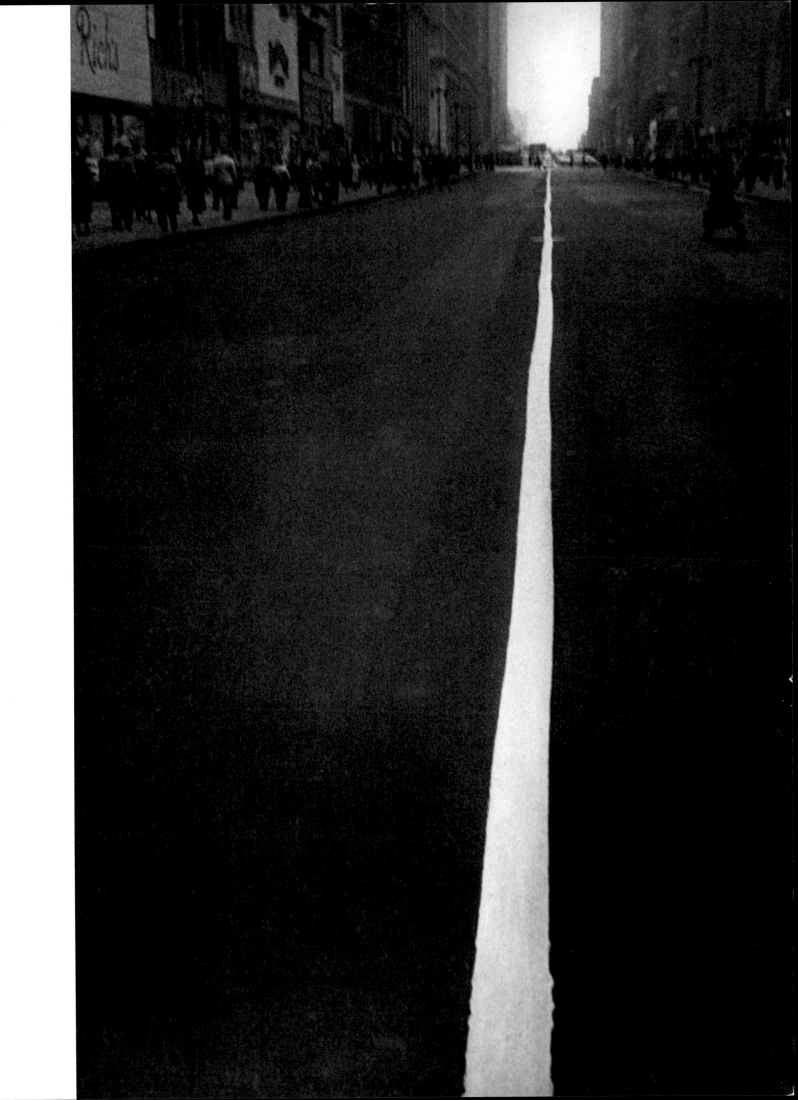

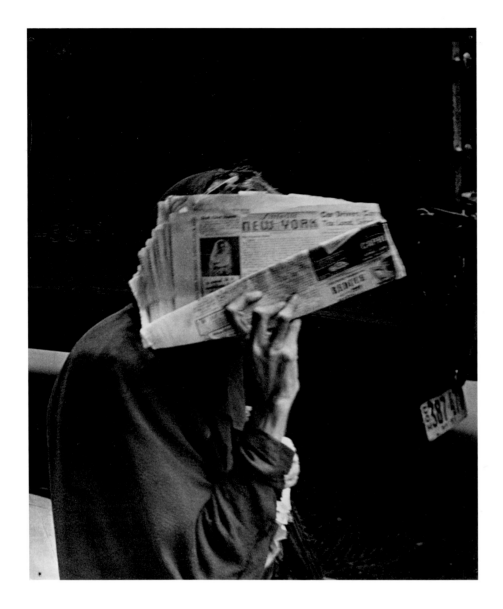

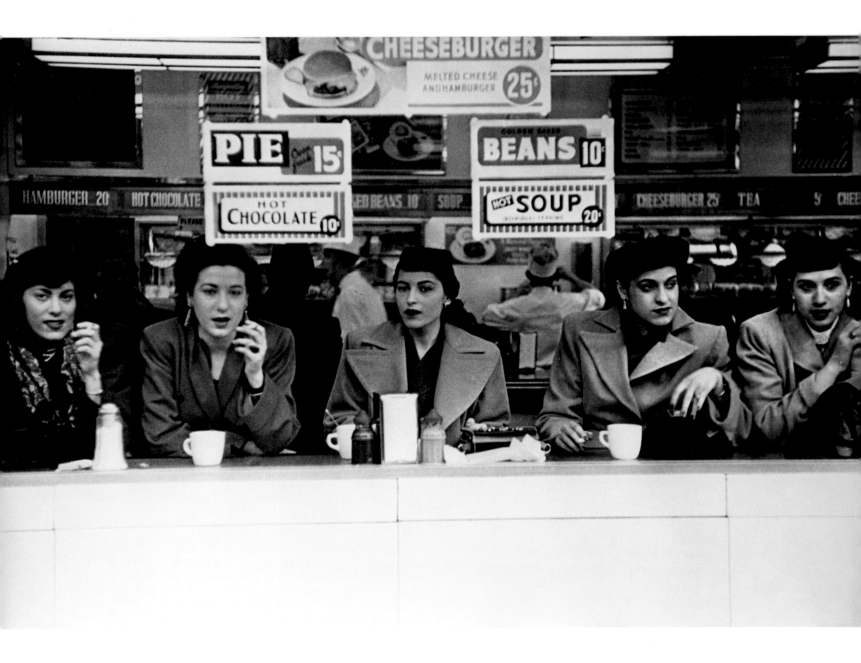

14th Street White Tower, New York City, 1948 **33**

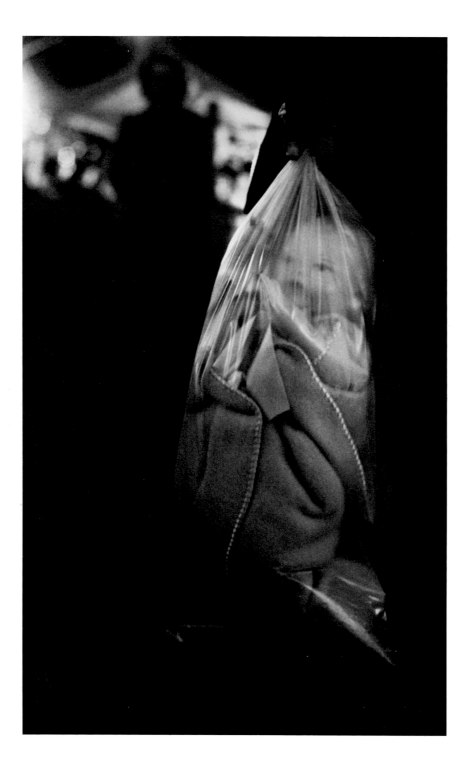

34 Doll, New York, 1949
Medals, New York, 1951

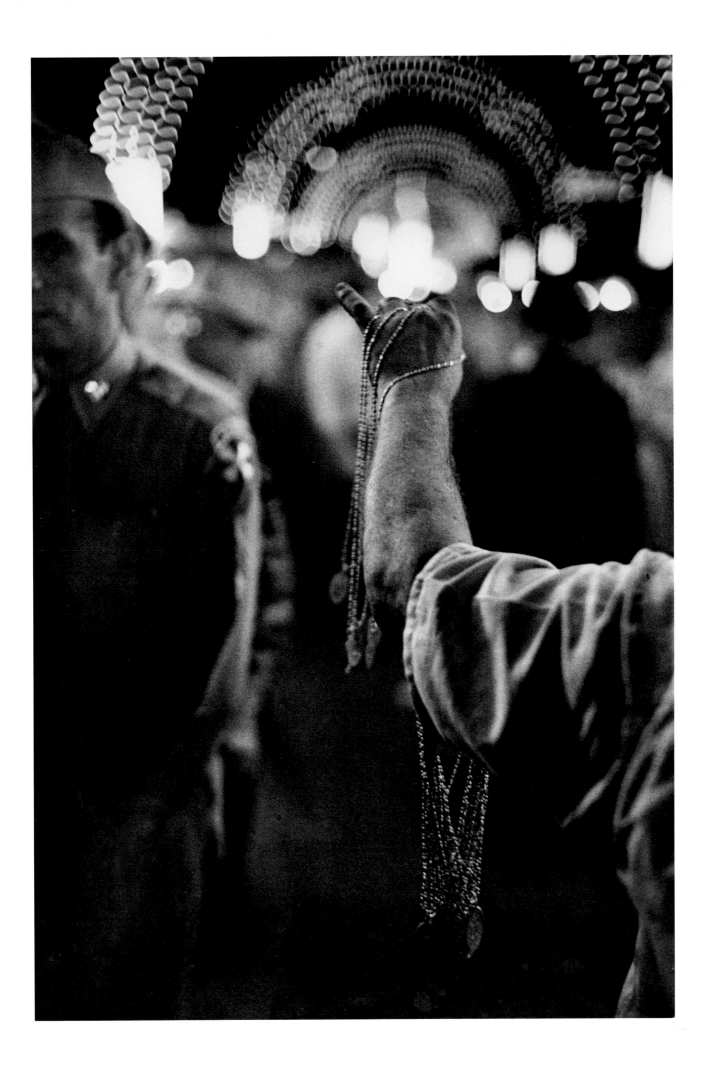

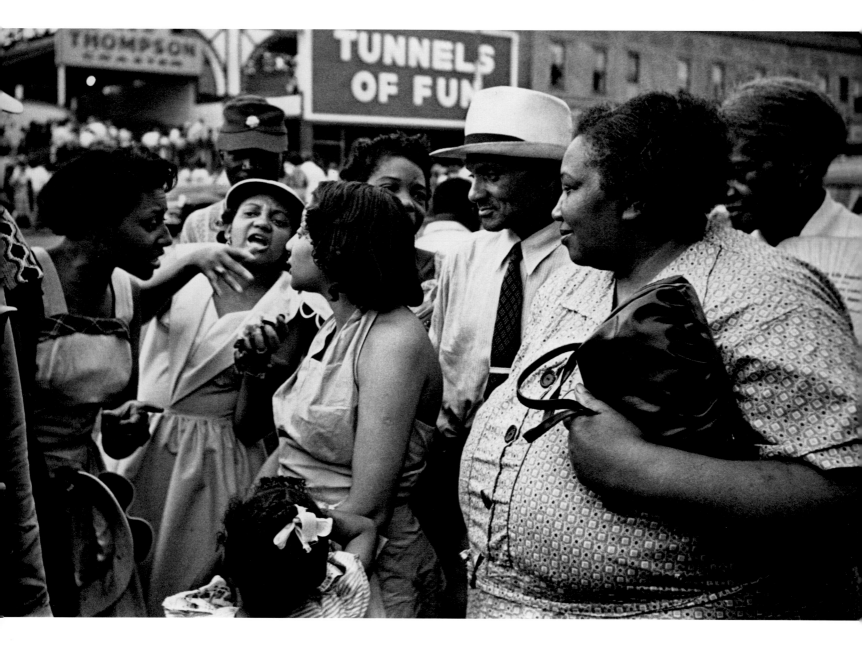

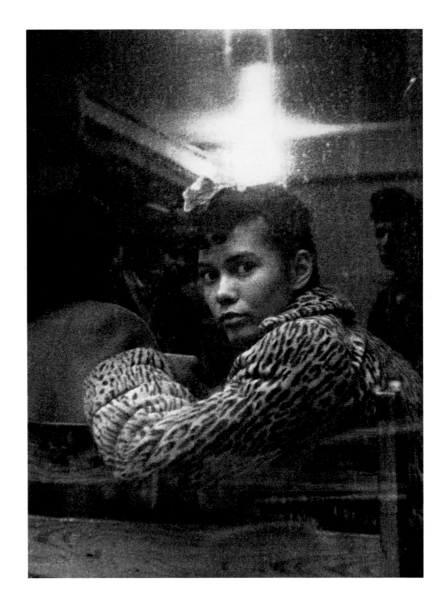

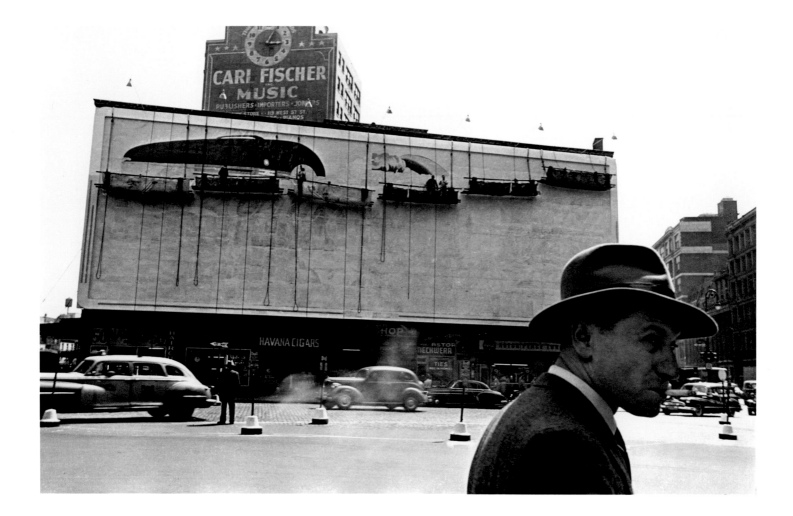

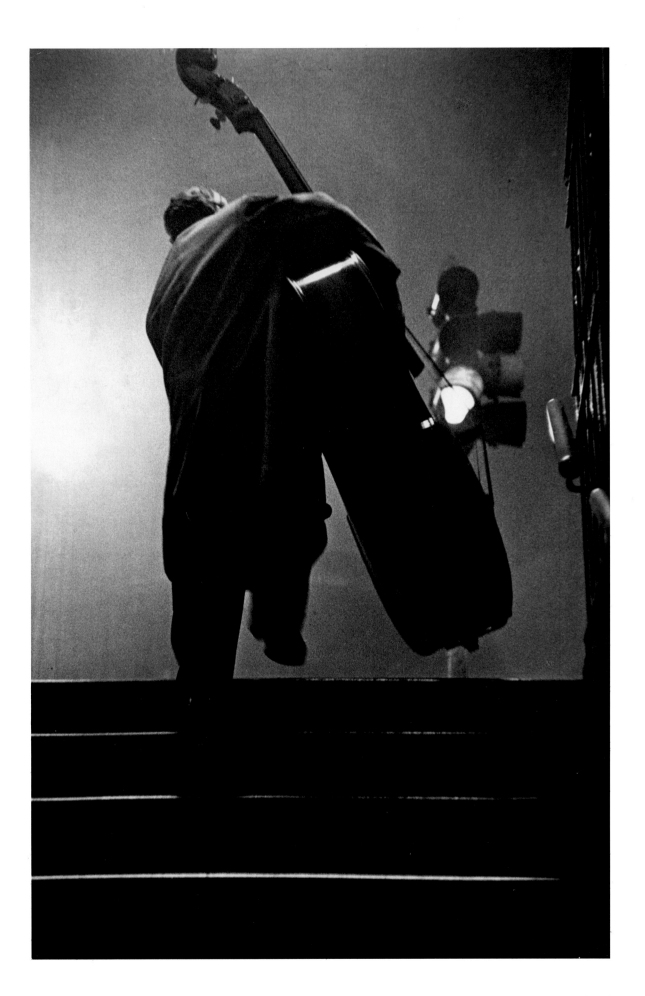

New York Subway, 1953　**39**

Zurich to New York
"Robert Frank, Swiss, unobtrusive, nice…"

In 1990 Robert Frank sent a friend in Switzerland five photographs that he had made almost fifty years ago—four of a May Day parade in Zurich and one of a Swiss flag on a mountain top. Beneath the images, Frank wrote: "I am a Swiss boy and love my homeland."[1] The irony of this remark is unmistakable: in 1990 Frank was not a boy, nor did he appear to take particular pride in being born in Switzerland. He had spent most of his adult life far beyond what he more than once referred to as the smallness of his homeland. Since 1946 he has photographed in France, Italy, Belgium, Peru, Bolivia, Spain, England, Wales, and Canada, as well as throughout the United States, but only occasionally has he made Switzerland the subject of his art. Moreover, like many artists and intellectuals before and after him, he had left the "Enge" (narrowness) of Switzerland, with its oppressive moral values and concerns for prosperity and social position.[2] And yet, in several respects his statement is true. Without doubt, when he made these photographs in the early 1940s, Frank had wanted to be a good Swiss boy who loved his homeland.[3] As a youth, he was a member of the boy scouts, and, like many of his peers, an avid mountain climber and skier. He also served in the military and joined the mountain infantry. In addition, many of his photographs celebrate symbols, such as the flag and the mountains, of Swiss national pride, unity, and strength. Moreover, Frank's remark, which was written in 1990 in the present tense, indicates his own continuing awareness of the importance of his Swiss heritage. His past has indelibly shaped his vision of the world, his understanding of his position within that world, and of course, the nature of his art.[4]

Frank grew up during the economic and political chaos of the 1930s and 1940s, but his childhood, at least on one level, was relatively calm and secure. Born on 9 November 1924 in Zurich, Robert Louis Frank was the second son of Hermann and Regina Frank. His father, an interior designer from a Jewish family in Frankfurt-am-Main, emigrated to Switzerland after the end of World War I. In Basel he married Regina Zucker, the daughter of a wealthy factory owner. A successful businessman, Hermann Frank established the APCO company in Zurich to import Luxor radios from Sweden. His acumen enabled the family to live comfortably, in a well-appointed apartment with a maid, in the Enge district near the lake.[5] The Franks were close to many of their relatives, especially the family of Robert's cousins Claude and Roger Brunschwig whose father owned a hat factory in Zurich. The two families often vacationed together in the Alps or in Italy or France. Hermann Frank also had some talent as an artist and collected a few oil paintings—

mostly realistic landscapes—as well as drawings and miniatures painted on ivory. Frank's mother also drew well but, for as long as Frank could recall, she suffered from serious eye problems. Despite intensive treatment, her vision gradually deteriorated until she was practically blind.

While Frank was in secondary school, he, like his elder brother Manfred, joined a boy scout troop where he was given the nickname "Brush" because of his wild hair. Although it was a strenuous, almost military organization, Frank enjoyed the boy scouts, for he liked being away from home and on his own.[6] He made many friends, eagerly indulged his interests in athletics, including swimming, hiking, skating, and skiing, and was introduced to mountain climbing. He soon became a passionate climber and after completing several high mountain tours, including one to the Dent Blanche, a "Viertausender" (a mountain higher than 4,000 meters), he joined the Swiss Alpine Club.

Yet, while Frank's activities would seem to epitomize those of any middle-class Swiss youth of the time, he was different from many of his peers. Frank recalls that his father, who was exceptionally well-educated, spoke English and French fluently, and could recite whole pages of Goethe's *Faust* from memory, refused to learn Swiss German. "He considered it an inhuman language. I was very embarrassed at my father; he couldn't speak the way we did."[7] Although Frank himself did speak Swiss German perfectly, he too was an outsider both because he was Jewish, in a culture that had at least some latent anti-semitism and because, even though his mother was Swiss, Frank, like his father, was a German citizen. Hitler's decree of 25 November 1941, denying citizenship to all German Jews, rendered the Frank family stateless and forced Hermann Frank to deposit 10,000 Swiss francs as a bond, permitting him to retain his Zurich residence and continue his business. He also immediately applied for citizenship for himself and his two sons. In the application it was required that the "Fremdenpolizei" (aliens branch of the police) be offered evidence that the "two upright youths were well able to cope with life," were "fully assimilated," and had "absolutely nothing Jewish about them anymore."[8] Robert and his brother Manfred Frank were not granted Swiss citizenship until 24 April 1945, just days before the end of the war.[9]

During this time, Frank, like most people in Switzerland, was well aware of the persecution of Jews in Germany. Shortly before the outbreak of the war, a German cousin came to Switzerland to attend school and live with the Frank family. She was allowed to stay in Zurich, but the Swiss borders remained closed to her parents, who ultimately were victims of the Holocaust. Although nominally secure, the Frank family lived with a very real sense of imminent danger. Frank vividly recalls the fear in his parents' faces as they listened to Hitler condemning the Jews in the speeches that were broadcast over the radio: "…if Hitler had invaded Switzerland—and there was very little to stop him—that would have been the end of them. It was an unforgettable situation. I watched the grownups

Detrola Camera, c. 1942

decide what to do—when to change your name, whatever. It's on the radio every day. You hear that guy talking—threatening—cursing the Jews. It's forever in your mind—like a smell, the voice of that man...."[10]

During his last year in secondary school, Frank was indecisive about what profession to pursue. He became infatuated with the *Landi 39* (the Swiss National Exhibition) being held just a few blocks away from his parents' home. Taking place on the eve of World War II, this exhibition was a powerful manifestation of the "Geistige Landesverteidigung," a movement that asserted the people's spiritual, cultural, and military will for self-defense and independence. This demonstration of Swiss identity, unity, and strength profoundly impressed Frank. He probably saw the photography exhibitions in the photo pavilion on popular themes of the time: portraits of the different types of Swiss people (to demonstrate unity), studies of the daily bread (to stress the simple life and self-sufficiency), and photographs of the Swiss landscape (celebrating the symbols of both Switzerland's origin and final refuge in case of war). All of these were themes that Frank himself would soon explore.

After Frank graduated from secondary school in 1940, his parents sent him to the Institut Jomini in Payerne, in the French-speaking part of Switzerland, to improve his French. It was only after his return to Zurich in late 1940, when he needed a profession, that he thought of becoming a photographer. To be sure, as a twelve-year-old he had experienced the "magic" of photography at a carnival in Viareggio, Italy, while vacationing there with his family. He had seen his father photograph the family with either a Leica or a stereo camera, and he had been fascinated by looking at the stereo pictures in his special viewer.[11] However, it was not a profession that either he or his parents would have envisioned. As a tolerated foreigner, he could only perform volunteer work; he could not enter a formal training program in photography, or earn a salary. Therefore, it may have seemed logical to him to volunteer for Hermann Segesser who operated a "Fotografik" studio in the attic apartment in the same building where the Frank family lived. Initially, Frank's father was not impressed with his son's chosen profession: for him photography was a hobby, not a means to earn a living. As no alternative materialized, though, he acquiesced, and Frank began an unsalaried apprenticeship with Segesser in January 1941.[12]

The apprenticeship, which lasted a little more than a year, taught Frank such basic tasks as mixing chemicals, developing, exposure techniques, and retouching, as well as more complicated aspects of graphic design such as photo- and typographical montage. Segesser also introduced him to modern art, especially the work of Paul Klee, which in spirit and intent was radically different from the more conventional art collected by Frank's father. It was during this time that Frank increasingly came to understand that the most creative artists broke rules, took risks, and "that art permitted you to be absolutely free."[13] As a parting gift, Segesser, who also painted, gave Frank a small oil painting of the open sea.

This expansion of Frank's vision continued with his brief work as a still photographer for the films *Landammann Stauffacher* and *Steibruch,* both dealing with issues of political freedom and personal liberty. More significantly, he continued his training at Michael Wolgensinger's studio in Zurich from 1942 to 1944.[14] Wolgensinger had audited classes taught by the influential Swiss photographer Hans Finsler and served as his assistant at the Kunstgewerbeschule (School of Arts and Crafts) in Zurich before opening a commercial photographic studio in 1937.[15] Finsler, a member of the "Werkbund," was one of the first Swiss photographers to espouse the style of the New Photography group which, like the f-64 group in the United States, stressed clarity of vision, the "straight" use of photographic technique, sharp focus, and truthfulness to the form and material qualities of the objects before the camera.[16]

Frank's early photographs clearly indicate that Wolgensinger passed the aesthetic ideals of the New Photography on to his pupils. Frank quickly became adept not only at arranging his subjects to emphasize their formal structure and physical properties but also—perhaps influenced by the early work of Werner Bischof, another of Finsler's students—at effective lighting.[17] A clever technician, Frank appears to have adopted Wolgensinger's credo: "Photography is the representation of reality—its mission is to convey essence, form and atmosphere. When these elements are appropriately balanced, the charm and authenticity of an object emerge."[18] According to Friedrich Engesser, another apprentice who along with Ditty van der Poel worked in Wolgensinger's studio at the time, one or more of them helped Wolgensinger either as assistants or lighting aides. Thus, the students learned a great deal about the profession through practical, hands-on experience. Despite rationing, Wolgensinger sometimes gave his pupils photographic materials for their own use, and when he was away, they experimented with his cameras and lights, or they photographed one another.[19]

Wolgensinger taught Frank to contact-print his own 2 ¼ inch negatives; to cut, number, and order them by topic; and to glue them onto cardboard filing sheets.[20] Among his early images are many sport and landscape views, scenes of Zurich—especially of his home district, the Enge, and the adjacent lake—and journalistic shots of national holiday celebrations and local festivals such as the "Knabenschiessen" and the "Sechseläuten." One

Grapes, 1944–1946

sheet of photographs shows billboards and advertisement pillars throughout the city with posters for Luxor radios.

Despite the strong formal emphasis of his training, Frank made several extended documentary studies of subjects that were especially important to the Swiss people and were popular in illustrated journals of the time, such as the *Zürcher Illustrierte*. Beginning in 1929, Arnold Kübler had turned this weekly into an illustrated magazine of international reputation, which increasingly addressed problems of everyday life and later, as the political situation in Europe worsened, themes related to the "Geistige Landesverteidigung." Kübler put great emphasis on photographs that at once communicated information and embodied strong aesthetic qualities, but since few journalistic photographers followed his precepts, he educated and cultivated his own team of photographers. Foremost among those whose pictures appeared in the pages of the *Zürcher Illustrierte* were Hans Staub,

Paul Senn, Gotthard Schuh, Ernst Mettler, Jakob Tuggener, Walter Läubli, and Werner Bischof.[21] After the magazine folded in 1941, Kübler became editor of its successor, the cultural monthly *du*. Its first issue was devoted to the so-called "Anbauschlacht" (cultivation battle), the wartime plan to use all arable land in Switzerland, including parks and sports fields, for agricultural purposes.[22] It is not surprising that one of Frank's first attempts at reportage deals with this same topic. Like Wolgensinger, he photographed the wheat field on the "Bellevue" in the center of Zurich as well as farmers harvesting the grain, against the backdrop of the city.[23] Frank's first documentary study also has to be seen in the context of the Swiss efforts at self-sufficiency from the years 1942 to 1944. In thirty-four pictures, Frank documented the arrival, unloading, and sale at market stands of Swiss grapes, which were offered under the slogan "Fruchtzucker erhöht die Gesundheit" (fructose improves health).

In his final evaluation of Frank, Wolgensinger wrote, "He approaches every task assigned to him efficiently and with enthusiasm. In everything he undertakes he is aided by

his intelligence, his good education, and his farsightedness even for things outside the purview of his job."[24] Luzzi Wolgensinger, who helped run her husband's business, recalls that Frank was well-spoken and argued convincingly. From the beginning she realized he would not stay very long, because his opinions were not compatible with either the commercial orientation of the studio, or with the dominant Swiss bourgeois mentality. She remembers Frank as someone with an "expansive" outlook who was unclear on exactly what he was searching for and was an "unsettled" and "driven" young man. Recalling these years, Frank later said, "I didn't know exactly what I wanted but I sure knew what I didn't want."[25]

Frank left Wolgensinger's studio in September 1944 and over the next year worked briefly first for Victor Bouverat, a photographer in Geneva, and later for the well-known Basel studio of Hermann, Reinhold, and Willi Eidenbenz. Founded in 1933, it was the largest graphic and photographic studio in Switzerland at the time and also one of the most prestigious. As his employment certificate makes clear, Frank "was responsible for all darkroom work; oversaw the activities of one assistant and three apprentices; and assisted them in the completion of all assignments." Frank's friend Werner Zryd, then a graphic designer at the same firm, remembers that Frank had his hands full coordinating the darkroom work during the day, but that the laboratory was entirely at his disposal after business hours and at night.

At the end of his apprenticeship to Wolgensinger, Frank—like the other apprentices—had been required to produce a final portfolio. It followed the format and style of *12 Fotos,* one of the books that Wolgensinger prepared as New Year's gifts for his clients.[26] In the preface for his book, Wolgensinger wrote that it was designed to show "the diversity of work we can perform." In 1946, Frank made *40 Fotos,* a spiral-bound volume of images taken between 1941 and 1945.[27] Frank's *40 Fotos* included architectural, natural, and industrial objects, landscapes, and street scenes. Some of the photographs clearly are demonstrations of Frank's technical skills, while others celebrate mountains, the landscape, and peasant life in a spirit related to the "Geistige Landesverteidigung."[28] Emphasizing the prevalent feelings of Swiss patriotism, Frank shows the Swiss flag at the top of a mountain marking the very center of the Swiss identity with its defense strategy of the "réduit." Countless photographs of the flag were published at the time, and Frank's preoccupation with the Swiss flag was certainly related to the "Zeitgeist," but simultaneously it expressed his

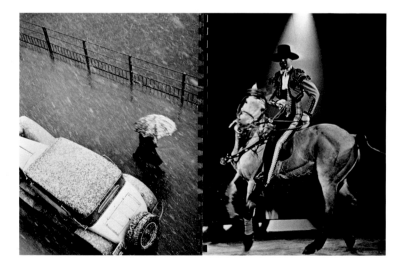

Michael Wolgensinger, *Winter* and *Variété* from *12 Fotos,* 1942

own search for his Swiss identity. Also included in *40 Fotos* are dynamic street photographs taken at public events such as the Zurich spring festival or the May Day parade, showing Frank's early fascination with traditional and political gatherings. While the typical low-angle Rolleiflex perspective is still prevalent in many of these photographs, others clearly point to his future style (pages 16–18). At the end of the book Frank himself is shown climbing to the peak of a mountain, set against a bright cloud.

Frank most likely made *40 Fotos* as a portfolio to be used on his search for a job. Although the position at the Eidenbenz studio was one that tested his technical skills and although Wolgensinger already had praised his "clean working habits"—a trait highly valued by his employers in particular but also by Swiss culture in general—Frank was clearly unchallenged and restless. These work habits, so deeply rooted in the Swiss mentality, corresponded strongly with the rationality and sobriety of the New Photography style. Finsler, Wolgensinger, and Eidenbenz continued to work in this idiom, even after the war, despite increasing criticism that it was in conflict with life itself. Aware of what was happening outside Switzerland, Frank was less and less able to identify with these "clean" attitudes toward work and life. Further, Frank had outgrown his parents' focus on "money and respectability,"[29] his father's authoritarian personality, and the way his mother treated his cousin and the maid. He recalls that "the family was not good, the atmosphere was not good," the result of "too much money, not enough challenge, too much comfort, and too many lies."[30] Rebelling against his parents, he joined the May Day parades and, together with a friend, intended to join the French "résistance."

With the war over, the borders open again, and his military service completed at the end of summer 1945, Frank, like many others, traveled through Europe. In 1946 he went with his father to Paris, where he looked unsuccessfully for work, and to Milan. Although he knew about the death, deprivation, and destruction of the war, the direct experience of its aftermath inspired him to depict its victims.[31] Although Frank remembers having been greatly impressed by the photographs Paul Senn took of refugees—particularly children—during the Spanish Civil War, he followed the lead of Werner Bischof, whose first photographs of the destruction of Europe were published in *du* beginning in 1945. Frank's few extant photographs from his trips to Paris, Milan, and later Brussels depict people struggling to survive among destroyed houses or walking on desolate streets. As with the earlier street photographs made in Switzerland, Frank, like many other photojournalists then working with the Rolleiflex, was still a somewhat uninvolved spectator. These photographs also mark his movement toward the kind of social observation that he would pursue further with his small Leica in South America, England, and Wales.

Frank decided to travel to America to pursue further training, as his two cousins had already done in November 1946.[32] For Frank and many other Swiss people of his generation, America was the "land of the free." In his case, these words were associated

with the fictitious world of adventure described in the novels of Karl May, and the freedom and democracy promised by the New Deal policies of Franklin D. Roosevelt, as well as safety for some Jews who had escaped the Holocaust. During this time, enthusiasm for America and American culture was very strong within Swiss society, encouraged by books, magazines, movies, and plays, such as Thornton Wilder's *The Skin of Our Teeth,* performed at the Schauspielhaus in Zurich.[33] Frank remembers being particularly impressed with this tragic parody, in which a New Jersey family survives a series of natural disasters, including extreme cold and a flood. The popularity of Wilder's play seemed to reflect the hope held by many Swiss citizens "of a new, America-oriented horizon."[34] Frank also read Jean-Paul Sartre's *Roads to Freedom* novels. The first volume, published in 1945, tells the story of the young Parisian Mathieu, who realizes that by leaving his pregnant girl friend, instead of marrying her, he lost both his love and his freedom. While avoiding political propagandizing, Sartre's novel embodies his existentialist philosophy, which strengthened Frank's resolve to make his own decisions, and to pursue his own road to freedom. As he later recalled, "The war was over and I wanted to get out of Switzerland. I didn't want to build my future there. The country was too closed, too small for me."[35]

After some difficulties Frank obtained passage to New York on the freighter S. S. James Bennett Moore on 20 February 1947. His first extended exposure to an American occurred on this trip. As he wrote to his parents, he was entertained by two fellow passengers, a bishop and a boorish American: "The American, a wild fellow, a gangster hat perched rakishly on his head, unshaven, the sauerkraut he eats with his fingers etc. Next to him, the bishop, red sash, huge crucifix on his chest, some rosaries, prays before he begins to eat etc. The waiter places the full plates on the table; the bishop crosses himself and mumbles a prayer while the American flicks off his cigarette and exclaims, Oh damned I'm hungry! How I laughed about this guy today."[36]

When Frank landed in New York in March 1947 he did not intend to abandon his Swiss homeland and take up permanent residence in the United States. However, he was overjoyed by the freedom he found, writing to his parents, "this country is really a free country. A person can do what he wants. Nobody asks to see your identification papers."[37] He was awed by New York. Soon after his arrival, he began regularly asking his parents to send such Swiss items as chocolate, cherry brandy, as well as Zurich newspapers and journals—he even asked for his ski equipment.[38] He told them, "I would not want to live here forever."[39] A few months later he reiterated this statement, writing, "I do not think I will remain here for very long. Everything goes so exceptionally fast and I am only one out of eight million people living here….The only thing that counts is MONEY. I now understand people who, after the war, despite the success they had in this country, returned to Switzerland to live."[40]

Unlike many other immigrants, Frank found work, but not without some difficulty. Through his contact with the Swiss graphic designer and photographer Herbert Matter, he showed his work to Alexey Brodovitch, art director at *Harper's Bazaar,* who hired him to take photographs both for *Harper's* and *Junior Bazaar.* His thorough training undoubtedly helped him persevere in a tough environment. He wanted to be successful both for himself and his parents but he was increasingly bothered by American business practices, particularly by the concept that "time is money." *Harper's* closed its in-house photography studio in January 1948 due to economic difficulties, and Frank left New York soon after.

Initially he traveled to Peru and Bolivia, and then in 1949 he returned to Europe, traveling in France, Spain, Italy, and Switzerland. There he photographed the "Landsgemeinde," the annual communal voting at the village of Hundwil in the Canton of Appenzell Ausserrhoden. It is significant that Frank chose to record this event, in which citizens gathered to discuss and vote on pending laws and to elect their government. Especially during the time of the "Geistige Landesverteidigung," this was one of Switzerland's most overtly symbolic manifestations of its direct democratic rule. Frank's aim was not so much to document the event—not to show how it worked or what it was all about—but rather to suggest how it felt to participate (as a person with the right to vote) in this spectacle. As his contact sheets clearly demonstrate, he eschewed the more traditional and privileged position of the news photographers who pushed their way to the center of the action. Instead he remained at some distance from the authorities, observing the action as a member of the crowd. He mingled with the citizens, recording their view of the proceedings, noting the spotless shine on the helmet of a fireman, the display of the traditional "Appenzeller" pipes, or the swords carried by the citizens to prove their right to vote. Through these vignettes Frank signaled that the ultimate political authority rested with the voters. More significantly, these photographs prefigure his future scrutiny of many social, political, and cultural events from a highly personal, outsider's perspective.

Also in 1949, Walter Läubli published in *Camera* magazine the first overview of Frank's early work, including his first photographs from New York and one from the "Landsgemeinde" in Hundwil. Läubli seems to have intended this publication to counter the charges leveled by Georg Schmidt in *Photo 49* that the most objective methods of the New Photography had become "a shield with which to hide the truth." Schmidt argued for "an eminently photographic desire to unearth hidden beauties and unpleasantnesses, to reveal forbidden truths, a photographic hankering after the anxiety as much as after the poetry of twilight," desires that usually "arouse the very strongest antipathy in the average Swiss mentality."[41] Frank's photographs seemed to accomplish exactly this. Läubli explained that Frank was someone who "out of a desire to experience life has gone out into the world and jumped into life with his camera," and

concluded, "we believe Robert Frank can teach us how to see...."

Between 1949 and 1953 Frank made several trips between Europe and the United States. Despite the fact that he married in 1950 and had a child in 1951, he was unwilling, or unable, to settle in one place for long. During these years he maintained close ties to Switzerland and stayed in Zurich for some time. In cooperation with Werner Zryd, he produced three copies of a hand-bound book, *Black White and Things,* and gave one to Edward Steichen, director of the department of photography at the Museum of Modern Art in New York. In 1952, Frank also took Steichen, who was looking for work to include in the forthcoming exhibitions *Postwar European Photography* and *Family of Man,* to the studios of several Swiss photographers, including Gotthard Schuh, Kurt Blum, and Jakob Tuggener. Mainly through his friendship with Schuh, Frank came to the attention of the Kollegium Schweizerischer Photographen (Academy of Swiss Photographers). Founded in 1950 as another re-

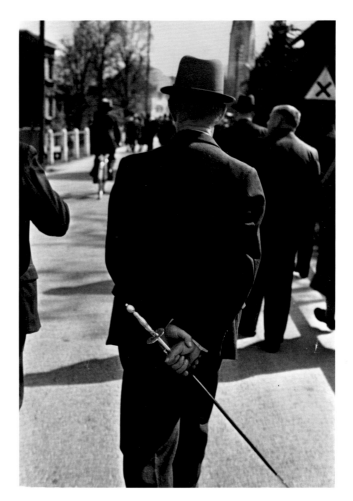

Landsgemeinde, 1949

action to the outdated aesthetics of the New Photography, this group, including Bischof, Schuh, Senn, Tuggener, and Läubli, tried to make its work "more wholesome, concentrating again more on the poetry of real things."[42] Frank was included as a member in the second major exhibition of the academy entitled *Photography as Expression* at the Helmhaus in Zurich, in 1955. His work was highly praised. "Frank belongs to the very personal," Edwin Arnet wrote. "Eschewing the officially sanctioned, he searches for intimate secrets like a hunter stalking a deer." Noting with relief that the New Photography style of the immediate postwar years finally seemed to have waned, Arnet continued that Frank, along with other members of the academy, represented a specifically Swiss outlook, which united the "unarranged, the discreet, and the completely un-theatrical" with an "unmistakable human touch."[43] In his first exhibition in Switzerland, Frank was hailed for his distinctly Swiss style. Despite the fact that he had spent much of the last eight years beyond the Swiss borders, none of the critics considered him to be an outsider and none reviewed his American photographs in the exhibition.[44]

By the time of this exhibition, though, Frank was far removed from Switzerland. In 1953 he had returned to America, "not with a great deal of enthusiasm," as he wrote to his

parents. "This is the last time that I go back to New York," he continued, "and try to reach the top through my personal work."[45] Like other Swiss photographers such as Annemarie Schwarzenbach, Paul Senn, Walter Läubli, and Emil Schulthess, Frank decided to travel across the United States to document with fresh European eyes "the kind of civilization born here and spreading elsewhere."[46] Although in his application for a Guggenheim Foundation grant he referred to himself as "a naturalized American," he had shortly before admitted to Schuh that notwithstanding his rather "funny" sounding German, he "had not yet become much of an American."[47] During the next four years Frank would immerse himself in American culture. Even though Jack Kerouac described Frank as "Swiss, unobtrusive, nice"[48] in the introduction to the American edition of *The Americans,* published in 1959, Frank would forever be associated with the American spirit and culture.

Were Frank's photographs of America an expression of the freedom he dreamed about before leaving Switzerland? After all, when he left the "Enge," he took with him Segesser's painting of the open sea, and kept it with him throughout his career, even taking it with him to his retreat on the Nova Scotia coast. Following his journey across America during the 1950s, he sent some of the pictures back to Schuh in Switzerland, who was shocked, and wrote to Frank, "Your disturbing package has arrived and does not let us sleep anymore. A long time will have to pass before we can separate the impression of this world conveyed by your images from our respect for your exceptional achievement." Overcome, Schuh continued, "Never before have I seen such an overpowering depiction of mankind who became a mass of people hardly distinguishable one from another, seemingly moving in a vacuum without direction at all. A dour mass of insidious aggressiveness....[49] I do not know America, but your photographs scare me....How little one finds of what we knew and of what we loved in your earlier work."[50] Frank had photographed a side of America unknown to the Swiss, an America that had perhaps made Frank into a different person. In a 1993 letter, he described the Segesser painting, "It is...just the water (the sea) it is peaceful it is alive & moving with the wind and currents from below. It seems to have a prophetic quality feeling—this man in the little attic room below the roof in the Schulhausstrasse 73 gives this boy—going away from home—his understanding or longing for freedom for space for mystery for nature. All this I would begin to understand much later...and try to express in my work...."[51]

Notes

1. The original German text reads, "Ich bin ein Schweizer-Knabe und hab die Heimat lieb…"

2. For a discussion of the spiritual narrowness of Switzerland, which prompted a great many Swiss artists to leave the country and work elsewhere in places less disconnected from history and the "power circuit" of the time, see Paul Nizon, *Diskurs in der Enge. Aufsätze zur Schweizer Kunst* (Bern: Kandelaber, 1970). Also see Hans Ulrich Jost, "Bedrohung und Enge," in *Geschichte der Schweiz und der Schweizer,* vol. 3 (Basel and Frankfurt-am-Main: Helbing and Lichtenhahn, 1983), 101–183.

3. Frank repeatedly stated that he was raised by his mother to be a "good Swiss boy." See "Bericht über den Bürgerrechtsbewerber" (report on the applicant for citizenship), dated 4 October 1944, Zurich City Archives.

4. The information available regarding Frank's years in Switzerland is extremely sparse, limited to a few passages of often vague and misleading details. The fullest account is "Dates and Events 1924–1971," in *The Lines of My Hand* (Tokyo: Yugensha, 1972), 17. In interviews Frank regularly eluded questions about his past, believing that to remember impeded his current work and hindered his imminent development. Exceptions are interviews in "The Pictures are a Necessity: Robert Frank in Rochester, NY, November 1988," edited by William S. Johnson, *Rochester Film and Photo Consortium Occasional Papers* no. 2 (January 1989).

5. The district's name "Enge" (narrowness) most likely refers to the medieval description of a group of houses on a narrow strip of land. See Paul Guyer, *Die Geschichte der Enge* (Zurich: Orell-Füssli, 1980), 11–12.

6. As tensions increased with neighboring Germany in the 1930s, the Swiss boy scouts developed into a kind of preparatory course for the military. A delegation of Frank's scout corps, for instance, served as honorary guard for a visit of General Henri Guisan, the commander-in-chief of the Swiss Army, in Zurich in October 1939. See Alfred Cattani, *Zürich im Zweiten Weltkrieg* (Zurich: Verlag Neue Zürcher Zeitung, 1989), 20.

7. "The Pictures are a Necessity," 160.

8. Several letters and reports, among them the first application to the federal police and justice department, 24 December 1941, and a "Leumundsbericht" (character report written by the aliens branch of the police), 21 June 1943, Zurich City Archives, document the lengthy proceedings. Frank remembers that citizenship was denied to his father on grounds that he was not assimilated enough. A goal of the "Fremdenpolizei" was to "prevent Switzerland from becoming Jewish." Heinrich Rothenmund, then chief of the aliens branch of the police, quoted in Jost 1983, 113; also see 153–158.

9. Documents in the Zurich City Archives.

10. "The Pictures are a Necessity," 26. Frank recalls that his father followed the war fronts with pins on the map but that he never spoke of the fate of his relatives in Germany. During the critical time in May and June 1941, after the defeat of Belgium and Holland, the Frank and Brunschwig families—like many others in the northern part of Switzerland—feared an invasion by the Nazis and moved briefly to the mountain village of Château-d'Oex. For a discussion of the situation in Zurich during those months see Cattani 1989, 22–31.

11. Also see *Robert Frank: New York to Nova Scotia,* Anne W. Tucker and Philip Brookman, eds. (New York: New York Graphic Society, 1986), 82.

12. Although it was Frank's elder brother Manfred who was expected to enter their father's business and he did so against his will, Frank later said, "I took up photography, as a first little step out of the orbit they [the parents] proscribed for me." "The Pictures are a Necessity," 28.

13. "The Pictures are a Necessity," 28.

14. Arranged by his father, Frank served as a stand-in for the still photographer for *Landamman Stauffacher* directed by Leopold Lindtberg in 1941. The movie dealt with the tense times on the eve of one of the wars of liberation of the young Swiss Confederation in 1315, a situation similar to the one after the defeat of France in summer 1940. In the spirit of the "Geistige Landesverteidigung" the movie was understood as a direct appeal to spiritual and military resistance against Nazi Germany. See Hervé Dumont, *Geschichte des Schweizer Films* (Lausanne: Schweizer Film Archiv, 1987), 303–336. Although Dumont lists Frank as the only photographer for this film, Frank states that none of the photographs published in the brochure to the film is his. Immediately after his apprenticeship with Segesser, Frank accepted a three-month position as an assistant to the still photographer on Sigrit Steiner's movie *Steibruch*. A provocative social drama, it is about an ex-convict suspected of murder, an outsider who must defend himself against a society which

includes intolerant and opportunistic peasants, a crude policeman, and a fascist teacher. See Dumont 1987, 242–245. Work on these two films intensified Frank's own interest in filmmaking, which might have been initiated by the amateur family films made by his uncle Jules since the middle 1930s. Most likely also under the influence of Michael Wolgensinger, who made cultural films, Frank began considering giving up photography to become a filmmaker as early as 1943.

15 See *Camera* 12 (December 1956), 577–596.

16 See *Hans Finsler. Neue Wege der Photographie.* Klaus E. Göltz et. al., eds (Halle and Leipzig: Staatliche Galerie Moritzburg, Halle, and Edition Leipzig, 1991).

17 In "Drei Photos," *du* 1 (January 1942), Bischof's theme was light as the image-forming agent in both nature and photography. In the accompanying text (page 15) Klara Egger states: "Light gives us the objects, their forms. There, where darkness borders on light, the pictures emerge and our entire life." By this time Bischof was already well-known and Frank remembers seeing the early work of this "great man" in *du*. Conversation with the author, 31 December 1991.

18 Michael Wolgensinger in the preface to "12 Fotos" (Zurich, December 1942).

19 See Frank's portrait of Engesser operating the studio camera in *The Lines of My Hand* (New York: Lustrum Press, 1972), unpaginated.

20 This system is still apparent in Wolgensinger's own archive and was, for instance, also used by Paul Senn. See illustration in *Photographie in der Schweiz von 1840 bis heute.* Edited by the Schweizerische Stiftung für die Photographie (Bern: Benteli, 1992), 8.

21 As Guido Magnaguagno argues, the photographers active for the *Zürcher Illustrierte* formed something like a Swiss equivalent to the group of photographers working for the Farm Security Administration in the United States during the 1930s. See "Der Photojournalismus. Beginn und Entwicklung in den dreissiger Jahren", *Photographie in der Schweiz* (1992), 178–204.

22 The goal of the so-called "Plan Wahlen," introduced at the end of October 1940, was Switzerland's total self-sufficiency in the production of foodstuffs. See Cattani 1989, 80–85, and Jost 1983, 168–169.

23 At the time Wolgensinger was also taking photographs and shooting a film for a traveling exhibition dealing with the "Anbauschlacht."

24 "Zeugnis," 2 October 1944.

25 "The Pictures are a Necessity," 28.

26 I am grateful to Friedrich Engesser for providing me with a copy of this book of original photographs.

27 The front cover shows a human eye serving as a photographic lens, directly referring to both *photo-eye*, the seminal book published after the 1929 *Film und Foto* exhibition in Stuttgart, and the cover for the *Schweizerische Photo-Rundschau* designed by the Eidenbenz studio in 1944.

28 Frank observed the making of one of the important "Heimatbücher" of the time, Michael Wolgensinger's *Terra Ladina* (1944) about the mountain region "Engadin" in the Grisons. The photographs in this book clearly influenced the ones Frank was taking in the mountains at that time.

29 "The Pictures are a Necessity," 28.

30 Frank in conversations with the author and with Martin Schaub, 29 and 31 December 1991 in "Postkarten von überall und innere Narben", *Tages Anzeiger Magazin* 44 (3 November 1984), 13.

31 Similarly, Bischof made the "suffering face of mankind" the central motif of his work after directly encountering the misery caused by the war. Bischof quoted in Magnaguagno 1992, 202.

32 A "Welschlandaufenthalt" to improve French comprehension, in the French-speaking part of the country, or a stay abroad was part of the education and professional training of many Swiss middle-class youths.

33 For instance, in one issue of *du*, American culture was hailed as a "world culture of lasting value" and the twentieth century was described as the "American Century." *du* 11 (November 1945). In German Wilder's play was titled "Wir sind noch einmal davongekommen" (We've Escaped One More Time).

34 See Jost 1983, 183, and Cattani 1989, 144.

35 See "The Pictures are a Necessity," 26–29, and Tucker and Brookman 1986, 82.

36 Letter to his parents, 19 February 1947, private collection.

37 Letter to his parents, March 1947, translation in Tucker and Brookman 1986, 14.

38 He subscribed to *du* magazine and began receiving it regularly in November. Letters to his parents, 6 October and 9 November 1947, private collection.

39 Letter to his parents, March 1947, in Tucker and Brookman 1986, 14.

40 Letter to his parents, 17 November 1947, private collection.

41 Georg Schmidt, "Where do we stand?" in *Photo* 49 (Geneva: Publicité et arts graphiques, 1949), XX. Independently of the publication, an exhibition entitled "Photography in Switzerland—today" was held at the Gewerbemuseum Basel. Photographs by Wolgensinger and the Eidenbenz brothers were included prominently in both the exhibition and the book.

42 Edwin Arnet, *Camera* (3 March 1951), 74.

43 *Neue Zürcher Zeitung* (8 March 1955).

44 Apart from the photographs of Mary and their two small children, Frank showed *Rodeo, Yom Kippur,* and *Charity Ball,* all of which were later included in *The Americans.* Together with Tuggener and Gröebli he was seen as one of the most expressive members of the Kollegium. See, for example, Hermann König, *Schweizerische Photo-Rundschau* 9 (8 May 1955), 185.

45 Letter to his parents, 28 February 1953, private collection.

46 Application for Guggenheim grant, 21 October 1954. Starting in the middle 1930s Annemarie Schwarzenbach published documentary reports about the United States in the *Zürcher Illustrierte* (at first illustrated with photographs from the FSA files, later with her own). See Annemarie Schwarzenbach, *Auf der Schattenseite* (Basel: Lenos, 1990). Senn traveled to the United States before and after World War II. See Guido Magnaguagno in the introduction to *Paul Senn. Photoreporter* (Zurich: Stiftung für die Photographie, 1981), 14–15. Läubli lived and traveled in the United States from 1929 to 1933. See Hugo Loetscher in *Walter Läubli. Künstlerbildnisse* (Zurich: ABC, 1974), 114–117. Frank's cousins Roger and Claude Brunschwig had traveled across the United States in 1947. In addition, Frank was well aware of Henri Cartier-Bresson's "Highway Cyclorama" published in *Harper's Bazaar* (September 1947), 208–211, and of Schulthess' American issues of *du* (letter, dated 23 October 1954; a comparison of the opening photograph in the first issue of *du* entitled "A Car Trip Across the United States" and Frank's *U.S. 285, New Mexico* in

The Americans supports this notion). Kübler also promised Frank to devote an entire issue of *du* to the photographs taken on his trip across the United States. See Application for a Guggenheim Foundation grant, Tucker and Brookman 1986, 20. Immediately after Robert Frank, it was Bernhard Moosbrugger who traveled across America and whose photographs were published in his *USA – Europa sieht Amerika* (Einsiedeln: Waldstatt, 1959) in the same year as Frank's *The Americans.*

47 Letter to Schuh, 12 May [1954]. I am grateful to Dr. Annamarie Schuh for allowing me to quote from this letter in the Schuh Archive. Frank did not become a naturalized United States citizen until 18 October 1963 but never renounced his Swiss citizenship with Swiss authorities and thus never lost it. Letter from the "Zivilstandsamt" (registry office), Zurich, to the author, 23 March 1994.

48 *The Americans* (New York: Grove Press, 1959), vi.

49 Schuh in *Camera* 8 (1957), 339–340.

50 At the time, Frank was afraid that people who read this letter might think he was a communist (undated letter to Schuh [c. 1957], Schuh Archive), but later described it as "prophetic." *Camera* 3 (March 1968), 4.

51 Letter to the author, 11 May 1992.

Black and white is the vision of hope and despair.

This is what I want in my photographs.

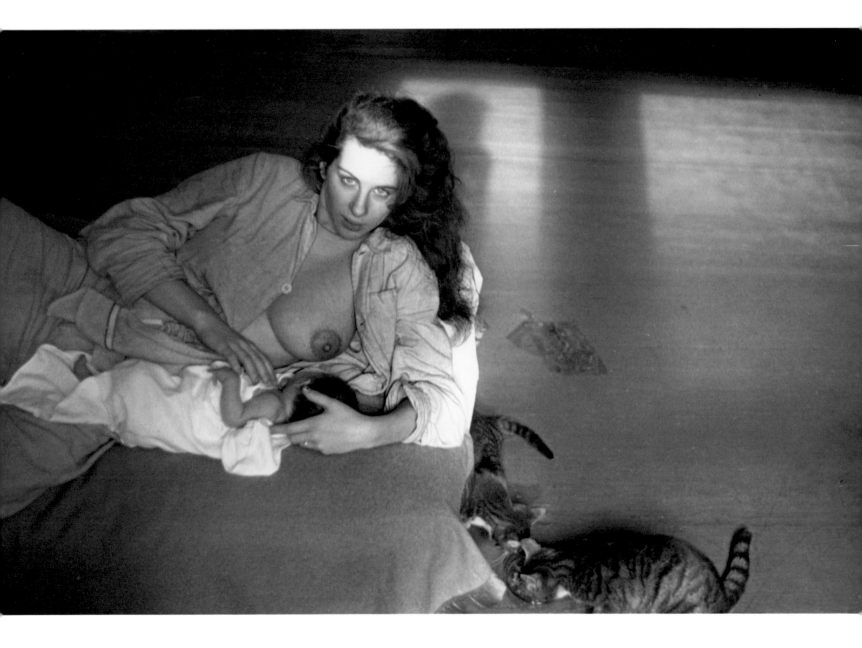

Mary and Pablo NYC, 1951 **55**

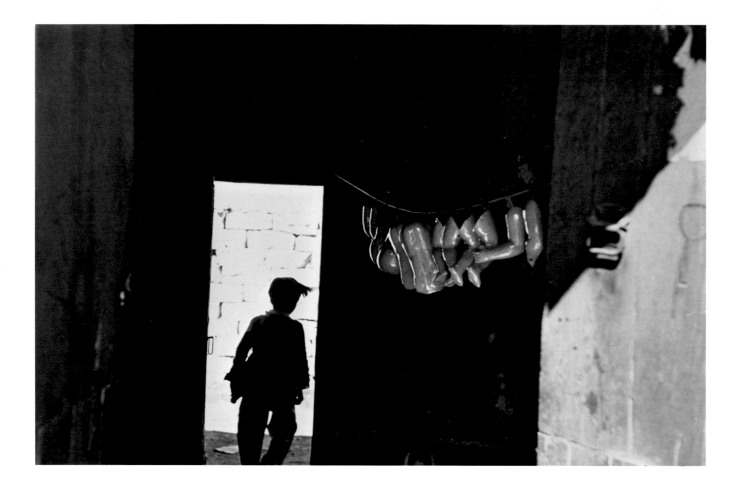

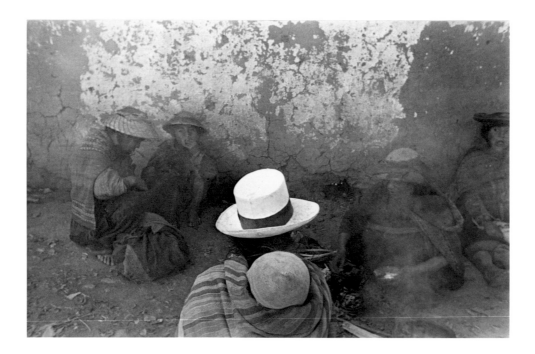

Peru, 1948
Arequipa, Peru, 1948

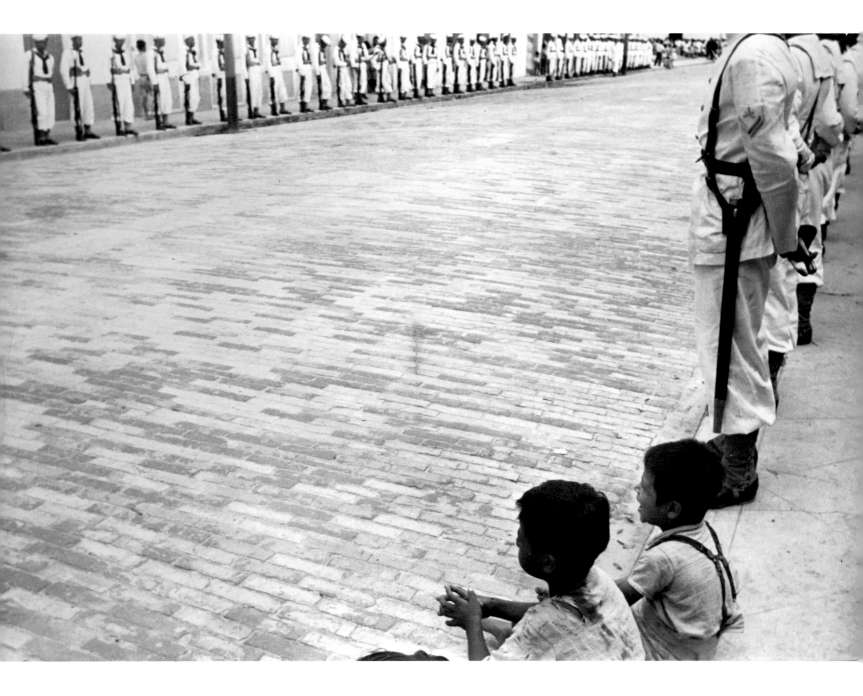

Peru, 1948 **57**

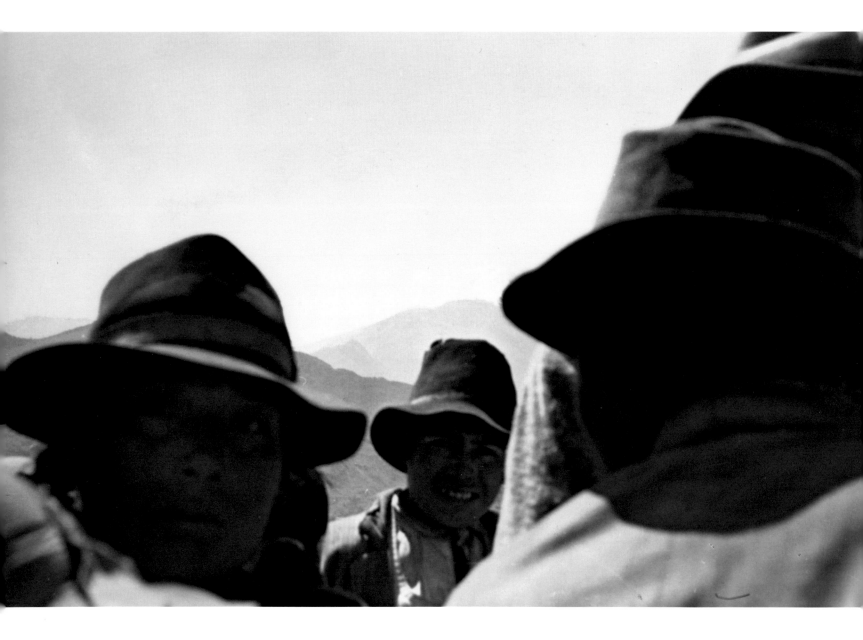

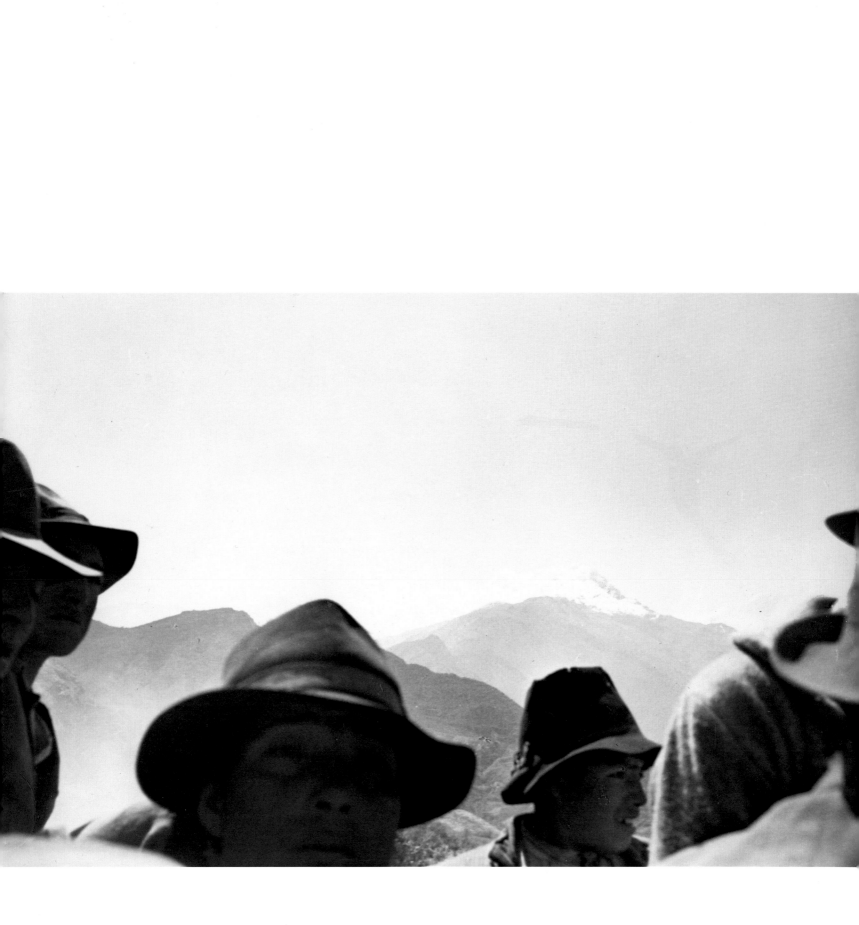

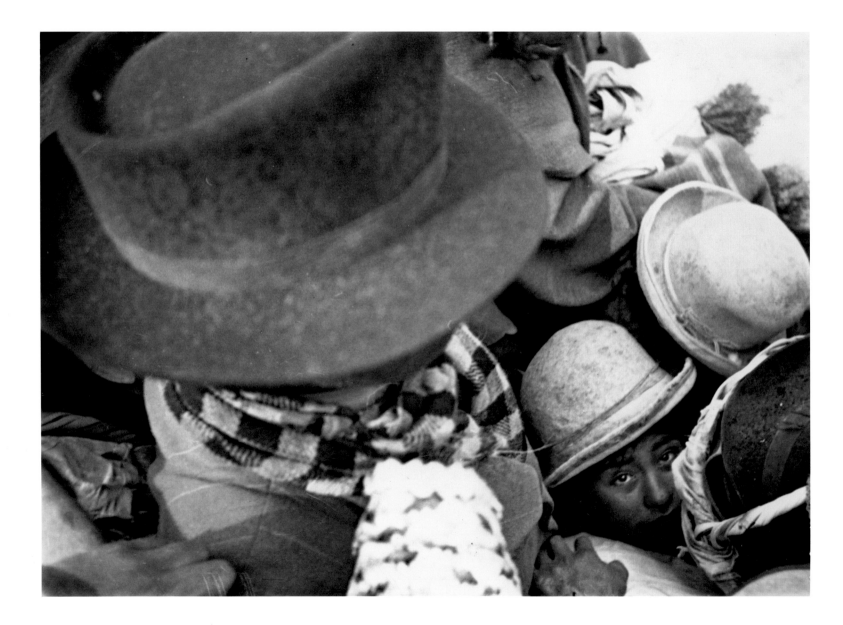

60 Passengers to La Paz, Peru, 1948
Mary's Book, 1949–1950 (pages 62–65)

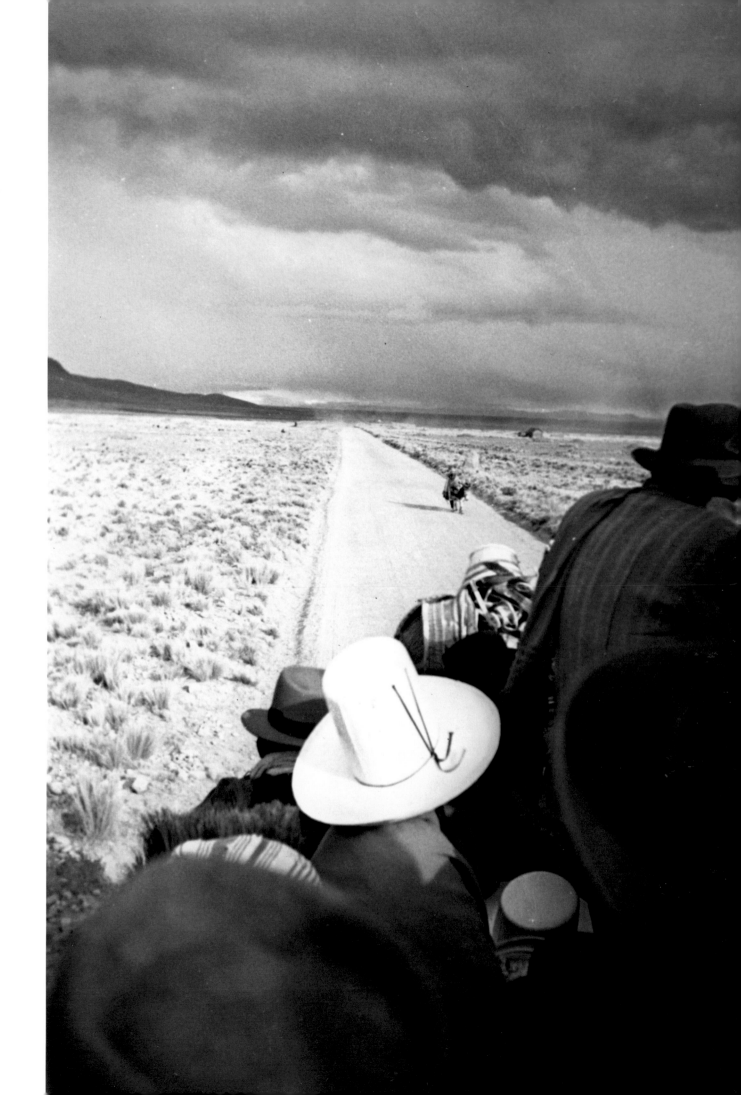

Même u

Peu de choses.. Une lanterne à gaz, un pont et la Seine, les marguerites, les murs où les toits avec leurs cheminées — tous cela ça fait beaucoup.

Les choses les plus simples changent si l'homme prends contact avec.

...issoir ...

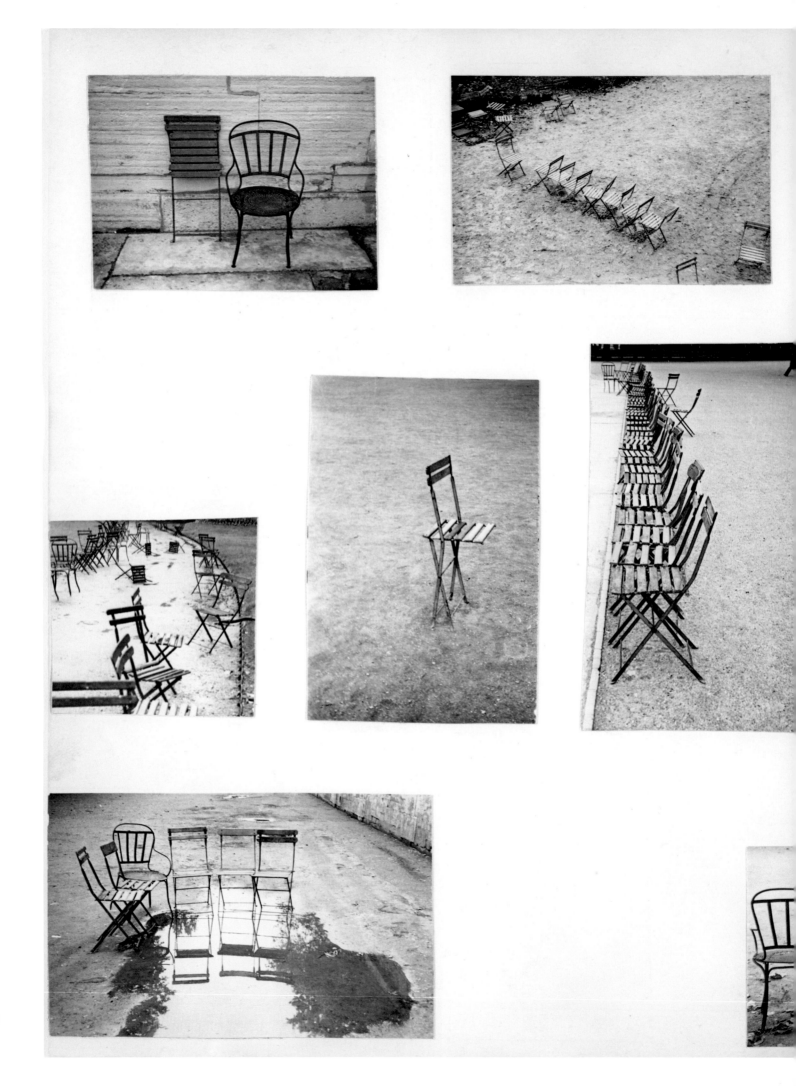

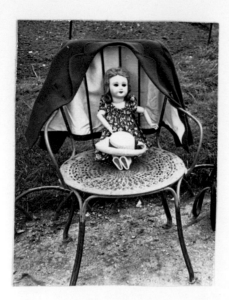

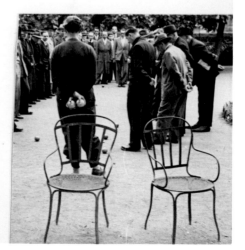

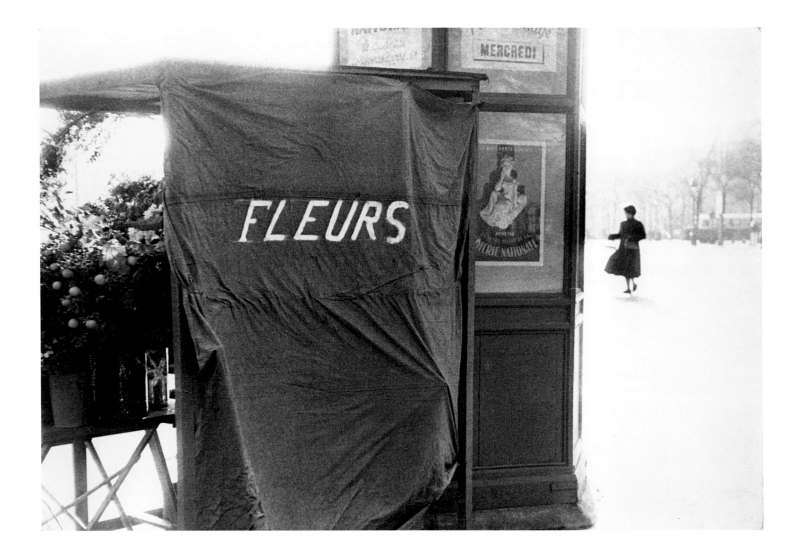

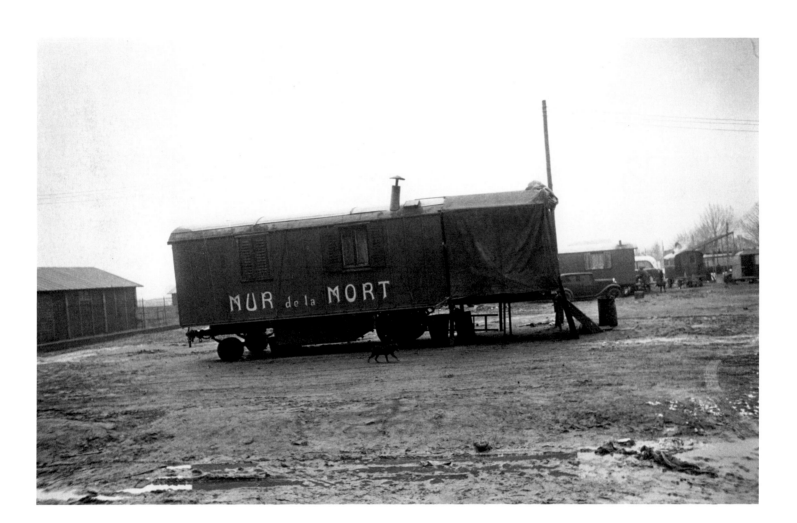

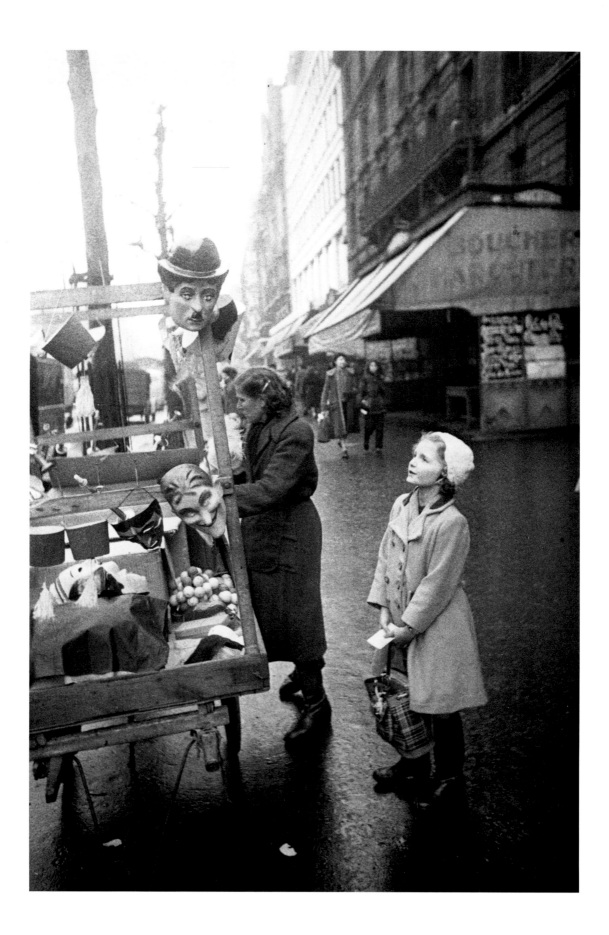

68 Paris, 14ᵉᵐᵉ, 1951–1952

Avenue du Maine, Paris, 1949–1950

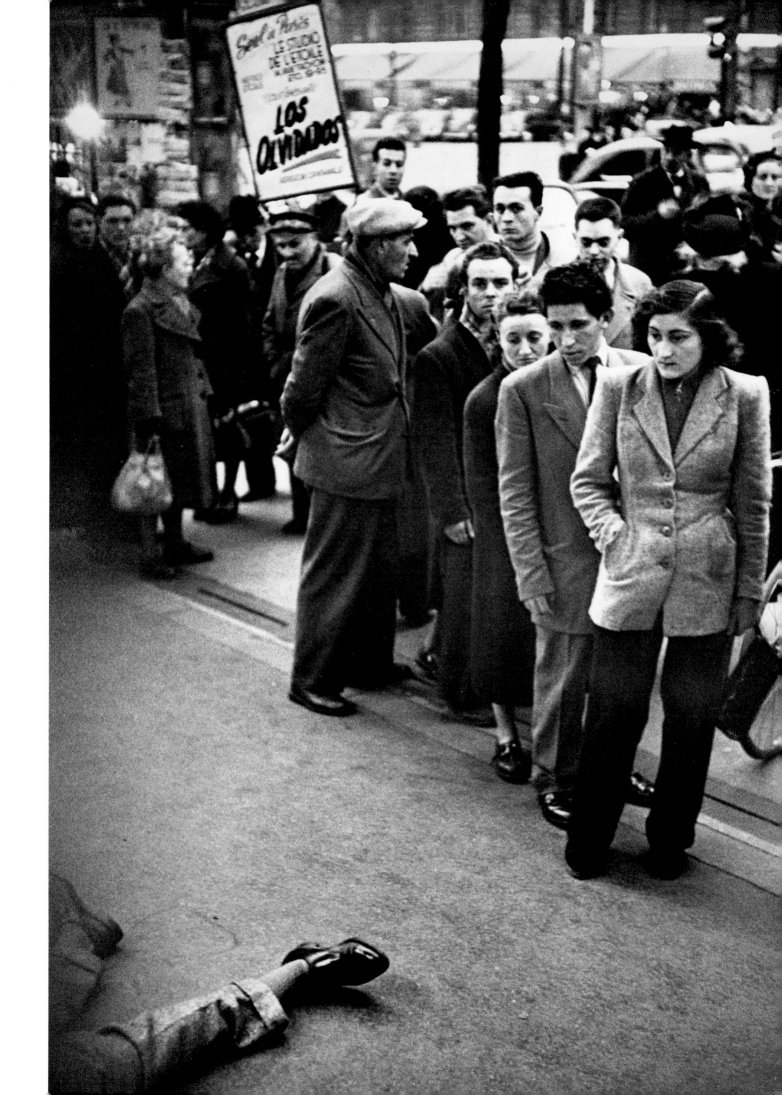

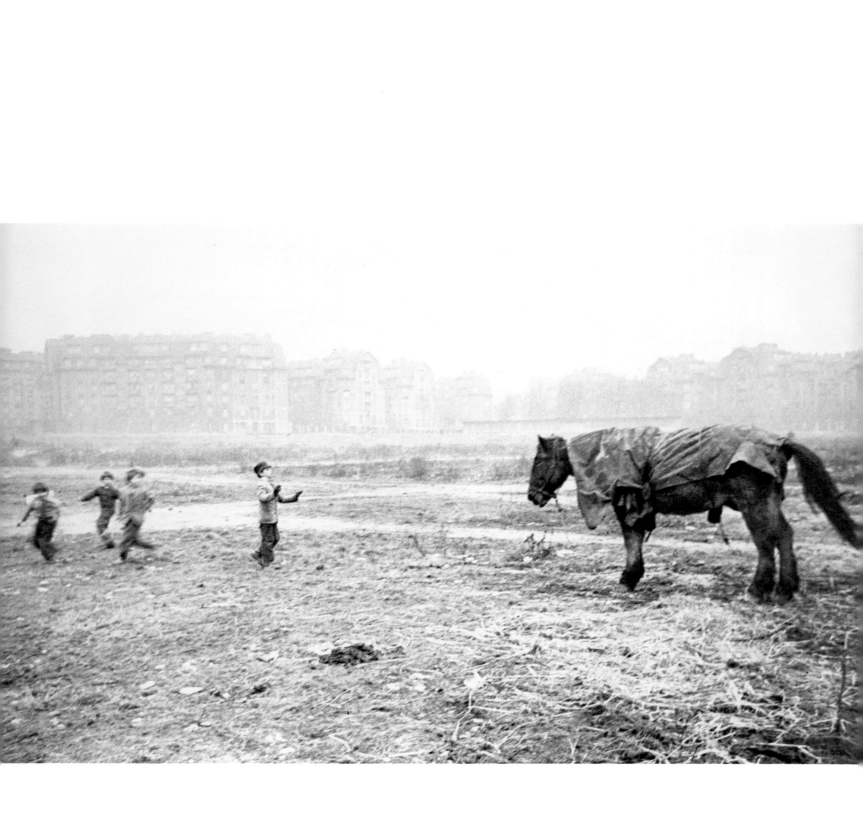

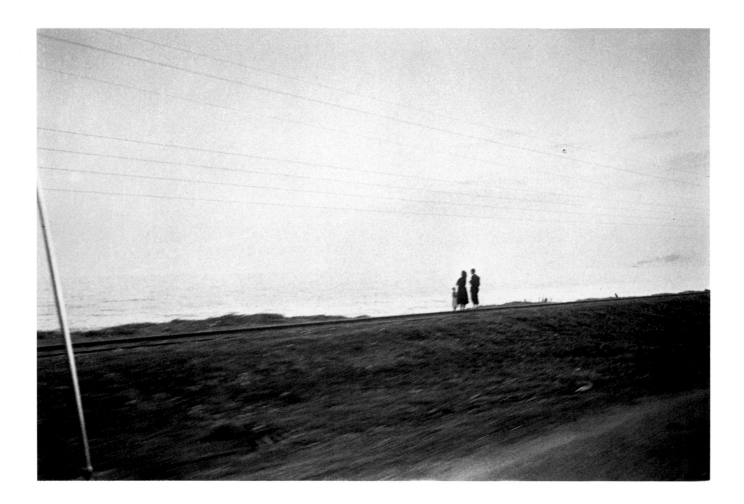

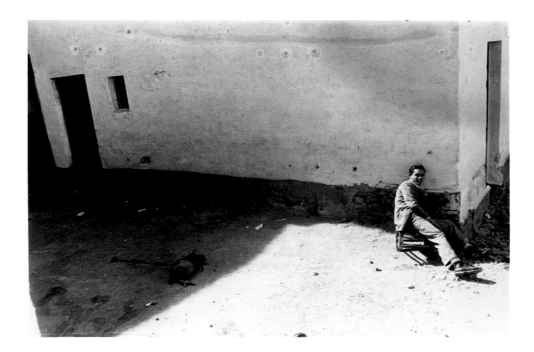

Spain, 1952
Mallorca, Spain, 1952

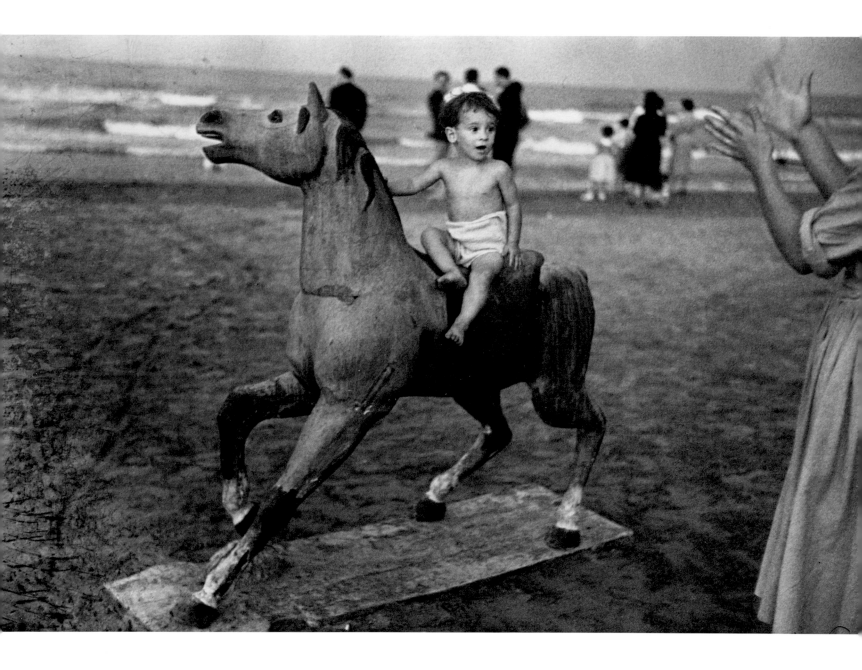

Pablo in Valencia, 1952 **73**

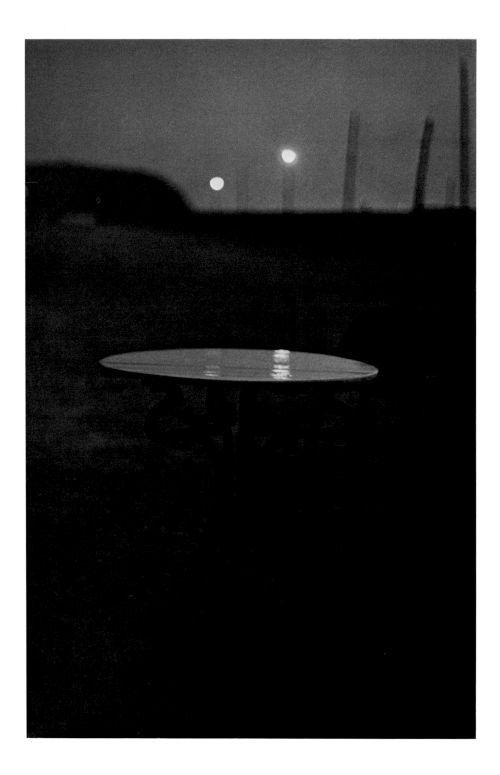

74 Table, Mallorca, 1952

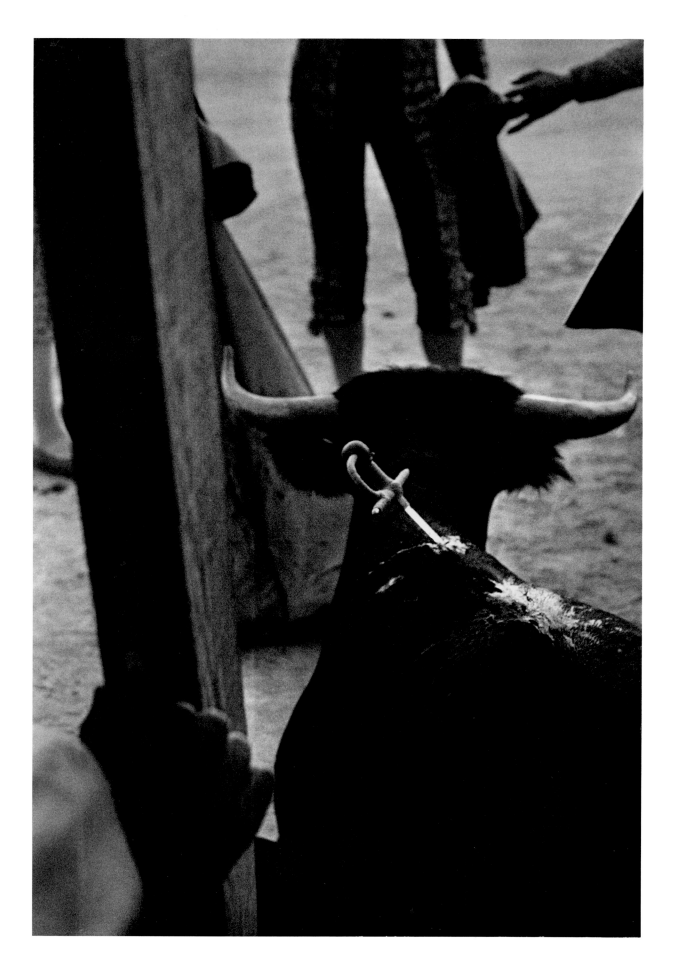

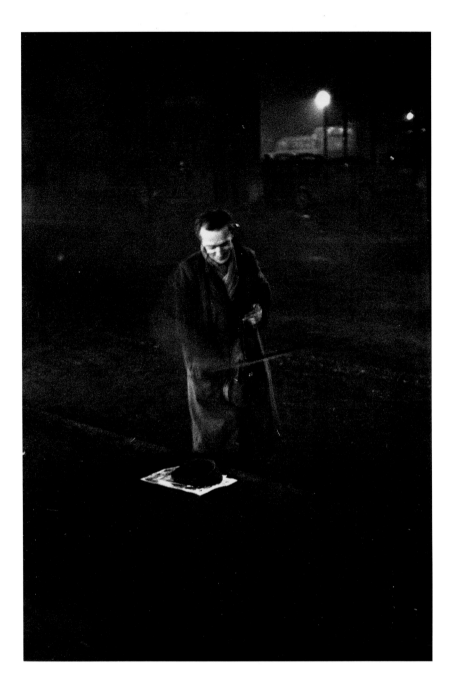

76 Near Victoria Station, London, 1951

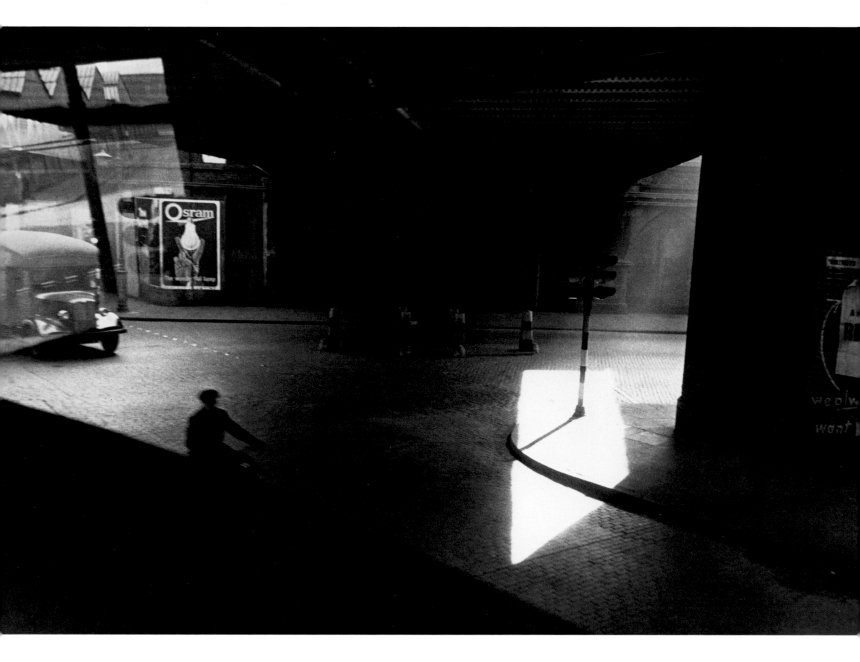

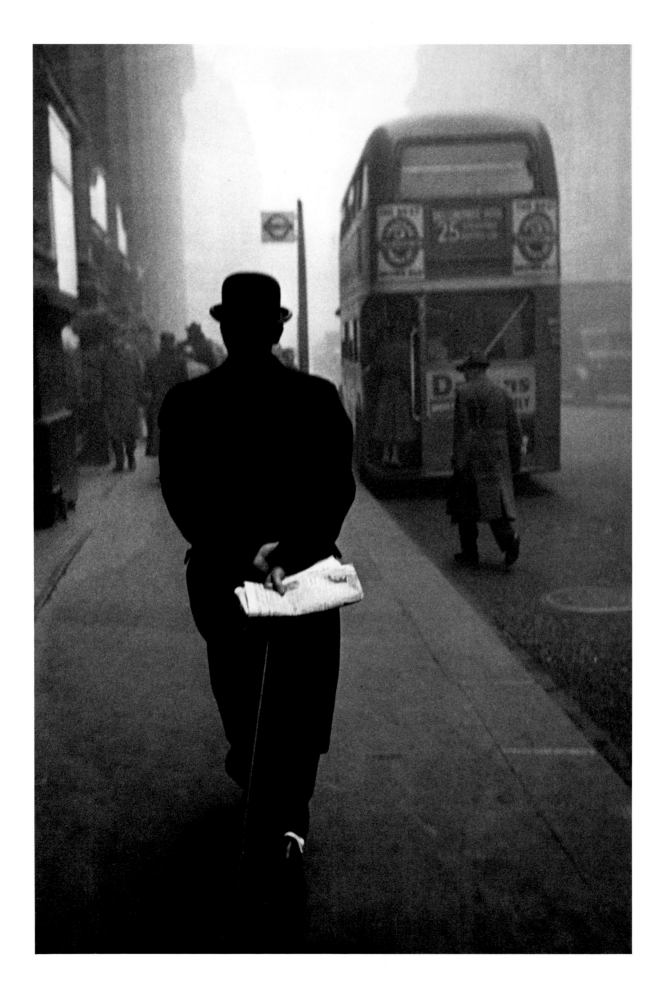

78 City of London, 1951

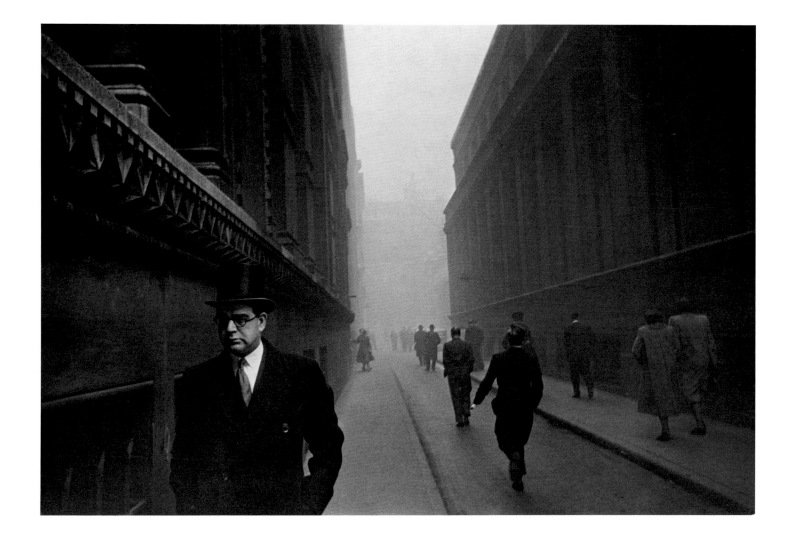

City of London, 1951 **79**

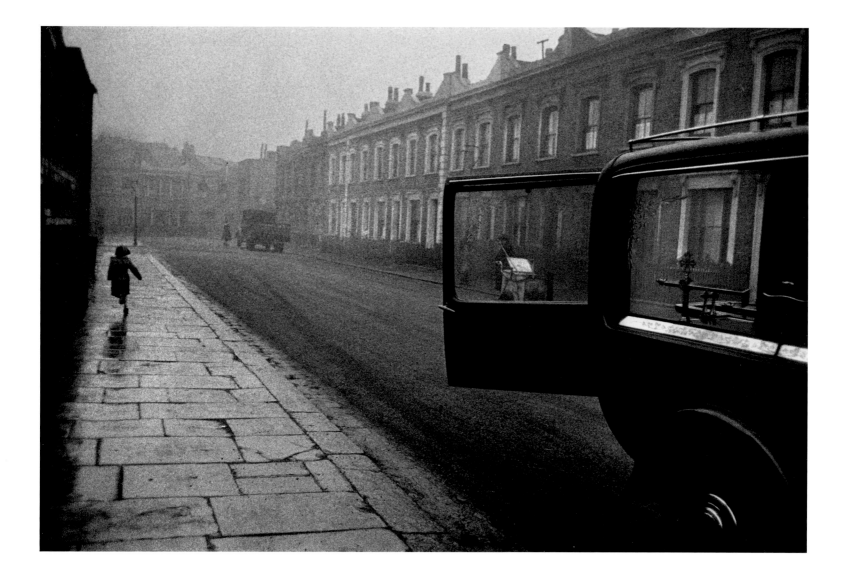

London, 1952–1953 **81**

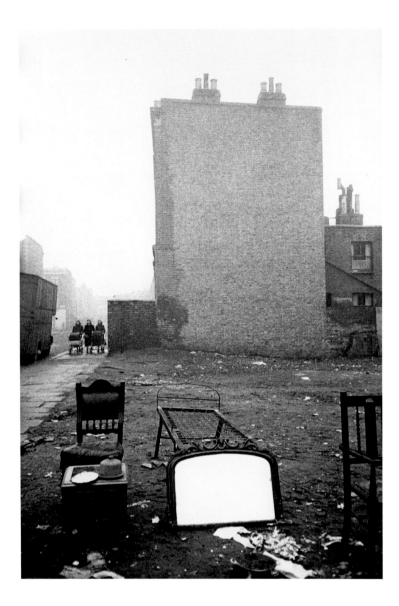

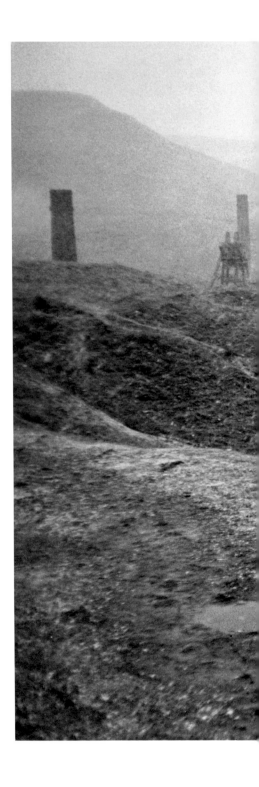

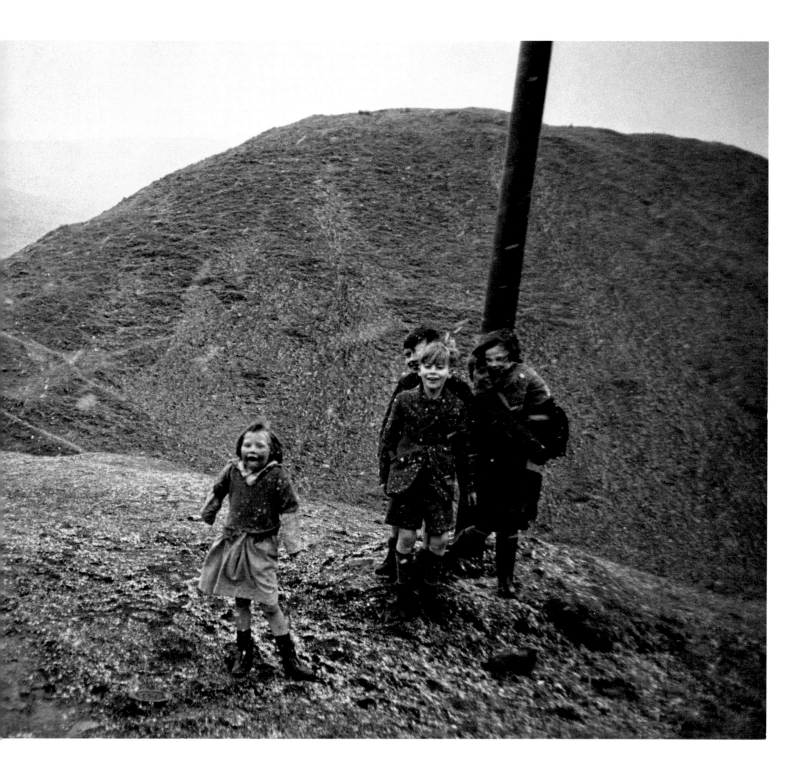

Caerau, Wales, 1953 **83**

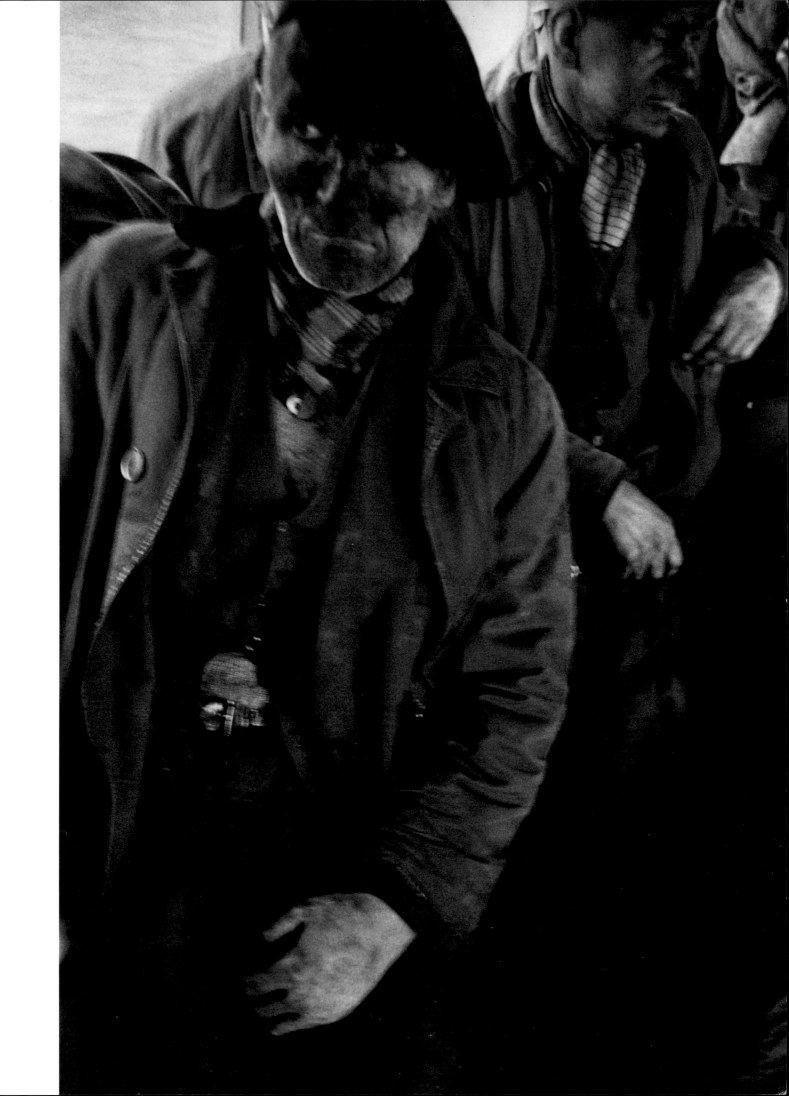

BLACK WHITE AND THINGS 1952

It is only with the heart that one can see rightly

What is essential is invisible to the eye.

Antoine de Saint-Exupéry, *The Little Prince*

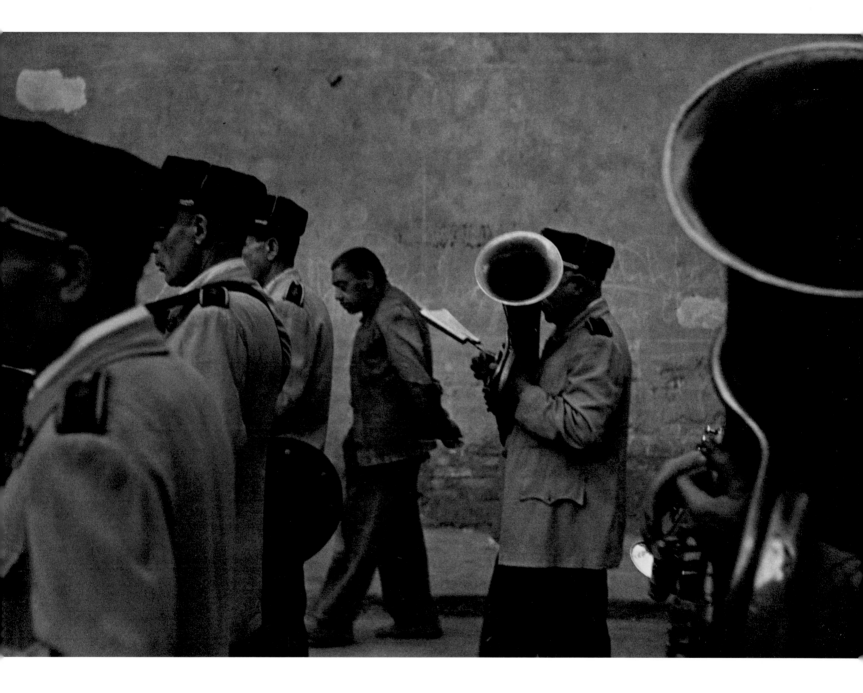

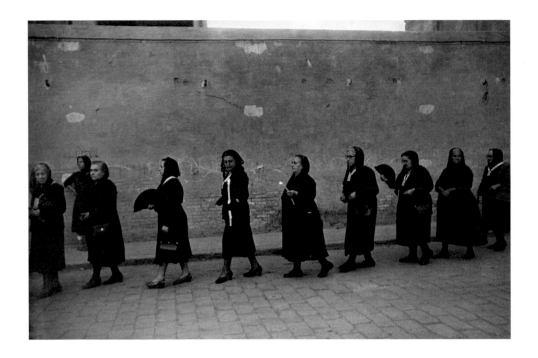

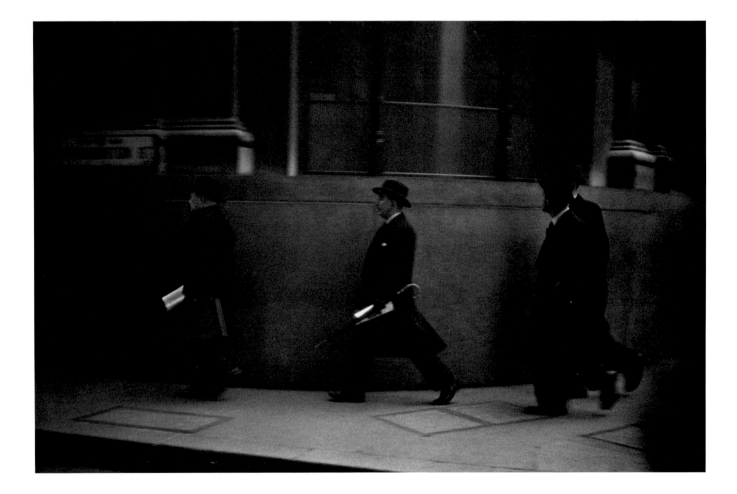

88 Procession/Valencia, 1952
Bankers/London, 1951

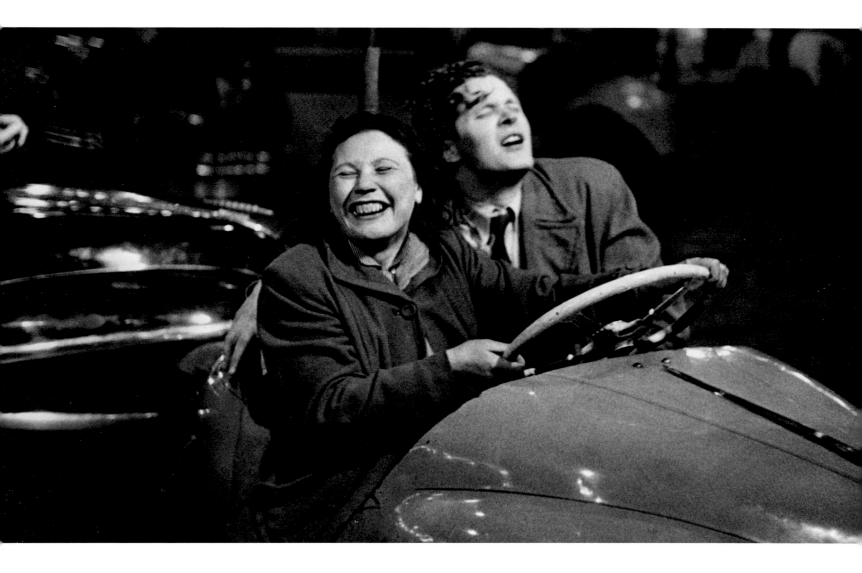

Couple/Paris, 1952 **89**

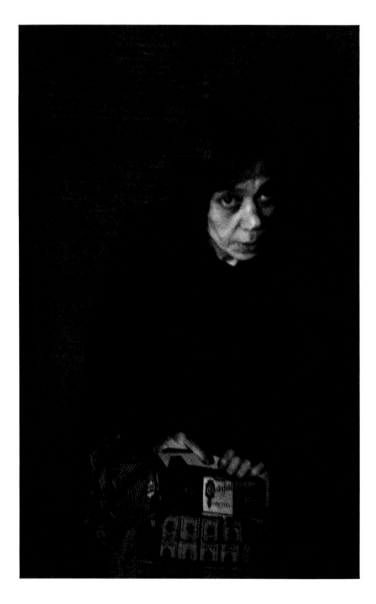 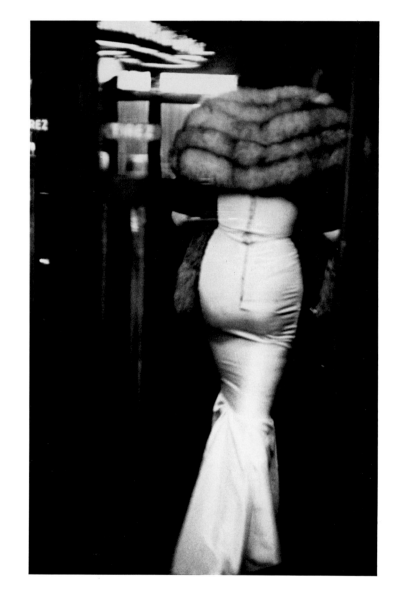

90 Old Woman/Barcelona, 1952 Woman/Paris, 1952
Tickertape/New York, 1951

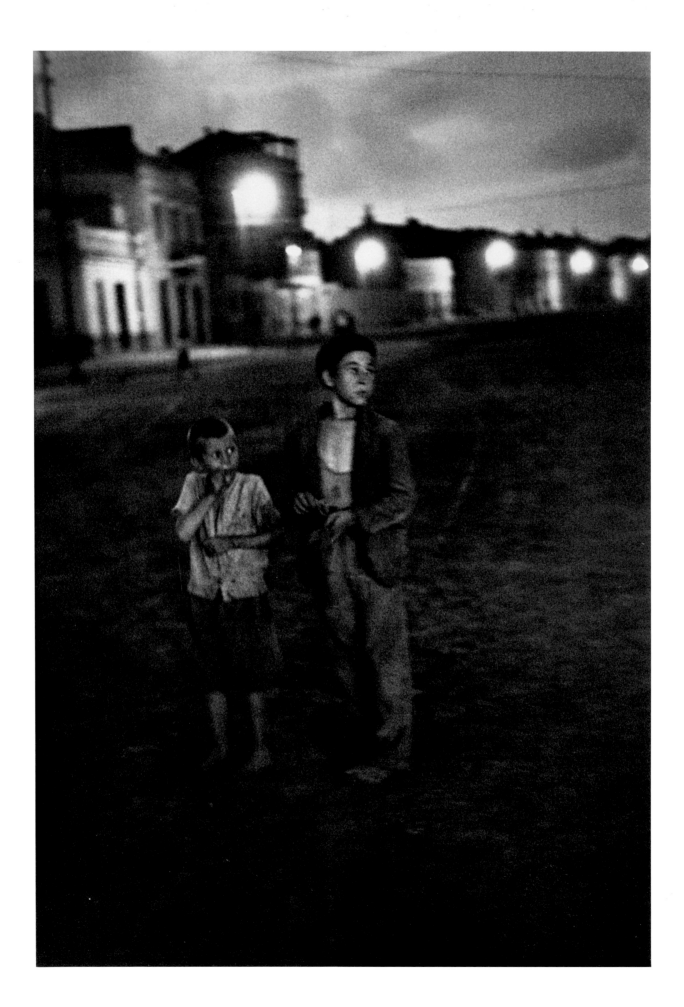

92 Boys/Valencia, 1952

Profile/Venice, 1951 **93**

94 Chauffeur/London, 1951
Funeral/Paris, 1951–1952

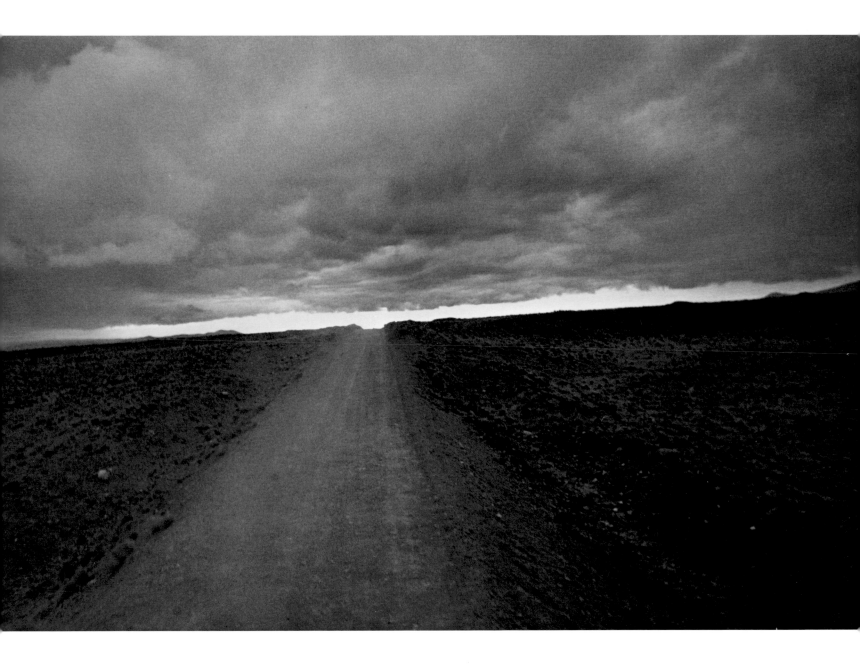

Landscape/Peru, 1948 **95**

SARAH GREENOUGH Fragments that Make a Whole
 Meaning in Photographic Sequences

"A masterpiece is not the result of a sudden inspiration but the product of a life-
time of thought." VIRGINIA WOOLF

In December 1955, while traveling through the United States on a grant from the
Guggenheim Foundation, Robert Frank went to the Hoover Dam near Boulder City,
Nevada. Earlier that year he had received funding for a highly ambitious project to make,
as he wrote, "a broad, voluminous picture record of things American, past and present,"
and create "a visual study of a civilization."[1] Until then he had avoided such obvious
tourist locations, preferring instead to photograph more mundane
sights such as cafes, gas stations, or even the road itself. Perhaps he
went to the dam because he thought this manmade wonder of the
American west would amuse his young son and daughter, relieving the
tedium of their long drives through the vast desert. Or perhaps, recall-
ing the great dams and tunnels of his native Switzerland, he was intri-
gued by this feat of engineering.

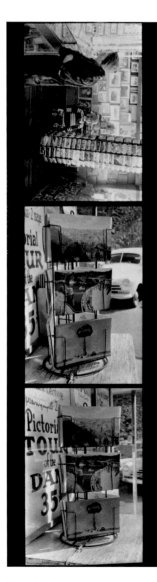

 Whatever the reason, before visiting the dam Frank stopped
at a small souvenir store where his attention was first drawn to a
woman wearing a turban and a fur coat. Behind her, standing next to
a magazine rack and postcard stand, was a life-sized mannequin of a
young boy in a striped shirt and hat, sporting a holster and guns.
Frank made three exposures as the woman completed her purchase,
then he went outside, only to be confronted with yet another display
of postcards. Although he had frequently been assaulted with exam-
ples of American commercialism on his trip and had photographed
quite a few postcard stands, this one was surely different (*Hoover Dam,*
page 168). There in the brilliant, unforgiving Nevada sun on a small
rack, next to a sign that promised tourists a "pictorial tour of the dam"
for 35 cents, were three postcards that together comprised a succinct
allegory of modern man.[2] Reading from top to bottom, the first view
presents a majestic vista of vast, pristine canyons stretching as far as
the eye can see, while the middle image is of the Hoover Dam itself.
Depicting the remarkable formal beauty of this manmade form, the

Negative Strip, *Hoover Dam,* **1955** image also boasts an American flag proudly displayed in the center of

the composition. The bottom postcard shows the detonation of a nuclear bomb in the empty desert. Separately, each of the postcards is highly celebratory—the untamed wilderness is just as awe-inspiring as the technological strength of the dam or the destructive force of the mushroom cloud—but because of their shared subject matter—man and nature—and because they are stacked one on top of another and isolated within the center of the image, we are forced to see them in succession and understand them as a group. With eloquence, clarity, and brevity, the three postcards tell a multilayered story. Most obviously they speak of the desecration and destruction of a once pure land; more fundamentally, they allude to the megalomania of modern man, to his compulsion to conquer and control his environment, and to his new-found ability to harness nature both as a powerful force for positive change and as an agent of utter annihilation. Not only does this sequence have a clear narrative quality, but it also has an obvious linear progression through time: the unsullied landscape is the Edenic American past, while the dam is its present, and the bomb its future. In addition, it has an emphatic moral lesson: left unchecked, this is the future not just of mankind but all life on earth. As a group, the series assumes an entirely different meaning and tone from that of the individual postcards: no longer a celebration of either man or nature, the three images together are at once a poignant requiem to the past and a profoundly disturbing omen.

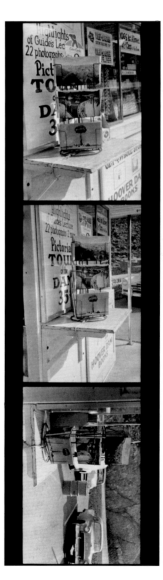

Recognizing that the scene was too good to lose, Frank made five negatives from slightly different angles.[3] He did not, however, include *Hoover Dam* in his seminal publication *The Americans,* 1958 and 1959, perhaps because he felt its meaning was too emphatic and didactic or its tone too strident. It was not until many years later that he resurrected the photograph in his 1972 autobiographical survey *The Lines of My Hand.* Having spent more than a decade working on films, he was now fascinated with the problem of how to combine several images and words in a single still photograph, and *Hoover Dam* clearly resonated with his current work. But that earlier image also demonstrated a solution to a problem that has preoccupied Frank throughout his entire career, from his first photographs made in Switzerland in the 1940s to his most recent work of the 1990s: how to create, as he has said, "a more sustained form of expression." To a great extent, over the last fifty years he has achieved that goal by constructing sequences of photographs. He explained, "there had to be more pictures that would sustain an idea or a vision or something. I couldn't just depend on that one singular photograph any more. You have to develop; you have to go through different rooms."[4] As a youth he had worked extensively in

Negative Strip, *Hoover Dam,* **1955**

97

both a commercial tradition and the then-fashionable style of photojournalism, and thus he was conditioned to see the photographic series not just as a logical and viable method of presentation, but as the highest accomplishment of a photographer and his most effective means of communication. However, while he had many precedents, what he constructed was radically different. Frank's understanding of the potential of a tightly orchestrated sequence of photographs to collapse or even to subvert time, to present multiple and layered meanings, to elicit numerous and often conflicting emotional responses, and to recreate experience rather than merely describe it has resulted in some of the most passionate and universal expressions the medium has ever produced. Frank has used the photographic sequence as a means to reveal the dense mysteries of everyday reality with a rare intensity and vision that few other photographers have been able to equal.

"When people look at my pictures I want them to feel the way they do when they want to read a line of a poem twice." ROBERT FRANK, 1951[5]

On 20 February 1947 Frank sailed from Antwerp on the S. S. James Bennett Moore bound for the United States. Like many young people who had been confined within the boundaries of neutral Switzerland during World War II, Frank was eager to look beyond the limited horizons of his homeland. The "smallness" of Switzerland had frustrated him, as did its traditions, its restrictions, and, as he has said, its "concerns about money and respectability."[6] Twenty-two years old, with five years of photographic experience behind him and solid letters of recommendation in his pocket, he left a world of predictable security for an uncertain future. With him on his journey to the New World were a missionary, a cabinetmaker, a mechanic, a printer, a student, and a bishop.

Upon his arrival in New York, Frank showed Alexey Brodovitch, the renowned designer and art director of *Harper's Bazaar,* a carefully constructed, bound volume of images titled *40 Fotos.* Approximately 9 by 7 inches, the book was a compact and safe way to bring his photographs across the Atlantic. The photographs in the volume are studies of such diverse subjects as lace and the Swiss landscape, portraits and public gatherings, radio tubes and sporting events. The photographs are not linked by a narrative or linear progression, nor is there a shared theme among the images. Instead the book is an eclectic compendium, a portfolio designed to demonstrate to prospective clients or employers Frank's ability to record a wide variety of subjects. It proved effective: Brodovitch hired Frank to take photographs for *Harper's Bazaar* and its companion magazine *Junior Bazaar.*

The idea for *40 Fotos* and its method of construction are the direct result of his early years in Switzerland. Although isolated by World War II, Switzerland had an active photographic community. Zurich in particular was dominated by two strong but by no means mutually exclusive movements, each headed by energetic proponents. Hans Finsler

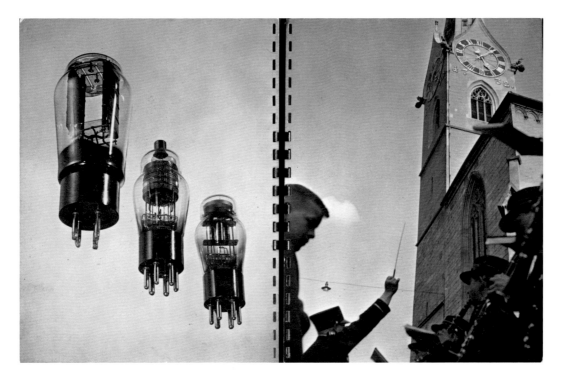

40 Fotos, 1946

taught a course in photography at the School of Arts and Crafts where he indoctrinated pupils with the lessons of the Bauhaus, with an emphasis on formal experimentation, while Arnold Kübler encouraged the style of photojournalism, first as editor of the weekly *Zürcher Illustrierte* and later as publisher of *du.* As much as Frank would later rebel against Swiss moral, social, and aesthetic values, in the 1940s he absorbed all that he could from students of Finsler, Kübler, and others. He mastered the craft of photography in Zurich—that is, he learned how to process film, light objects, and make technically perfect prints—but he also began to intuit his own approach to the medium. Through looking and reading, teachers and friends, trial and error, he began to understand how he wanted to construct his photographs, how he wanted to create compositions, and even, to a certain extent, what he wanted to photograph. Many of the subjects he would later explore in the United States—for example, parades or flags—first appeared in his work in Switzerland and were included in *40 Fotos.* Also present were many of the stylistic attributes that he would later exploit—for example, low-angle or over-the-shoulder studies of people in the streets, which gave a sense of immediacy and emphasized the point of view of the photographer.

Frank also began to learn how to order and present his photographs. It was his teacher, Michael Wolgensinger, a student of Finsler, who showed Frank how to construct a presentation volume of his photographs. *40 Fotos* is very similar to a 1942 book of photographs Wolgensinger had made to send to potential clients as a New Year's gift. Titled *12 Fotos,* Wolgensinger's book is the same size and format as Frank's later *40 Fotos* and uses

an identical comb binding.[7] Displaying the range of his talents, Wolgensinger had also included a variety of photographs from close-up details of hands, lace, and machine parts to studies of industrial buildings, street scenes, and landscapes. In addition, like other Swiss photographers of the time, and particularly photojournalists, Frank meticulously organized his work by subject matter.[8] He carefully trimmed and numbered his 2¼ inch contact prints and mounted them onto boards, usually twelve to a page, which he labeled, for example, "Ar" for *Arbeiter*, workmen, "T" for *Tier*, animals, "Vk" for *Verkehr*, transportation, or "La" for *Landschaft*, landscape, his largest grouping with 148 prints. These subject categories afforded Frank's potential clients a simple and efficient way to examine his studies of any one topic, but of far greater importance, they provided an easy framework within which Frank himself could review and edit his work. The act of cataloging his photographs by subject matter also conditioned Frank to look for recurring motifs and to recognize, and perhaps further pursue, those scenes or objects that had captured his attention.

In *40 Fotos* Frank occasionally juxtaposed similar subjects, such as two howling, caged animals, but more often he chose pairs of opposites. He contrasted a scene of a cluttered flea market table with a highly simplified study of a wheel, and he compared a flag in a crowded demonstration with a flag on the top of an empty snow-covered mountain. Revealing his strong formal training, most of the pairs—and particularly the most disparate comparisons—are united through a repetition of form: for example, in the pairing of a study of three radio tubes with a view of a band, the baton and upraised arm of the conductor, as well as the hats and clarinets of the orchestra, echo the shapes of the radio tubes. Emphasizing the relationships between images, Frank contrasted not only ideas—nature and culture, man and technology, simplicity and chaos—but also sensations—warm and cold, quiet and noisy. Although a youthful production, *40 Fotos* displays Frank's growing recognition that, when placed side-by-side, two photographs could not only affect each other in subtle and complex ways, but also could assume entirely new and often unexpected meanings.

In New York Frank was initially exhilarated by the freedom he found, and he quickly achieved a certain degree of success, securing a by-line with his photographs of purses, shoes, or other items published in both *Harper's Bazaar* and *Junior Bazaar*. However, he did not find either his work or the community around Brodovitch comfortable or conducive. "There was no spirit there," he later remembered, "the only thing that mattered was to make more money."[9] Yet, while the fashion world held little appeal for Frank, he was greatly impressed with Brodovitch's knowledge of photography and his book *Ballet*.[10] Published in 1945 and containing 104 photographs of the Ballets Russes taken by Brodovitch from 1935 to 1937, *Ballet* is an extraordinary accomplishment. In an era that celebrated clear, sharp, precisely defined, literal photographs, *Ballet*, with its rough prints,

random compositions, unfocused studies, blurred movement, indistinct form, and extreme contrasts of brilliant whites and dense blacks, was a radical and innovative departure. Brodovitch sacrificed all the conventional rules of photography in order to capture not one particular ballet, but the experience of dance in general, its energy, movement, and passion. While Frank's training had encouraged experimentation, it was a controlled, ordered, formalist investigation, radically different in spirit from the wild abandonment of *Ballet*. Just as he was awed by the freedom of life in America, so too was Frank impressed with the freedom of expression he saw in this book.

Brodovitch's success was due, in part, to his inclusion of studies not of the dramatic climaxes or highlights of a ballet, but, as Edwin Denby wrote in the introduction, "the un-emphatic moments, the ones the audience does not applaud but which establish the spell of the evening."[11] Further, he recreated the emotional impact of a ballet through his design and sequencing of photographs. *Ballet* is a long, thin horizontal book with all the photo-graphs printed to the edge of the page. The soft, uncoated paper imparts an indistinctness that evokes a trancelike reverie. This quality is further enhanced through the frequent juxtapositions of images of similar subjects that seem to merge into one panoramic illusion. Beyond a brief introduction, the sequence has no discernible narrative progression. It is not an intellectual or rational order, but an intuitive one that evolves as the images flow into one another in cinematic fashion; it is not a descriptive record, but a subjective interpreta-tion composed of many separate scenes that together evoke an experience.

In the late 1940s Frank had a youthful, eclectic eye and a catholic approach, and he learned from a wide variety of sources. He remembers being impressed with André Kertész's 1945 book *Day of Paris* and with work by Bill Brandt, whom he met in the early 1950s.[12] Brandt's books, *The English at Home*, 1936, *London at Night*, 1938, and *Camera in London*, 1948, provided the younger photographer with a clear model of how dichotomy could be

Alexey Brodovitch, *Ballet,* 1945

used to unify a group of photographs, imparting order as well as tension and rhythm. All three works contain not only dramatic contrasts between different economic, social, and political classes, but also less obvious comparisons between security and insecurity, loneliness and intimacy, light and dark, inside and outside, life and death. The sequencing in these books is not a simplistic, dialectical comparison, nor is it overtly didactic or moralistic, for Brandt's aim was not social reform but social observation. He wanted to impart to his viewers not just the politics of his subject but also its poetry, and to share with them a sense of its moods and mysteries. But Brandt did much more than stimulate Frank to follow a particular method of structural organization. His fascination with atmosphere, his exploration of the symbolic qualities of light and dark, his insistence, as he wrote in 1948, that the photographer "must have and keep in him something of the receptiveness of the child who looks at the world for the first time or of the traveller who enters a strange country," and above all his ability to make his subjects appear both very familiar and yet profoundly strange, deeply impressed Frank. Brandt's photographs went "right through my eyes into my heart and to my stomach," Frank later explained. "I heard a sound, and a feeling inside me woke up. Reality became mystery."[13]

Day of Paris, with photographs by Kertész and designed by Brodovitch, is very different from any of the other books that influenced Frank at this time. Using both photographs and writings, it is a lyric poem that describes the passage of a typical day in Paris from dawn to late evening. Far more controlled and traditional in its plan than Brodovitch's *Ballet,* it is also more literal and narrative in its organization. The layout of *Day of Paris* is similar to that of other photographic books of the period: often two photographs are paired on a page opening; occasionally one image extends across both pages; while in other instances only one work appears on either the left- or right-hand side. The resulting syncopated rhythm echoes the way a person might travel through a city, at times meandering, at other moments moving quickly, and, every once in a while, stopping for a rest. This sense of cinematic flow through time is further enhanced by the sequencing of the images. When two photographs are juxtaposed on a page they often present similar subjects and compositions, making the viewer instinctively discern affinities. The sequencing from one opening to the next also frequently repeats formal or iconographic motifs in order to achieve a transition between such disparate elements as, for example, the Eiffel Tower and chimney pots.

Day of Paris is also an early example of a post-war publishing phenomenon. Building on a growing sense of humanism and a profoundly felt need to promote harmony among nations, numerous books published from 1945 through the late 1950s depict countries around the world. Some, like *Day of Paris,* attempt to convey the distinctive qualities of life in a particular city or region; others, like Paul Strand's *Un Paese* from 1955, combine photographs with the inhabitants' own words to describe their homeland; while still others,

like Werner Bischof's *Japan,* 1954, present detailed records in both words and images of a country's history, as well as its present social, religious, political, and economic conditions.[14] As more photographically illustrated books devoted to the study of countries around the globe were published, augmenting the extremely popular picture magazines, there emerged an understanding of the photographer as a fearless, righteous, globe-trotting journalist who documented war, famine, and revolution, as well as the mundane details of everyday life. Robert Capa and W. Eugene Smith are but two of the photographers whose work, adventures, and personalities fueled this legend.

In 1948 Frank left New York to go to South America. Traveling by boat, plane, bus, jeep, and donkey, he roamed throughout Peru, and went briefly to Cuba, Panama, Brazil, and Bolivia. While he may have decided to go to South America because he recognized the growing market for photographic studies of foreign cultures, or because he too shared the romantic perception of the photojournalist as a rootless wanderer, it is more probable that he was propelled there in part by chance and in part by calculation. Unquestionably, he wanted to escape the New York commercial world of high-paid and high-fashion photography, but he may also have been intrigued by South America because it was, for him, a very foreign culture, one where he might be forced to see more intensely, more like the child Brandt described who looks at the world for the first time. Undoubtedly, too, Frank went to South America for the same reason he has made so many other bold, ostensibly rash, and often abrupt decisions throughout his career: because he abhors—and seems to rebel instinctively against—the secure, the safe, and the known. "I realized that security didn't matter," he said many years later, "I could never have the security that I had in Switzerland, so there was no reason for me to attempt to get into the high-fashion world. I went to Peru to satisfy my own nature, to be free to work for myself."[15]

Peru, 1948

In South America Frank shot black-and-white film as well as color transparencies, using both his 2 1/4 inch camera and a 35mm Leica that Brodovitch had encouraged him to try; the Leica proved to be an essential element of his developing style, while the color experiments were soon abandoned. With no assignments, except those he gave to himself, no deadlines, and no pressure to astonish Brodovitch, Frank wandered around the continent for several months, photographing mainly in rural areas. "I was very free with the camera," he said of his work in South America, "I didn't think of what would be the correct thing to do; I did what I felt good doing. I was like an action painter.... I was making a kind of diary."[16] When he returned to New York later that year he assembled two copies of his "diary," one for Brodovitch and one that he sent to his mother as a birthday present.[17]

Although the two Peru books are identical in size and construction and contain the same thirty-nine images, the sequence of photographs is different. This indicates that while Frank may have described his images of South America as "a kind of diary"—that is, intuitive and unrehearsed—he did not conceive of the books themselves as travelogues of his journey. In neither book does the sequence depict either Frank's actual trip or that of a hypothetical tourist, nor does either progress in a linear manner through time or theme—for example, the viewer is not first shown the big cities, followed by the more rural villages. Instead each book is a collection of Frank's impressions, showing how he came to know a country by wandering about "a bit like a detective...[following] a man whose face or way of walking interests me."[18] Each shows how he began to intuit objects that reflected his understanding of a people, their land, and their culture. In South America, in general, and in Peru, in particular, Frank was drawn not to the obvious, dramatic, or exotic—he rarely photographed the majestic Andes or the ancient ruins—but to the unobtrusive and ubiquitous, "the most banal things," as he has said.[19] He was especially fascinated with the hats people wore. Practical and unpretentious, the hats seem to echo his perception of Peruvians as unpretentious, quiet people with a strong sense of integrity. The hats also created extreme contrasts of light and dark, at once protecting and concealing the individual. Making it difficult to see the face, a hat formed a physical as well as a psychological barrier between the individual and the world, imparting an aura of mystery and unfamiliarity.[20]

Yet, while the order of the photographs is different in the two versions of the Peru book, both copies contain the same pairings of images on each opening.[21] By emphatically mating one image with another, Frank demonstrated that, as with *40 Fotos*, he was still far more interested in exploring how two photographs worked together on a page—how they influenced what the viewer saw and understood as significant—than he was in constructing a sustained, tightly ordered sequence of images. As Brodovitch had done in his designs for *Ballet* and *Day of Paris*, Frank juxtaposed similar subjects, often depicted from different points of view: a group of children seen from a distance is matched with a close-up of three

boys, while a group of people walking down a street in daylight is contrasted with a crowd of people at night. In this way he merged lessons learned from Brodovitch, on creating unity through iconographic and formal repetition, with his own investigations, first explored in *40 Fotos* and later intensified by his study of Brandt, of contrast as a way to create tension and suggest layered meanings. By repeatedly pairing variations on a theme—a group of people seen from above, a group seen from below—Frank also emphasized the fragmentary and personal nature of his photographs. These are not the authoritative, inclusive statements of a crusading photojournalist; the photographs do not strive to summarize the essence of South American life or culture, or even to document one small segment of Peruvian society. In their design and layout, the books have no sense of totality, wholeness, or completeness; without an introductory text or even titles, they are unrelated to a specific time, place, or issue. Instead the thirty-nine photographs are like entries from a diary—partial, fleeting, manifestly personal, and introspective—and seem to suggest that reality or any basic truth about a country or region cannot be discerned through an exercise of reason and logic, but only through the more intuitive process of perception.

Frank has described the years from 1947 to 1950 as being like "a training camp." Like any young person coming to maturity, he tried on many hats. "I tried out things," he continued, "I learned about life. I learned how to live in New York." After 1950, though, "because of getting married and because of where I lived, I entered into a much more conscious period where I knew more about what I was doing and what I wanted."[22] What he wanted, and ultimately achieved, was to be independent and to divorce himself from fashion photography. At the same time it was his ambition to make a living as a freelance photographer and reach a wide audience through selling his work to such publications as *Life,* and with this he was only moderately successful.[23] He continued his peripatetic wanderings, making several trips between Europe and America, traveling to Paris, London, Spain, and Wales. In each place he sought out objects that embodied his feelings about that city or country. In Paris he made dozens of photographs of both flowers and chairs; in Spain he photographed bullfights and animals; in London he recorded bankers; while in Wales he depicted a miner named Ben James. He submitted many of these photographs to magazines and some were published, but only occasionally as photographic essays. Motivated in part by a significant cash prize, Frank also attempted to construct a conventional photojournalistic essay—that is, a sharply defined story with a clear beginning, middle, and end. He submitted the essay, titled *People You Don't See,* to a "Young Photographers' Contest" at *Life.* The sixteen photographs recorded the activities of six people who lived on his block on 11th Street in New York. The series as a whole, however, is merely descriptive, lacking flow, cohesiveness, and unity. Only the captions, which describe the daily activities of the neighborhood, bind the images together. While Frank did win an award for other photographs submitted, the series did not win a prize for the best picture story.[24]

In December 1949 and the fall of 1952 Frank assembled two more handmade books. The first, a lyric, wistful, romantic love poem for Mary Lockspeiser, whom he married in 1950, consisted of seventy-four small photographs mounted on twelve sheets of paper, 9 by 14 inches, folded in half (pages 62–65). Each page, with an accompanying text written by Frank either in French or English, is devoted to one subject: photographs of signs—advertisements for horoscopes, torn posters, or scrawls requesting silence because "my wife is sleeping"—are mounted with a handwritten note that "the most simple things change when man comes in contact with them. Even a urinal." Several studies of chairs are prefaced with a missive on the sadness of the solitary, empty chair one sees so often in Paris.[25] While the layout is reminiscent of other illustrated books or picture magazines of the period, this book is not a traditional photographic essay because it has no chronological or narrative progression, as in Brandt's *London at Night* or Kertész's *Day of Paris,* nor does it treat social or economic issues, as in *The English at Home.* Instead, through images, words, and layout, *Mary's Book* recreates an intensely personal experience or emotional state, establishing an atmosphere and a point of view. "I promised you a little story," Frank wrote in his inscription to Mary, but, "maybe this is not a story." Maybe it was, as he continued, quoting Antoine de Saint-Exupéry, merely evidence that "it is only with the heart that one can see rightly; what is essential is invisible to the eye."[26]

In 1952 Frank again used this quote from Saint-Exupéry's *The Little Prince* to begin *Black White and Things* (pages 87–95), a bound volume of thirty-four original photographs, and in so doing established the challenge that would dominate his work for many years.[27] Rebelling against his pragmatic and ordered upbringing, Frank had come to believe that truth, or a fundamental understanding of the nature of things, could not be obtained through the deductive and rational methods of the mind or "eye," but only through intuition or the "heart." Like Saint-Exupéry, as well as European existentialists and American beats of the postwar period, Frank felt that reason was inadequate to explain the enigmas of life; intuition was the only way to address these baffling mysteries. And like Saint-Exupéry, he sought a means to transpose what had been perceived or grasped through the heart to the level of the eye, so that what was seen and felt could, in some manner, also be known and understood. He wanted to convey that knowledge directly, without overt reasoning or sentimental descriptions, but in such a way and with such force that he would engender similar intuitions in his viewers.[28] In *Black White and Things* Frank discovered that he could recreate those feelings of the heart through a carefully sequenced series of photographs.

Black White and Things differs from all of Frank's previous books because it was the result of a specific conceptual challenge, motivated at least in part by anger and rejection. As he explained several years later, "I wanted to sell my pictures to *Life* magazine and they never did buy them. So I developed a tremendous contempt for them, which helped me.

You have to be enraged. I also wanted to follow my own intuition and do it my own way, and not make concessions—not make a *Life* story. That was another thing I hated. Those god-damned stories with a beginning and an end." And he continued, "If I hate all those stories with a beginning, a middle, and an end then obviously I will make an effort to produce something that will stand up to all those stories but not be like them."[29]

Including thirty-four photographs made on three continents between 1948 and 1952, *Black White and Things* was Frank's most ambitious and public statement to date. Rebelling against the accepted practice of the picture magazines as well as most photographic books, Frank did not include extensive captions or an explanatory text, for he clearly agreed with the fox in *The Little Prince* who cautioned that "words," the agent of the mind, "are the source of misunderstandings."[30] *Black White and Things* is prefaced with only a very brief introductory statement: "somber people and black events / quiet people and peaceful places / and things people come in contact with / this, I try to show in my photographs." Organized conceptually, the book is divided into three sections, one each on "Black," "White," and "Things." It is about black and white, the colors of despair and hope, and about "things," the range of emotions that fall in between those two extremes.[31] The "black" photographs depict funerals, bankers, an elegantly dressed woman, children alone on a beach, a desolate landscape; they allude to death, money, materialism, loneliness, suspicion, anonymity, and emptiness. The "white" photographs are of families, riverbanks, misty landscapes, communions, and couples; they refer to home, love, religion, companionship, and serenity. The "things" photographs are the most complex and troubling: on one level they are pictures of parades, religious festivals, couples, children, dolls, chairs, and animals, but they are about courtship and cruelty, attachment and loneliness, devotion and inhumanity, as well as idolization, capitalism, and pervasive sadness. Many of the photographs, particularly those in the "things" section, are arresting because the subjects are depicted in a manner that defies our expectations: a group of young boys throws rocks at an old horse, taunting it cruelly; a doll, which should evoke the warmth and creative vitality of childhood, suffocates inside a plastic bag and seems to be praying for its life.

Of all Frank's early books, *Black White and Things* is the most sophisticated in its pacing. In only four instances are two photographs paired on an opening, and in those few juxtapositions Frank began to use wit and irony, as well as ambiguity. He matched a photograph of tickertape dancing in the air with a study of the back of a woman in a tight evening dress and fur stole, and he compared a photograph of a statue of Christ on the cross with a balloon in the Thanksgiving Day Macy's parade. While this latter pairing is an emphatic contrast between the sacred and the secular, Frank added an ironic note by calling them respectively *Men of Wood* and *Men of Air*.

Most of the photographs in *Black White and Things,* however, appear opposite blank pages, and for the first time in Frank's career, the sequence established the tone, im-

parted meaning, and transmitted emotion. As the viewer turns from page to page, quietly studying one photograph at a time, the images, no matter how seemingly dissimilar on first glance, begin to relate to each other. They repeat subtle formal and compositional arrangements, echoing iconographic motifs and enriching the mood of each section. In this way Frank connects such disparate subjects as, for example, a parade, a funeral procession, and a group of bankers (pages 87–88). These three images, the first in the book, are all studies of groups of people walking from right to left in a shallow space in front of a wall; most of the people are carrying something—a musical instrument, a candle, or an umbrella. It is the fourth photograph, though, that clarifies Frank's intent (page 89). Taken in an amusement park in Paris, it is a study of a couple driving a bumper car. The woman, who faces the camera, is nearly hysterical with laughter, while the man seems almost transposed to a state of ecstasy. At first glance this photograph appears out-of-place in the sequence: while it is also set in a shallow space, the giddy, out-of-control couple seems to have little to do with the stately processions before them. Yet, with this image Frank clearly announces that he is not just describing people, places, and things, nor is he only alluding to ideas, such as spirituality and materialism or rich and poor. By contrasting the private grief of the single-file funeral procession with the bankers' absence—even denial—of emotion, and the young couple's wild abandonment, he is also alluding to emotional states.

In *Black White and Things* Frank began to create something that would, as he said, "stand up to all those stories but not be like them." It was unlike a typical photographic essay of the period, with a strict linear progression and a clear moral lesson.[32] Without an extensive text or explanatory captions, and without thematic or chronological organization, the photographs, and therefore the meaning of the series, could not be read or understood in a traditional manner. *Black White and Things* revolted against the popular notion of the 1950s that photography was a universal language, "understood by all—even children," as Frank disdainfully noted in 1958.[33] Clues are presented, symbols, such as hats, chairs, flowers, and animals, are used, but their meaning is not entirely clear. They are but a set of codes to be intuitively comprehended. "Something must be left for the onlooker," Frank explained, "He must have something to see. It is not all said for him."[34] The viewer must move backward and forward through the sequence, remembering what has been seen before and knowing what will come next, in order to begin to make sense out of the book as a whole. Like a poem, the series must be read several times; like a poem, it can be appreciated on many different levels; and like a poem, it has multiple, even contradictory meanings that can only be inferred by each individual viewer. It is a sequence that, like real life, is disjointed, circular, ambiguous, and tentative. It demonstrates that there are no decisive moments, no instances when the truth is clarified through the perfect combination of form, gesture, and expression. It is a sequence that reveals the equivocal way we know reality, that creates a place for memory, and ultimately does not clarify its nominal sub-

jects—somber people, peaceful places, and things people come in contact with—but compounds their mystery.

On 17 March 1953 Frank, his wife Mary, and son Pablo sailed from Southampton, England, back to New York. It was not just one more trip in his global wanderings, but the end of his youthful travels. With a second child expected in 1954, Frank, albeit somewhat equivocally, adopted New York as his home and America as his country. (As he wrote in a book published in English, "Ich bin ein Amerikaner."[35]) In retrospect, he, as well as others, saw his return to New York as a signal of his break with his past work. "Even though I liked them a lot and got very attached to them," Frank explained in the 1980s, "I went away from my early lyrical images because it wasn't enough anymore."[36] The rejection of an old world style for a new world style makes for a tidy story, and while it is true that Frank did give up some of the romanticism and all of the sentimentality of his earlier work, his approach, his methods of working, and indeed his intention remained largely the same. Much as he had done in Peru, France, Spain, and England, he set out to understand his newly adopted home through his photographs. As in the past, he wanted to identify those objects that seemed to encapsulate what he saw and felt about America and he wanted to explore their symbolic potential. And, as before, he wanted to publish the results of his exploration in a book.

Two things did change, however. First, Frank abandoned all hope of creating an individual photographic masterpiece. Although he had constructed four books, through 1952 he had "always tried to come up with a picture that really said it all, that was a masterpiece."[37] By 1953 Frank no longer believed this was possible: people, relationships, human understanding, even nature were too complex, too ambiguous, too fluid to be summarized in one photograph. But, in addition, the intensity of both his vision and his ambition also changed. Beginning in 1954 he formulated and embarked upon a mission that was certainly bold, even audacious in its scope and intent: he wanted to produce no less than a "visual study of a civilization." Admitting that "'the photographing of America' is a large order—read at all literally, the phrase would be an absurdity," he clarified his thoughts in his proposal to the Guggenheim Foundation in 1955: "What I have in mind, then, is observation and record of what one naturalized American finds to see in the United States that signifies the kind of civilization born here and spreading elsewhere....I speak of the things that are there, anywhere and everywhere—easily found, not easily selected and interpreted. A small catalogue comes to the mind's eye: a town at night, a parking lot, a supermarket, a highway, the man who owns three cars and the man who owns none, the farmer and his children, a new house and a warped clapboard house, the dictation of taste, the dream of grandeur, advertising, neon lights, the faces of the leaders and the faces of the followers, gas tanks and post offices and backyards."[38]

It is, perhaps, not coincidental that Frank's list of possible subjects recalls Walker Evans' descriptions of his own photographs or his intended projects, for the two met in 1953, and Evans, in addition to offering counsel, employment, and friendship to his younger colleague, also reviewed a draft of Frank's Guggenheim application.[39] As with the abstract expressionist painters, many of whom he befriended at this time, Frank has said that he was more impressed and influenced by Evans' personality, particularly his integrity and commitment, than with his art. But, he admitted "I learned a lot from the way that he looked at things; he wanted to look at one thing and look at it very clearly and in a final way."[40] Evans' cool, dispassionate, and seemingly objective and rational style helped Frank to reject the lyricism of some of his earlier work, and his refusal to compromise his standards to conform to the needs and desires of magazine editors undoubtedly impressed the rebellious—and often rejected—younger photographer. In addition, *American Photographs,* Evans' 1938 publication on the "physiognomy of a nation," as Lincoln Kirstein phrased it, may also have given Frank confidence that his project, though ambitious, was not too foolhardy nor his mission unattainable. Most immediately, Evans' support of Frank's Guggenheim application, along with that of Meyer Schapiro, Edward Steichen, Alexey Brodovitch, and Alexander Liberman, was critical to Frank's securing a fellowship in 1955, as well as a renewal in 1956.[41]

In his application Frank was quite clear that his would not "be a carefully planned trip, but a spontaneous record of a man seeing this country for the first time....The project I have in mind is one that will shape itself as it proceeds, and is essentially elastic." His meandering route confirms his desire to pursue an intuitive quest.[42] Between April 1955, when he was awarded a Guggenheim fellowship, and June 1956, he made several short trips out of New York and one long nine-month journey to the west coast. Using his Leica cameras, often with a wide-angle lens, he shot 687 rolls of film. He developed about a quarter of the film in Los Angeles and Orinda, California, made contact sheets, and reviewed his results; he developed and proofed the remainder when he returned to New York in June 1956.

Although Frank's close friendship with some beat authors, including Allen Ginsberg and Jack Kerouac, did not begin until after he made the photographs for *The Americans,* he shared much in common with them as he embarked on his journey in 1955. His style was as free, loose, and innovative as Kerouac's brilliant linguistic leaps and as direct, spontaneous, and intense as Ginsberg's impassioned cries. Describing his trip as "pure intuition," Frank noted, "I just kept on photographing. Kept on looking." Placing primary importance not on thought but experience, Frank insisted that "a photographer cannot be inspired in such a large project. Everything has to come by and out of experience while working."[43] He had to, as Kerouac wrote, "tap from yourself the song of yourself, *blow!—now!—your* way is your only way—'good'—or 'bad'—always

Negative Strip, *Hoboken, New Jersey,* 1955

honest, ('ludicrous'), spontaneous, 'confessional,' interesting because not 'crafted.'"[44] This looking, these experiences, resulted in photographs that appear uncrafted, like glimpses from a passing car. Seen out of the corner of the eye, they sometimes have no central subject. People are frequently photographed with their backs to the camera or their faces turned and partially obscured, their expressions unclear. Figures occasionally loom in the extreme foreground, abruptly cropped by the edge of the print. The photographs are often under-lit and underexposed; the images are frequently off balance with tilted, out-of-kilter planes that are vague and ill-defined; and the subjects are occasionally out-of-focus. These photographs are not merely casual in their composition or relaxed in their framing, like snapshots, but aggressive, haunting, and deeply disturbing. Ginsberg explained that "Robert had invented a new way of lonely solitary chance conscious seeing, in the little Leica format (formerly not considered true photo art?). Spontaneous glance—accident truth."[45]

Frank's contact sheets reveal that he was extremely free in his seeing and spontaneous in his reactions, much more so than he had been in the past (pages 172–173). Whereas in Europe he had often labored to find his photographs, shooting several frames, even whole rolls of film to make one image, on his Guggenheim trip, time after time he got the image he was after in his first shot, confirming Ginsberg's dictum, "first thought, best thought."[46] Like a boxer in a ring, Frank seems to have responded immediately and intuitively to the changing scene in front of his eyes. Awed both by the way Frank looked at the world—his quick, seemingly cursory but devastatingly concise seeing—and by his actual physical movement, Kerouac later described him "prowling like a cat, or an angry bear, in the grass and roads, shooting whatever he wants to see." He continued, "It's pretty amazing to see a guy, while steering at the wheel, suddenly raise his little 300-dollar German camera with one hand and snap something that's on the move in front of him, and through an unwashed windshield at that." Recounting a trip they took to Florida in 1958, Kerouac said where he saw nothing unusual, "Robert suddenly stopped and took a picture of a solitary pole with a cluster of silver bulbs way up on top, and behind it a lorn American landscape so unspeakably indescribable, to make Marcel Proust shudder."[47]

While it is tempting to view Frank as one of Kerouac's "madroad driving men…the crazed voyager of the lone automobile," his work on this project was much more methodical than the legend generally admits.[48] Although he sought to experience the vast stretches of the United States with the fresh eyes of a European, he did not embark upon his journey without preparation and preconceptions. Before he received his Guggenheim fellowship he had identified and systematically begun to explore some of the subjects, such as flags, diners, and juke boxes, that he would relentlessly pursue on his cross country travels. In his application he announced his plans to "classify and annotate my work on the spot, as I proceed." Although this proved impossible to accomplish while on the road, during his extended stays in California he not only developed and made contact sheets of his negatives, but also, as he reported to the Guggenheim Foundation, "edited" his work.[49] Besides selecting potential photographs from his contact sheets, he also noted what subjects had caught his attention, determining which ones had symbolic potential and warranted further attention, and which ones had been sufficiently explored.[50] He even returned to the Fourth of July celebration in Jay, New York, on two different occasions to photograph a transparent American flag (page 183). Traces of his Swiss training also surfaced in his organization of his negatives. Although he did not meticulously trim and mount his contact prints onto subject cards as he had done in Switzerland, he did establish a large file that included all the negatives made on the Guggenheim trip. In addition, he put in this file film from other projects shot before and after his fellowship that he thought he might use in his final photographic essay. With some exceptions, he numbered the rolls of film in approximate chronological order and created negative and contact sheet files, which he labeled most often by location—Santa Fe, New Mexico, or Butte, Montana, for example—but also by event—the Democratic convention or the Motorama—and by subject matter—juke boxes, motorcycles, or cowboys.

The product of this intuitive quest, *The Americans,* was published in 1958, only after many months of intensive editing. With more than 20,000 frames from which to choose, Frank could have told many different stories. "The biggest job, I think, on that book," Frank told a group of students, "was the selection and elimination of prints."[51] When he returned to New York in the summer of 1956 he finished developing his film. By October 1956, he may have made a preliminary selection, as he wrote to an editor at Random House asking if he could show William Faulkner "his finished project," in the hope that the eminent author would write an introduction.[52] He spent most of the fall and winter of 1956 and 1957 making 8 by 10 inch proof prints of approximately 1,000 images that interested him. He stapled and thumbtacked these to the walls of his apartment, or spread them out on the floor, gradually eliminating the ones he did not like and methodically arranging and rearranging those he did.[53] By April 1957 he was quite certain the French publisher Robert Delpire would, as promised, print his book, and Evans

had agreed to write an introduction. By June 1957, when he arrived in Paris to meet with Delpire, Frank had selected and sequenced about ninety prints and made a maquette.[54]

In several respects, the maquette reveals Frank's original intention. Approximately the same size as the first and second editions published in France by Delpire in 1958 and in the United States by Grove Press in 1959, the sequence of pictures is also nearly identical.[55] The maquette and the Grove Press version have the same design with all of the photographs on the right-hand pages facing blank pages on the left. (In the French edition Delpire added texts criticizing the United States to the left-hand pages.) In an era that favored elaborate, seductive but superficial layouts, staccato rhythms of images, and the integration of type and photographs, Frank's design was radical for its seeming lack of style and its old-fashioned presentation. Sedate, methodical, and intensely serious, the lay-out of his maquette was more like Evans' *American Photographs* than other photographic books of the period, even those published by Delpire.[56] Moreover, in all of his previous books Frank had juxtaposed at least a few photographs. Here he established a much more subtle and complex sequence that was devoid of obvious, side-by-side comparisons and therefore did not immediately make its point. Here he created a quiet procession where both recollection and anticipation play an active role, allowing for a far wider range of expression.

The maquette is also divided into four clearly labeled sections, each beginning with a photograph of a flag. Even though Frank eliminated the divisions in the published version, the "chapters" are extremely important because they are the organizing structure of the book. As in *Black White and Things,* each of the four sections addresses different aspects of Frank's understanding of America and expresses a different feeling. Like a musical score, the first chapter establishes the themes the book will explore: the role of patriotism and politics, business and the military, African-American culture and racism, rich and poor, youth and religion in American society. The second, as Frank wrote to his parents, depicts, "how Americans live, have fun, eat, drive cars, work."[57] The third presents those few areas of deviance and non-conformity, as well as the strength and vitality that Frank saw in African-American society, motorcycle gangs, alternative religious sects, young people, and music. (Frank clearly allied himself with these outsiders by placing a photograph of his shadow falling on the exterior of a barber shop's screen door as the second image in this chapter [page 182].) The fourth section speaks of the alienation of the American people and their lack of physical and spiritual connection to either their cities and towns or to nature.

Written in Frank's hand on the back cover of the maquette are the words "America, America," and this too is indicative of the photographer's intent. When the book was first titled in France as *Les Américains* and translated into English as *The Americans,*

it was strongly criticized because of the specificity of its title, because it did not fully describe all Americans, only some Americans. "Chicago has more valid facets to its personality than haranguing politicians," critics argued, "New York more than candy stores and homosexuals."[58] But as his preliminary title clearly indicates, Frank had no intention of describing all Americans. Like Whitman, Kerouac, or Ginsberg, he wanted to create an ode; he wanted to sing his song, expressing his reactions to America. His aim was not a didactic exposition: unlike the authors of photographic travel books of the 1950s, Frank was not attempting to tell his audience all about this country, nor was he striving to create a list or recitation of the component parts of American civilization, as Evans had done before him.

The Americans is a "vision, not an idea," as John Clellon Holmes described the beat movement. It is an attempt to chronicle, as Frank wrote, "the kind of civilization born here and spreading elsewhere."[59] With a regular, emphatic cadence that grows louder and stronger as the sequence progresses, this book of eighty-three photographs speaks of the profound malaise of the American people during the 1950s. It reveals the deep-seated violence and racism, and the mind-numbing roteness, conformity, and similarity of the ways Americans live, work, and relate to one another. It describes our symbols of patriotism as transparent and meaningless, our public celebrations as hollow, our religion as commercialized, and our politicians as fatuous or distant at best, and egomaniacal or corrupt at worst. It shows a country that despite vast wealth and a seemingly endless array of consumer products, admitted little real freedom of choice, expression, or thought. It shows a country that plastered smiling faces on its walls and seemed to demand a universal optimism from its people, but was, in reality, joyless and depressed. But, as in *Black White and Things,* Frank not only described the "somber places and black events," but also those people, places, and things that seemed true and genuine, with a spiritual integrity or moral order. In *The Americans* he saw those sources of strength in the subcultures of music, symbolized most evocatively in the glowing juke boxes, which often seem more alive than the people who feed them coins; in African-American culture and alternative religious groups, neither of which seemed choked by puritan values; and in the integrity of the family unit. Frank concluded his highly personal record with a photograph of his wife and children in his car.

The Americans does not easily or readily admit dissection, though it can be analyzed on many different levels. We can applaud the intensity of the individual photographs with their tough subject matter and radical style, and we can analyze their social and political implications, interpreting them as statements on American life in the 1950s. We can recognize the structural use of the four chapters and begin to chart the formal, iconographic, social, and political connections between the photographs.[60] We can note, for example, how the first four photographs seem to introduce the cast of characters—the powerful

politicians and the powerless poor—and the dominant symbol of the American flag, and we can marvel at the way Frank used facial expressions and gestures to create a flow and unity from one photograph to the next. Inevitably, though, we come upon one photograph, such as the fifth one in the book, of a military man escorting a woman across a street, whose meaning is less than clear, and all of our interpretations, assumptions, and expectations are called into question (pages 175–178). We can even appreciate the sophistication of the sequencing, noting how Frank, like Brodovitch and Evans before him, recognized that his book needed not only emphatic images with obvious symbolism, but also unemphatic and ambiguous notes to function as transitions, pauses, or even merely to add mystery. Ultimately, though, none of these approaches, either separately or collectively, fully elucidates the book. Too cerebral, analytical, and rational, such analyses are like dissecting a poem word by word: when finished, we may understand the words, we may even understand the connection between the words, but not the poetry.

In *The Americans* Frank was not constructing a story with a logical progression from one idea to another, nor was he formulating a conscious, rational polemic, for he was not working on the level of the literal, specific, or didactic. The integrity and wholeness of the sequence were his primary objectives.[61] He did not want the photographs dissected as discrete, precious objects, but rather, meaning was to be garnered from the concatenation of the whole. In this larger whole of the book he wanted to create some thing close to what Kerouac sought to achieve in his prose. In one long breath filled with literary leaps and allusions, in words rich with onomatopoeia and nonsense which seem to tumble over one another, throwing the reader both forward and backward, and with sentences so impossibly long that when they end it is difficult to remember where they began, Kerouac sought to encapsulate and engender an experience. He wanted to convey the rush and energy, as well as the multiplicity, complexity, and ambiguity of a keenly felt perception; he wanted to describe what it felt like to drive into "the sad American night" with such intensity and immediacy that his reader would also participate in his quest. Frank also knew that only a sequence, made up of one long rambling sentence, could catalyze and sustain the experience he wished to convey, and only a sequence would allow him to address the multiple, occasionally contradictory, and often allusive feelings that formed his perception of America. In one long breath Frank constructed a sequence, united by formal, iconographic, and symbolic repetitions and mutations, that speaks about his journey into the "sad American night." It is a sequence that does not cleanly and logically progress from beginning to end, but, like our perception of reality, at times doubles back on itself and at other points makes perplexing leaps forward. It is sometimes strangely silent, like a dream or a memory: while juke boxes and television sets glow, politicians cajole, and wide-mouthed tubas confront us, we hear no sound, but instead undefinable feelings and vague associations are evoked. It is a sequence with an emphatic voice

and tone, but whose specific meaning is intentionally slippery and open to numerous interpretations. Finally, it is a sequence with a distinct, intense order that nullifies explanation. All discourse is rendered useless and irrelevant, for Frank succeeded in evoking not a metaphor for his experience of the United States, but the experience itself. Not dependent on words, this sequence speaks to the heart, not the mind. It does not record, depict, display, or present, but rather it catalyzes and engenders experience; it simply is.

In the years since its publication, *The Americans* has gone through a peculiar transformation and assumed a life of its own well beyond that originally intended by its creator. Initially scorned as anti-American, it was fervently embraced in the 1960s by a generation of painters, photographers, filmmakers, writers, and others who saw in it an affirmation of their own values. During the 1970s as Frank's reputation soared, curators, critics, and historians singled out a few images from *The Americans* and conferred iconic status on these works. (Frank himself also contributed to the creation of these "masterpieces" by exhibiting and selling single prints from *The Americans*.) Removed from the context of the sequence, these separate images began to represent the entire book. Many viewers have come to read these photographs more as masterpieces, singular and complete unto themselves, than as integral and related elements in the larger whole of the book. In addition, when *The Americans* was first printed in 1958 and 1959, rich photogravure reproductions were made of the original photographs. Beginning with the 1969 edition, however, the reproductions have markedly more contrast and less subtlety: the images became harsh, gritty, and bleak, as did Frank's own prints of works in *The Americans* from the late 1960s and 1970s.[62] However, prints made in the late 1950s and early 1960s, like the earlier photogravures, are lush, poignant, and evocative with a luxurious use of rich dense blacks. The mood they created is not harsh or bitter, but romantic, sad, and elegiac. They show that *The Americans* was not born out of hatred or disgust, not out of a desire to destroy, but rather it was a passionate cry. As Frank wrote in its defense in 1958, "criticism can come out of love."[63]

> "I am making souvenirs. I am making memory because that is what I know,
> that is what I learned to know about, that is hopefully an expression of my true
> feeling. To tell my story. How I know the weakness of these concepts."
> ROBERT FRANK, 1985[64]

Frank's personal and professional story changed dramatically after the publication of *The Americans*. In the summer of 1958 he borrowed an 8mm movie camera from a friend and made a whimsical, short film about a woman who was pursued by numerous suitors. It proved to be the first of more than twenty-five films and videos that he would direct, write, or photograph. Having spent more than a decade trying to achieve that

"more sustained form of expression" through sequences of still photographs, it was logical for him to venture into filmmaking. Yet in many ways it was a curious choice. Frank was very much one of those "characters of a special spirituality," as Kerouac described the beat writers, "who didn't gang up but were solitary Bartlebies staring out the dead wall window of our civilization."[65] As a non-conformist and an outsider, naturally skeptical of organized activities, he had spent much of his adult life avoiding group endeavors. Filmmaking, though, is unquestionably a collaborative art form, and Frank soon discovered that editing films and working with actors, producers, directors, and cameramen could be much more difficult than sequencing still photographs. Yet the restlessness that pervades his character, his abhorrence of repetition, his deep suspicion of success, and his desire not only to push himself but to court actively both risk and failure made it im-

Jack Kerouac, 1959

possible for him to continue to work as he had. By 1958, Frank knew, as he later explained, that "film was first choice. Nothing comes easy, but I love difficulties, and difficulties love me."[66]

Frank did not abandon still photography altogether, but the few photographic projects he worked on in the late 1950s and early 1960s indicate a deep sense of frustration with the limitations of the medium. In late 1957 and 1958 he made what he later called his "last project in photography," a group of photographs taken from a moving bus.[67] Just as Evans in his photographs made on the New York subways twenty years before had only photographed those people who happened to sit opposite him, Frank only recorded what could be seen from the windows of the bus. After the unparalleled freedom of the Guggenheim trip, it was as if Frank was challenging himself to see if he could extract something of significance from an extremely restricted environment. Because he was in motion when the photographs were made and because many of the people depicted were also moving, the images often appear to be still frames from a film, as if the bus were a dolly and the window a viewfinder. Yet, while he often referred to them as the "bus series," Frank never ordered them into a specific sequence. In addition, through 1963 he worked with Louis Silverstein, art director of the promotional department of *The New York Times,* on a series of dynamic advertisements titled "New York Is…."[68] Initially these consisted of single images celebrating the sophistication of *The New York Times'* readers. However, by

1961 Frank began to submit photographs that were composed of two identical images, and by November 1962, indicating his complete rejection of the single still photograph, he made prints from filmstrips.

After ten years of intensive work in filmmaking, Frank returned to still photography in the early 1970s. He fell back on his earlier method of expression for a variety of reasons. In 1972, at the instigation of Kazuhiko Motomura and Toshio Hataya, he published a very personal, retrospective examination of his life titled *The Lines of My Hand*. (It was first printed as a limited edition in Japan and subsequently a condensed and slightly altered version was printed by Lustrum Press in the United States.) This book undoubtedly rekindled his interest in both his past work and the process of photography in general. In addition, in 1970 Frank and June Leaf, a painter whom he would marry in 1975, bought land in Mabou, Nova Scotia, and that more isolated existence also encouraged a more solitary method of making art. But more than anything else it was the sudden death in 1974 of his twenty-year-old daughter Andrea, coupled with the earlier disappearance and presumed death of his good friend and fellow filmmaker Danny Seymour, that propelled his return to still photography. In order to continue to work, Frank needed to express and vent the pain of these tragedies. Although he did make films that embodied his grief, still photographs became his most immediate and direct means to try "to show how it feels to be alive."[69]

The 1972 publication of *The Lines of My Hand* was, of course, one more manifestation of his desire to use the book format as a way to create a more sustained form of expression with still photographs. Including work from the early 1940s to 1971 and punctuated with brief, candid remarks by Frank himself, the book is an extremely eloquent and moving account of the artist's struggle to know himself and his world. Unlike his previous books where the sequences were structured by formal, iconographic, social, and political relationships, the photographs in *The Lines of My Hand* are arranged chronologically to tell Frank's story. Moreover, the images were selected not so much for their historical or aesthetic significance as for their personal meanings to Frank. Many of the photographs had never before been published, including several studies of friends and family, as well as work from

"New product...new idea. Got to have something new...something big...something great. Why wasn't I born a plumber?"

New York is where the selling starts. Because more of the nation's big corporations are headquartered here. Because 60% of advertising agency billings originate here. Because it is the world's biggest consumer market, $23-billion strong. If your next sale is the one you are most interested in, look to The New York Times. It not only serves New Yorkers with the most news...it sells them with the most advertising. New York *is* The New York Times.

Advertisement from the series "New York Is...," 1962

the Guggenheim trip; others were variants or different croppings of more well-known work. Although *The Lines of My Hand* indicated a new direction for photographic books that were overtly autobiographical, it was not Frank's most innovative exploration of how to construct a more extended expression in photography. Since 1970 that can be found not so much in his books as in his individual photographs.

The last work in the American edition of *The Lines of My Hand, Mabou,* 1971, succinctly summarizes not only the way Frank would create many of his later photographs, but also some of the subjects and ideas that would pervade his art for the next twenty years (pages 230–231). Composed of several different prints that have been cut and taped together, it consists of two sweeping panoramas of the stark landscape, the empty bay, and the expansive horizon seen from Frank's new home in Mabou. The bottom vista appears to have been taken on a stormy day in the late fall or early spring, while the top view, made during the winter, shows the frozen ocean. Below the panoramas Frank has written, "Yes it is later now... The ice is breaking up... The water will be warm and blue. The boats will be out there. The hills will look green again. Will we go back to New York? Just stay and watch the weather and June is looking through the microscope. I will do something. Isn't it wonderful just to be alive."

Little in Frank's earlier still photographs prepares us for the raw and unrefined nature of *Mabou.* While he had made works using two negatives as early as 1948, he neatly printed the separate frames so that the final work appears like a page spread from a magazine[70] (see *Peru,* pages 58–59). No such care has been taken with *Mabou.* None of the edges of the prints, with their insistent black borders, are aligned. Instead they jump up and down as if they had been blown about by the wind or carelessly thrown onto the page. By splicing and taping together fragments of several different prints to create a composite whole, Frank emphatically declared "that for me the picture had ceased to exist."[71] *Mabou,* with its deliberate, self-conscious crudeness, is an obvious signal, not just that he was bored with the single photographic image, but, like other artists of the 1970s and 1980s, that he wanted to defile its aura and violate its sanctity. At the time he said that he would rip photographs, double-print, "I mean do all kinds of things so I wouldn't be stuck with that one image."[72] For years he had been frustrated with what he saw as the limited potential of the single image and he had compensated for that by first making sequences of photographs, and later films. After 1971 he corrected that deficiency by printing two or more negatives on one piece of paper or by combining anywhere from two to more than one hundred separate prints in one work, taping, gluing, and even nailing the individual pieces into place (see *Sick of Goodby's, Halifax Infirmary,* or *Untitled* and *Mute/Blind,* pages 251, 253, 287, 289). He recognized that with these later works the discrete photographs were not as important as what he did with them, how he edited and presented them. "It isn't in the pictures," he explained to a group of students in the late 1980s, "the pictures

Anonymous, *Robert Frank with Super-8 Camera*, 1972

are a necessity: you do them. And then the way you present them, and the way you put them together—it can strengthen the simpleness of the visual series, image, whatever."[73]

In addition, from his years of editing films, Frank was challenged not only to combine several different images in a final print, but also to make his photographs speak. He felt that if he could merge words with his images he would "be more honest and direct about why I go out there and do it."[74] Sometimes, as in *Mabou*, the accompanying texts are quite extensive. More often, though, they are terse dictums, laconic phrases, even shrill pleas that have been scratched into the negatives or written directly on the prints. As in *Sick of Goodby's* or *Boston, March 20, 1985,* it is often difficult, on first glance, to distinguish between words that are scored into the negative, words that are written, painted, or glued onto the print, and ones that Frank has written and then photographed (pages 260–261). By intentionally streaking the edges in processing his Polaroid film, he further complicates the image surface. And because he frequently uses mirrors and windows on which he writes or hangs words and objects, it is also hard to determine what is a reflection and what is actually in front of the camera. Merging words and images, inside and outside, reality and illusion, these are ambiguous, complex, and cluttered images that deliberately "destroy the descriptive elements," as Frank wrote, "show how I am, myself…to show my interior against the landscape I'm in."[75]

Frank's interior as well as exterior landscapes had changed significantly by the early 1970s and the issues of time and change, memory and perception are critical to his later work. *Mabou* was placed at the end of the second edition of *The Lines of My Hand* as a coda and when Frank wrote, "Yes, it's later now," he wanted to suggest the passage of time between the earliest images reproduced in the book and this final work, between his past and his present. But *Mabou* itself is also intrinsically about time and change. It is not just about the change of seasons, from winter to early spring or late fall, but also about changes in the physical landscape itself. The top study is of the pure, unsullied vista—rolling hills, rocks, frozen ground, snow, ice, water, and sky—while the bottom image shows the detritus of modern civilization—telephone poles, wires, piles of wood, a truck, a car, and a fence. These are the markers of Frank's presence, his impact on this barren hillside. *Mabou,* though, is also about a change in Frank's interior landscape, a change in his point of view. Whereas once he traveled all over the world searching for objects that expressed his under-

standing of a people or place, now "it's later," now he looks mainly at this view, scanning from left to right and right to left for both the minute and monumental changes in the weather and the light, celebrating both the continuity and diversity of his new perspective. Like June, who as Frank metaphorically wrote, "looks through the microscope," he too is looking at a limited field, but it is one that is continually, if subtly, changing. It is interesting to note that while the edges of the prints, like our memory of the past, are jagged, unaligned, and unfinished, the horizon line, like the future, is unambivalent and certain. The hills will get green, the boats will return, for both change and continuity are inevitable.

In his 1985 video *Home Improvements* Frank again surveyed this vista. As the camera pans from a reflection of his face in a window out to the bay and ocean and back to the house again, Frank said, "I'm always doing the same images. I'm always looking outside trying to look inside. Trying to tell something that's true. But maybe nothing is really true. Except what's out there. And what's out there is always different." In *Black White and Things* and *The Americans* Frank found that he could say something that was true by extending time. He discovered that by joining together a series of photographs he could evoke the ideas, feelings, and associations of a keenly felt perception. In his later works, though, such as *Mabou* or *Untitled* and *Mute/Blind,* it is as if he has condensed and collapsed time. Like an archaeological site, they consist of layers of time literally and metaphorically piled on top of each other. They merge past and present—images that were taken a week or a month ago with ones thirty or forty years old—to suggest that reality, or any fundamental understanding of the world, is a result not only of our present perception but also our past. In this way, these later photographs are fundamentally about memory. They are about the ability of photography to freeze and thus preserve a feeling or an idea, to hold it still, while the world keeps on moving. They are about those intensely perceived moments when the heart, speaking to the mind, floods our consciousness with the evocative and allusive sensations, feelings, and thoughts of the past. It is the memory of the green hills and the boats in the water that not only makes our present life both so poignant and rich, but also defines our very existence and shapes our perception of the truth. For Frank, the truth is not stable and immutable; while it can be perceived and felt, it can never be fully defined or finally fixed. As he wrote to a good friend in 1985, "the truth is like a slippery fish escaping from your hands."[76]

Notes

1 Robert Frank, "Guggenheim Application and Renewal Request," reprinted in *Robert Frank: New York to Nova Scotia*. Edited by Anne W. Tucker and Philip Brookman (Houston and New York: Museum of Fine Arts and the New York Graphic Society, 1986), 20.

2 For an excellent discussion of this photograph, as well as its relationship to Frank's later work, see Shelley Rice, "Some Reflections on Time and Change in the Work of Robert Frank," *The Photo Review* 13:2 (Spring 1990), 1–9. See also Penny Cousineau, "New Work by Robert Frank," *Artscanada*, 224–225 (December 1978–January 1979), 58–59.

3 When Frank first started working it was quite common for him to make many negatives of a subject. However, by the middle of the 1950s he came to rely much more on his intuitive response to a situation and often made only one or two exposures of a subject. Usually, it was his first response that was the most directly seen and clearly felt, and thus proving to be the most successful (see pages 172–173).

4 "The Pictures are a Necessity: Robert Frank in Rochester, NY, November 1988." Edited by William S. Johnson. *Rochester Film and Photo Consortium Occasional Papers* no. 2 (January 1989), 38. Hereafter cited as "The Pictures are a Necessity."

5 "*Life* Announces the Winners of the Young Photographers' Contest." *Life* 31:22 (26 November 1951), 21.

6 "The Pictures are a Necessity," 28.

7 Besides Wolgensinger, other Swiss photographers had also published books with similar titles: in 1942 Gotthard Schuh published *50 Photographien,* with an introduction by Edwin Arnet (Basel: Urs Graf Verlag), detailing different subjects that could be effectively rendered by photography; while in 1946 Werner Bischof, who was a student of Finsler and would become renowned as a photojournalist, published *24 Photos,* with an introduction by Manuel Gasser (Bern), summarizing his modernist investigations of line, form, shape, and light.

8 See Hans Staub in *Photographie in der Schweiz von 1840 bis heute* (Bern: Benteli Verlag, 1992), 8.

9 "The Pictures are a Necessity," 30.

10 "The Pictures are a Necessity," 29.

11 Edwin Denby [Introduction], *Ballet: 104 Photographs by Alexey Brodovitch* (New York: J. J. Austin, 1945), 12.

12 "The Pictures are a Necessity," 29. When he was in London in 1952 Frank arranged to meet Brandt in order to tell him of his admiration for his work.

13 Bill Brandt, *Camera in London* (London: The Focal Press, 1948), 14. Robert Frank, "Robert Frank: Letter from New York," *Creative Camera* 66 (December 1969), 414.

14 Whereas many photographically illustrated books of the 1930s were concerned with social issues—Erskine Caldwell and Margaret Bourke-White's *You Have Seen Their Faces,* 1937, or Dorothea Lange's *An American Exodus: A Record of Human Erosion,* 1939, for example—those of the late 1940s and 1950s often promoted harmony among nations and sought to domesticate the exotic. Other photographic books published after World War II include: Henri Cartier-Bresson, *Les Danses a Bali,* 1954, *The Europeans,* 1955, *Moscow,* 1955; Robert Capa and Irwin Shaw, *Report on Israel,* 1950; Gotthard Schuh, *Italien,* 1953, and *Iles des Dieux,* 1954; and Werner Bischof, Robert Frank, and Pierre Verger, *From Incas to Indios,* 1956.

15 "The Pictures are a Necessity," 30.

16 "The Pictures are a Necessity," 30.

17 Although Frank did not actually title the volumes, these two works are usually referred to, by both Frank and others, as the *Peru* books. However, while the majority of images were made in Peru, a few were taken in other South American countries.

18 "Robert Frank by Robert Frank," *Robert Frank.* Pantheon Photo Library. (New York: Pantheon Books/Centre National de la Photographie, Paris, 1985), unpaginated.

19 "Robert Frank by Robert Frank," *Robert Frank,* unpaginated.

20 According to the photographer Ed Grazda, each village or region in Peru has its own style of hat, thus identifying where the wearer lives.

21 Although both volumes are now bound, it is possible that either or both could have been unbound at some point. However, because the photographs are dry mounted back-to-back and because the same pairs of photographs appear in each book, this seems highly unlikely. The sequence is the same for the first five page spreads; thereafter it is different. Both end

with the same photograph of a man wearing a hat back-lit by sun.

22 "The Pictures are a Necessity," 31.

23 On 3 June 1952 Frank wrote to W. Eugene Smith, stating that although he could sympathize with the difficulties Smith encountered working at *Life,* "You had the best photographic story's [sic] known published in *Life* and with that reached a great audience, no other publication could have done as much for you as they did." W. Eugene Smith Archive, Center for Creative Photography, University of Arizona.

24 "*Life* Announces the Winners of the Young Photographers' Contest."

25 This is translated from the French: "Les choses les plus simples changent si l'homme prends contact avec. Même un pissoir."

26 *Mary's Book,* private collection. Misquoting the original, Frank actually inscribed the book, "Maybe / this is not a story— / Seulement 'l'essentiel est / invisible pour les yeux, on / ne voit bien qu'avec le coeur.' / You remember / Le petit Prince." The correct version of this quote has been taken from Antoine de Saint-Exupéry, *The Little Prince* (New York: Harcourt Brace Jovanovich, Inc., 1943, 1971), 87.

27 Robert Frank, *Black White and Things* (Washington: National Gallery of Art and SCALO, 1994). Frank made three copies of *Black White and Things.* He gave one to his mother, another to Steichen, which is now in the collection of the Museum of Modern Art, New York, and kept one for himself, which he gave in 1990 to the National Gallery of Art, Washington. Designed by his friend Werner Zryd, all three copies are identical in size, construction, and sequence.

28 For further discussion of Saint-Exupéry, see Colin Anderson, "Creative Intuition and Conceptualization in Saint-Exupery's Epistemology," *AUMLA* no. 70 (November 1988), 296–312.

29 "The Pictures are a Necessity," 37, and *Photography Within the Humanities,* Eugenia Parry Janis and Wendy MacNeil, editors. (Danbury, New Hampshire: Addison House Publishers and the Art Department, Jewett Arts Center, Wellesley College, Wellesley, Massachusetts, 1977), 56.

30 *The Little Prince,* 67.

31 Edna Bennett, "Black and White are the Colors of Robert Frank," *Aperture* 9:1 (1961), 22, quoted Frank as saying: "Black and white are the colors of photography. To me they symbolize alternatives of hope and despair to which mankind is forever subjected."

32 Frank may have constructed *Black White and Things* in reaction to Henri Cartier-Bresson's highly successful book, *The Decisive Moment,* which was published in Switzerland in July 1952, only three months before Frank, who was also in Switzerland at the time, put together his own book. In this work Cartier-Bresson wrote that a picture story is "a joint operation of the brain, the eye, and the heart." He suggested that it was possible to order, perhaps even control the flux of life to reveal an underlying harmony (unpaginated). Frank did not believe that such a harmony or universal truth existed.

33 Frank "A Statement…," in *U. S. Camera 1958.* Edited by Tom Maloney. (New York: U. S. Camera, 1957), 115.

34 Bennett, "Black and White are the Colors of Robert Frank," 22.

35 Frank, "Chronology," *Robert Frank* (New York: Aperture, 1978), 92.

36 "The Pictures are a Necessity," 38.

37 "The Pictures are a Necessity," 38.

38 Frank, "Guggenheim Application and Renewal Request" (1954–1955), reprinted in *Robert Frank: New York to Nova Scotia,* 20. Frank's insistent belief in the validity of recording what "one naturalized American citizen finds to see" in the United States was very similar to that of Simone de Beauvoir who, in an account of her journey to America, wrote "it does not seem to me altogether useless to relate, even in comparison with the great descriptions left by more competent writers, how America revealed itself to a single conscience day by day: my conscience. In place of a study that it would be presumptuous for me to attempt, I can at least give faithful testimony here of what I saw. Just as concrete experience embraces both subject and object, so I have not sought to eliminate myself from this account." *America Day by Day* (London: Gerald Duckworth and Company, 1952), unpaginated.

39 A copy of a draft of Frank's Guggenheim application is now in the holdings of the Walker Evans Estate. For a listing of Evans' projects that are similar to Frank's description of his intended subjects, see *Walker Evans at Work* (New York: Harper and Row, Publishers, 1982), 98, 107, or 184.

40 "The Pictures are a Necessity," 35.

41 Evans' influence on Frank has been the subject of much speculation (see Tod Papageorge, *Walker Evans and Robert Frank: An Essay on Influence* [exh. cat., Yale University Art Gallery, New Haven, 1981] and Lesley K. Baier, "Visions of Fascination and Despair: The Relationship Between Walker Evans and Robert Frank." *Art Journal* 41:1 [Spring 1981], 55–63). Despite the close association between the two photographers, *American Photographs* was not an iconographic source book nor a theoretical model for Frank's subsequent publication. Frank did not need Evans' encouragement to record vernacular life—he had been recording the roadside culture of Switzerland, Peru, France, Spain, England, and to some extent the United States, for more than a decade. Nor did he need Evans' example to prompt him to publish his photographs in a book format for, as this essay demonstrates, he had been striving to do that long before he met Evans or saw *American Photographs* or *Let Us Now Praise Famous Men.* It is possible, however, that Frank was influenced by the spare, classic design of *American Photographs,* for none of his previous books was constructed in such a manner.

42 Draft of Frank's Guggenheim application, Walker Evans Estate, and "Fellowship Application Form, John Simon Guggenheim Memorial Foundation," reprinted in *Robert Frank: New York to Nova Scotia,* 20. For a map of Frank's journey as reconstructed by Anne Tucker, see in *Robert Frank: New York to Nova Scotia,* 95.

43 Dennis Wheeler, "Robert Frank Interviewed," *Criteria* 3:2 (June 1977), 4.

44 As quoted by Adam Gussow, "Bohemia Revisited: Malcolm Cowley, Jack Kerouac, and *On the Road,*" *The Georgia Review* 38 (Summer 1984), 304.

45 Allen Ginsberg, "Robert Frank to 1985—A Man," in *Robert Frank: New York to Nova Scotia,* 74.

46 Thomas Merrill, *Allen Ginsberg* (Boston: Twayne Publishers, 1988), 6.

47 Jack Kerouac, "On the Road to Florida," *Evergreen Review,* 74 (January 1970), 43, referring to plate 74 in Frank, *The Lines of My Hand* (Tokyo: Yugensha, Kazuhiko Motomura, 1972).

48 Jonathan Green, *American Photography* (New York: Harry N. Abrams, Inc., 1984), 89.

49 Guggenheim application and application for renewal, *Robert Frank: New York to Nova Scotia,* 21.

50 In an extensive interview conducted at Yale University in 1971 Frank implied that his perusal of his negatives in Los Angeles and Orinda was rather summary. See "Walker Evans on Robert Frank / Robert Frank on Walker Evans," *Still/3* (New Haven: Yale University, 1971), 2–6. (This is an edited version of "Walker Evans with Robert Frank and Others, Yale University, New Haven, Connecticut, May 5, 1971," unpublished manuscript in the Walker Evans Estate.) However, while he frequently photographed juke boxes in 1954 and 1955, after he developed his negatives in Los Angeles in late 1955 or early 1956, and presumably saw his numerous images of this subject, he made no further studies of juke boxes on the Guggenheim trip.

51 Interview, Yale University, 5 May 1971, 21.

52 Frank to Saxe Commins, 8 October 1956, National Gallery of Art.

53 John Cohen, "Memories of Third Ave. and Robert Frank 1957–1962," (unpublished typescript), National Gallery of Art.

54 In the "Yale Interview," 5 May 1971, 21, Frank said when he arrived in Paris, Delpire "only objected to three or four pictures" which he took out. The maquette that Frank presented to Delpire is now in the collection of the Museum of Fine Arts, Houston.

55 While the order of images in the maquette is almost identical to that of the version that was subsequently published, beneath the photostats in the maquette are numbers which record an earlier, slightly longer sequence. Although each of the four sections begins with the same images as the published version, thereafter the order is different. In many instances the published sequence is more condensed and concise than the earlier version, focusing more tightly on central themes, such as the road or politics, or imposing a sense of structure and closure to critical passages. For example, in the earlier version, the series of "road" pictures at the end of the second section begins with the same image of the hitchhikers, but includes another study of a young man in a car; it ends not with the photograph of the empty highway, but with a picture of a body next to the road in New Mexico. In some cases, in the published version, Frank altered the tenor of an entire section, removing or rearranging whole passages to make them less simplistic and literal and to render his symbolism more complex and multi-layered. For example, in the earlier version of the first section he included several photographs about love, marriage, and male / female relationships and seems to have conceived of this opening passage as being about politics, religion, family, power, and youth, as

opposed to the more inclusive statement included in the final published form.

56 See, for example, *Emile Schulthess: USA,* edited by Robert Delpire (Zurich: Manesse Verlag, 1955).

57 Frank, letter to his parents, winter 1955, translated from German, in *Robert Frank: New York to Nova Scotia,* 28.

58 James M. Zanutto, in "An Off-Beat View of the U.S.A.," *Popular Photography,* 46 (May 1960), 105. In this collection of reviews, several authors commented that the title was one of the more controversial aspects about the book, and one even suggested that it should have been called *Some Americans,* John Durniak, 104. For further discussion of this issue as well as the reception of *The Americans,* see Stuart Alexander, "The Criticism of Robert Frank's *The Americans*" (unpublished master's thesis), University of Arizona, Tucson, 1986.

59 Ann Charters, "Introduction: Variations on a Generation," in *The Beat Reader,* edited by Ann Charters. (New York: Viking Penguin, 1992), xx; Frank, "Guggenheim Application and Renewal Request," in *Robert Frank: New York to Nova Scotia, 20.*

60 For various interpretations see John Brumfield, "'The Americans' and the Americans," *Afterimage* 8:1/2 (Summer 1980), 8–15; and Jno Cook, "Robert Frank's America." *Afterimage* 9:8 (March 1982), 9–14.

61 Frank, in untitled manuscript notes in the collection of the Walker Evans Estate, wrote that the photographs in *The Americans* "are intended to be understood as a whole."

62 It is interesting to note that while *The Americans* was criticized for a great many things in 1959 and 1960 — including prints "flawed by meaningless blur, grain, muddy exposure, drunken horizons, and general sloppiness" — the images were never condemned as "harsh" or "gritty." Those adjectives only began to be applied to the book after its later reprintings in the late 1960s and 1970s. Compare, for example, Arthur Goldsmith's comments in "An Off-Beat View of the U.S.A.," 104 (as quoted above) with Kenneth Naversen's comments in "Robert Frank's America," *Performance 1* (April–May 1979), 6, where he writes that Frank's prints "have a gritty look that enhances the tawdriness of his subject matter," or John Brumfield's assessment that *Parade—Hoboken, New Jersey* is "grainy and contrasty," and the photograph "is a bit on the harsh side, almost scuzzy." Brumfield, "'The Americans' and The Americans," 10.

63 Frank, "A Statement...." *U. S. Camera 1958.* Vintage prints of images in *The Americans* are very similar in quality to other vintage prints made by Frank before 1953; they have a rich, full tonal range and are just as carefully fabricated as, for example, the prints in *Black White and Things.* This is further indication that the division that is usually seen in Frank's work between his photographs made before and after 1953 is not a valid distinction.

64 Frank, "Letter, winter 1985, to Anne Tucker regarding forthcoming Houston catalogue," published in *Robert Frank: New York to Nova Scotia,* 72.

65 Charters, *The Beat Reader,* xviii.

66 Frank, "Robert Frank: Letter from New York."

67 Frank, *The Lines of My Hand,* 100. Frank also photographed from a bus in March 1959 and May 1961.

68 The later advertisements were called "Where Else But New York?"

69 Frank, in *Robert Frank,* edited by Sabino Martiradonna (exh. cat., Riminicinema Mostra Internazionale, Rimini, Italy, 1990), 7.

70 Besides *Peru,* in 1948 Frank made at least one other photograph composed of two negative frames: a diptych of a bridge illustrating Virgil Thompson's "The Last Time I Saw Kansas City," in *Junior Bazaar,* 4:3 (March 1948), 3.

71 Dennis Wheeler, "Robert Frank Interviewed," *Criteria* 3:2 (June 1977), 4.

72 "Walker Evans on Robert Frank/Robert Frank on Walker Evans," in *Still/3,* 6.

73 "The Pictures are a Necessity," 164.

74 Janis and MacNeil, 58.

75 Frank, *Flower Is....* (Tokyo: Yugensha, Kazuhiko Motomura, 1987), unpaginated and *Contemporary Photographers* edited by George Walsh et. al. (New York: St. Martin's Press, 1982), 249.

76 Frank, *Flower Is...,* unpaginated.

VISIT WITH PABLO -TREVOR MANOR, PA. JUNE 1994

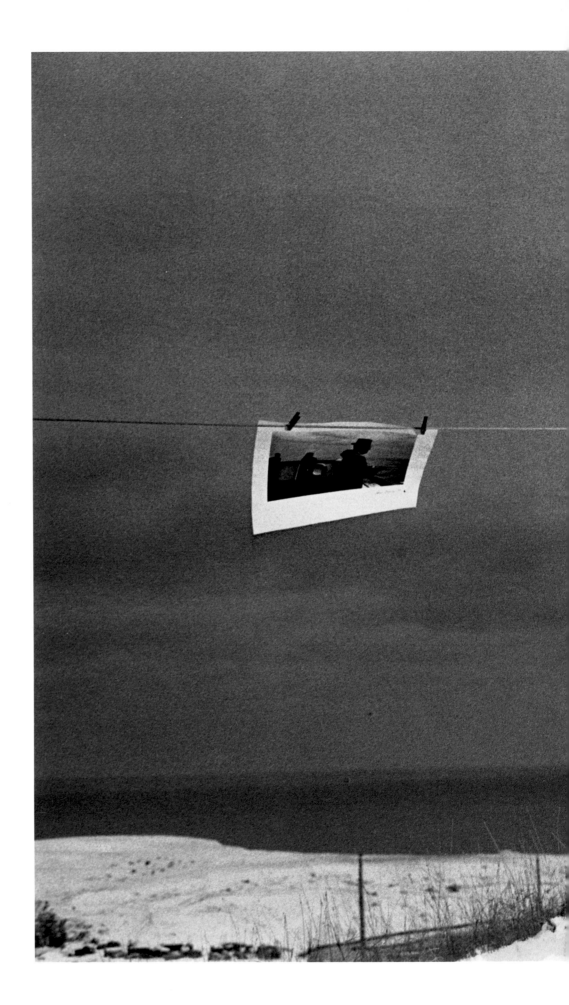

128　Mabou, Nova Scotia, 1977

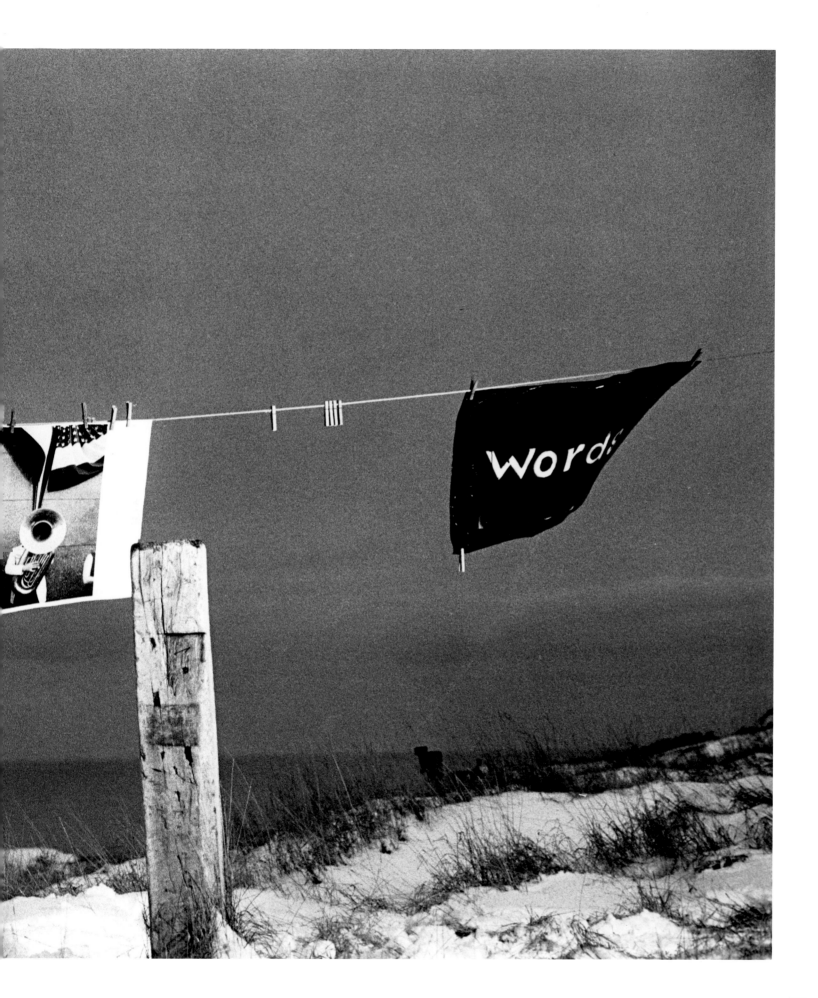

132 Sagamore Cafeteria, New York City, 1955

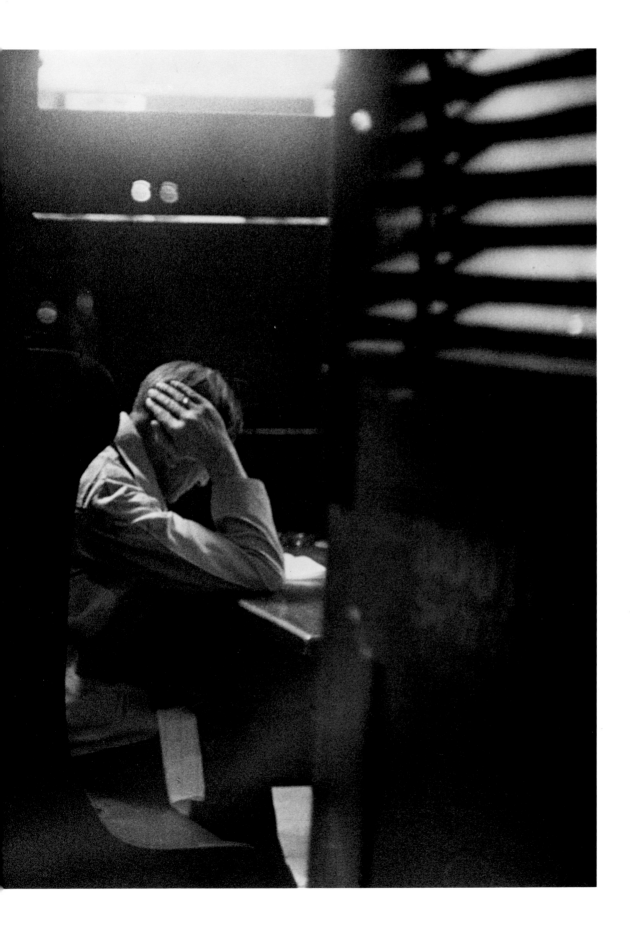

ABOUT FATE

DURING THE NIGHT OF MAY 19th 1987
AT THE BROOKLYN ZOO.

THE BEARS KILLED AND ATE THE

YEAR OLD BOY CLIMBED INTO THE CAGE OF THE POLAR BEARS

THE POLICE SHOT THE TWO POLAR BEARS

eaton H.S May 20th 1987

for Michal

135

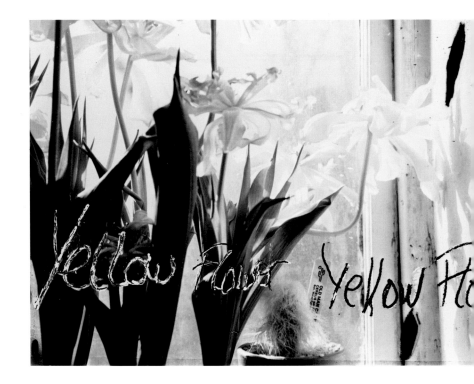

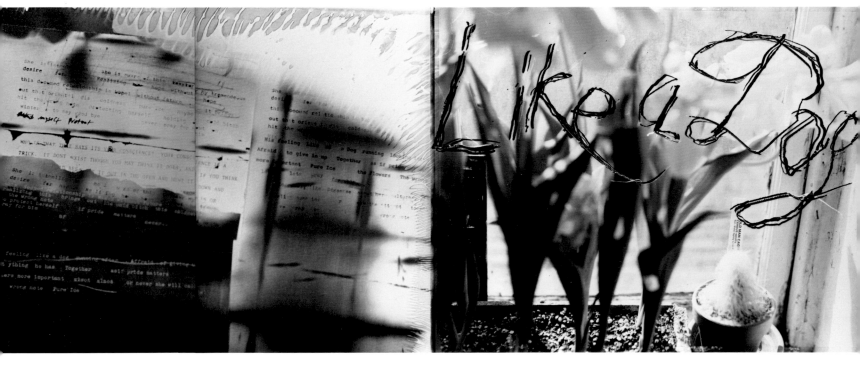

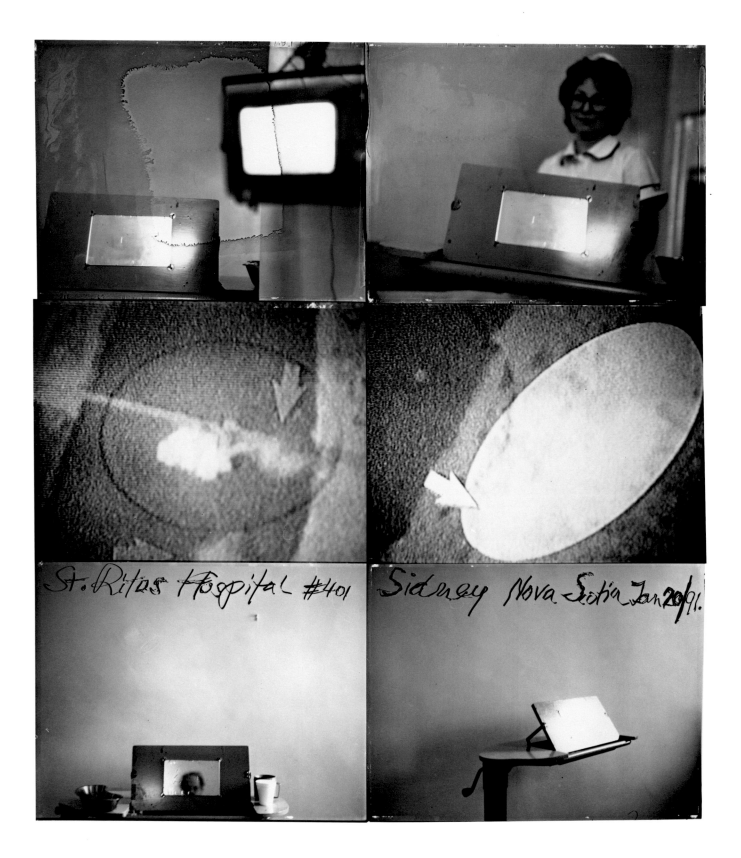

138 St. Rita's Hospital, Sidney, Nova Scotia, 1991
Fear—No Fear, 1988

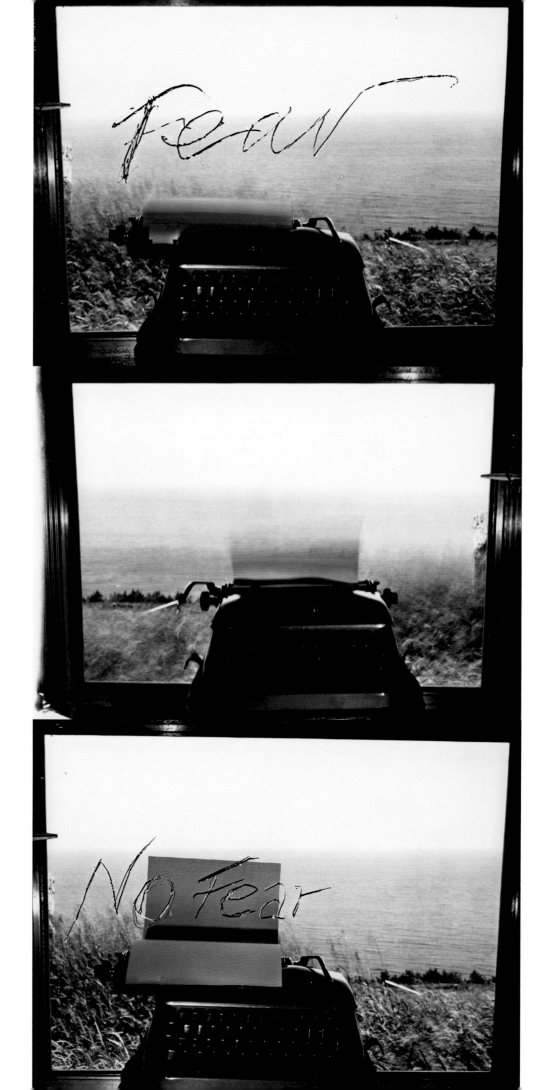

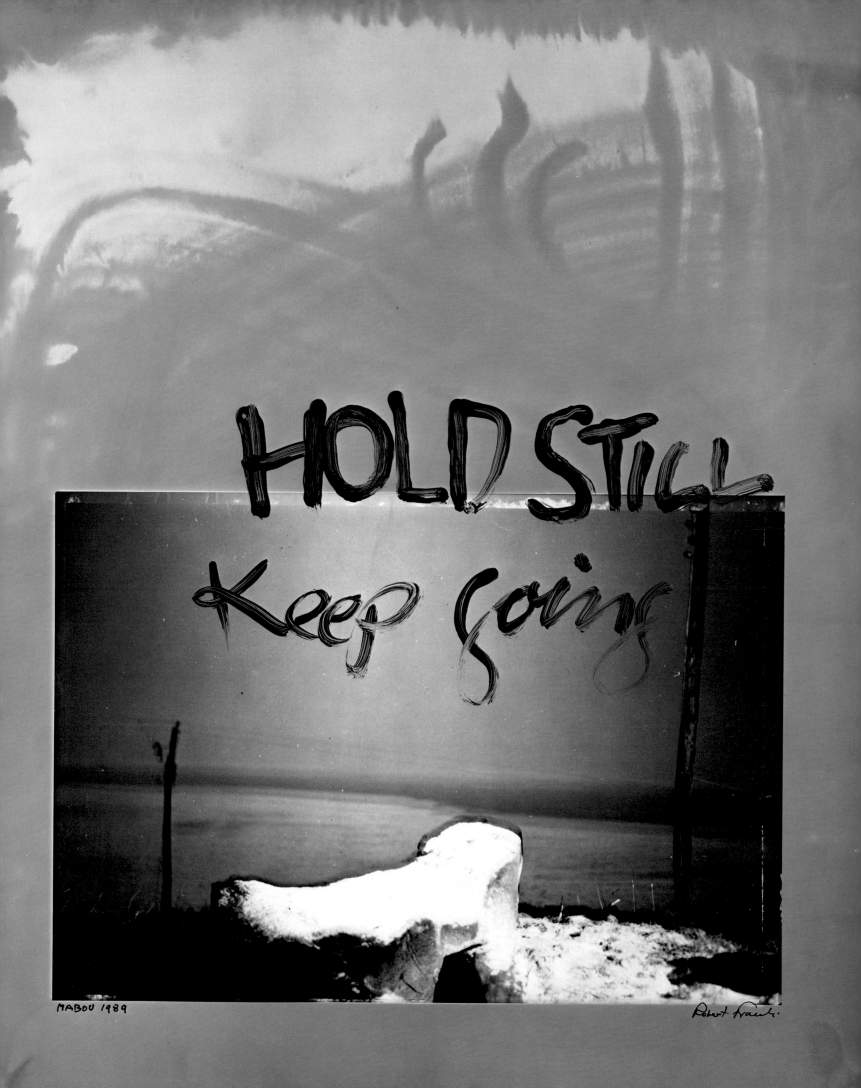

Windows On Another Time
Issues of Autobiography

"The truth is the way to reveal something about your life, your thoughts, where you stand. It doesn't just stand there alone, the truth. It stands there combined with art. I want to make something that has more of the truth and not so much of art. Which means you have to go out on a limb—because people are more comfortable dealing with art than with the truth."[1] ROBERT FRANK

"I hope your documentary is fiction."[2] JEAN-LUC GODARD

Robert Frank's search for the truth, and for a language in which to express it, propels him to examine his own life through his art. In much of his recent work Frank merges his memories, which are often disturbing, with his perceptions of the present. Sometimes he makes up stories. Sometimes he probes an actual situation, seeking and creating metaphors for his own life in the lives of people he finds on the street. In his 1992 film *Last Supper* he does both. It begins on a well-worn path through an empty lot in Harlem. Someone asks, "Why do you want to make a film here in this place?" He responds, "When the people of the neighborhood walk on the path while we film, they're very good. It will help the film." Working with anonymous residents of the neighborhood and actors portraying his friends, Frank skirts the boundaries of fiction by incorporating elements from his life into a made-up story. This approach recalls Ken Kesey's idea that "Passing off what might be true as fiction seems a better vocation to me than passing off what is quite possibly fiction as truth."[3]

Last Supper is overtly autobiographical, revealing Frank's concerns about family, friends, and fame. It tells the story of Bobby, a well-known writer who invites his friends to a book-signing party for his latest publication, *Self-Portrait.* Each person brings to the party a different image of the writer. Bobby, however, never arrives. He is present only by implication. As the film begins, a lawyer complains, "The social mask, the mask is all important....That's why people hate lawyers because they hate the...everyday truths about things." A young photographer frowns as an art dealer tells her, "I did think that all the photographs were taken at the right moment. Now all you have to do is get the right photographs at the right time." For the dealer, contextualizing the moment is all that matters. The writer's son waits for a subway train as a homeless man tells him, "You look nice. You're all dressed up. Where you going? A party? We had a party down here. It was a drinking party." The sequence concludes in the room of an actor where an empty picture frame

hangs on the wall. The words "Intelligent—Silence" are visible on a scrap of paper pinned to the wall inside the frame. The actor removes the frame from the wall and heads for the party. Here, the actor stands for both the writer, a character in the story, and for the filmmaker, who is telling the story. Each of these opening comments has a special significance for Frank. This melding of fact, fiction, and autobiography is both the author Bobby's theme and the filmmaker Frank's struggle.

"Your picture frame ruptures time," wrote philosopher Walter Benjamin. "The tiniest authentic fragment from daily life says more than painting."[4] Frank's use of framing devices, often literal frames that are transparent to the world, symbolizes his gaze—

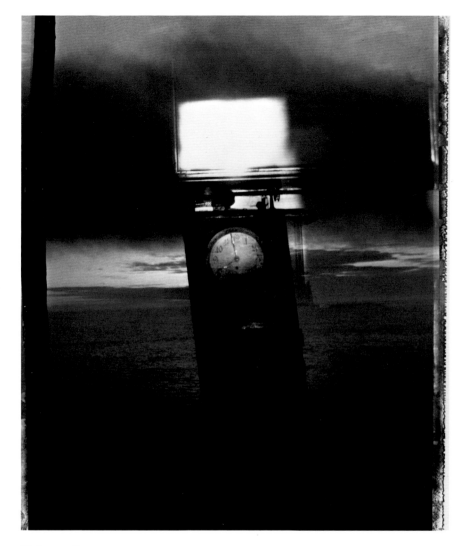

Mabou, 1978

through a lens or window, out across a barren landscape or empty street—bringing the real world and daily life into focus and into the realm of art. In *Last Supper* the empty frame carried by the actor symbolizes the author's vision. The frame both focuses and fragments Frank's narrative, one that is edited by the artifice of photographic storytelling. In *Last Supper* the author paints his own self-portrait by soliciting the impressions of others. As people arrive at the party, his wife reveals, "I feel I'm his witness. You know, the truth, they say, is as slippery as a fish. But not for me. For me the truth isn't slippery." She looks mysteriously at a banquet table piled high with smoked fish. While the guests wait for the author they talk about him, questioning their respective roles in his life. One friend says, "Real fiction against invented reality. We're waiting for a man who reveals nothing except fiction." "Do you believe that?" asks another. A taxi driver standing among the author's friends interrupts them. "It's time to quote Godard," he says. "Society never makes a man. It destroys him. What we see never fits what we say. The eye should learn to listen before it looks."

Like filmmaker Jean-Luc Godard, Frank hesitates to accept what is inherently true since things around him are always changing. He strives to represent elements of truth, often presenting people and events from many points of view, distilling a portrait from concepts and metaphors. The characters in *Last Supper* probe each other's intimate knowledge of the author. It is the combination of their experiences that creates his character. One person reveals, "He took my innermost thoughts and put them in a frame," echoing lines from an earlier film by Frank, *Life Dances On...*, 1980. Another points out, "He observes himself. He is cooking the soup. He reveals nothing. He is rewarded." In an accusing soliloquy, the author's son repeats, "You don't catch him revealing himself.... He knows the veil of self-consciousness, the arrogant shyness will overcome him and make him false."

Frank's script for *Last Supper* evolved through a complex, layered process of self-disclosure. "It starts like everything. You get up in the morning and decide to look for something," he said. "I thought about what I had achieved and what I feel about it. I wrote about my feelings for the people that I have known, and it's very personal."[5] He worked closely with British novelist Sam North to produce a first draft of the script from intimate, diaristic notes. North remembers, "He handed me bits of paper with sentences on them and we worked out a way he could do an autobiographical portrait."[6] Frank then extensively rewrote the script with Israeli photographer Michal Rovner. Later it was rewritten on the set where the cast and writers improvised the lines.

Further blurring the boundaries between fiction and reality in this film, Frank also incorporated video footage he shot in the Harlem neighborhood. In one such scene, a young mother interrupts the film, saying, "Hey, take a picture of my baby." In another, a plane flies over the set, signaling Bobby's departure. Superimposed with time and date stamps, the video footage intrudes into the narrative and reminds us of Frank's presence behind the camera.

Last Supper only vaguely alludes to the biblical story, in which Jesus reveals to his disciples his understanding of a plot to betray him. The themes of betrayal and sacrifice are introduced when the author's son, tired of waiting for his father, yells to the assembled guests, "You all belong to his group.... You start to look like each other. How long are you

Jung Jin Lee, *Last Supper,* **1991**

going to wait for him? He is using you again!" Realizing the author will not show up, people start to leave the party as darkness envelops the set. His wife goes to pick up their car only to discover that he has already left town. The actor returns home with his frame, and a message on his answering machine reveals, "Robert will be back in town tomorrow. Could you put him up for a few days?" This scene parallels the ending of Samuel Beckett's play *Waiting for Godot,* in which a messenger arrives on stage with news that Godot—whom everyone is expecting but who has yet to arrive—will come tomorrow. Beckett's characters, like Frank's, also wonder what happens in the world during a pointless vigil. They lose track of time, unsure of the truth or the context of their own position in relation to others. "Was I sleeping, while the others suffered? Am I sleeping now?" asks Vladimir in *Waiting for Godot.* "Tomorrow, when I wake, or think I do, what shall I say of today?"[7] Like Beckett, Frank constantly questions the ways his characters define themselves at the same time that he seeks to understand himself through their perceptions.

As the author's friends return to their own lives, briefly sketched in the film's introductory scenes, a crowd from the Harlem neighborhood gathers in darkness around the table still set with the leftover feast. A flashlight illuminates a kitschy plaster frieze of Leonardo's *Last Supper* while someone says: "Food, we got chicken, fish, and bread. Where's the wine? To be honest with you I couldn't say too much about it." Several people begin to sing a soulful reggae rhythm. As the film concludes, the camera focuses on their faces as they enjoy the supper. While partaking of the feast and giving thanks for their own lives, the one remaining fictional character—the caterer—speaks his only lines in the film as the community toasts him. "Always the same cheating lies, the same wounds, still the same silences," he recounts laconically.[8]

In *Last Supper* the cover of the author's book is illustrated with a photograph by Frank of an ornate clock, superimposed onto a rural Nova Scotia landscape. The hills merge with the sea and horizon beyond. Below this is the title, *Self-Portrait.* When the taxi driver asks about this title, the author's wife replies, "That's just something he scratched on the negative. But he says that since we all carry a gallery of people around in our heads all the time, that a portrait of them is really a portrait of the person who chooses to remember them.... It's always a self-portrait."

Just as Frank constructs his own portrait through his photographs and films such as *Last Supper,* so too does his character Bobby define himself through the perceptions of others. In *Last Supper* Frank's memories of family and friends merge with his new feelings for what is happening in front of his camera and for a group of invented characters. As each of these groups interact in the film they gain or lose the influence of the author. Therefore this film is about the imbalance of power: between classes and races, between those who seek redemption through the illusory nature of their intellect and personality, and those who are redeemed in their daily struggles.

"My work forms a fabric with my life," Frank once explained. "I can never get too far away from it."[9] This attitude has informed Frank's work since he left Switzerland in 1947, to join the ranks of New York's fashion photographers and commercial artists. He was hired by art director Alexey Brodovitch to illustrate fashion news and feature stories for *Harper's Bazaar* and *Junior Bazaar*. He photographed shoes and handbags with a large-format camera in the studio and made pictures of models on the streets. At this time his most creative project was a series of stylized images for an article called "New York Was Never Like This."[10] Exhibiting the casual, cinematic elegance that became his trademark, a story is told in a series of paired images, each depicting a different person's perception of a situation. It suggests that photographs might represent both imagined and real activity, just as Hollywood films of the late 1940s would characterize dreams or memories of reality as elements within complex fictional narratives.

In 1947 Frank met photographer Louis Faurer at the *Bazaar* studio. "He called me Sammy and I called him Sammy," Faurer later recalled. "What makes Sammy run? How do the people come here and how do they keep running?"[11] *What Makes Sammy Run?* was Budd Schulberg's popular 1941 novel about the meteoric rise of Sammy Glick, an office boy, to the pinnacle of power at a Hollywood film studio. Schulberg's book questions both the motivation and ethics of this ruthless young man who would do anything to gain power and privilege. Sammy Glick symbolized the archetypal American white-collar worker, emerging from Depression-era poverty into a wartime economic expansion. Glick's cunning reminded Frank and Faurer only too well of people they knew in the fashion world. "The only thing that mattered was to make more money," Frank remembers.[12]

Frank grew increasingly wary of the lack of expressive freedom he found at *Harper's Bazaar*. For him, the idea of freedom was a critical one at this time. While living in Switzerland during the war, he and his family feared that Germany would invade their country. "Being Jewish and living with the threat of Hitler must have been a big part of my understanding of people that were put down or were held back," he remembers.[13] In addition, Frank also read the early novels of Jean-Paul Sartre and Albert Camus. *The Age of Reason,* the first of Sartre's *Roads to Freedom* trilogy published in 1945, tells the story of a small group of young, disaffected intellectuals wrestling with their own confusion about societal roles. Sartre compared their individual struggles for personal freedom with concepts of national discord and divided states, debating the means to attain freedom in a world where personal action often seemed meaningless. In this story, one character, Mathieu, realizes, "All I do, I do for nothing. It might be said that I am robbed of the consequences of my acts; everything happens as though I could always play my strokes again. I don't know what I would give to do something irrevocable."[14] The struggle of Sartre's characters foreshadows Frank's own search for artistic freedom in his work.

Between 1949 and 1953 Frank traveled back and forth several times between Europe and the United States. In 1952 he constructed a hand-bound volume of thirty-four photographs titled *Black White and Things*. The first image in the "White" section, devoted to "peaceful places and quiet things," depicts Frank's wife Mary nursing their newborn son. His shadow, eclipsing a bright light streaming in a window behind him, is cast across Mary's hair, in contrast to the light reflecting from her face. He projects himself into the picture, though he is present only as a shadow. The second image in this section shows a Peruvian family cooking over an open fire as a mother carries a baby on her back. By combining these mother-and-child images, which are reflective of his own life and sentiments, he is also comparing them. This is one of the first overtly autobiographical statements in his work.

When Frank returned to stay in the United States in 1953 he joined a younger generation of American artists, writers, and musicians who began to reexamine shifting cultural values. In their work as well as in their lives, members of a growing beat generation began to question what David Halberstam has called "the blandness, conformity, and lack of serious social and cultural purpose in middle-class life in America."[15] Some, like Charlie Parker, found a rebellious emancipation in the bebop rhythms of black music. Others, like Allen Ginsberg, adapted jazz and blues rhythms to create new, poetic cadences that expressed their personal disaffection. "In this modern jazz, they heard something rebel and nameless that spoke for them, and their lives knew a gospel for the first time," wrote John Clellon Holmes in his 1952 autobiographical novel, *Go*. "It was more than a music; it became an attitude toward life…and these introverted kids (emotional outcasts of a war they had been too young to join, or in which they had lost their innocence), who had never belonged anywhere before, now felt somewhere at last."[16]

Frank settled into New York's downtown artistic milieu of painters, poets, musicians, and photographers, which included, among others, Ginsberg, Jan Müller, Willem de Kooning, Walker Evans, Ben Schultz, John Cohen, and Miles Forst. Then, in 1954, in his application for a Guggenheim fellowship, Frank outlined a new project that would define his work during the fifties. He proposed, "The making of a broad, voluminous picture record of

Allen Ginsberg, 1959

Negative Strip, *Robert Frank in Junkyard, South Carolina,* **1955**

things American, past and present....What I have in mind, then, is observation and record of what one naturalized American finds to see in the United States that signifies the kind of civilization born here and spreading elsewhere."[17] In April 1955 he was awarded the first of two Guggenheim fellowships to photograph the changing nation in small towns and urban centers. Influenced by both European existentialism and American humanism, Frank set out across the United States in the mid-1950s to produce a metaphorical document from his personal experience. The pictures he made presented an outsider's perspective of a nation beset by post-war social and economic conversion and permeated by undercurrents of youthful and racial discontent.[18] Frank depicted some of the same trends identified by David Riesman in his book *The Lonely Crowd,* 1950, a popular study of the American middle class. Most notably, Frank, like Riesman, recognized that Americans were becoming increasingly dominated by both commercialism and consumerism and were rejecting their traditional values. Frank's photographs made these trends visible and, in doing so, criticized the loss of freedom and control people had in establishing their own direction. As Walker Evans later recalled, Frank had "a vision of America wrapped in the culture and traditions of the times. He saw it happened to be an angry one and he put down what I feel is a very subjective view."[19]

The Americans focuses on such themes as politics, religion, racism, wealth, poverty, alienation, redemption, landscape, youth, music, media, birth, and death, but Frank's subtext is autobiographical.[20] Like Walt Whitman's *Leaves of Grass* or Walker Evans' *American Photographs, The Americans* is a poetic vision of time and place. There is no clear story but a journey is evident. As in *Leaves of Grass, American Photographs, Go,* or Jack Kerouac's *On the Road,* the artist's presence is strongly felt. In *The Americans* Frank is a solitary traveler, traversing a strange and wondrous world in search of himself. Although only one photograph of his family appears in the book, Frank's proofs of more than 600 rolls of film shot for this project reveal that he sometimes traveled with his wife and two children, often photographing them as a tourist might. He positioned himself as one among many Americans, attempting, like Kerouac, to interpret the society and culture through images of the people he encountered, as well as those closest to him. One of the many photographs

of his children that he made on this trip shows Pablo and Andrea staring longingly into his camera while seated at a table in a temporary Los Angeles home. In another, Pablo peeks from behind a curtain in a lonely motel room in Gallup, New Mexico. In yet another motel room the children are propped before a glowing television, while portraits of Hollywood stars hang on the wall above (pages 212, 170–171, 169).

In *The Americans* one photograph that perhaps best signifies the artist's subjectivity is *View from Hotel Window—Butte, Montana,* a lonely, gray, scarred landscape he witnessed from behind a curtain (page 188). A series of black, rain-soaked rooftops fills the foreground, receding along an empty road toward the coal mines that provide the town its livelihood. The gauzy curtain softens, absorbs, and flattens this panorama. The curtain and window frame place us all in the photographer's shoes. A similar dichotomy is established in *Barber Shop through Screen Door—McClellanville, South Carolina,* where the street is reflected in the glass behind the screen (page 182). In another layer of this image, Frank's silhouette eclipses the reflection, allowing the viewer to peer through the door into the shop. Despite the ambiguity created by the simultaneous depiction of interior and exterior space, Frank's shadow lends clarity to this otherwise disorienting photograph.

The final image in *The Americans, U.S. 90, en route to Del Rio, Texas,* reveals Frank's family for the first time in the book. Mary, Pablo, and Andrea are huddled in their car parked by the roadside as the light fades to dusk. The car dominates the frame, coming to life as one headlight glows like a mechanical eye. The family, exhausted from travel, is dwarfed by the car and the receding landscape, but they seem at home on the road, protected by the automobile. In later editions, Frank added a more emphatic conclusion by including a sequence of three images, beginning with the photograph of his family in the car and ending at a truck stop in the Texas twilight. A giant neon sign in the graying sky reads, "Truck Rates." This final picture implies that his journey continues. It does not depict the end of his search but a point on the road between stops, moving on or out, recalling Whitman's words, "…to that which is endless as it was beginningless."[21]

Following publication of *The Americans* in 1958, Robert Frank's art continued its inward spiral, reflecting more on his own life and personal experiences. He began to photograph anonymous people on the streets of New York through the windows of city buses. "It had to do with desperation and endurance—I have always felt that about living in New York," he wrote.[22] The directness and reductive simplicity of these pictures recalls those made by Walker Evans in 1950 when he photographed midwestern landscapes through the window of a speeding train. The cinematic quality of Frank's bus series portends his simultaneous transition to filmmaking. Early in 1959 he began his first film, *Pull My Daisy,* a poetic parable. It suggests that creativity is a powerful gift that brings art and life together. The film helped to validate independent cinema in the United States and to define the

beat generation. "The origins of the word 'beat' are obscure, but the meaning is only too clear to most Americans," Holmes had written in 1952. "More than mere weariness, it implies the feeling of having been used, of being raw. It involves a sort of nakedness of mind, and, ultimately, of soul; a feeling of being reduced to the bedrock of consciousness. In short, it means being undramatically pushed up against the wall of oneself."[23] By the early 1960s, *Pull My Daisy* had helped a wide audience to understand this concept. Co-directed by painter Alfred Leslie, *Pull My Daisy* was made with writers Ginsberg, Kerouac, Peter Orlovsky, and Gregory Corso, artists Larry Rivers, Alice Neal, and Mary Frank, composer David Amram, and actress Delphine Seyrig. The title comes from the first line of a nonsensical poem written by Ginsberg, Kerouac, and Neal Cassady in 1948.[24] Based on the third act of "The Beat Generation," an unpublished play by Kerouac, the film tells the story of a young Swiss bishop invited to the home of a railroad brakeman, Milo. The bishop arrives with his mother and aunt, only to be met by a group of young poets. The comical, unrehearsed confrontation between the bishop and the artists is the core of the film. Kerouac improvised a lyrical, syncopated narration after the film was shot. Dubbed "Zen-Hur...the first pure-Beat movie" by *Time, Pull My Daisy* expresses an irreverent impatience with convention and traditions, and questions the nature of normalcy through both its experimental, fragmented structure and its ironic story.

The improvisational structure of *Pull My Daisy* can be compared to some African American music. Like blues, the film is arhythmic. Like jazz, it appears spontaneous, yet it follows a plan. "What we had to do was invent, following the script in a very general way," says Ginsberg. "The film had the quality which Robert allowed, of planning for eternity and, at the same time, being right there in time."[25] The film's structure is one of contrasts. Frank's cinematography exhibits deep blacks and glaring whites, while Kerouac's free-flowing narration was improvised in counterpoint to David Amram's lyrical jazz score. *Pull My Daisy*, like *The Americans,* was criticized for its style. Frank's cinematography was described as "foggy,"[26] or "tattle-tale gray."[27] "As satire, the film is mildewed Sinclair Lewis," wrote Stanley Kauffman.[28] In defense, filmmaker and critic Jonas Mekas wrote that *Pull My Daisy* "...blended most perfectly the elements of improvisation and conscious planning.... Its authenticity is so effective, its style so perfect, that the film has fooled even some very intelligent critics: they speak about it as though it were a slice-of-life film...a documentary."[29] Critics were confused about whether *Pull My Daisy* represented real life, whether it was a documentary or fictional film. This happened because some of the characters were adapted from real life and played themselves in the film. Drawing on his memories and diaries, Kerouac frequently wove autobiographical elements into his prose. For example, in 1956 Kerouac's friend Cassady met a young bishop and invited him home to meet Kerouac. The bishop arrived with his mother and aunt. "I was present when a priest...from the coastal nut belt who believes in kharma arrived with his mother," remembers Ginsberg. "What

Kerouac wrote was a very simple down-home story of family life."[30] Ginsberg, Orlovsky, and Corso, who were all present during the actual incident, played themselves in the film. "All we had to do was improvise in that situation…the same as we might have improvised in Neal Cassady's living room," Ginsberg concludes.

Frank's own interest in the use of film to visualize memories led him to further experiments. "You can't express what I want to express in stills," he said. "In stills you are really an observer. In film, you come much closer, by the nature of the medium, to being inside what you are filming."[31] In 1960 he joined a group of other independent filmmakers in New York to form New American Cinema. A loose-knit group dedicated to producing experimental films without the constraints of studio financing, members were stimulated by young French filmmakers of the New Wave such as Godard, François Truffaut, and Alain Resnais, who emphasized the notion of authorship.

The films that Frank directed in the early 1960s were pessimistic. *The Sin of Jesus,* 1961, was adapted from a tragic short story by Isaac Babel. Echoing the tone of Ingmar Bergman's 1960 classic *The Virgin Spring,* Frank's second film depicts the desolate descent of a pregnant woman, whose irresponsible lover is replaced by an angel, forcing her to reflect on her own mortality. *O.K. End Here,* completed in 1963, is about contemporary alienation. It follows a man and a woman through one day of their lives. As in Maya Deren's 1943 experimental film *Meshes of the Afternoon,* the woman is trapped by the outside world, which can be seen reflected in the window of her room. Her gaze out the window conveys aspects of her tedium and loneliness. "It's so hard not to forget," the woman says at the conclusion of *O.K. End Here.* "At least photographs stop everything. They stop the passing of time….

I want something between me and loneliness." Her request again echoes Frank's own interest in the ability of photographs to conjure memories.

Based on his experience with *Pull My Daisy,* Frank perfected his technique of marrying documentary footage, improvised scenes, scripted performances, actors playing real people, and friends portraying actors to create *Me and My Brother.* Made between 1965 and 1968, this film describes the intricate relation-

Julius Orlovsky, from Me and My Brother, 1965-1968

ship between Allen Ginsberg, poet Peter Orlovsky, and his brother Julius Orlovsky. *Me and My Brother* is about perception, illusion, memory, the voyeurism of the media, and how the chaos of the modern world influenced Julius' dependence on other people. "At that time Robert developed this really interesting relationship with Julius Orlovsky, who had been for twelve years in Central Islip State Hospital, had emerged catatonic, and was slowly coming back in and out of contact with people," remembers Ginsberg. "So finally…he began filming around the house, filming Julius Orlovsky and Peter and their relationship."[32]

Me and My Brother calls attention to the filmmaking process to emphasize Frank's introspection. The film begins as the camera focuses on a street sign flashing the words "Stop, Do Not Enter." Superimposed over a bible in a storefront window is the disclaimer, "In this film all events and people are real. Whatever is unreal is purely my imagination." Two actors, Christopher Walken and Roscoe Lee Browne, play Frank in the film. Julius Orlovsky is also portrayed intermittently by an actor, Joseph Chaikin, and by Julius himself, supporting Frank's thesis that people are always acting in both social and political situations. Julius, however, often refuses to act. In one scene a psychiatrist tells him, "All you have to do is behave however you behave in real life. You don't have to act." When Julius disappears during filming, Chaikin is cast to play him. Walken interviews Chaikin in a screen test while images of Julius are projected on a screen behind Chaikin. "I can't get Julius to do what I want," says Walken, with Frank's voice dubbed in. The sound cuts back and forth between Julius, speaking from the projection on the screen, and Chaikin's voice in front of the screen. Chaikin raises his arms before the projected image of Julius and says, "I suffer for what I do and what I say."[33] The dichotomy between Frank's documentary portrait of Julius and Chaikin's fictional portrayal of Julius forms the film's underlying theme.

As early as 1929, Soviet filmmaker Dziga Vertov in *Man With a Movie Camera* had explored the concept that one could approximate the illusion of real life by presenting it from the camera's point of view.[34] In the late 1950s and 1960s, American avant-garde filmmakers re-investigated the idea of the camera as a truth-seeking "eye," and began to depict real time and real events. Robert Drew and Richard Leacock took audiences behind the scenes of political events in television documentaries like *Primary* and *Crisis*. At the same time, experimental filmmakers, such as John Cassavetes in *Shadows* and *Faces,* Andy Warhol in *Sleep* and *Empire,* and Jim McBride in *David Holzman's Diary,* created the illusion of truth to tell fictional or autobiographical stories. They subverted the notion of documentary truth by exploiting documentary techniques to create fabricated narratives. For example, McBride's 1967 film tells a fictional story from the point of view of a film-maker who was shooting a *cinéma vérité* diary. Jean-Luc Godard also sought documentary authenticity in fictional narrative films. His early films stressed the illusion of realism, which was achieved by shooting and recording sound on location, using natural light, and

frequently improvising with his actors. Highly abstract in structure, his films convey an aura of existence in real time. For Godard, as for Frank, the process of telling a story becomes part of the story itself.

Me and My Brother also questions the truthfulness of Frank's depiction. Frank introduced additional visual and structural effects, including split screen techniques, superimpositions, flashbacks, and a combination of color and black and white imagery to further distance his audience and subvert any implication of narrative sequencing. However, during one documentary scene, an off-screen actress demands of the filmmaker, "Make a movie of how it really is. Don't make a movie about making a movie, make *it….* Wouldn't it be fantastic if you didn't even have to have a piece of celluloid between you and what you saw, if the eye were its own projector, instead of its own camera." Recalling Vertov, she concludes, "I am a camera." By questioning the veracity of photographic images and by proposing to eliminate the camera that stands between experience and documentation, Frank declares that memories of an experience are more real than photographs of it.[35] His interest in finding new mechanisms with which to represent reality brought him back to Julius, whose schizophrenia in the film represents the separation between memory and real time. Frank's juxtaposition of documentary and fictional portraits of Julius mirrors his bifurcated vision. For Frank the only way to find the real Julius is to explore his internal feelings in relation to his external environment and circumstances. Julius is constantly quizzed by psychiatrists or social workers. Each has a theory about his relationship to the real world. Julius first refuses to speak to anyone, and finally runs away. As the film concludes, Julius has been found at a hospital in California. "In the last scene in the film, Robert turns to Julius and asks him what he thinks about making a movie," remembers Ginsberg. "And Julius has been almost silent all through the film and then Julius comes up with some astonishingly conscious answer."[36] Julius haltingly reveals to Frank that "The camera seems like a reflection of disapproval or disgust or disappointment or unhelpfulness, unexplainability to disclose any real truth that might possibly exist." "Where does truth exist?" asks Frank. "Inside and outside the world," Julius responds.

In 1968 Frank was commissioned to make *Conversations in Vermont,* his first openly autobiographical film. It begins in his New York loft with a brief scene of the filmmaker cleaning his camera lens, representing his search for clarity and order amid the chaos of the city. The piercing sound of sirens on the street mixes with blues music from the stereo, as Frank says, "This film is about the past. The present comes back in actual film footage. Maybe this film is about growing older. It's some kind of family album." Frank had photographed his family and friends throughout his career, creating personal images that were frequently published in magazines, advertisements, and books.[37] In *Conversations in Vermont* the pictures frame his family history. Through old proof sheets and prints, he shows images of his children growing up in New York and traveling in Europe and

153

America. Frank arrives in Vermont, where his two children, Pablo and Andrea, are in school. He asks them to discuss their childhood memories. His questions force an awkward confrontation when Pablo and Andrea reveal their discomfort at being photographed. Frank's children seem more intent on understanding themselves than revisiting the past. Pablo tells him, "I feel the burden of bringing myself up. I care more about what I am." By going back through the pages of his family album with his children, Frank sees his relationship to them in a new light. He confesses, "Looking now at these photographs I realize how tight Mary and I were about living our way and not giving in to the children."

In the fall of 1970 Frank bought land with artist June Leaf on a hillside overlooking the sea in rural Cape Breton, Nova Scotia. Together they renovated a fisherman's shack, creating a home and studio, "…in order to get away from it all and to see the clear Ocean and to be more alone."[38] In 1969 Frank had begun several new documentary films that are informed by an introspective vision, including *Liferaft Earth* and *About Me: A Musical,* which synthesized divergent ideas about the character of music and its ability to circumvent social conventions. With a grant from the American Film Institute he started to document musicians and then decided, "Fuck the music. I'm going to make this film about myself." Completed in 1971, *About Me* was the second of Frank's autobiographical films and included passages about his childhood in Switzerland and his career as a photographer. He also hired an actress to play himself and shot scripted fictional sequences to mix with the documentary footage of improvised music. In the film the actress expresses Frank's feelings and responds to the other characters from outside the narrative in order to break the episodic flow. As a surrogate for the filmmaker, she guides the film, describing his memories, as well as his present feelings. "My mother is blind," she exclaims, as Frank reveals his parents and his childhood home. As his father looks at photographs of a young boy through a stereo viewer, Frank says, "It's me, it's me." When the actress angrily sweeps away a group of Frank's old photographs screaming, "That's it, that's my past. I have to get rid of all this," a friend declares, "These are fabulous." She responds cynically, "I could make a musical out of all this," as the film cuts to two actors rehearsing an operatic, passionate melodrama. June Leaf later described this film as one that was "…striving to make Art and 'a way of life' one and the same…. Robert (or rather the actress who plays 'Robert') sweeps away, as he had swept away in his own life, his past. That gesture—that sweep—is perhaps an attempt to be true."[39]

By questioning his own position as an artist Frank also attempts to provide some answers. In *About Me,* he depicts a group of commune dwellers playing mysterious music. As their children join in an ethereal chorus in obvious joy, the film cuts to the dark interior of a Texas prison. In one of the most emotional passages in any of his films, Frank follows a group of inmates through the prison gates as they crash closed. The men sing a soaring gospel melody that begins, "Well, let me tell you about me…." Prompted by Danny

Lyon, who had previously photographed the same prisoners, one inmate reveals that he is serving a one-hundred-year sentence but has only been incarcerated for three years.[40] The sharp contrast that Frank establishes between the joyous freedom of children playing music on a hillside and the perfect, practiced harmony of five hardened inmates precipitates an awareness of the artistic nature of all life.

In late 1970 Frank also began to work on a retrospective, autobiographical book of photographs, *The Lines of My Hand.* This book, commissioned by Kazuhiko Motomura, indicates a renewed willingness to confront his past through the photographs he had callously dismissed in *About Me.* The majority of the images included are not from *The Americans,* his best known and most finely wrought photographic project, but are less frequently published ones that chart the development of his vision and carry the reader on a chronological journey that closely follows his biography. The structure of the book is cinematic and it clarifies Frank's transition from photography to film. For example, after a series of 1958 still images from Coney Island and another sequence of photographs from the bus series, he reproduced overlaid strips from several of his movies with brief texts from each.[41] Here, Frank separates his films from his photography, stressing the collaborative nature of filmmaking. "There is no 'decisive moment.' It's got to be created. I've got to do everything to make IT happen in front of the lens," he wrote.[42]

The Lines of My Hand may be read in several ways. Like *The Americans,* it combines layers of both personal and social meaning. Graphically complex, it relies on composite, multiple images in sequences that tell a personal story. The pictures represent memories,

Maquette for *The Lines of My Hand,* 1971

but the book reinterprets these memories, sometimes subverting their original meaning. For example, Frank reproduced proof sheets of some original strips of negatives from *The Americans,* showing a few of his well-known pictures. This strategy reveals his original unedited vision, reducing the iconic importance of these images. In this autobiography Frank further incorporates his point of view through innovative juxtapositions. For example, a portrait of Eisenhower next to the words "salami on rye" is paired with a picture of a man on a Chicago street corner staring at a sign advertising "Drugs Insulin." A photograph of an accident victim dead under a snow-covered blanket is coupled with a picture of a life insurance building, instead of a covered car, as it was in *The Americans.* The juxtapositions in *The Lines of My Hand* are ironic, almost cynical. They are more literary, labored, and opinionated than the formal, metaphorical, open-ended sequencing of *The Americans.* "Today it is different, people confront reality, things are more open...," he wrote to explain the variance of his new selections.[43]

The Lines of My Hand was first published in Japan in 1972. Later that year an American edition was released and was instrumental in encouraging the creation of new books that combined documentary and autobiographical elements.[44] The final pages of the Japanese edition show a panoramic view made from Frank's Nova Scotia home, pinned to a wall in his New York loft. A letter to the publisher is attached to the photograph.[45] By including this personal note, he concludes the narrative at a specific moment in time to emphasize that the process of writing his autobiography with pictures is the real subject of the book. This brings the reader into his life. In a similar manner, the panoramic landscapes that conclude the American edition also emphasize Frank's point of view. Titled *Mabou,* this collage is taped together from fragments of pictures and combined with a handwritten text, exhibiting an assembled quality (pages 230–231). Frank said, "...it was a deliberate attempt to show that for me the picture itself had ceased to exist.... It really expresses the way I felt about photography—that if I did it now it would be spliced together."[46] Frank's film-like technique of cutting and taping—editing together—segments of photographs implies a symbolic ordering of his experiences and prefigures his impending return to still photography.

During the early 1970s Frank began to make still photographs from multiple strips of movie film that were printed together. He also began to add words to these images by double-exposing the film. "I think this is a way that brought me back to being more of a still photographer," he said while making these composite still images.[47] These works, including *Goodbye Mr. Brodovitch I'm Leaving New York, December 23rd, 1971 OK?* (pages 228–229), and a cover and sleeve design for the Rolling Stones' 1972 album *Exile On Main Street,* convey a spatial sense of movement through time. He also began to use a Polaroid instant camera, enabling him to make images at his home in Nova Scotia where he had no darkroom. His first Polaroids, probably shot in 1972, include winter landscapes and snap-

shots of friends, family members, and objects.[48] Several of these incorporate Frank's writing directly on the tiny, unique prints, adding information about time, place, and personal feelings. One such landscape depicts telephone poles and a clothesline, with the sea and sky meeting in the distance. He wrote across the sky, "One evening early March. It's 6:30 pm 25° degrees. I love to be here." Another Polaroid

For the Glory of the Wind and the Water, 1973

shows an empty picture frame hanging on a clothesline stretched from a pole at the left edge of the picture. The clothesline mimics the distant and unreachable horizon, while the empty picture frame encloses a more focused view of the seascape to create a miniature photograph within the photograph. Frank's act of framing the horizon symbolizes his photographic vision. He wrote on this Polaroid image, inside the picture frame, "For the glory of the wind and the water."

Frank continued to experiment with multiple images, adding objects, notes, and scraps of paper to achieve a sense of intimacy in structure, form, and content. He documented commonplace moments by including letters, postcards, snapshots, or fortunes, bringing his art closer to the everyday context of his life.[49] In *Mabou*, c. 1976, he depicted a slaughtered steer and his dog, Sport, using multiple color prints glued to roofing paper (page 246). In 1975 he constructed the composite collage *Andrea* (page 243). Beginning with a portrait of his daughter, this work is assembled from a sequence of photographs that depict his Nova Scotia home. In one of his most impassioned statements, Frank roughly pasted several images on cardboard, adding layers of black, peeling paint, obscuring and defacing the overall picture. It was as if he was using the surface of the photographs as a palette on which to inscribe his pain. The picture is dedicated, "for my daughter Andrea who died in an airplane crash at Tical in Guatemala on Dec. 23 last year. She was 21 years and she lived in this house and I think of Andrea every day." Frank followed this work with a series of sequential collages created from multiple photographs

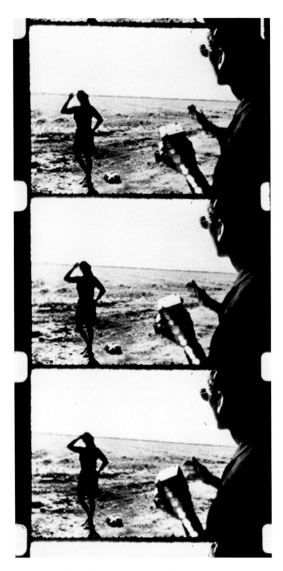

June and the Blind Man, from Life Dances On..., 1975

made with a cheap amateur camera.[50] These "drugstore" snap-shots were assembled into large panoramas or grids super-imposed with handwritten words, fortunes, and paint. His 1976 aggregate portrait of June Leaf on the beach in Mabou, with her hands, legs, feet, arms, and face jutting from all angles into multiple frames, presupposes other events happening out-side the images (pages 248–249).

While his move to Nova Scotia prompted a reevalua-tion of his still photography, Frank also continued to make films, combining the autobiographical, everyday sentiments conveyed in his Polaroids with a concern for both documentary and fabricated methodologies. In 1972 Frank shot *Cocksucker Blues,* a personal and controversial documentary about the Rolling Stones' North American tour. *Keep Busy,* perhaps his most abstract and cerebral project, was shot in Nova Scotia in 1975 in collaboration with the writer Rudy Wurlitzer. Mirroring Frank's own feelings, the film is about interpersonal politics, isolation, and survival. It relies heavily on the manip-ulation and cadence of language to tell a story about the regu-larity and hierarchical structures that guide the lives of a small band of residents on an isolated island off the coast of Cape Breton. The island's lighthouse keeper is the only person with a radio, their sole connection to the out-side world. Therefore he controls the residents' lives. The lighthouse then becomes a symbol of both isolation and warning, harboring people yet preventing them from moving beyond a level of bare subsistence. "We used actors and real people," said Wurlitzer. "What interested me was questioning where the boundaries of fiction lie and where the margins are, how to use reality on one level and a fictional approach on the other. They mutated where you use them together."[51]

Between 1980 and 1985 Frank completed the film *Life Dances On...* and *Home Improvements,* his first video project. *Life Dances On...,* like *About Me,* is a meditation on his own life and destiny, and the inability of film to document his true feelings. These themes are presented in counterpoint to Frank's memory of Andrea and his friend Danny Seymour, who disappeared in 1973. It is also a breakthrough in Frank's filmmaking pro-cess. It is edited from fragments of previously shot film footage woven together with new scenes in a loose narrative. Like his assembled photographs from the mid-1970s, *Life Dances On...* is also a collage of personal elements. The film opens with an outtake from *Conversations in Vermont* as Frank asks his daughter, "Do you think you'll go back to the

city?" Andrea replies, "I would never live there and bring up my children as the city is now." He then introduces a series of people struggling to cope with an imbalance in the urban environment. Pablo admits to his father, "I don't like Earth's gravity. I want to see what the gravity is like on other planets." Billy, an unemployed city dweller, says, "Here's that social outcast you hate so much. I know you people are reading my mind."

Frank uses discontinuous sound with some images to link disparate scenes. The sound of an argument on a busy street corner continues as the picture cuts to a sign reading "Words," followed by a series of Frank's still photographs that are held up awkwardly against the rolling Mabou sea. These photographs function as ironic icons, in much the same way that his 1950s prints of *Mauritania* and *Political Rally, Chicago,* seen in the 1977 photograph *Mabou, Nova Scotia,* flap on his Mabou clothesline (pages 128–129). In this film, Frank moves beyond his traditional vocabulary of visual and written symbols to superimpose these symbols against the backdrop of nature.

In *Life Dances On...,* Frank asks if photographs might record the invisible. Billy is afraid people are reading his mind and tells him, "You shouldn't be pointing the camera. My innermost thoughts are my secrets.... That's invading my privacy." The film then cuts to a scene in which June Leaf tries to teach a blind man to photograph the wind, suggesting that one can only picture the external effects of nature and not its internal presence. One might, however, document the internal struggles of people. In the film, Leaf asks Frank, "Why do you want to make these pictures?" He answers her without words, by positioning in front of his camera two symbolic toys—a model of the Empire State Building and a little wind-up skeleton. The film then erupts in a sequence that represents Frank's memories of Andrea. His photographs of his daughter are superimposed over beautiful footage of the Mabou landscape, creating an intimate tension between the beauty and his obvious pain. This tension is finally broken as the film cuts to a sentimental view of objects on his window sill, situating the viewer with him at home. The film concludes as Frank's son, Pablo, hints at his own internal turmoil, quoting Job 38:22, which asks, "Have you visited the storehouse of snow or seen the arsenal where hail is stored?"

The links that Frank makes between his expression of sentiment and his feelings about his family lend structure to this illusory film. In *Life Dances On...,* his depiction of both the natural and urban environments as symbols of his life parallels his investigation of various phenomena of representation, like sight and language. By establishing these relationships, he structures many diverse, emotional scenes.

Frank once said, "I have a lot in back of me and that's a tremendous pull, of what has happened in my life, backward. And in front of me I have the sea."[52] By looking ahead beyond this symbolic horizon, where sea meets sky, his video *Home Improvements* is like a visceral diary of daily thoughts and events, revealing important occurrences and glimpses of

the people around him. He introduces fragments of dialogue to express feelings and uses pictures to connect these feelings to others: June gets sick, the weather turns bad, they buy a car, and struggle with Pablo's illness. Sitting on the subway looking at graffiti, Frank's video camera records the word "Symptoms." Scrawled in cryptic calligraphy below, another statement completes the diagnosis: "It was dark." At home in New York he points his camera out the window and remarks, "I'm looking at the Christmas wrappers blowing in the wind. And I'm thinking of Kerouac when he said being famous is like old newspapers blowing down Bleecker Street." Again fearful of the power of his photographs to pull him backward into the past, and afraid of their commercialization, he asks a friend to drill holes through a large stack of valuable prints, which he later incorporated in his assemblage, *Untitled,* 1989 (page 287). In order to show what it means to throw the past away, he also videotapes himself throwing away his garbage. When the trash collector arrives he is surprised by Frank who yells, "Nice morning.... It's a big moment!" Frank's link between the destruction of his art and throwing out his garbage represents his desire to move from the past to the present and from photographs as symbols of memory to photography as an ongoing, living process.

Robert Frank continues to make innovations in autobiographical methods. His most recent work addresses not only his memories, but also the critical acclaim his work has received. Sometimes he confronts the past directly, turning issues that have come to dominate his life—like fame or the art market—into powerful fictional allegories. For example, his 1987 autobiographical feature film *Candy Mountain,* made with Rudy Wurlitzer, is a fictional story about Elmore Silk, a master guitar-maker who moved to a remote area and burned his creations rather than face the investors who wanted to buy them. Frank's next film, *Hunter,* 1989, depicts the existential journey of a fictional character who confronts post-war industrial Germany. Initially based on Franz Kafka's short story *The Hunter Gracchus,* adapted by Frank and actor Stephan Balint, the film is about the consequences of Germany's past and the inevitability of facing it. *Hunter* is both a documentary about industrialization and immigration in Germany's Ruhr valley and a fictional story of a drifter who crosses both political and psychological borders to find a nation at war with its own past. In the film, a banker decrees, "Money is everywhere, but money is timid like a deer." Money and the illusion of wealth created by industrial growth lead the drifter to his death.

In his recent photographic triptychs like *Moving Out,* 1984, and *Yellow Flower— Like a Dog,* 1992, Frank animates multiple still images with words (pages 283–285, 136–137). *Moving Out* presents a sequence of three abandoned rooms from different times of his life. Light spills through the windows across objects left behind. The words "Moving Out" written across the top of the pictures allow an exit from the rooms, as though his creation of the image was itself a rite of passage. *Yellow Flower—Like a Dog* includes a

haunting, dreamlike stream-of-consciousness text superimposed in multiple layers over photographs of tulips given to Frank following an illness. "Your conscience is a trick. It doesn't exist though you may think it does," he wrote on the pictures. *End of Dream* combines three enlarged black and white Polaroid photographs of ice melting on the Mabou coastline. Several collaged color Polaroid Spectra prints hover in the sky above the ocean (pages 267–269). The shadow of Frank's outstretched arm is visible

Video Still from *Cairo*, **1993**

in several of the pictures. *End of Dream* synthesizes his long-standing, symbolic relationship to nature. He later wrote of this relationship, "The map makes itself, I follow, no choice, like exorcising the Darkness come too early.... I wish that the feeling of that Memory will make a sound of music."[53]

Frank's moving pictures and his still photographs are interdependent. As an autobiographical vision emerged in his photography, he began to reinterpret his world through cinema. As his films became increasingly personal, focusing on the intricacies of his own relationships, he returned to still photography, creating narrative images with the illusion of movement and time passing, breaking down barriers between his art and personal life to reveal an interior vision and create a tension that itself became the subject of his work. His art is like a personal monument that he constructs day-by-day and layer-by-layer from the fragments of his own experience.

In 1993 Robert Frank traveled to Egypt to work on an improvised drama about the relationship between himself and two friends. Again the film merges fact and fiction. In a rough cut of the video footage, Cairo is foreign and bright, smoke-filled rooms are claustrophobic, and Frank's honesty and belief in his work—evident in scenes on a train and at the Cairo zoo—is fierce, like some of his recent photographs in which he is the subject. Rows of date palms flash past a train window as one friend tells him that it is impossible to continue filming. Lounging zoo keepers prod snakes and lions, waking them from obvious torpor. The animals, like Frank's memories, are caged. In order to clarify the relationship between these scenes, Frank made a series of photographs from his video footage, shooting

Polaroids directly from a video monitor. Portraits of his friends and himself are combined in a grid with other pictures that represent memories of their journey: fragments of Arabic writing on the sides of a paper pyramid hanging from a taxi mirror, and a painting depicting a leopard (pages 300–301). The video footage reveals Frank's shadow, a self-portrait projected by an early morning sun against the wall of his Cairo hotel room. Pacing back and forth like the leopard, Frank narrates, "Maybe this is the beginning of a friendship, beginning of love—beginning of a new story...."

Even though Frank's process is evident on the surface, the true nature of his message frequently remains mysterious or unexplainable. His symbolism goes beyond the personal, though, to encompass such universal concepts as nature and history, politics and time. Allen Ginsberg once described Frank's process: "...focus swiftly, 'invisibly'...shoot from the hip—turn the eye aside, then click chance in the 'windows on another time,' on another place...."[54] In this way he opens "windows on another time" by representing his own life in the context of his art, letting in fresh air as a way to situate himself and others in nature and in time.

Notes

1 Robert Frank, quoted in Liz Jobey, "The UnAmerican," in *The Independent on Sunday,* 29 March 1992, 10.

2 Jean-Luc Godard to the documentary film director in his film *First Name Carmen,* 1983.

3 Ken Kesey, as quoted by Robert Frank in a promotional brochure for *Last Supper* (Zurich: Vega Film AG, 1991), 2.

4 Walter Benjamin, "The Author as Producer," in *Reflections* (New York: Schoken Books, 1986), 229.

5 Jobey 1992, 9.

6 Jobey 1992, 9.

7 Samuel Beckett, *Waiting for Godot* (New York: Grove Press, 1954), 58.

8 In *Last Supper* the caterer recites these lines in French: "Toujours ces mêmes cochonneries. Ces mêmes blessures, encore ces mêmes silences."

9 Robert Frank, letter to David Killen, 7 May 1981, Archives, The Museum of Fine Arts, Houston.

10 "New York Was Never Like This," *Junior Bazaar* 3:9, September 1947, 84–85.

11 Louis Faurer, quoted from interview with the author and Anne Tucker, October 1985, New York. Many of the interviews quoted in this essay were conducted during production of the documentary video, *Fire in the East: A Portrait of Robert Frank,* by Philip and Amy Brookman. Transcripts of unedited interviews are in the Archives, The Museum of Fine Arts, Houston.

12 William S. Johnson, "History—His Story," in "The Pictures are a Necessity: Robert Frank in Rochester, NY, November 1988," *Rochester Film and Photo Consortium Occasional Papers,* no. 2 (Jan. 1989), 30. See Charles Wright Mills, *White Collar, The American Middle Class* (London: Oxford University Press, 1951). Mills proposed that Americans were alienated from their work during the 1930s and 1940s as the economy shifted from a rural to an urban base. Consequently workers were no longer satisfied with work as a process. Work became a means to attain greater status through increased income.

13 "The Pictures are a Necessity," 26–27.

14 Jean-Paul Sartre, *The Age of Reason* (New York: Random House, 1947), 395. Other novels in Sartre's *Roads to Freedom* trilogy are *The Reprieve,* 1945, and *Troubled Sleep,* 1949.

15 David Halberstam, *The Fifties* (New York: Random House, 1993), 295.

16 John Clellon Holmes, *Go* (New York: Thunder's Mouth Press, 1988), 161.

17 Robert Frank, "Fellowship Application Form," in Anne Tucker and Philip Brookman, eds., *Robert Frank: New York to Nova Scotia* (New York: Little Brown and Co., 1986), 20.

18 "Brown v. the Board of Education of Topeka," the historic Supreme Court order to desegregate U.S. public schools, was decided on 17 May 1954, just before Frank began his series of photographs, which became *The Americans.* The civil rights movement was just emerging in the American south at this time.

19 Walker Evans, quoted in "Walker Evans with Robert Frank and Others," unpublished transcript of a conversation that took place at Yale University, New Haven, 5 May 1971, 1. Walker Evans Estate.

20 During this time Frank also was included in Edward Steichen's exhibition *The Family of Man,* which opened at the Museum of Modern Art in 1955. Though close to Steichen, Frank was mistrustful of this sentimental, propagandistic exhibition that juxtaposed images of people and cultures from throughout the world. Individuals were represented through series of universal themes like creation, birth, relationships, love, family, democracy, justice, and death.

21 Walt Whitman, "Song of the Open Road," in *Complete Poetry and Selected Prose* (Boston: Houghton Mifflin Company, 1959), 113. This poem was also included in *Leaves of Grass.*

22 Robert Frank, letter to the author, 27 December 1977.

23 John Clellon Holmes, "This Is the Beat Generation," in *The New York Times Magazine,* 16 November 1952, 10.

24 The title *Pull My Daisy* comes from a poem titled "Fie My Fum," in *Neurotica,* vol. 6, spring 1950, 44. The first lines are: "Pull my daisy, Tip my cup, Cut my thoughts for coconuts." Also see Blaine Allan, "Oh, Those Happy Pull My Daisy Days," in *Moody Street Irregulars,* nos. 22 and 23, winter 1989–1990, 8.

25 Allen Ginsberg, quoted from interview with the author, October 1986, New York.

26 Archer Winsten, "Pull My Daisy Bows," in *New York Post,* 10 April 1960, 19.

27 Jane Knowles, "Reviews," *American Quarterly* 12:2, part 1, summer 1960, 208.

28 Stanley Kauffman, "Art and the Merely Arty," *The New Republic* 142:23, 6 June 1960, 23.

29 Jonas Mekas, "Notes On the New American Cinema," in *Film Culture* no. 24, spring 1962, 10.

30 Ginsberg, Interview, 1986.

31 Robert Frank in Thomas Albright, "One Man's End to Cynicism," *San Francisco Chronicle,* 15 October 1969, 41.

32 Ginsberg, Interview, 1986.

33 French playwright Antonin Artaud influenced New York theater during the mid-1960s. Artaud professed that actors must convey their actual pain in their work to bring theater into the sphere of real life. He called this concept "living theater."

34 Lev Kuleshov, Vertov's colleague, had produced earlier experiments in the juxtaposition of fact and fiction by combining documentary archival footage with a scripted narrative in his 1920 film *On the Red Front.*

35 Robert Frank's use of his own memories, juxtaposed with those of Julius Orlovsky in *Me and My Brother* also recalls Samuel Beckett's short stage play *Krapp's Last Tape,* first produced in New York in early 1960. This play is a favorite of Frank. *Krapp's Last Tape* presents an emotional, fractured monologue. During this speech, an aging Krapp verbally wrestles with a tape recording of his own memories as he listens and talks back to portions of an audio diary. His bitter memories of a failed love affair are recalled in a chopped, non-linear fashion as he plays back bits of a recording made years before. Winding the tape forward and back, he reconnects the circumstances of his own emotional demise. Krapp attempts to reinterpret his own history through the evidence of his past, brought back in the tape recording.

36 Ginsberg, Interview, 1986.

37 Frank also asked his children to pose for advertising assignments from the mid-1950s to the early 1960s. For example, photographs of Pablo and Andrea on a New York City pier at night were made for advertisements that would demonstrate the low-light capabilities of Ansco film.

38 Robert Frank, *The Lines of My Hand* (Tokyo: Yugensha, 1972), 1.

39 June Leaf, written statement, date and origin unknown, Archives, The Museum of Fine Arts, Houston.

40 See Danny Lyon, *Conversations With the Dead: Photographs of Prison Life, with the Letters and Drawings of Billy McCune #122054* (New York: Holt, Rinehart and Winston, 1971).

41 Similar collaged pages had previously appeared in the 1969 edition of *The Americans.* Frank had exhibited printed images from his films as photographic objects as early as 1962 in the Museum of Modern Art exhibition *Photographs by Harry Callahan and Robert Frank.* He also used this technique of printing strips of 16mm movie film for a 1963 *New York Times* advertising campaign called "Where Else But New York?"

42 Frank 1972, 105.

43 Frank 1972, 62.

44 Lustrum Press, which published the American edition of *The Lines of My Hand* in 1972, had also published *A Loud Song,* 1971, a concise autobiographical sequence of family pictures combined with photographs and handwritten text by Frank's friend and collaborator Danny Seymour, as well as *Tulsa,* 1971, Larry Clark's rough, personal look at in the drug culture of Oklahoma.

45 Robert Frank's notes written on this page in the first maquette for *The Lines of My Hand* indicate his early intention to superimpose words over film footage taken in the studio. However, he chose to end the book on a forward-looking note to his publisher, Motomura. Frank wrote in the maquette, "Dear People: from a letter for Words which I…superimposed over…footage taken in my studio in N.Y." This original dummy measuring nine by seven inches, is now in the collection of The Museum of Fine Arts, Houston. A second, more complete maquette, made for the 1972 Lustrum editon of the book, is in the collection of the National Gallery of Art, Washington.

46 Dennis Wheeler, "Robert Frank Interviewed," in *Criteria* vol. 3, no. 2, June 1977, 4. Robert Frank began photographing panoramic views around 1971 when Swiss designer Werner Zryd visited Mabou with a complex, precise, panorama camera. Frank's reaction was to photograph extremely wide views of the landscape with a hand-held camera, snapping multiple images that would never line up with the precision of

Zryd's cumbersome tool. Zryd had designed Frank's book *Black White and Things* in 1952.

[47] "Walker Evans with Robert Frank and Others," 32–33.

[48] Robert Frank frequently arranged groups of Polaroid prints in notebooks. These notebooks were like sketchbooks and helped him to generate possible ways to combine his photographs, together with text, in multiple combinations. In this way Frank began to use collage or montage techniques to juxtapose single images in groups that could express his feelings.

[49] June Leaf also began to glue Polaroid photographs on her drawings and paintings in 1973, making disjointed, animated portraits like *Albert, The Inventor,* and *Robert Enters the Room.*

[50] The Lure camera was a cheap, plastic, consumer-oriented tool that was preloaded with film. When the film was shot the entire camera was returned by mail to the manufacturer and the film was developed and printed commercially.

[51] Rudy Wurlitzer, interview with the author and Anne Tucker, 22 June 1985.

[52] Robert Frank in *Robert Frank: The Poetic Image,* documentary film directed by Giampiero Tartagini for Radio Television della Svizzera Italiano, 1985.

[53] Robert Frank, letter to Sarah Greenough and the author, 1993.

[54] Allen Ginsberg, "Robert Frank to 1985—A Man," in Tucker and Brookman 1986, 74.

AMERICA 1954–1959

"The Photographing of America" is a large order.
What I have in mind, then, is observation and
record of what one naturalized American finds to see
in the United States that signifies the kind of civilization
born here and spreading elsewhere.

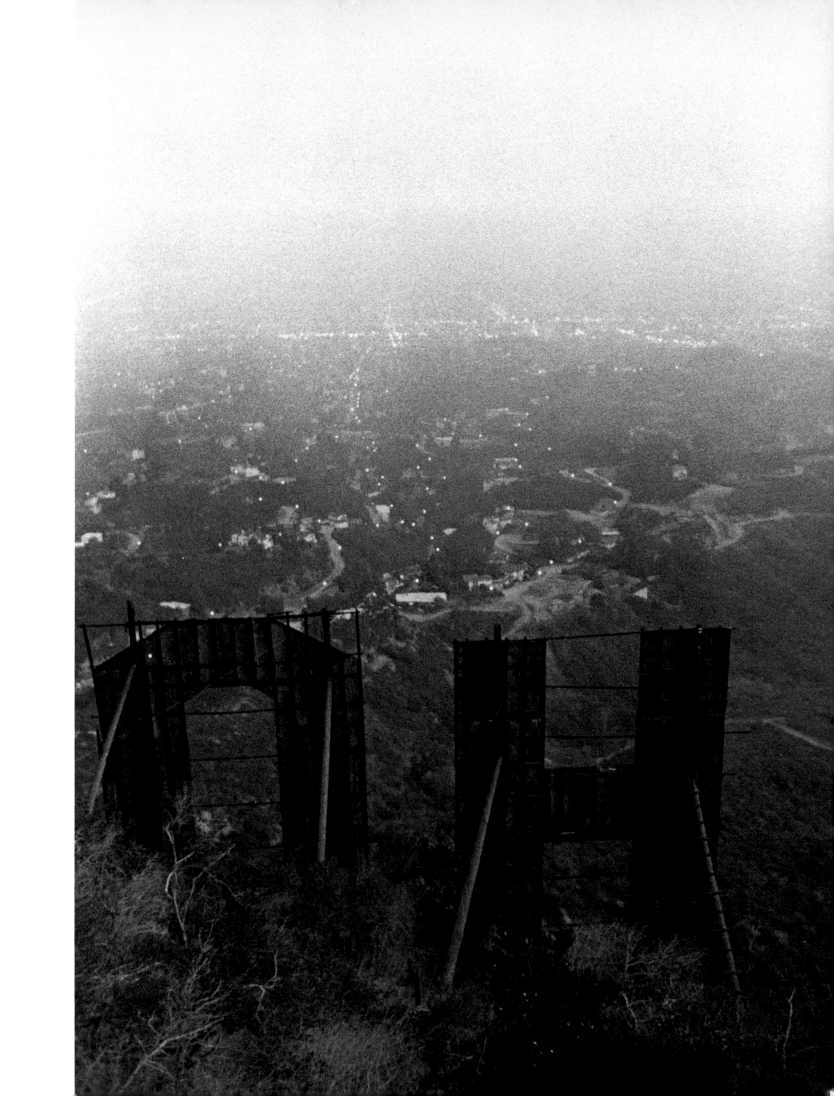

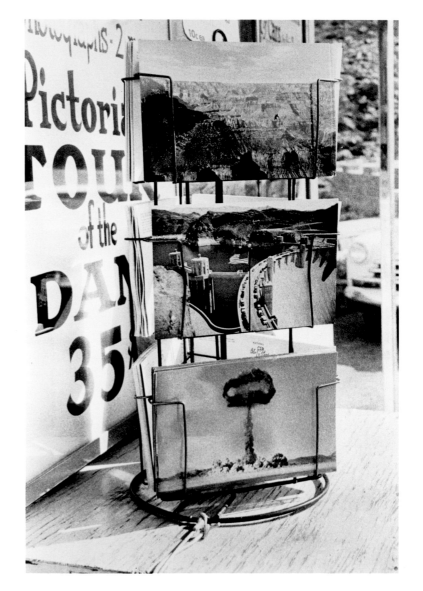

168 Detroit, 1955
Hoover Dam, Nevada, 1955

170 Gallup Motel, 1955

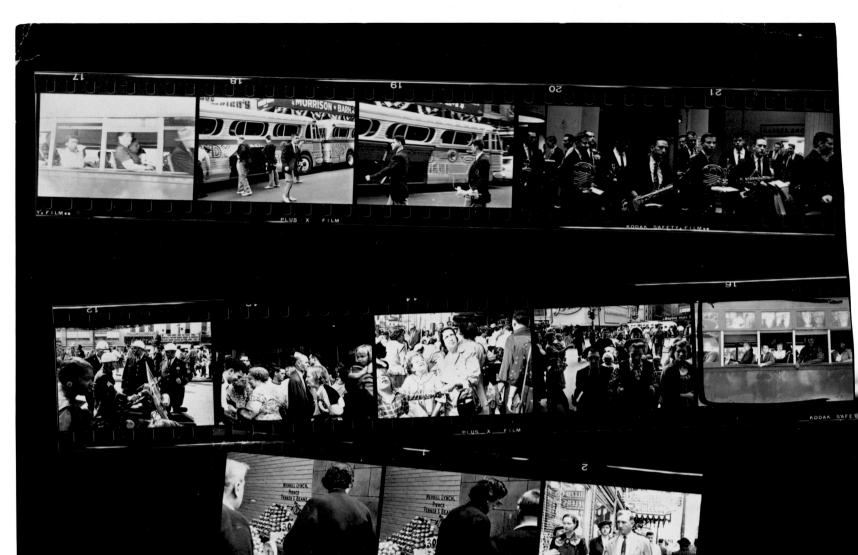
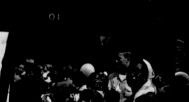

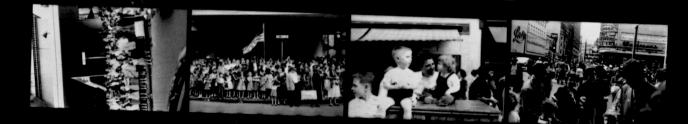

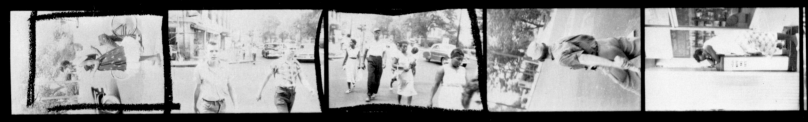

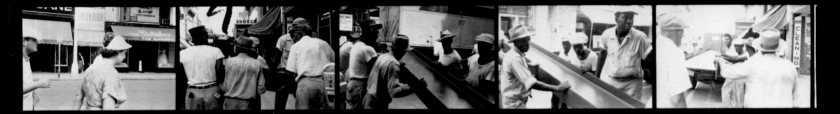

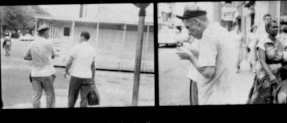

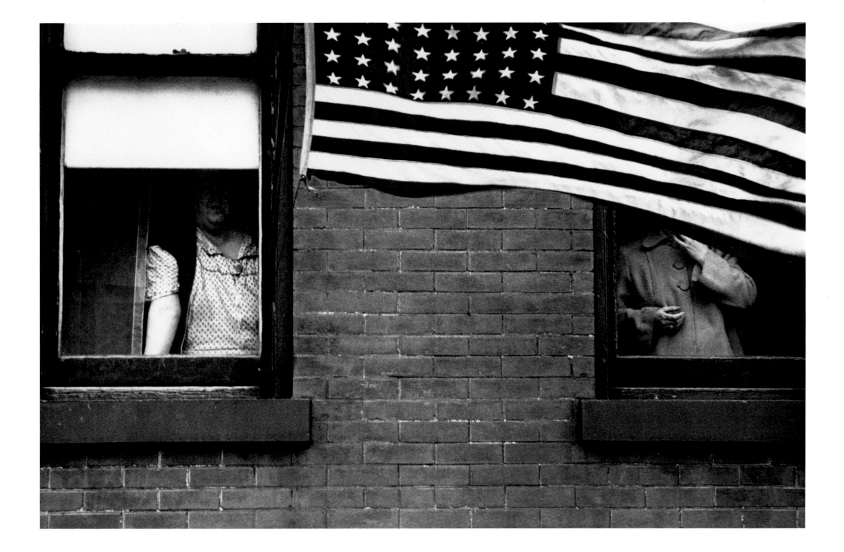

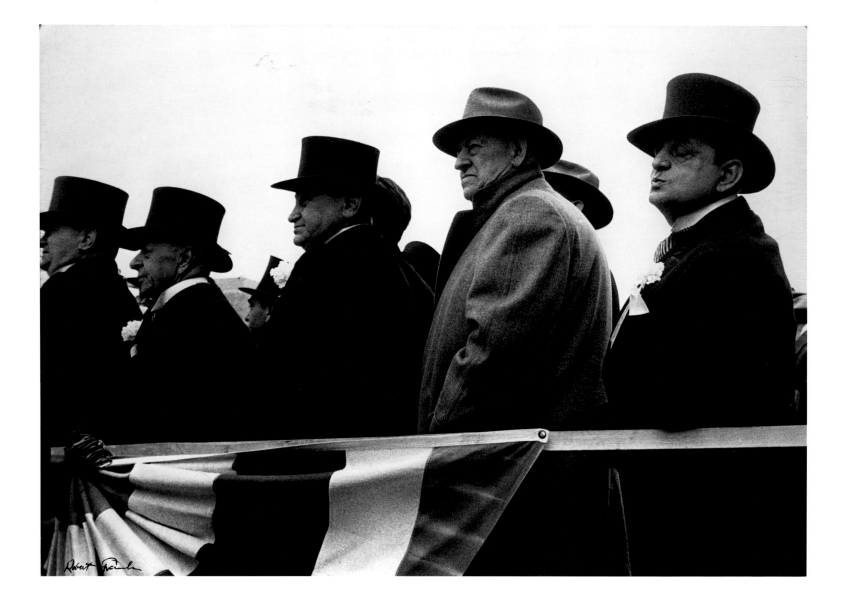

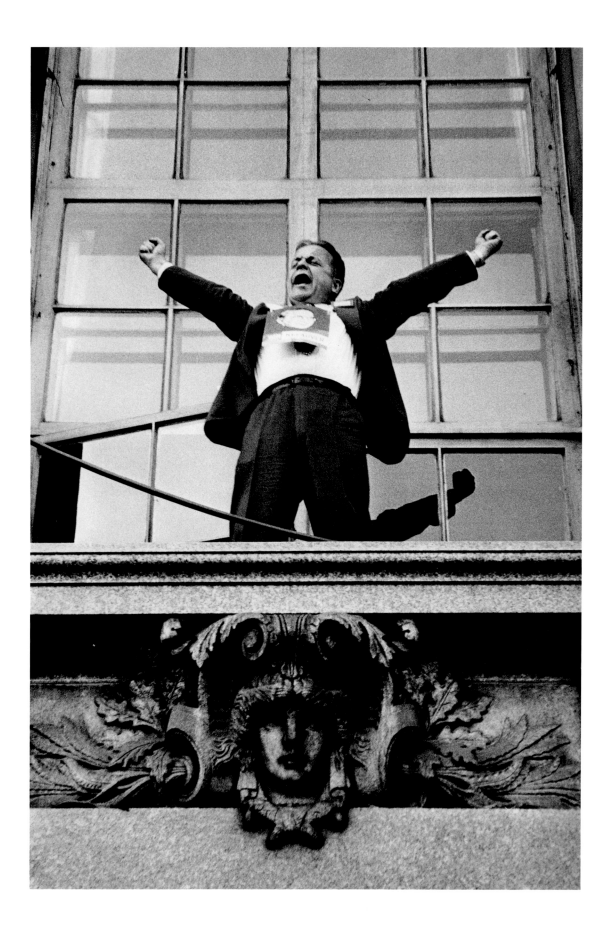

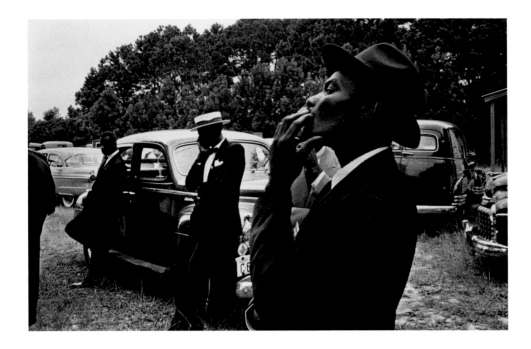

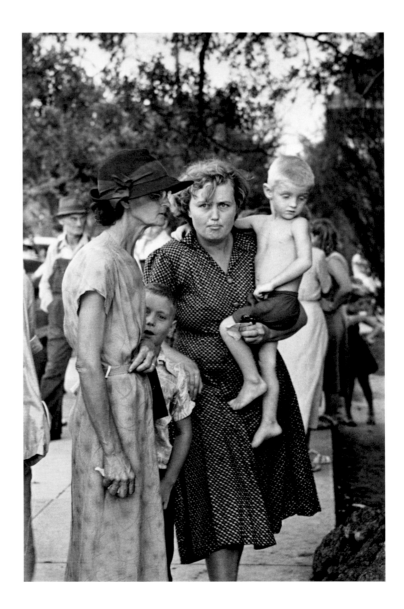

178 Funeral—St. Helena, South Carolina, 1955
Elizabethtown, North Carolina, 1955

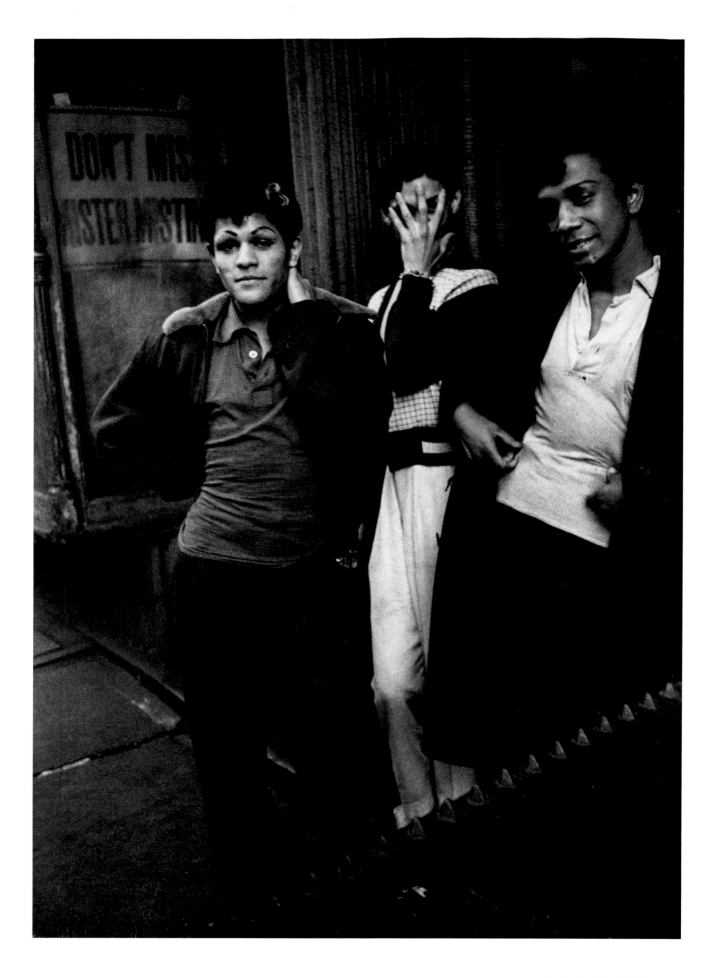

New York City, 1955 **179**

 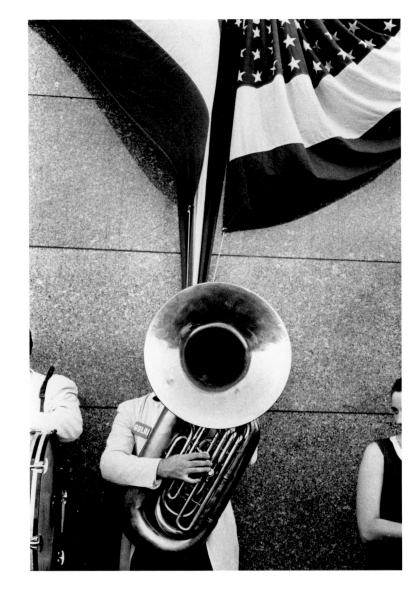

180 Democratic National Convention, 1956
Washington, D.C., 1957

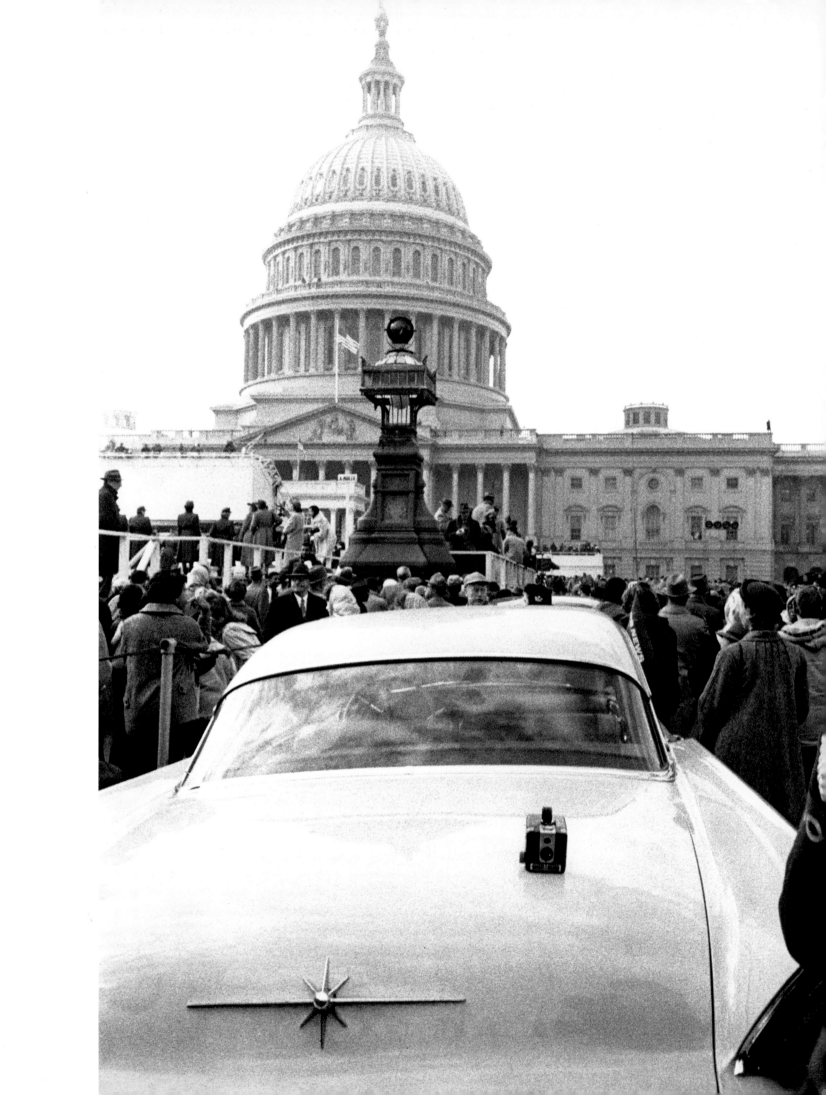

182 Barber Shop through Screen Door—McClellanville, South Carolina, 1955
Fourth of July—Jay, New York, 1954

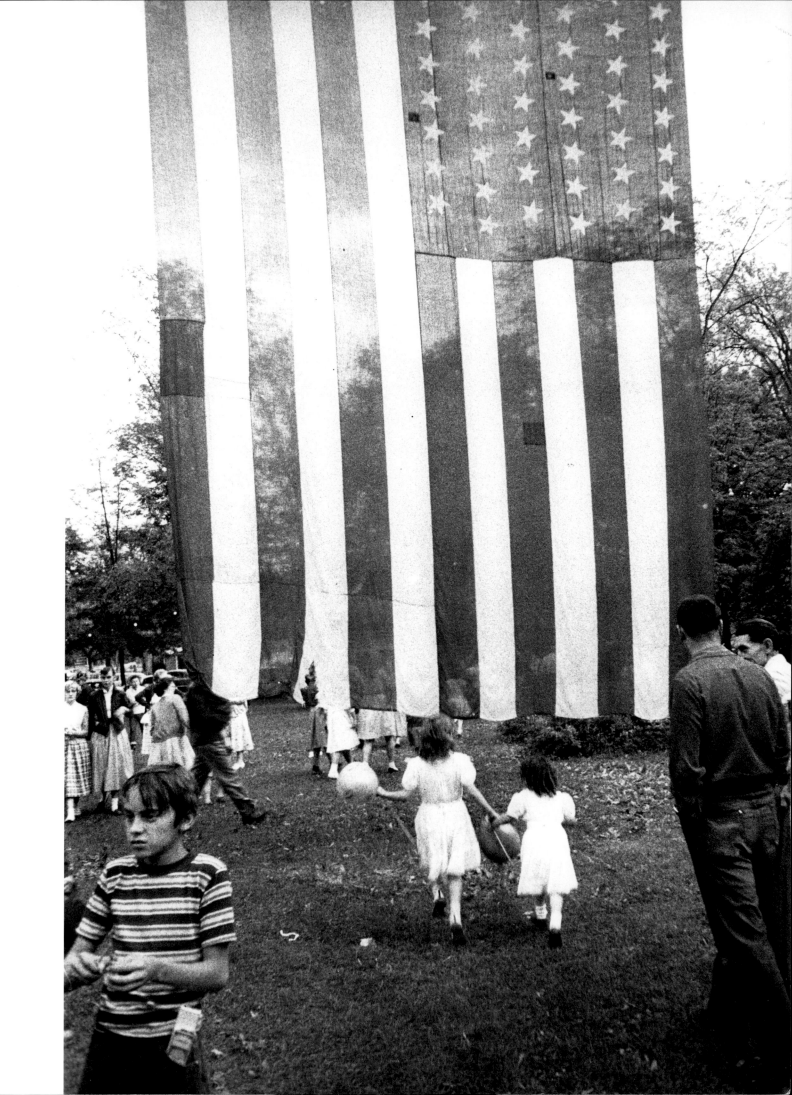

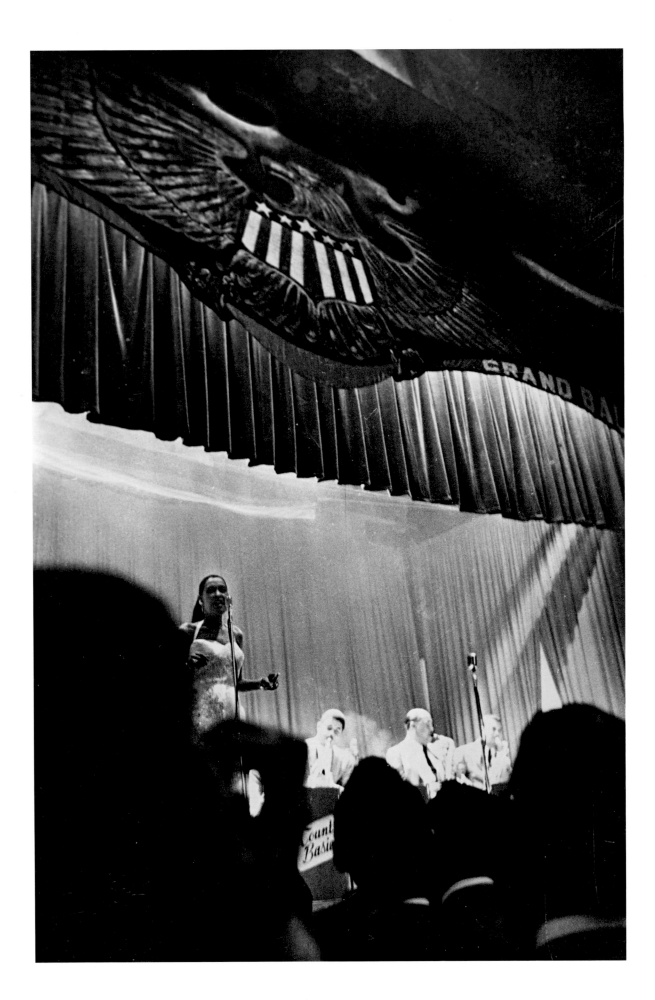

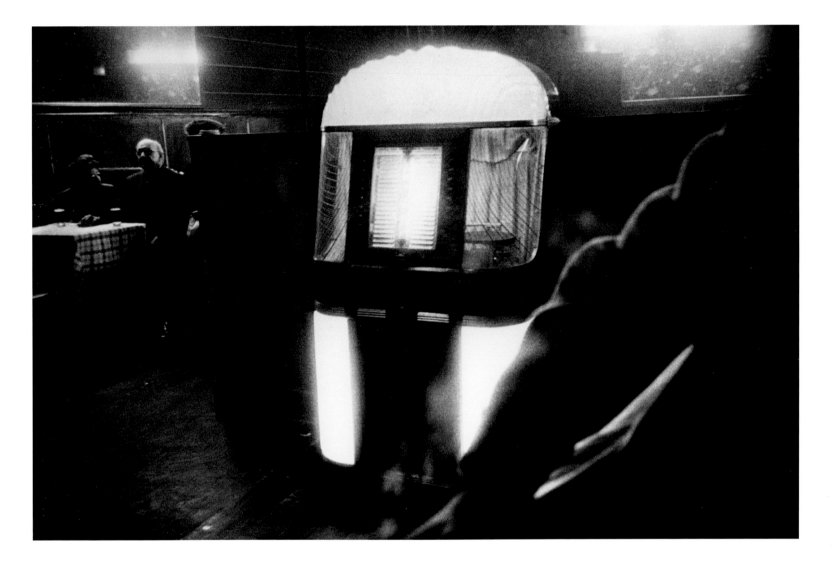

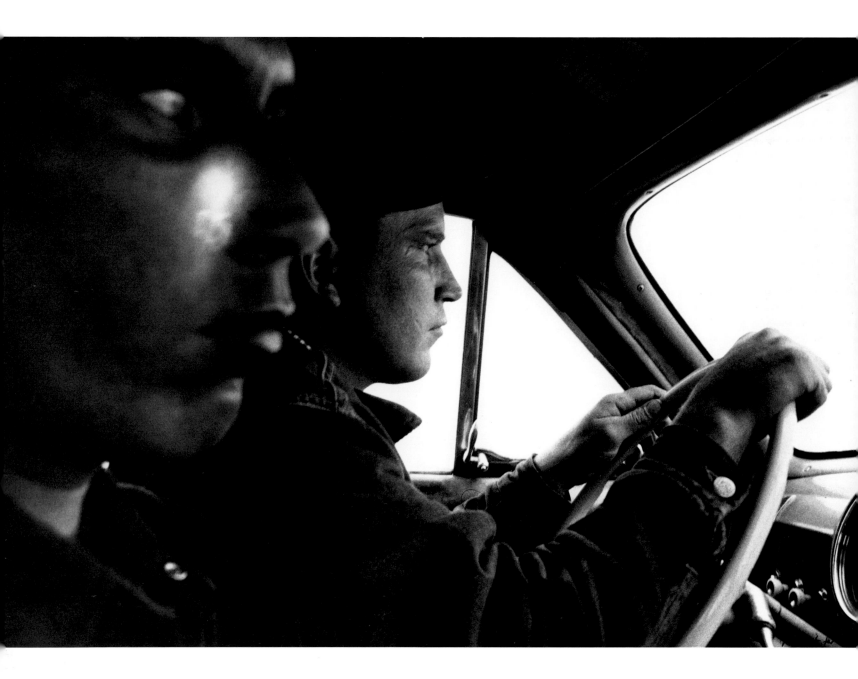

186 U.S. 91, Leaving Blackfoot, Idaho, 1956

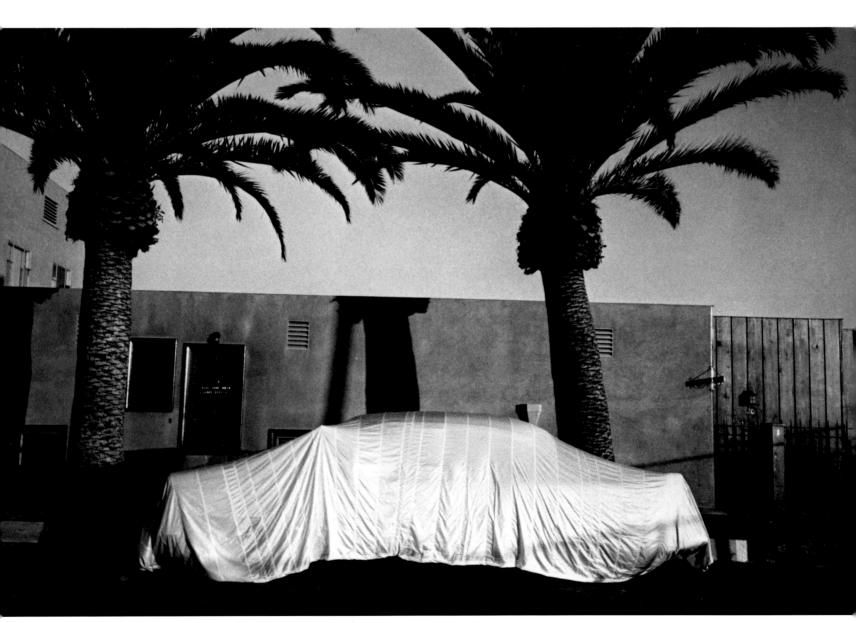

Covered Car — Long Beach, California, 1955–1956 **187**

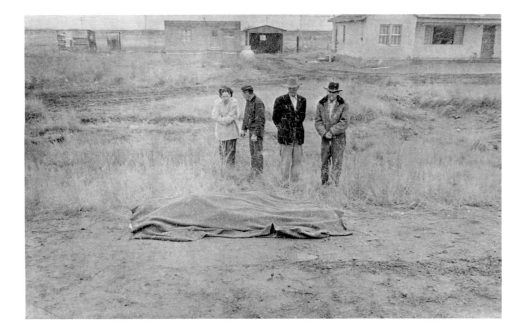

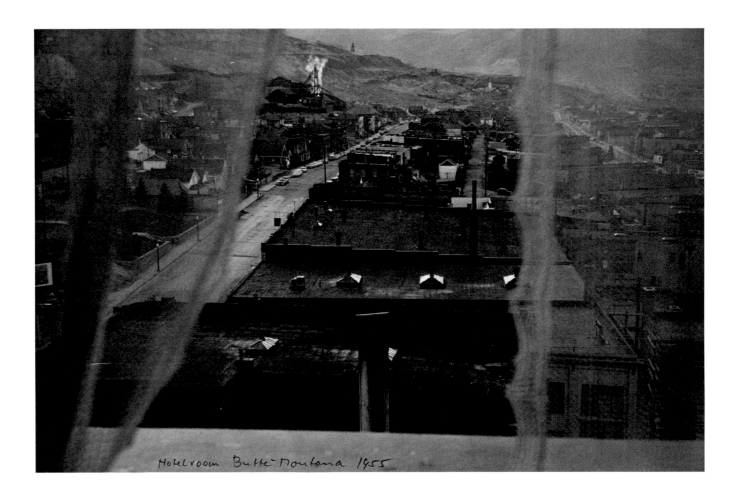

Hotelroom Butte Montana 1955

188 Car Accident—U.S. 66, between Winslow and Flagstaff, Arizona, 1955
View from Hotel Window—Butte, Montana, 1956

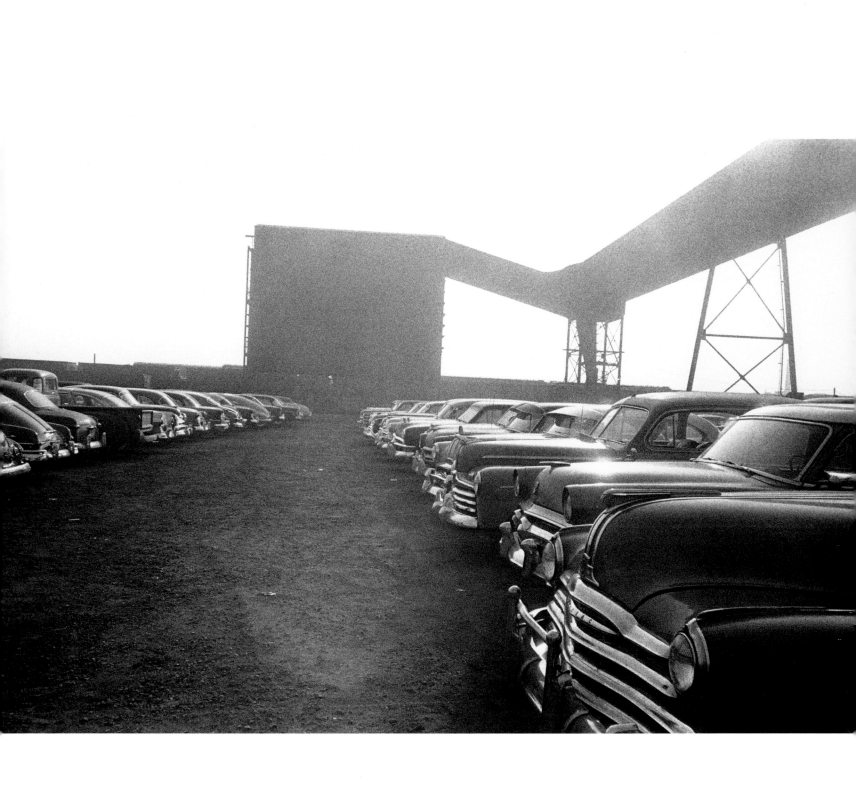

River Rouge Plant, Detroit, 1955 **189**

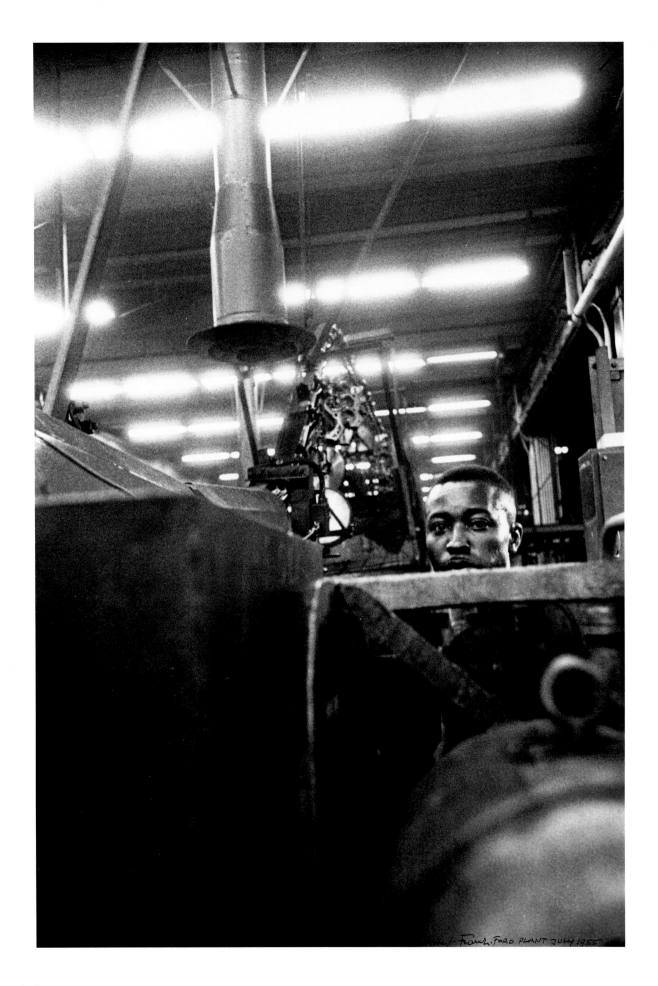

190 Ford Plant, 1955

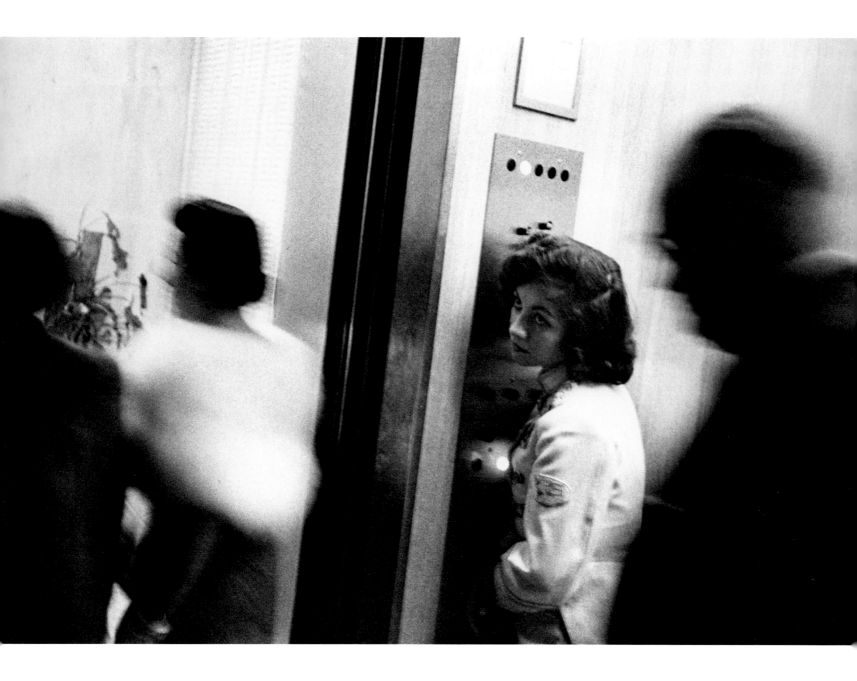

Elevator—Miami Beach, 1955 **191**

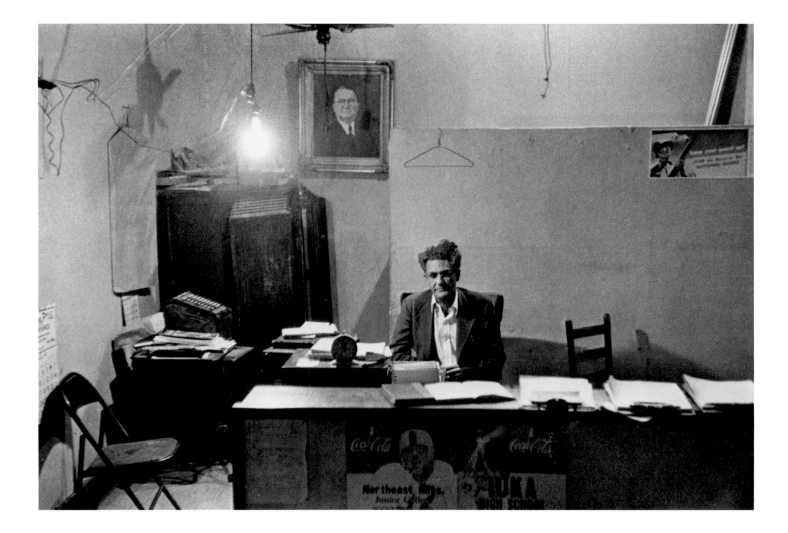

Iuka, Mississippi, 1955

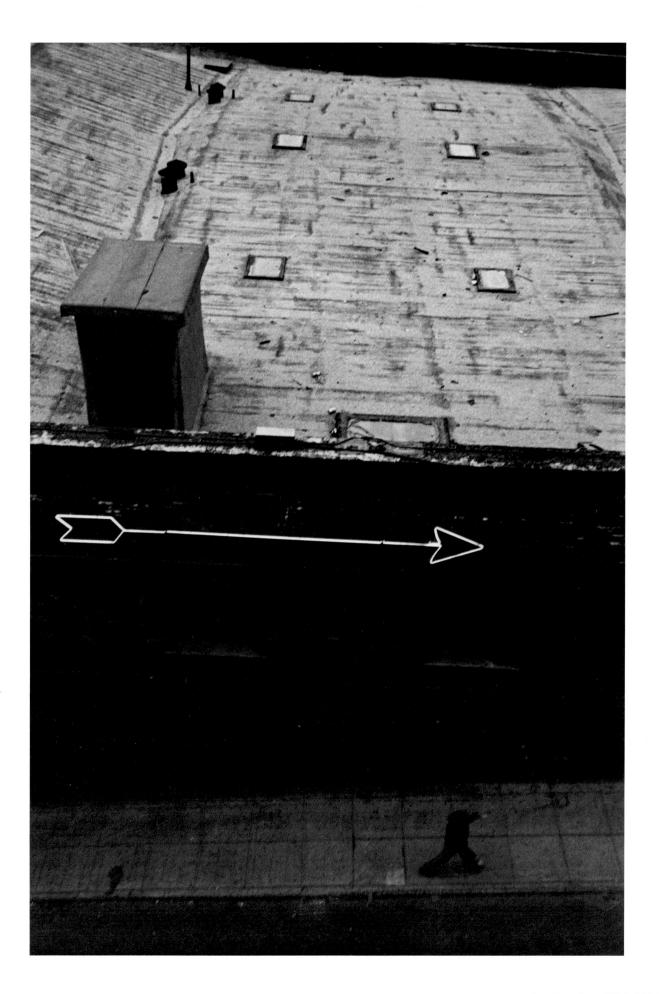

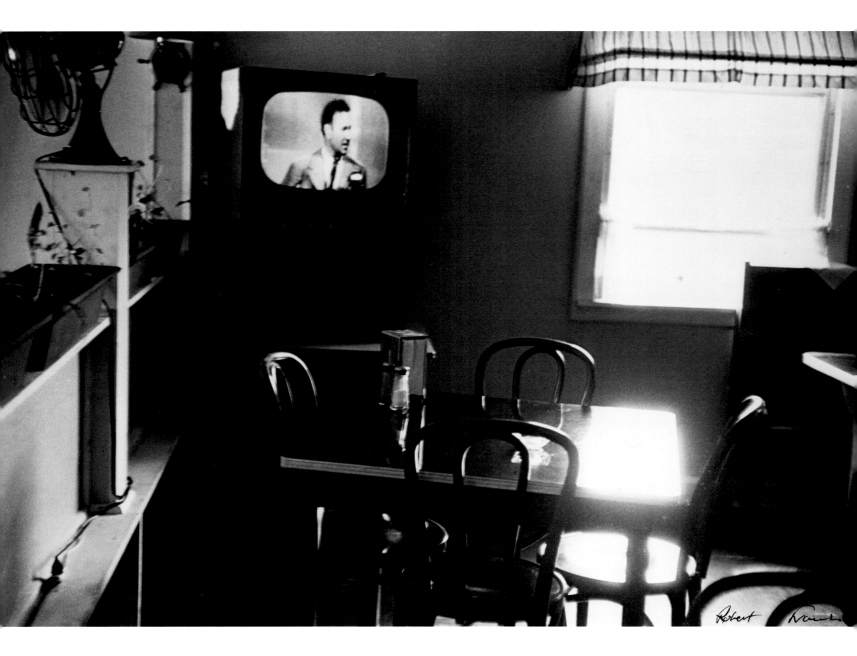

194 Restaurant—U.S. 1 Leaving Columbia, South Carolina, 1955

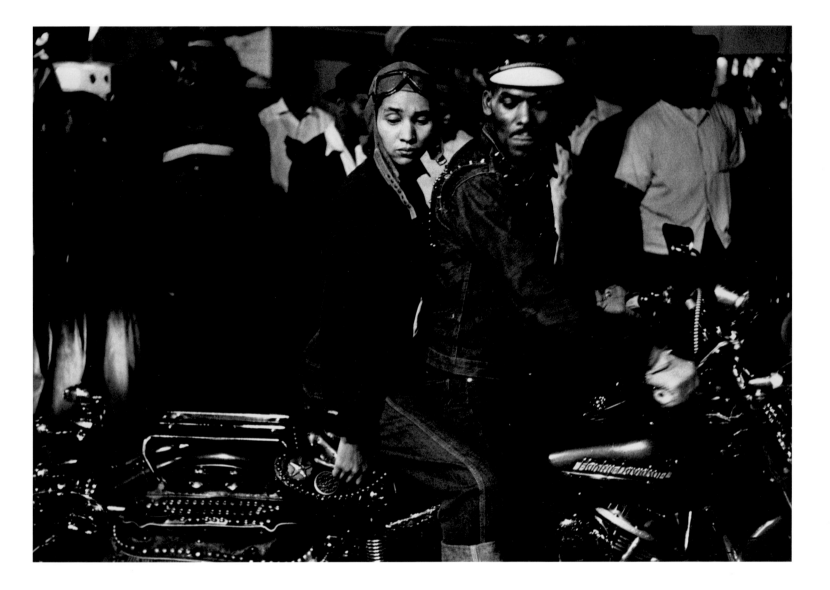

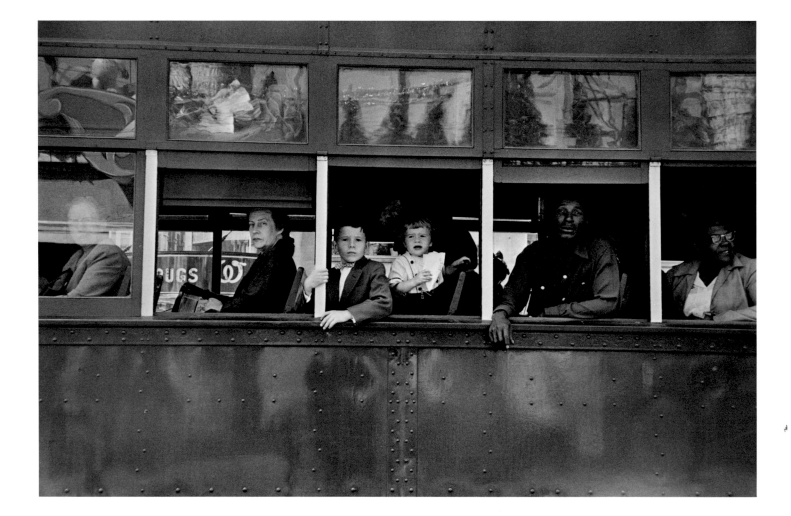

196 Trolley—New Orleans, 1955

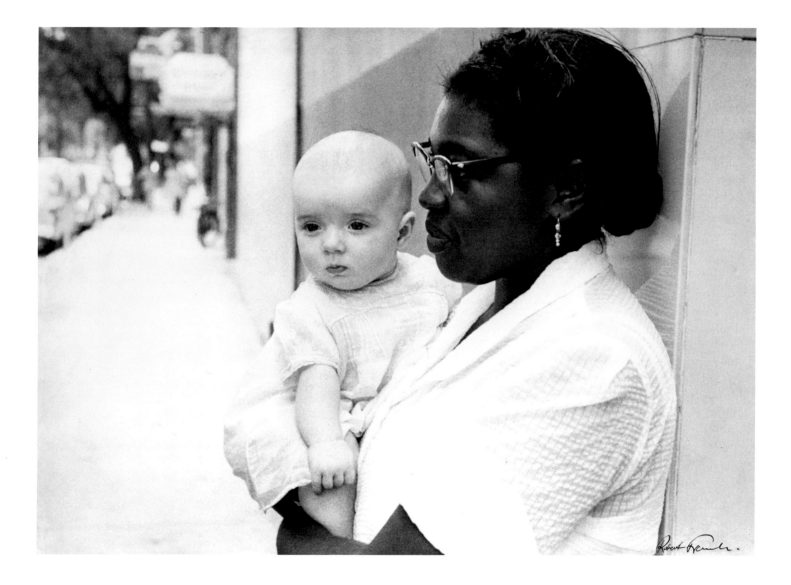

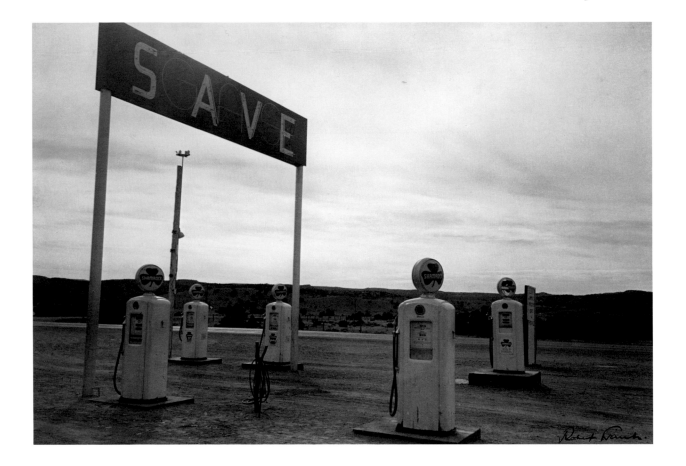

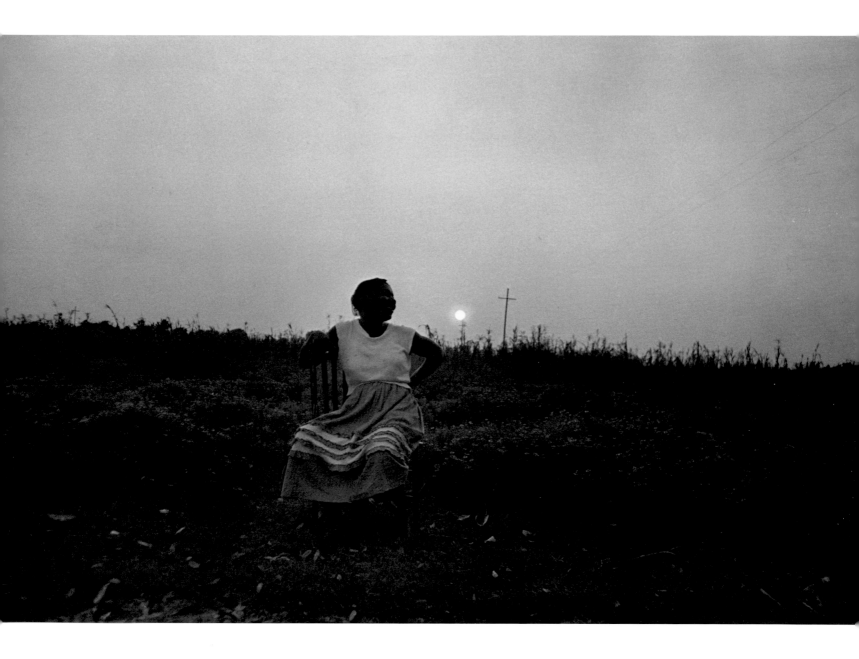

Beaufort, South Carolina, 1955 **199**

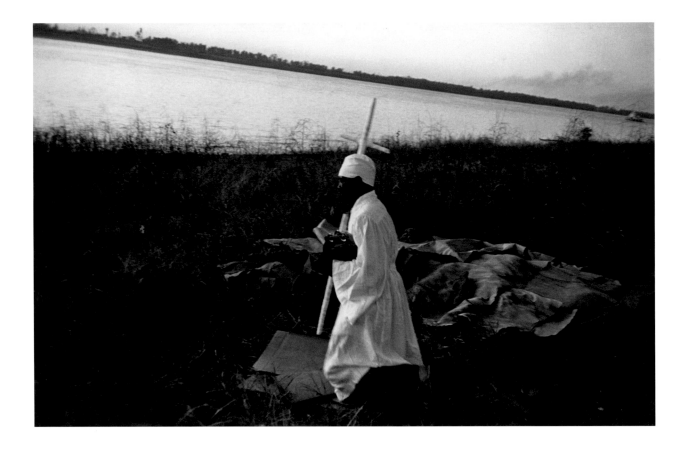

200 Mississippi River, Baton Rouge, Louisiana, 1955

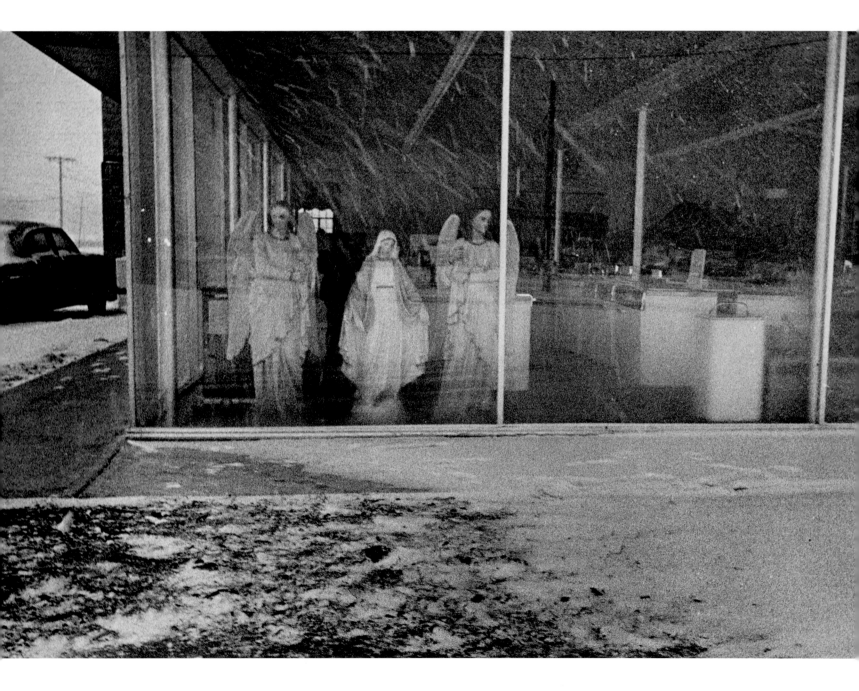

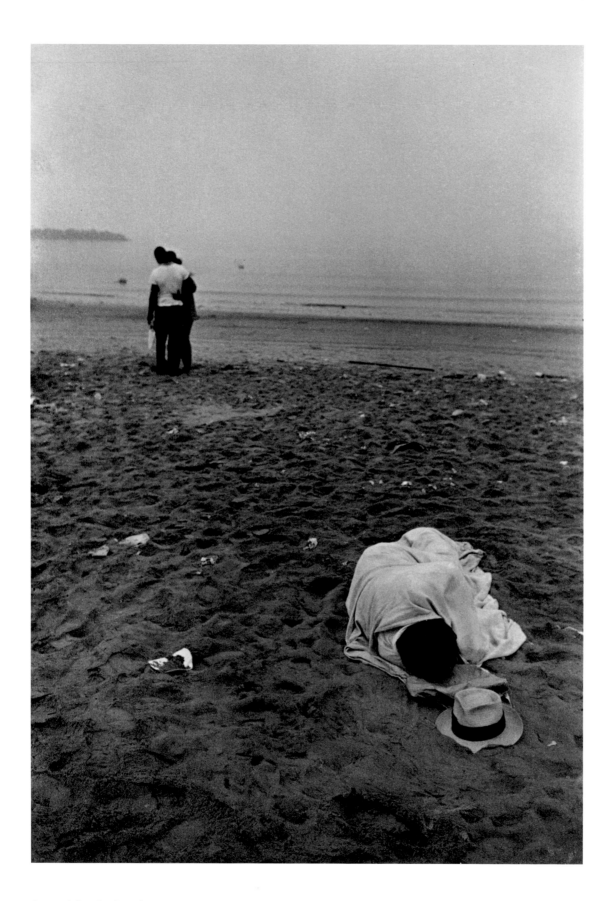

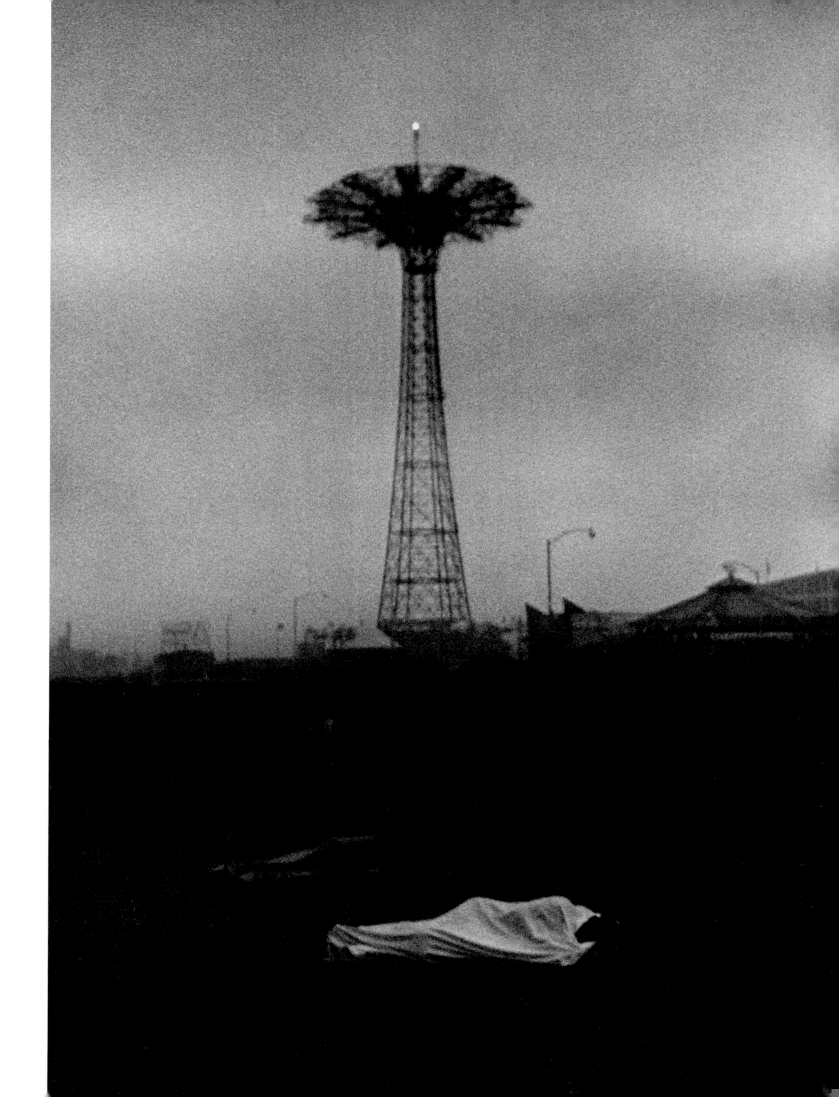

MOVING PICTURES 1955–1985

Whenever I look at these pictures I think that I ought to be
able to say something about the way it felt when I took them
and how I took them (with a Leica) and why I like them.
The Bus carries me thru the City, I look out the window, I look
at the people on the street, the Sun and the Traffic Lights. It
has to do with desperation and endurance—I have always
felt that about living in New York. Compassion and probably
some understanding for New York's Concrete and its people,
walking… waiting… standing up… holding hands… the summer
of 1958.

The gray around the picture to heighten the feeling of seeing
from the inside to the outside.

I like to see them one after another. It's a ride bye and not a
flashy backy.

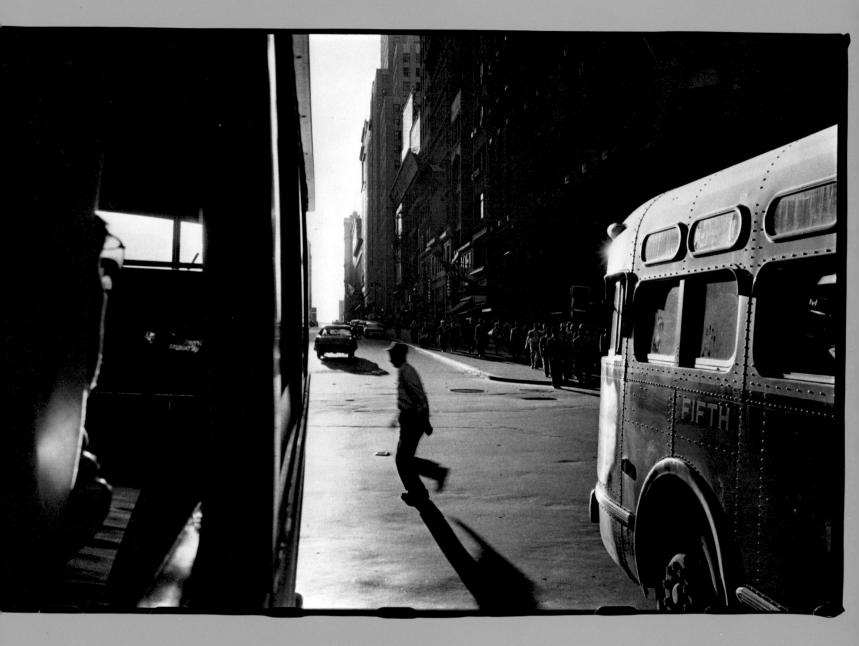

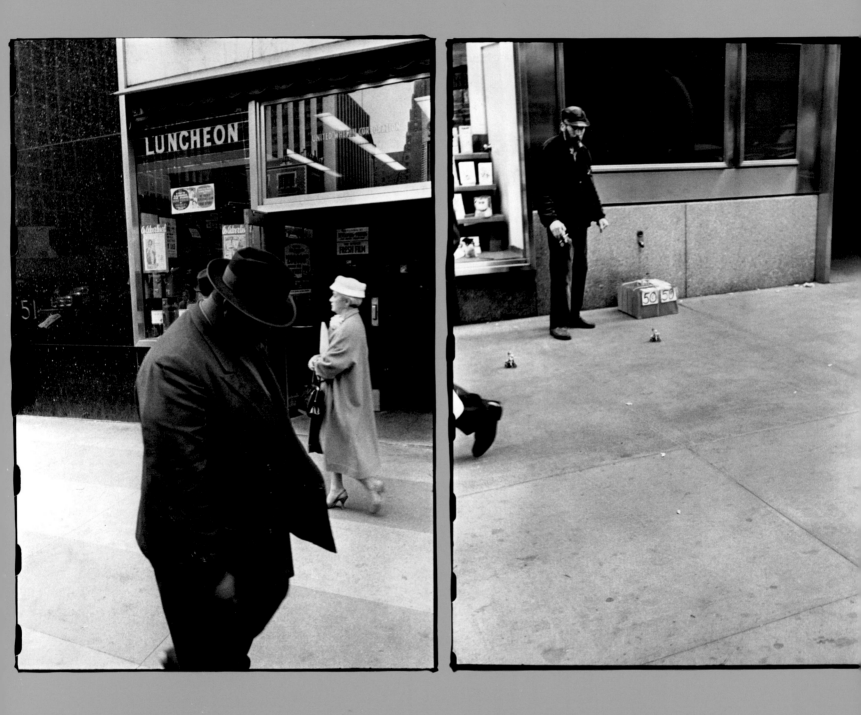

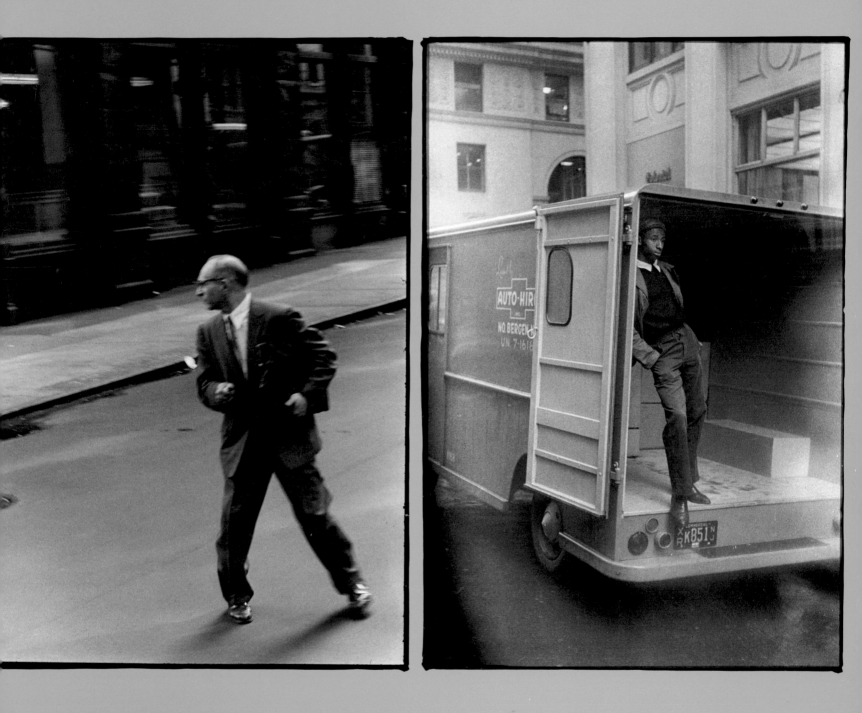

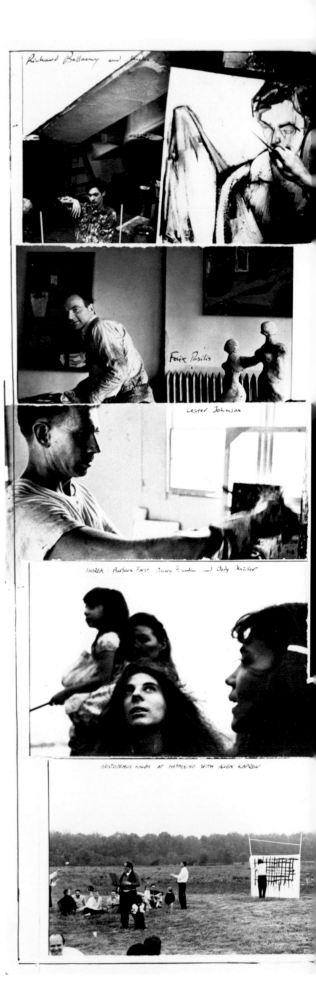

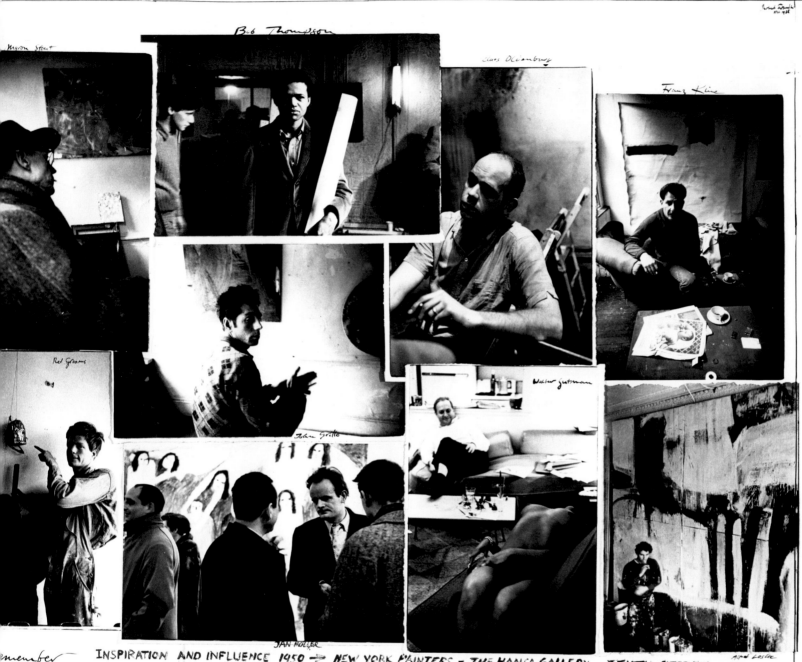

INSPIRATION AND INFLUENCE 1950 → NEW YORK PAINTERS - THE HANSA GALLERY · TENTH STREET LATER ... GINSBERG AND KEROUAC · MORE SPIRIT LESS TASTE · REMEMBER Keep going ...

210 Willem de Kooning, 1961

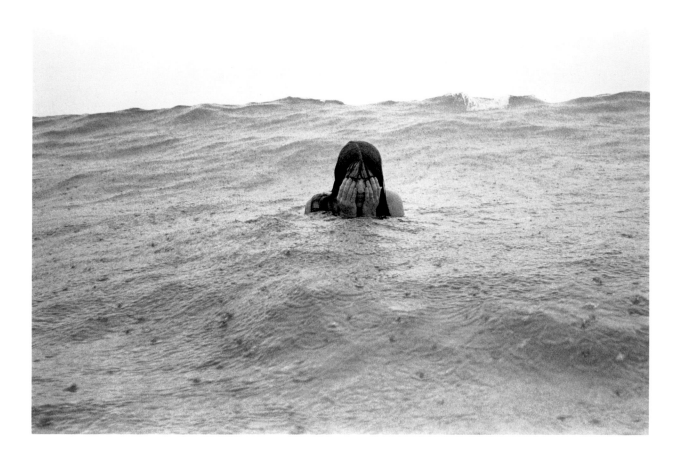

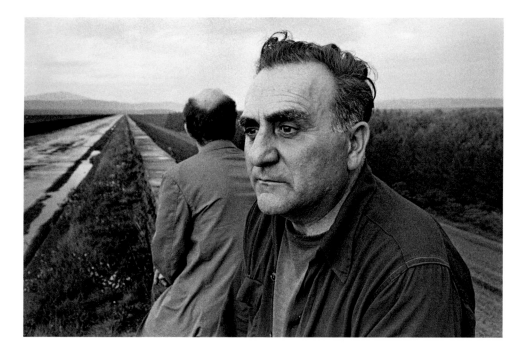

Mary, 1959 **211**
Raoul Hague, Woodstock, New York, 1962

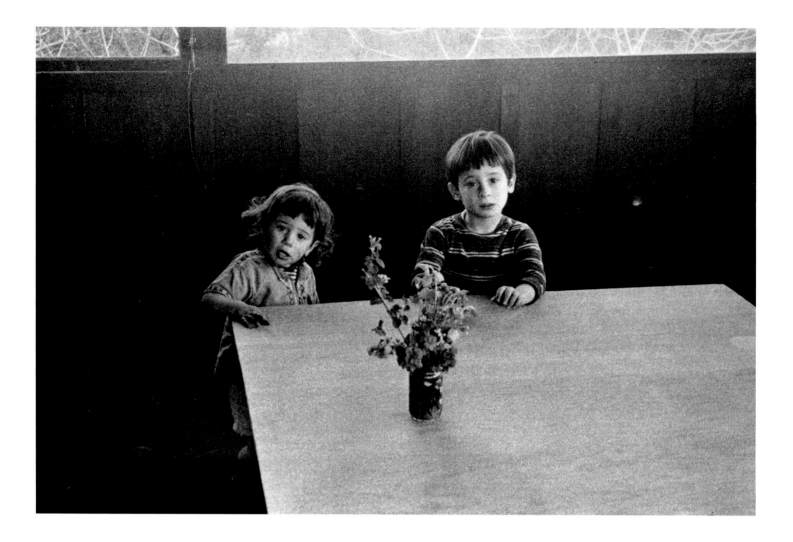

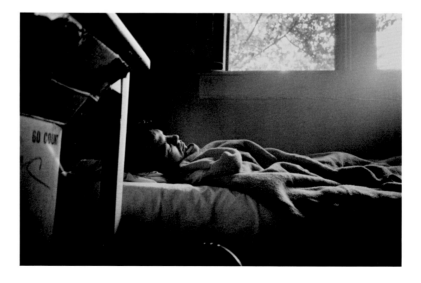

212 Andrea and Pablo, Hollywood, 1955–1956
Jack Kerouac, 1958

Allen Ginsberg, Peter Orlovsky, Kansas City, 1966 **213**

Lucien Carr and Shie

Sheila Sunday April 2 1978 R.f.

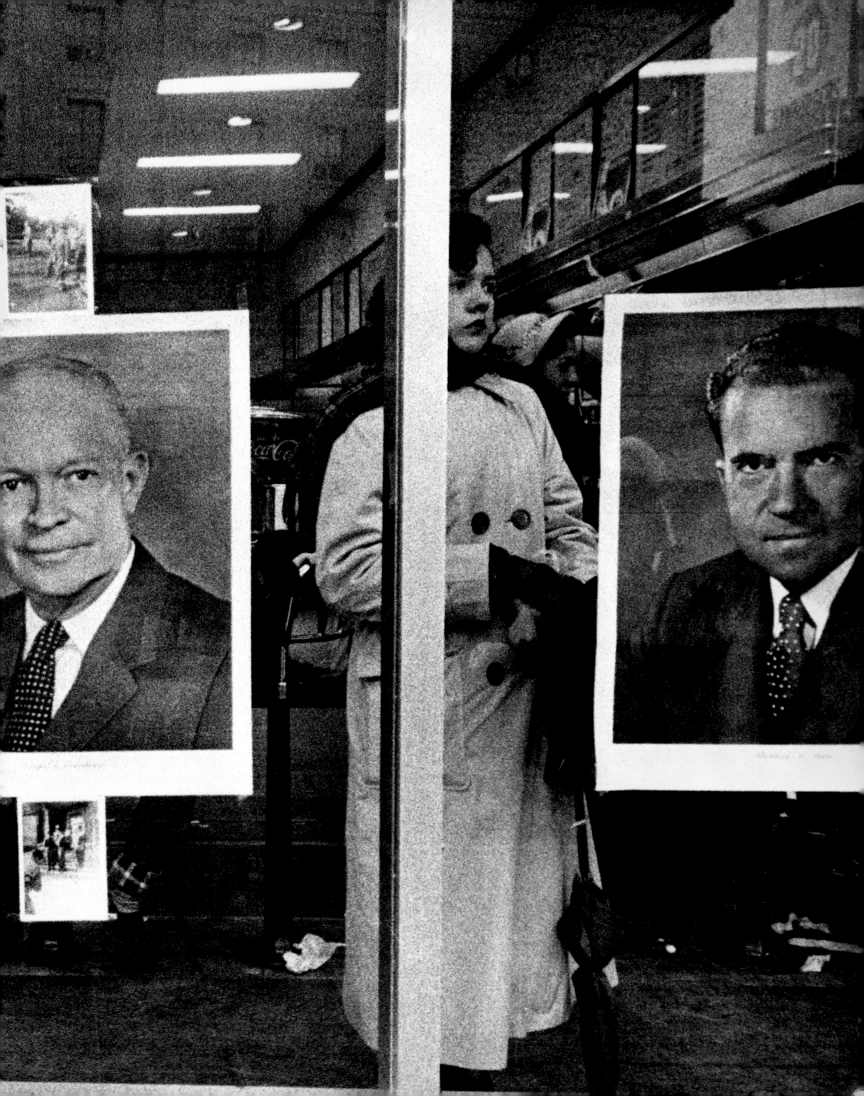

Instead of writing about my films, I will make a film (video)
about photographs leading (me) to moving images.
Fragments of saved up memories—my notebooks filled with
images: names, Heroes, Postcards, language (words) moving
inside that frame. Pushing towards another—scene—
Is there an obsession in these fragments? To reveal and to
hide the truth.

A photograph is fiction and as it is moving it becomes reality.

No sound — subtitles, letters and words.

PULL MY DAISY

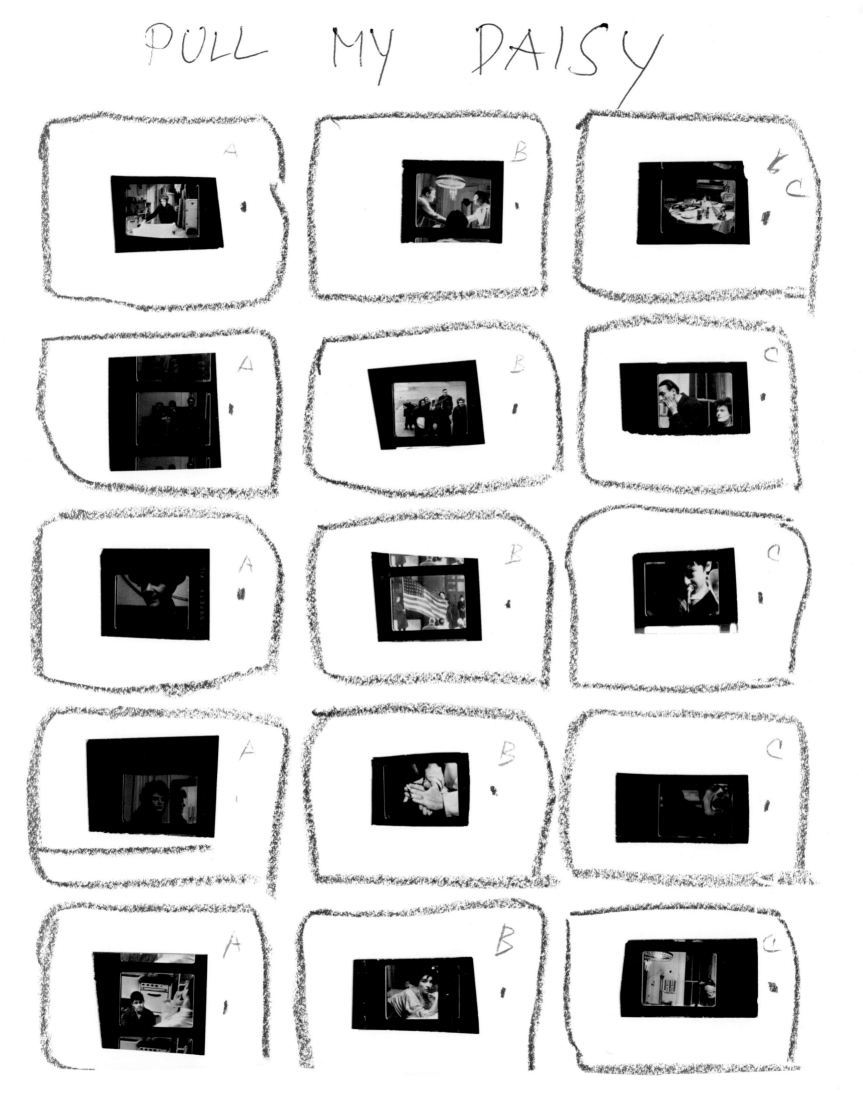

Yes, it's early, late or middle Friday evening in the universe.

Oh, the sounds of time are pouring through the window

and the key. All ideardian windows and bedarvled bedarvled

mad bedraggled robes that rolled in the cave of Amontillado

and all the sherried heroes lost and caved up, and

transylvanian heroes mixing themselves up with glazer vup

and the hydrogen bomb of hope.

<div align="right">Jack Kerouac, Pull My Daisy</div>

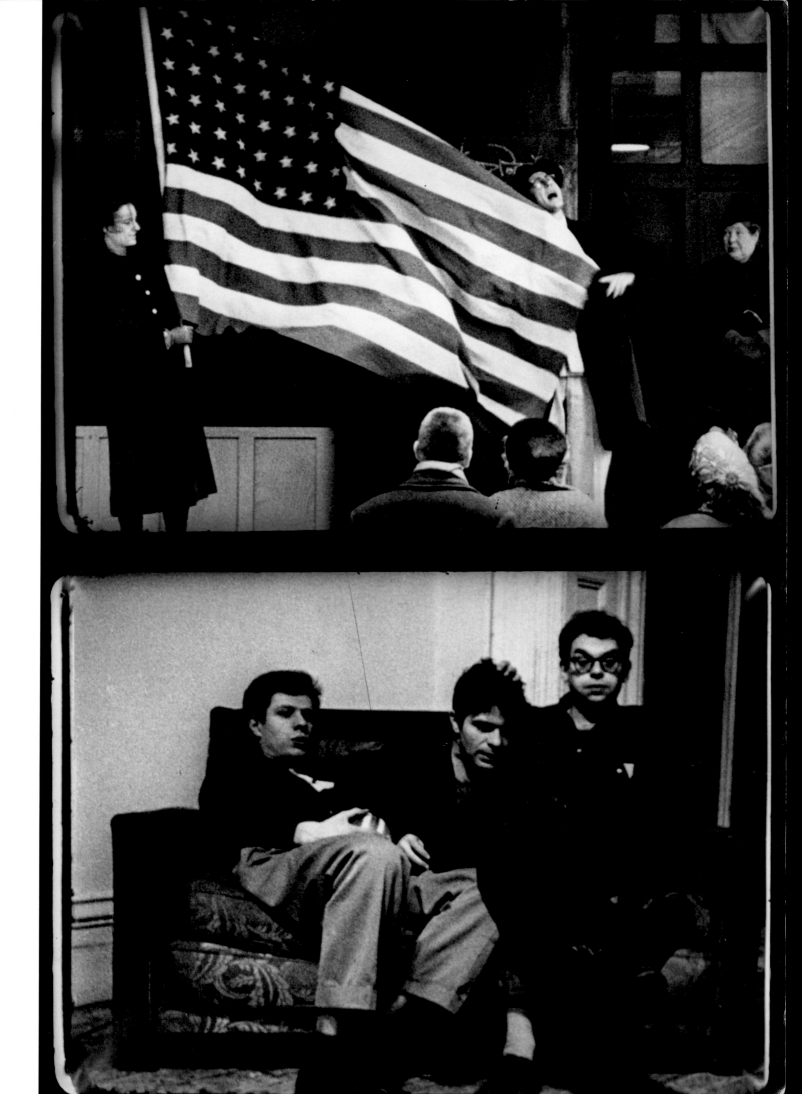

OK, you're a documentary photographer. Or maybe you're like a reportage photographer. You know—that's a strange thing, you know, because like some guy is killing a woman right in front of you—and like—you're taking a fucking picture of it. You're not helping a woman save her life—you're getting a story.

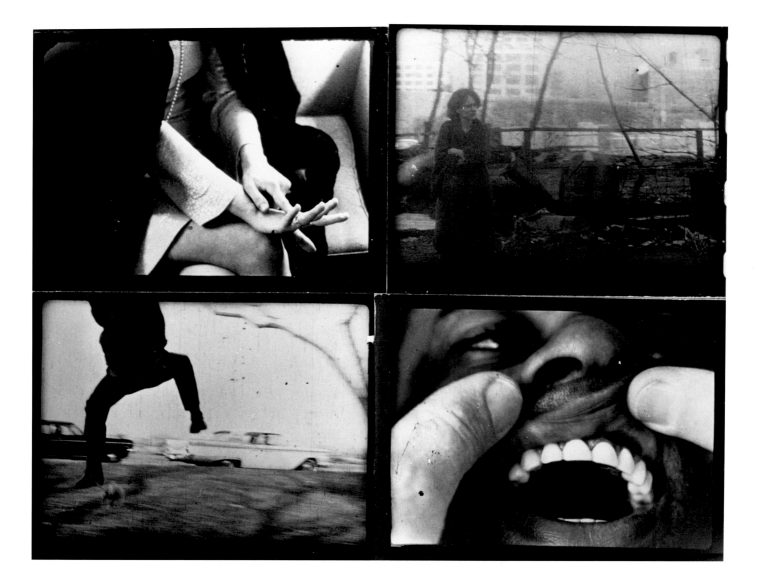

Maybe you're rich or something…with a secret life that you won't tell anyone about—no matter how lonely they are, or no matter how pretty they are—you just won't tell. Doesn't matter—I'll guess. I'll tell you about yourself.

...in that spirit, let me tell you simply and briefly about a man—he is the grandson of a peddler. A peddler who was a proud, honorable and spirited man who left his ancestral country in Europe at an early age. And it is about his grandson that I would speak to you this afternoon, and that grandson's name is Barry Goldwater....

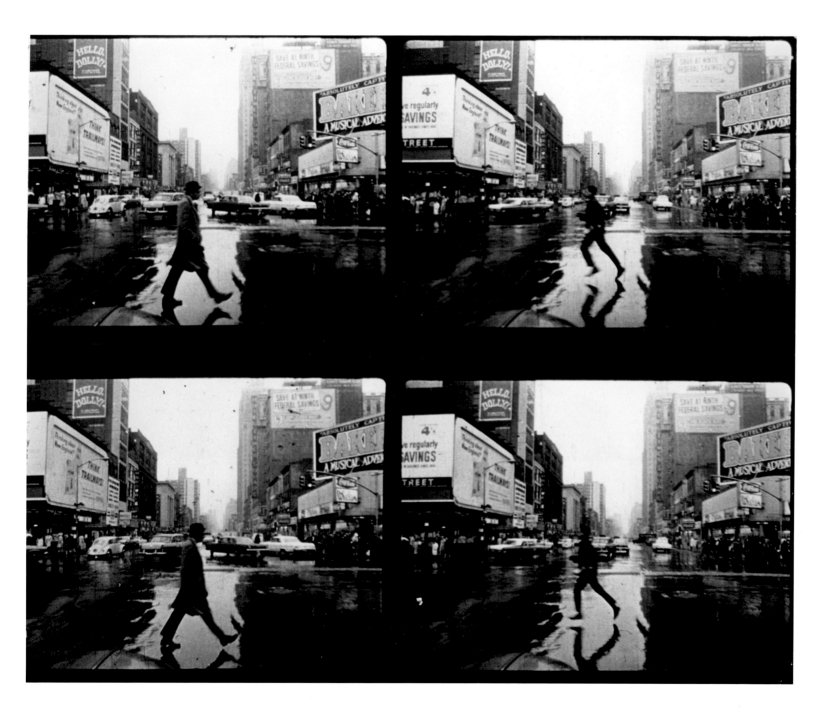

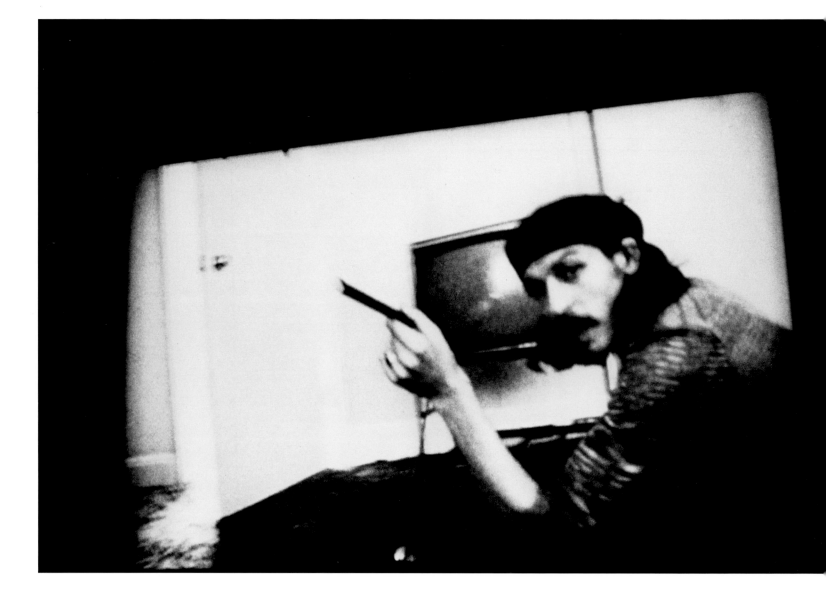

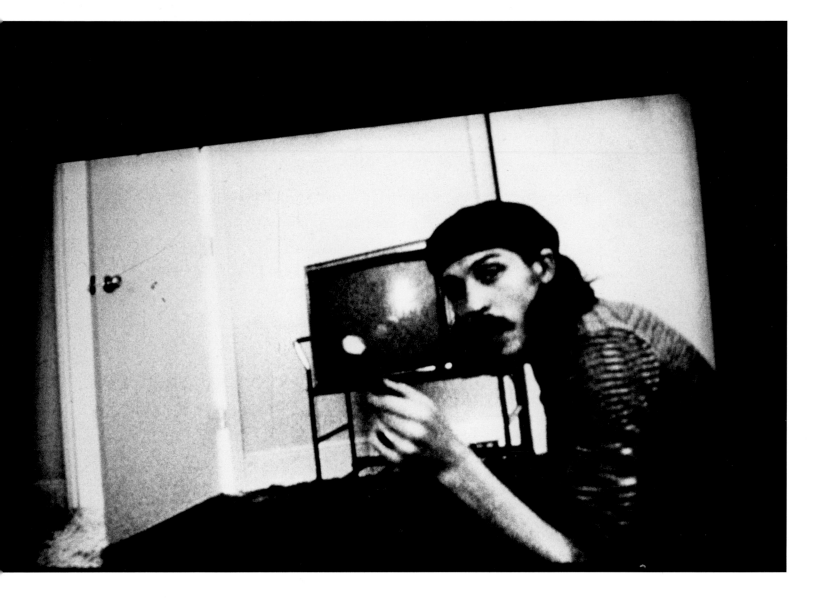

We meet in New York. He is young—crazy about images. We become friends.

Daniel Seymour travels fast. We work together—it ended with Cocksucker Blues. Fate.

And Danny will never return from his last trip. Good Bye.

Robert Frank: The movie footage was shot in just a few days in the school where the children stay in Vermont. Maybe this film is about growing older. Anyhow, it's about the past and the present. It's some kind of family album. I don't know. It's about. . . .

Robert Frank: There, I think the photographs are true. Even if they are sort of corny and sweet, there was something that the parents created by bringing up a child like that.

Pablo Frank: I'm older so now I have more control of what happens. . . . All I can really say is that now I feel the burden of bringing myself up in a way.

Conversations in Vermont

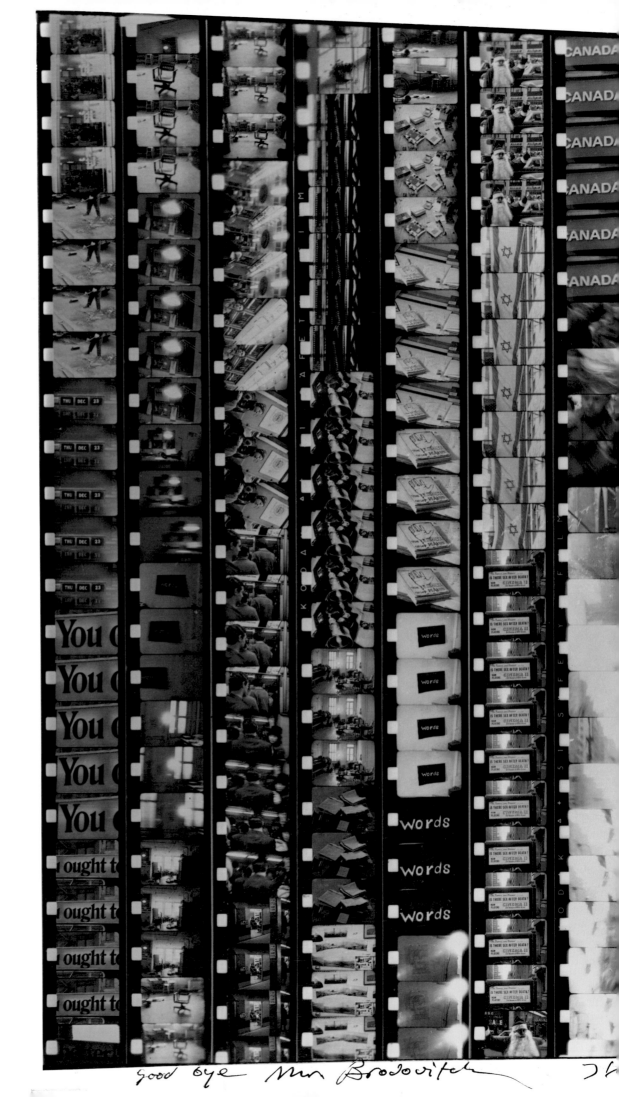

228

good bye Mr Brodovitch

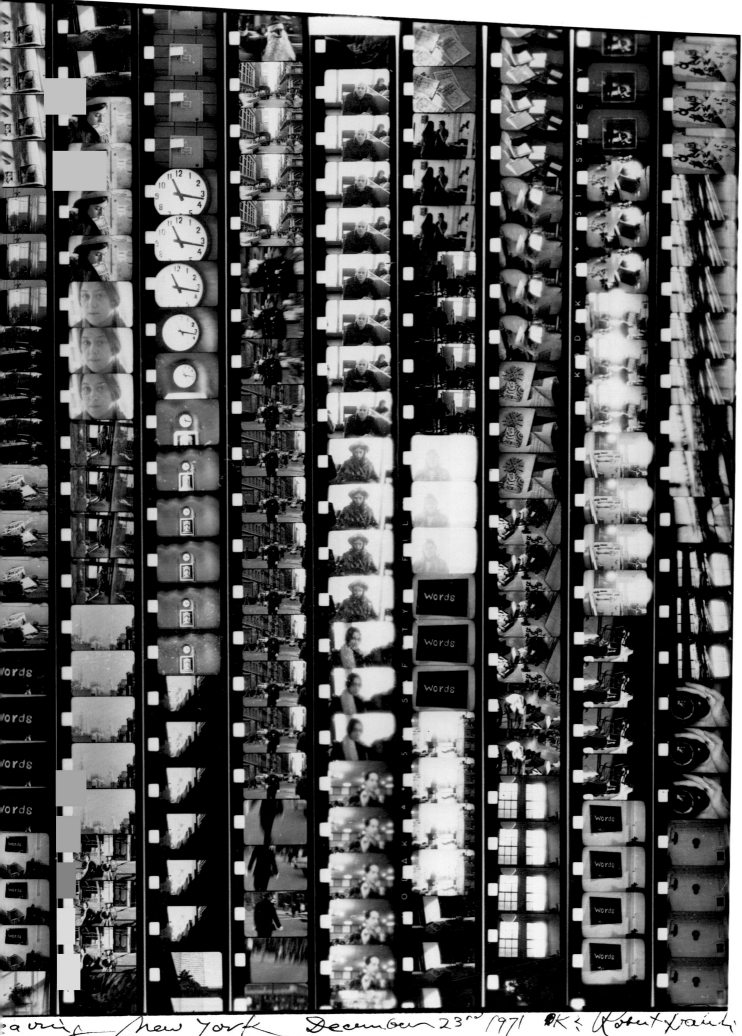

Leaving New York December 23rd 1971 OK: Robert Frank

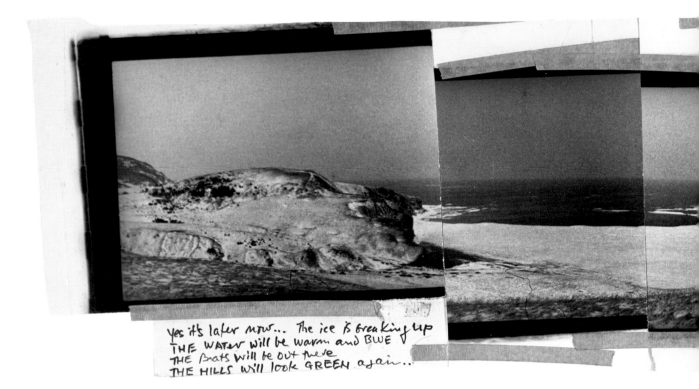

Yes it's later now... The ice is breaking up
THE WATER will be warm and BLUE
THE Boats will be out there
THE HILLS will look GREEN again...

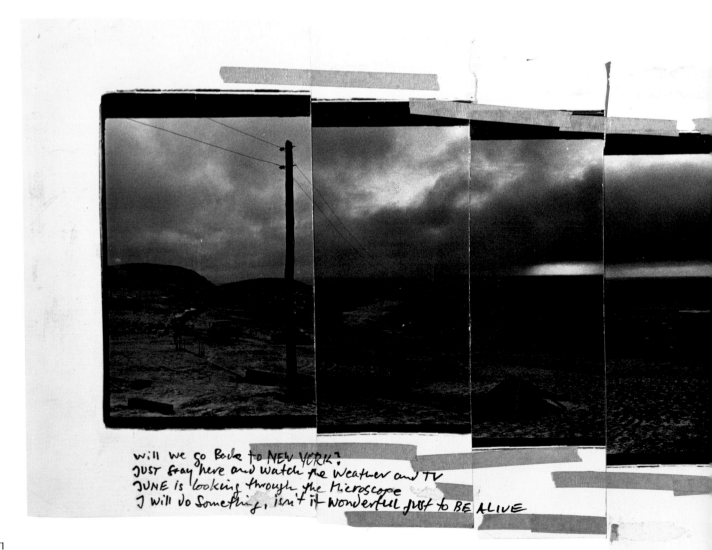

Will we go Back to NEW YORK?
JUST stay here and watch the Weather and TV
JUNE is looking through the Microscope
I will do Something, isn't it wonderful just to BE ALIVE

R. Frank Mabou 1971

Connoisseur of Chaos
The Films and Videotapes

A. A violent order is disorder; and

B. A great order is an order. These two things are one. WALLACE STEVENS

Robert Frank's films represent an intensely personal negotiation of private and public spaces, and the real and imagined worlds he inhabits in his daily life. Randomly unfolding scenes, chance encounters with people in homes and on streets, and shots that include Frank himself articulate the fiction and reality that play off and define one another in each film. In Frank's hands, the camera becomes a powerful means to reflect on his own place in the world.

A current of chaos, the result of Frank's resistance to a formal order, runs through his films. It disrupts the notion of a secure world; in fact, no easy answers, no secure relationships, exist between Frank and the world he records. The uneasiness and struggle that pervade his character are manifest in his art, as is his vulnerability to the vicissitudes of life, his experiences of loss, heartbreak, and happiness. Frank's relationship to the world is fragile and constantly being remade and rethought in many of his films.

Frank's films are informed by ironic reluctance to record what he sees, owing to his fear of the camera's ability to capture its subjects. His questioning of the camera's capacity to secure knowledge and truth is the subtext that permeates his films, as Frank says in *Home Improvements*, 1985. "I'm always doing the same images—I'm always looking outside, trying to look inside. Trying to tell something that's true. But maybe nothing is really true. Except what's out there. And what's out there is always different." Yet Frank is also aware of the strength to be gained in the filmmaking process. The physicality of his cinematography shows his constant battle with the camera, and his evident pleasure in the filmmaking process, mixed with his fear of the same, is revealed.

Through the movie camera Frank comes to terms with the world around him. His films express a temporal flow, revealing his restlessness as he moves before and behind the camera, wandering, for example, through the labyrinth of the city or the wind-swept fields of Nova Scotia. The films also engender reflections on his better-known still photographs. In the films, Frank often manipulates his photographs, or, in the *Home Improvements* video, has holes drilled into them, effacing the photograph as stillness. This process of change violates the defining stability of the photograph, allowing it, like Frank himself, to enter into the flow of life.

The history of the American independent cinema from the 1940s through the 1970s is one of artists fashioning a variety of styles and formal inventions through the medium of film. The result is a body of artistic work that shares in a conscious exploration of modernist aesthetics. Some examples are: Stan Brakhage's creation, through the abstraction of light and color and the belief in the mythic power of the artist, of a filmic world around his family; Paul Sharits' delving into the formal properties of the single-film frame; Ernie Gehr's rigorous exploration of the recorded image as a mediation of formal cinematic principles; and Yvonne Rainer's new narrative, self-reflexive feminist critiques of traditional film praxis. These filmmakers have in common their active inquiry into the epistemology of filmmaking. They accomplish this through strategies that incorporate the idea of the artist's central position in the modernist critique of the properties of the medium; this project sustains itself through formal procedures that center upon the powerful metaphor of the camera as eye, a means to reenvision and thus redefine art.

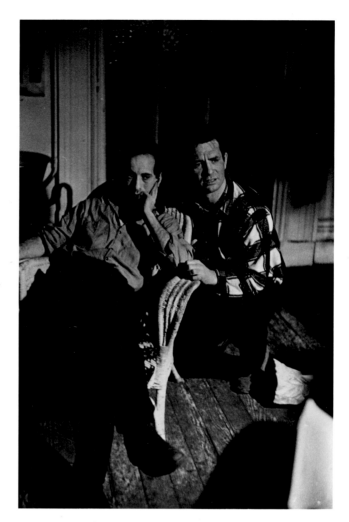

John Cohen, *Robert Frank and Jack Kerouac on the set of Pull My Daisy,* 1959

Frank's movements between his still photography method and those employed in his filmmaking have put him in a precarious space in relation to the art of the independent cinema. *Pull My Daisy,* 1959, created with Alfred Leslie, is his best-known film and the one that defined his relationship to the American independent cinema and film history. Together with John Cassavetes' *Shadows,* 1959, Shirley Clarke's *The Connection,* 1961, Morris Engel's *Weddings and Babies,* 1958, and *The Savage Eye,* 1959 by Ben Maddow, Joseph Strick, and Sidney Meyers, *Pull My Daisy* sparked the formation on 26 September 1960 of the New American Cinema group. The first meeting included twenty-three independent filmmakers brought together by Jonas Mekas and Lewis Allen, producer of *The Connection.*

The New American Cinema group did not identify itself with any aesthetic school and was open to anyone; its manifesto included: "1. We believe that cinema is indivisibly a personal expression. We, therefore, reject the interference of producers, distributors, and investors until our work is ready to be projected on the screen. 2. We reject censorship...."[1] This manifesto laid out for the first time a set of goals that would serve as a model for

future generations of independent filmmakers, increasing their control over production, distribution, and exhibition. Film critics recognized a freshness and immediacy that had not been seen before in commercial cinema, and the media in turn responded positively.

This group of filmmakers engaged in a number of important interdisciplinary collaborations. *The Americans,* with an introduction by Jack Kerouac in the second edition published in 1959, vibrantly expressed the quotidian and the struggle for existence, themes carried over to the film *Pull My Daisy.* Featuring Kerouac's narration and performances by Allen Ginsberg and Peter Orlovsky, this was the key beat film of its generation, with a story loosely constructed from improvised scenes. Its form is a disjointed narrative about a couple and the poets and artists who wander in and out of their loft and lives. The beat sensibility of anarchic fun and self-parody, and of the trickster—the person who disrupts and throws into relief the world around him—inspired *Pull My Daisy's* lively action. In awarding the work *Film Culture's* Second Independent Film Award, Jonas Mekas, linking the attitude of the film to its very look, cited "its modernity and its honesty, its sincerity and its humility, its imagination and its humor, its youth, its freshness, and its truth [which are] without comparison in our last year's pompous cinematic production. In its camera work, it effectively breaks with the accepted and 1000 years old official rules of slick, polished Alton & Co. cinematographic schmaltz. It breathes an immediacy that the cinema of today vitally needs if it is to be a living and contemporary art."[2]

Pull My Daisy's anarchy reflected its production process as well as a particular aesthetic—the spontaneous unfolding of action that is not framed or constricted by a master narrative—that continued to play an important role in Frank's later work. The film's intensity and rawness derive from its directness, which leaves one with the peculiar impression of having seen people acting like themselves, not simply improvising someone else's story. The story bubbles up and dies off as the actors play themselves and explore their real and imagined places in society and in relation to the other players. This exploratory course opens out, as the actors assume and shed roles in the film in the same frenzied manner in which they explored roles in the world outside.

Pull My Daisy is Frank's most public film. Its production and release defined the beat movement and contributed to a redefining of American independent feature cinema; its beat stars, also Frank's friends, continue to play a significant role in his art, as we hear about Kerouac and see Ginsberg and Orlovsky through to his most recent work. The public nature of *Pull My Daisy* coincided with the rise of a new avant-garde. Ten years after its release, it was deemed by the selection committee of Anthology Film Archives an "essential work of the art of the cinema." Founded by Jonas Mekas, Anthology Film Archives was devoted to the idea and ideology of a pure cinema, one of poets unmediated by commerce and, like the modernist poetics that it celebrated, one that canonized the avant-garde. Today the idea of the avant-garde is an historic moment, a part of the unfolding discourse

of an aesthetic that sought within its romantic origins and self-reflexive materialism a means to fashion a utopian present in the cinema world.

Robert Frank's position within the discourse of avant-garde film is that of an outsider, even though his fame as a photographer has resulted in the placement of his films in the category of the avant-garde. His early, radical improvisations, such as *Pull My Daisy*, certainly aided in positioning him within that ideology of both improvisation and films about artists. In his later films he resisted the idea of film as art for art's sake; rather, Frank sought an ethical redemption within himself and among family and friends, and the movie camera served as his witness. His cinema is against a purely aesthetic theory; it does not look to lofty ideas to hold it together. Instead, his camera cuts across a shifting terrain of personal experiences and interests. Also definitive of Frank's films is his movement between genres, from story-telling to documentary, as well as the constant challenge he places up on himself to record on film what he experiences in life. His work thus does not find itself easily categorized within any single genre of filmmaking strategy. Rather, a restless movement in Frank's filmmaking exposes his vulnerability and belief in people. The narrative quality derives from the recorded conversations with family and friends, binding Frank's life and art together.

The continuities of family and friendship, together with the worlds of both strong and vulnerable beings, complete Frank's cinematic vision. In our post-humanist age, which proclaims the death of modernism, Frank clings to a belief in the enlightening nature of art and community, and he expresses a belief in the shared dialogue of community, the supportive public sphere in and through which he moves and which his art articulates. His films testify to his convictions about the recuperative power of art and the idea of the avant-garde's ability to rebuild and shape the self and society. And yet, even within that history and the modernist/humanist project, Frank is a solitary figure who clearly is not at ease with the art world's historical categorization and the fellowships of the marketplace that it breeds. Frank's integrity and the honesty with which he treats his vision do not support that classification.

Frank's photographs, films, and videotapes move toward the quotidian. The films frame his passionate attachment to reality, a dedication that inevitably implies contradiction: "In this film all events and people are real," says Frank in *Me and My Brother*, 1968, "whatever is unreal is purely my imagination." Frank's method of laying the imagination at the service of the real and his constant oscillation between fiction and documentary are allowed by a poetic license that finds its perfect expression in the art and ideology of the beats. Through an improvised poetics of the search for a new life within the distinctly American terrain of both the western landscape and the urban metropolis, the beats articulated a belief in a *communitas* of the spoken word. *Pull My Daisy* pulled together those strands of friendship and creativity embodied in the social ideal of the artist. In it, the

largely static camera frames a story of artists and poets searching for freedom. Jack Kerouac's narration expresses Frank's belief in the vernacular of local speech as public knowledge. *Pull My Daisy,* like *Me and My Brother,* is constructed around the beat lifestyle (the patron saint of which is Kerouac) and its rebellious belief in language and the restless spirit of the artist. This was a world that Frank was to explore with his movie camera as he traced his own movements through a network of personal friendships, which parallel his emergence as an artist.

One of the most compelling issues explored in Frank's films is that of the self as artist seeking to shape one's life—a quest we all embark upon in one way or another. Robert Frank, the connoisseur of chaos, looks to record and represent that quality of disorder that exists in all lives, no matter how orderly they may appear. *Pull My Daisy's* action is centered around the idea of being an artist and free; the film is a poignant celebration of the beat lifestyle and anti-aesthetic philosophy. The representation of beat poetics appears as well in *Me and My Brother,* a partially scripted work, centered within a more jagged, less fixed cinematography. In this film, the idea of being an artist becomes a meta-framework; it is a film about the making of the film and artists as outsiders in society.

Later, Frank's films become more intensely personal and improvisatory; in *Life Dances On...,* 1980, for example, the filmmaker is on the streets of the Lower East Side where, in a memorable scene, he and his friends encounter a group of college photography students who are asked to name important photographers. Here, the now historical person of the artist begins to emerge in the playfully asked questions regarding his identity and public recognition. In the beginning of *Life Dances On...* we observe the artist with his daughter Andrea and friend Danny Seymour. This work is vivid in its exposure of the vulnerability of the artist's feelings. In a similar vein, Frank's videotape *Home Improvements* opens with a birthday celebration for Frank, and then the setting shifts between Nova Scotia and New York. The work is marked by the dialogue between Frank and his wife June Leaf as she battles illness; he also inscribes into the video the story of his son Pablo's illness and, in doing so, what family and friendship mean to him. His direct engagement with the image through the struggle with framing and focus, the use of zoom shots, and the discussion about what one is looking at, all layer the process of negotiating one's environment with a distinct perceptual awareness. We sense that the artist is looking through the camera to see his life better; this is enhanced by Frank's commentary, further reflecting upon what he sees.

C'est Vrai! (One Hour), 1990, is a continuous, unedited videotape commissioned by a French television station. The action is choreographed movement through New York's streets, real and imagined, acted and improvised upon by a kaleidoscope of people from Frank's past (Peter Orlovsky, Taylor Mead) as well as Frank's young friends. As in all his films and photographs, Frank struggles to capture life's intense moments. Yet a sort of

resistance lingers in his work; one young friend wonders aloud about the path the work is taking. Peter Orlovsky, a gray-haired beatnik in the subway, strains to entertain, understand, and shout back at the world around him. *C'est Vrai! (One Hour)* replays the idea of a pure cinema, direct and engaged, and yet, as Frank knows, it remains artificial and constructed despite his efforts to break down its form.

As the great modernist poet Wallace Stevens so perfectly stated, "I am what is around me." Frank is what is around him. His photographs, films, and videotapes are not "statuary posed for a vista in the Louvre. They are things chalked on the sidewalk so that the pensive man may see." That "pensive man," perhaps Robert Frank, may see himself as an eagle afloat for "which the intricate Alps are a single nest." For Frank it is his world, our shared world, that is his nest. He is engaged in a constant artistic struggle to understand. His restless quest for answers amid life's chaos provides its own and unique sort of shifting order, and his films, which exist on the margins of traditional film history, are a vivid expression of the creative drives and desires of artists. These films, like his life, dance on.

Notes

[1] "The First Statement of the New American Cinema Group," in *Film Culture Reader*, ed. P. Adams Sitney (New York: Praeger, 1970), 81–82.

[2] Jonas Mekas, "Appendix: The Independent Film Award," in *Film Culture Reader*, 424.

I hope to write to you

again—when the clear view

the cool air have improved

my feelings

Mabou 1977 Robert Frank

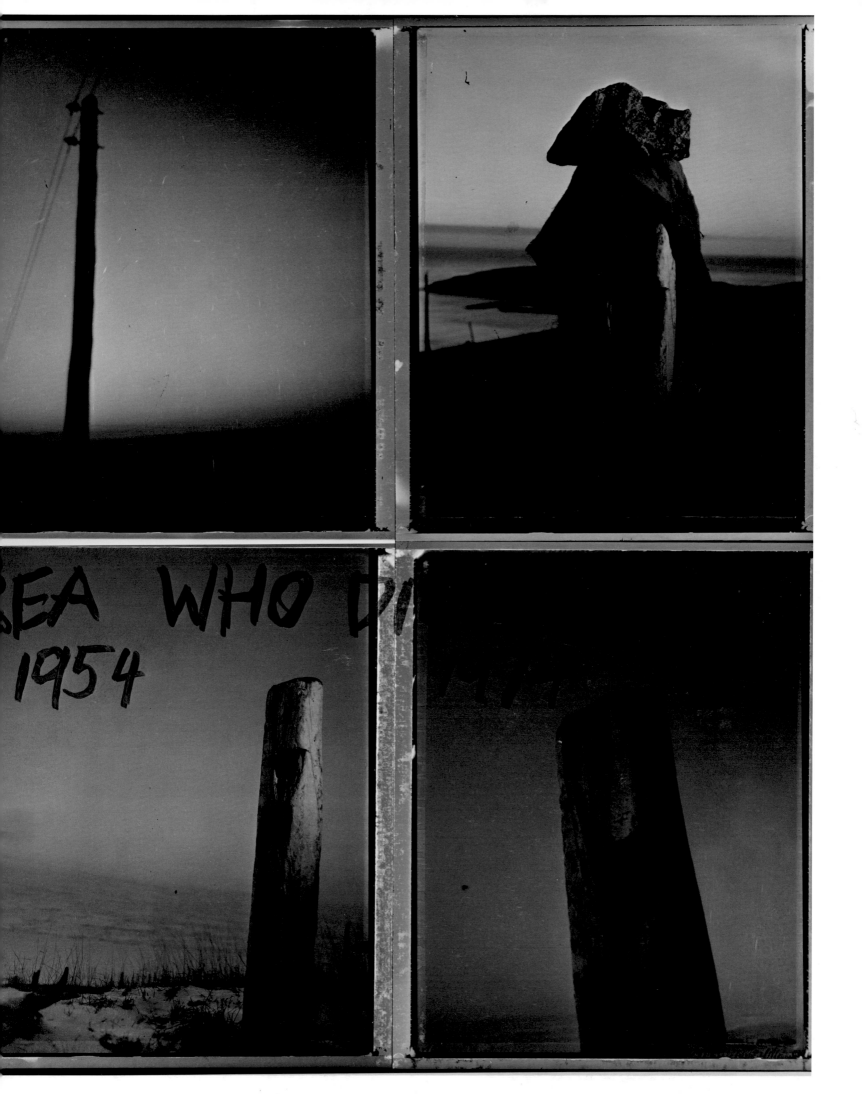

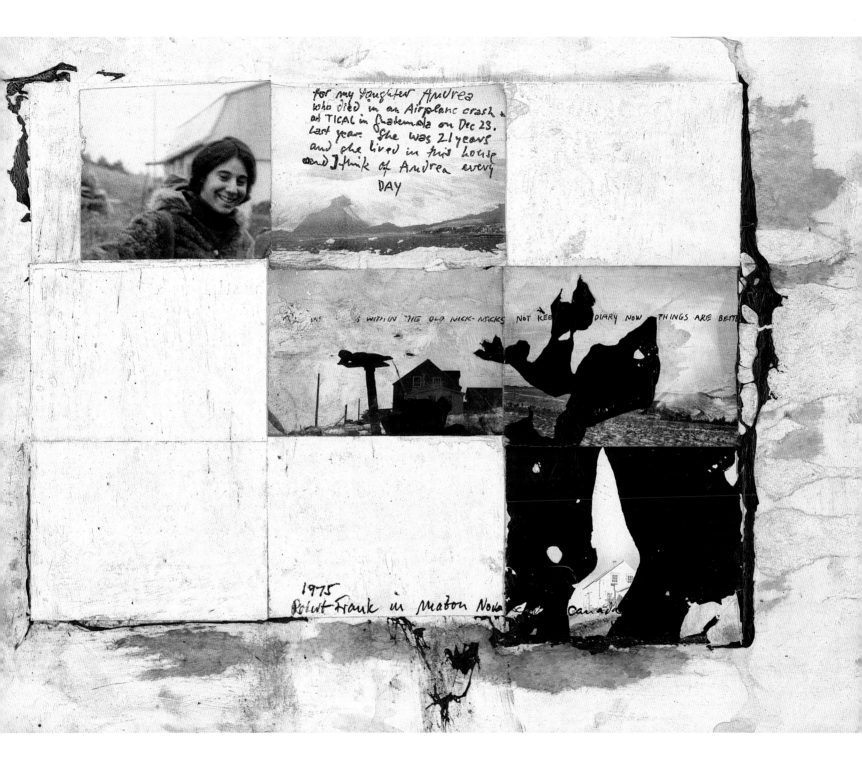

for my daughter Andrea
who died in an Airplane crash
at TICAL in Guatemala on Dec 23.
Last year. She was 21 years
and she lived in this house
and I think of Andrea every
DAY

...S WITHIN THE OLD NICK-NACKS ...NOT KEE... DIARY NOW ...THINGS ARE BETT...

1975
Robert Frank in Mabou Nova ... Canada

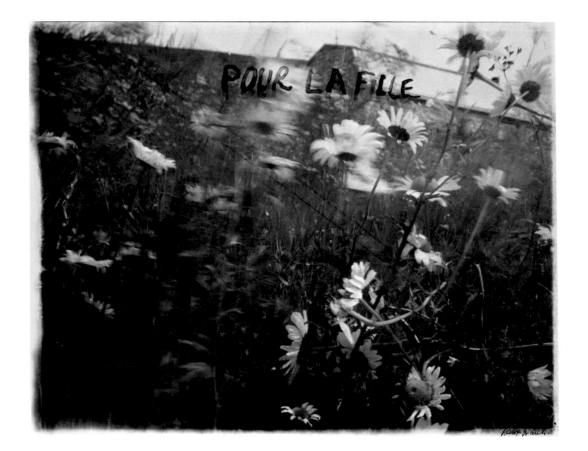

244 Zoe, Juin 21, 1980
Look Out For Hope, Mabou — New York City, 1979

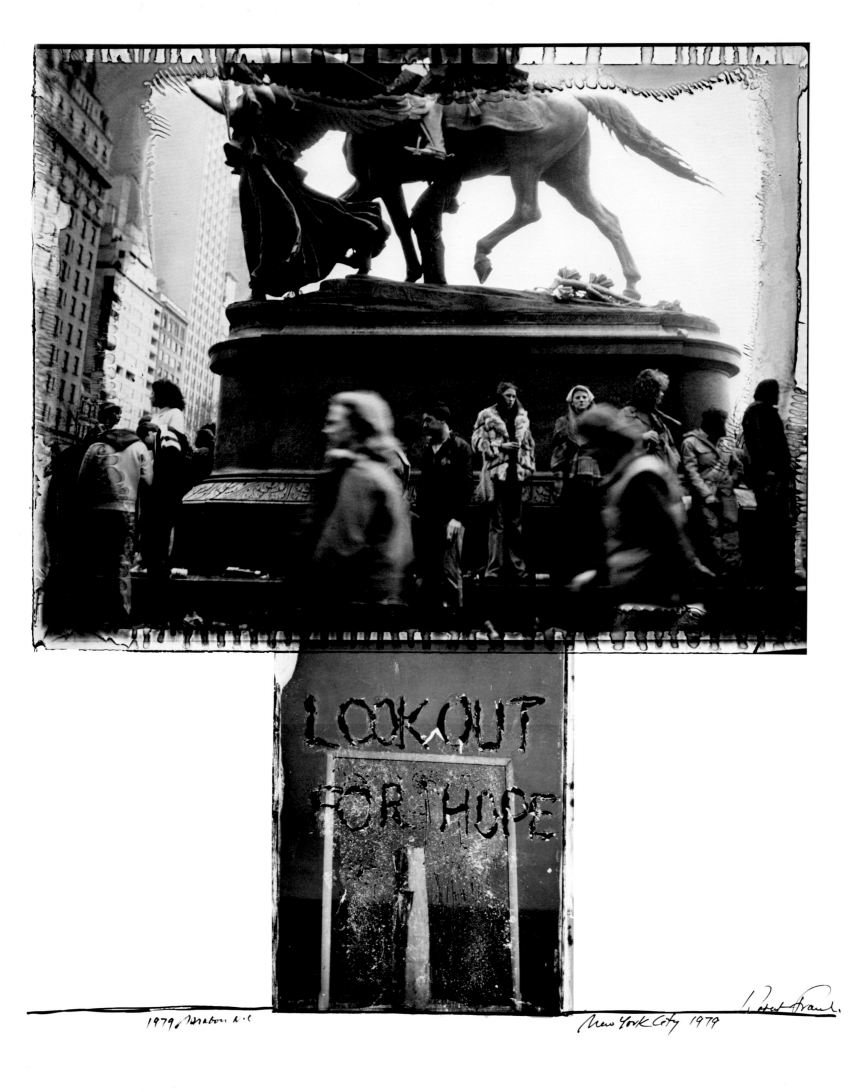

1979, Mabou N.S. New York City 1979 Robert Frank

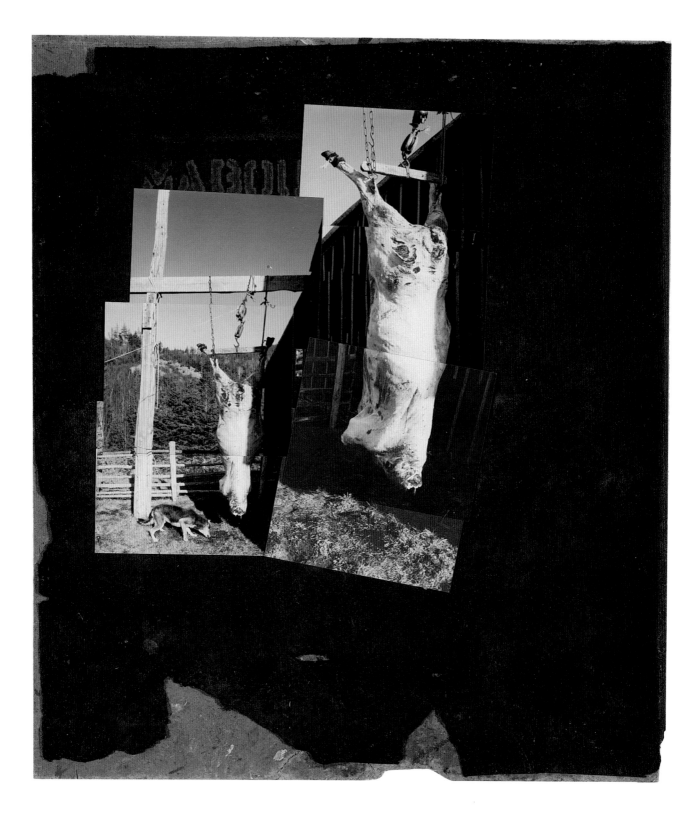

246 Mabou, c. 1976
Giles Groulx, Mabou, Nova Scotia, 1978

Gilles Groulx

Gilles Groulx Visite May 30 1978
Mason

In Mabou—Wonderful Time—With June, 1977

Enjoy each minute to the fullest

IN MABOU
WONDERFUL TIME
WITH JUNE
yours truly
Robert Franck.

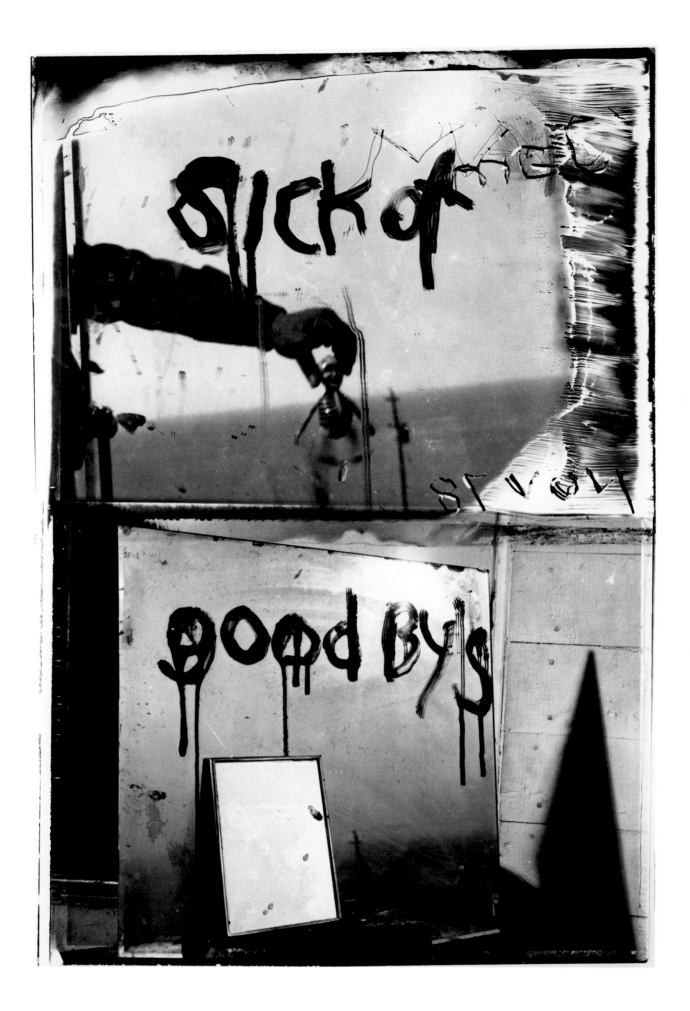

252 Halifax Infirmary, 1978

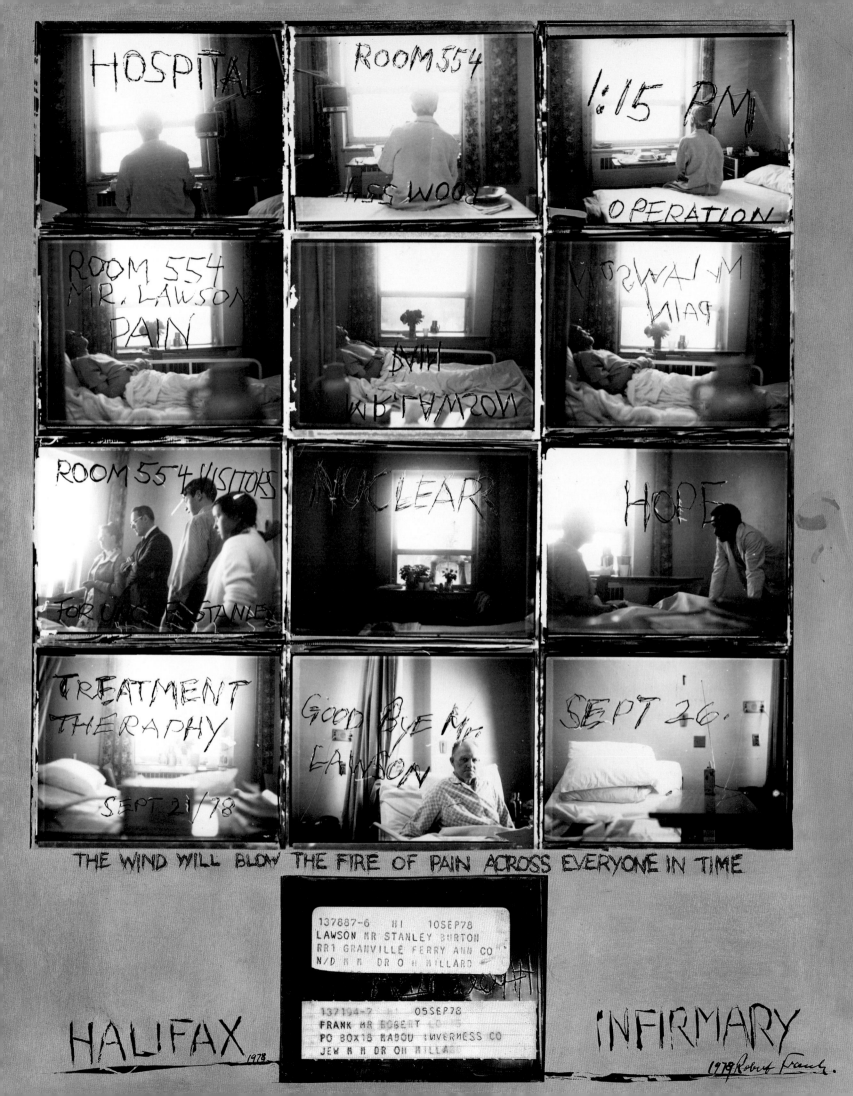

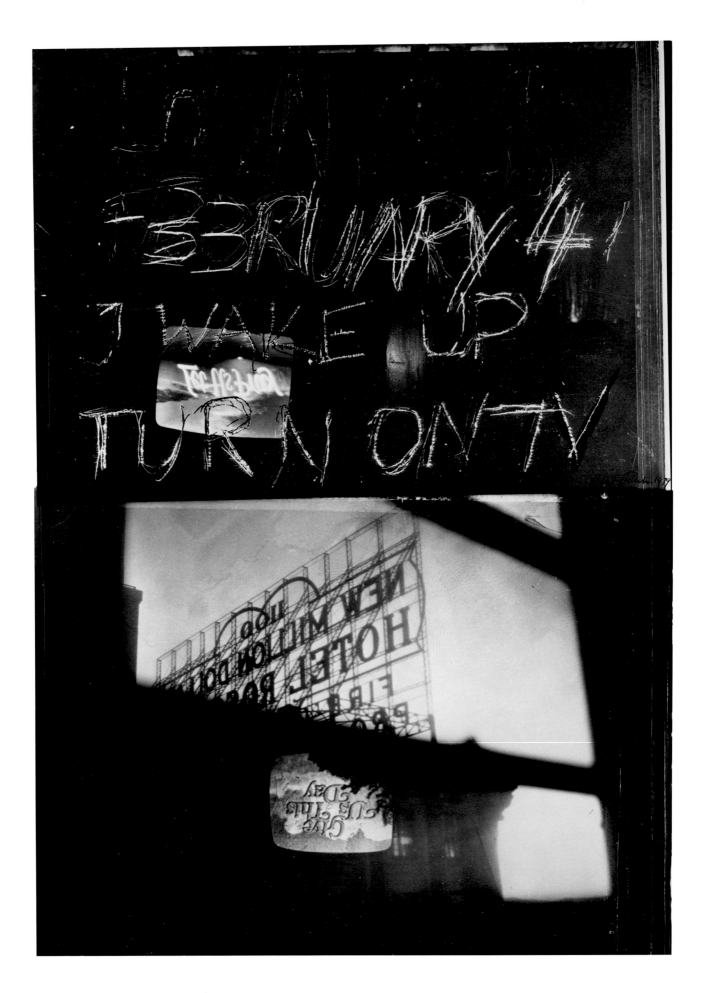

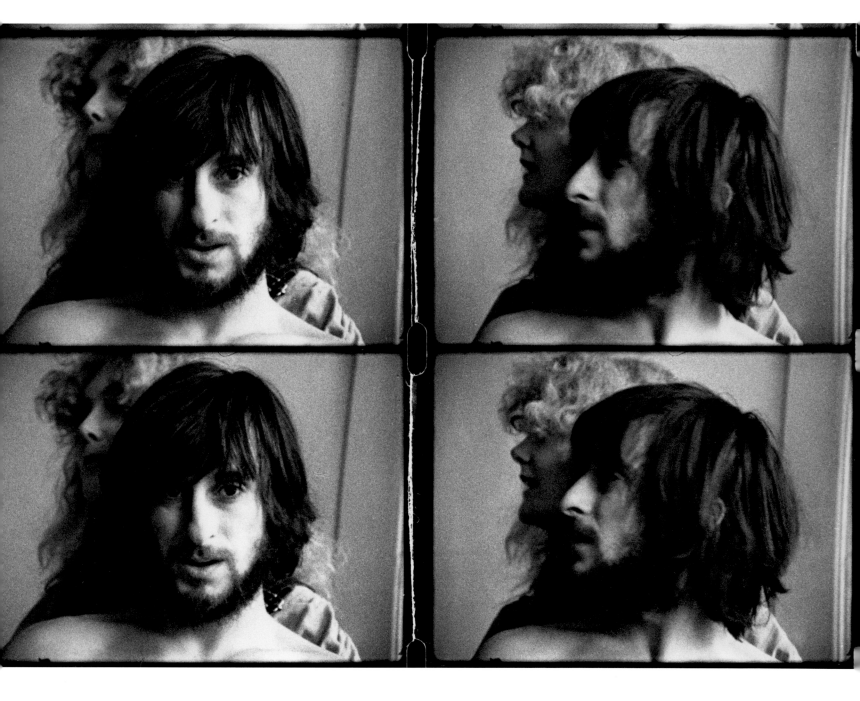

Pablo and Sandy, Life Dances On..., 1978 **255**

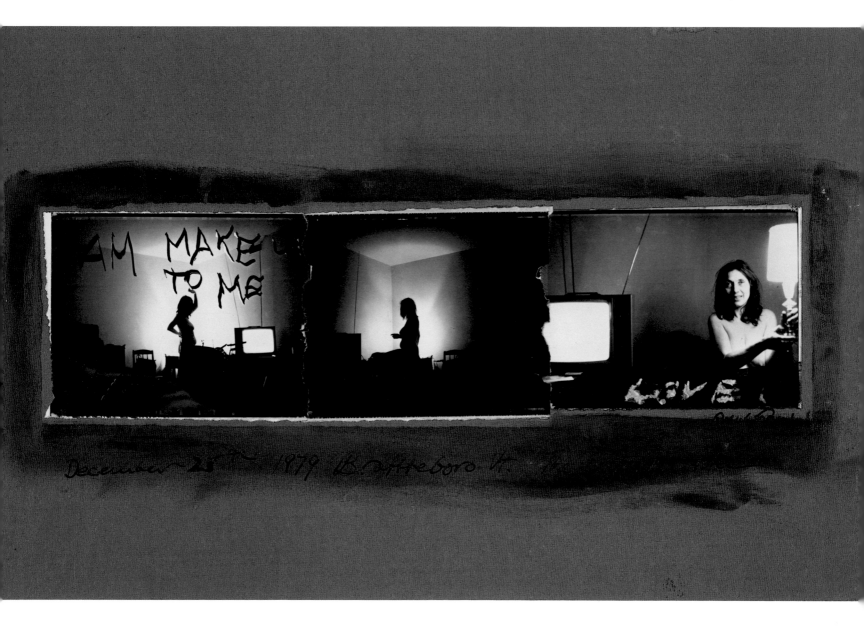

December 28th 1979 Brattleboro Vt. ...

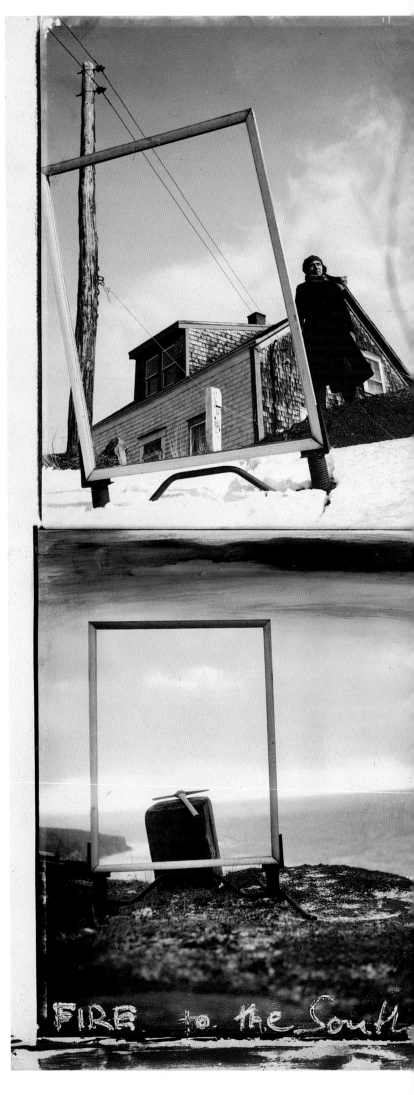

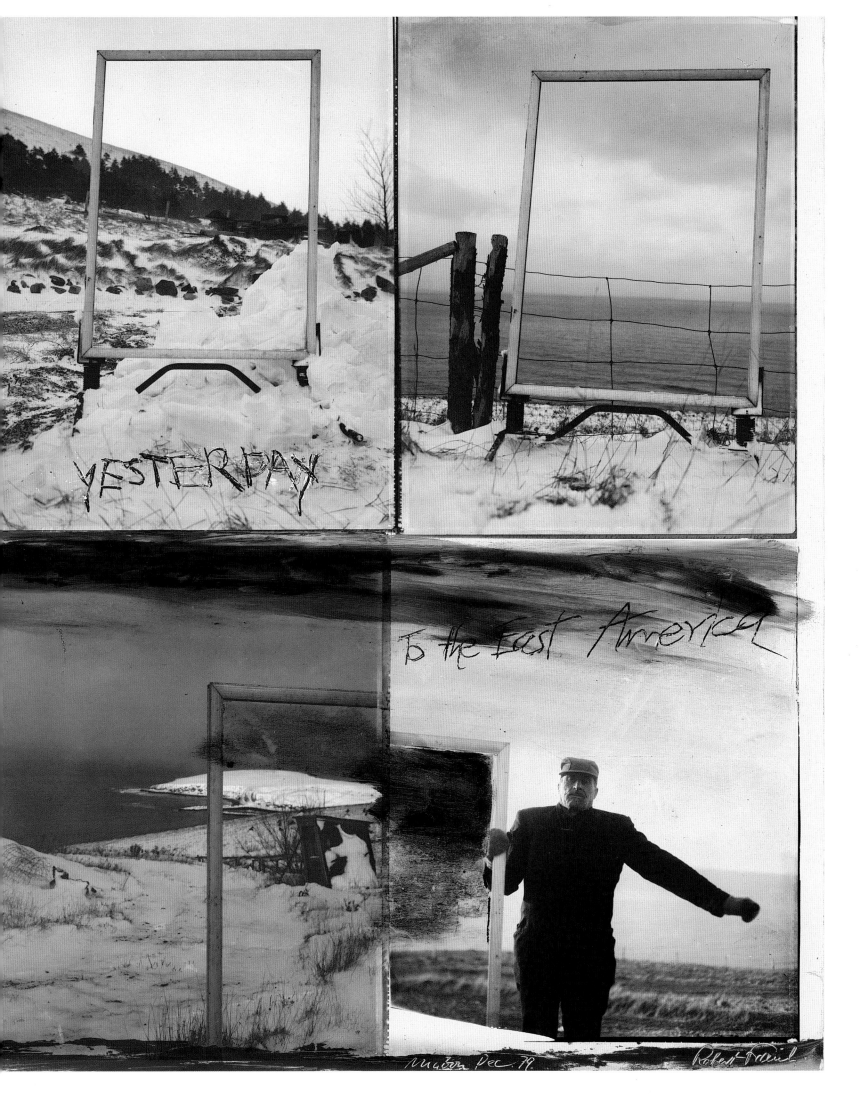

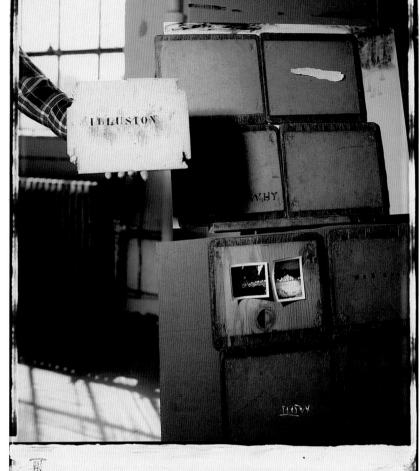

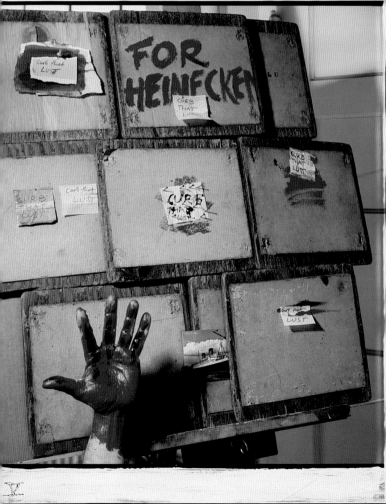

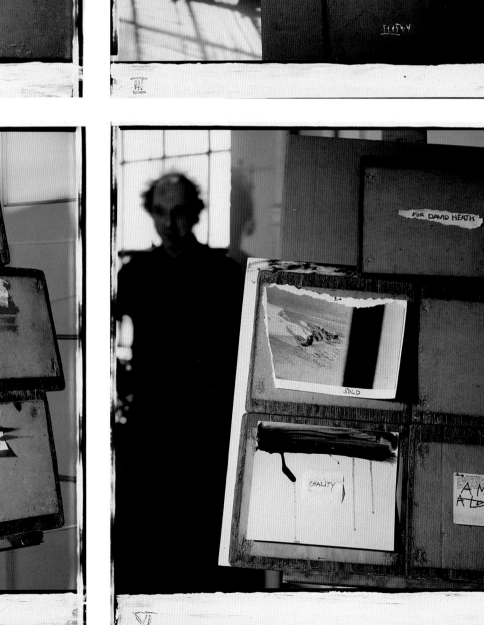

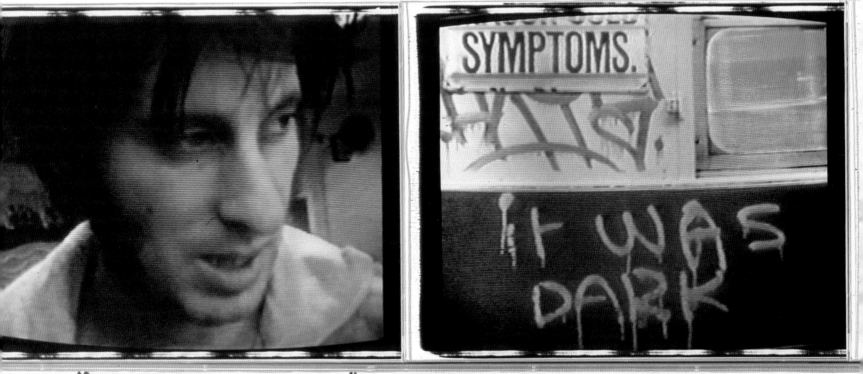

"HOME IMPROVEMENTS" — PABLO FRANK NEW YORK SUBWAY

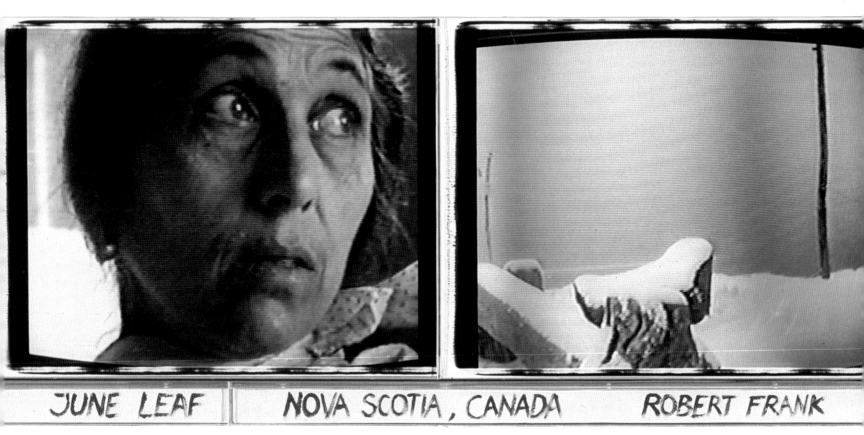

JUNE LEAF | NOVA SCOTIA, CANADA | ROBERT FRANK

"HOME IMPROVEMENTS"

It's just another title, End of Dream.

But these words mean what they say. It concerns time done and served.

I left New York City in Dec. 1971. Said good bye to Mr. Brodovitch.

I was going to make a new home in Mabou, Nova Scotia.

Then you find out that your vision was a dream.

Every year the ice melts, the winds and tides take the

broken up pieces out to sea. It is also the portrait of a man waiting

for another spring another spring another vision...another dream....

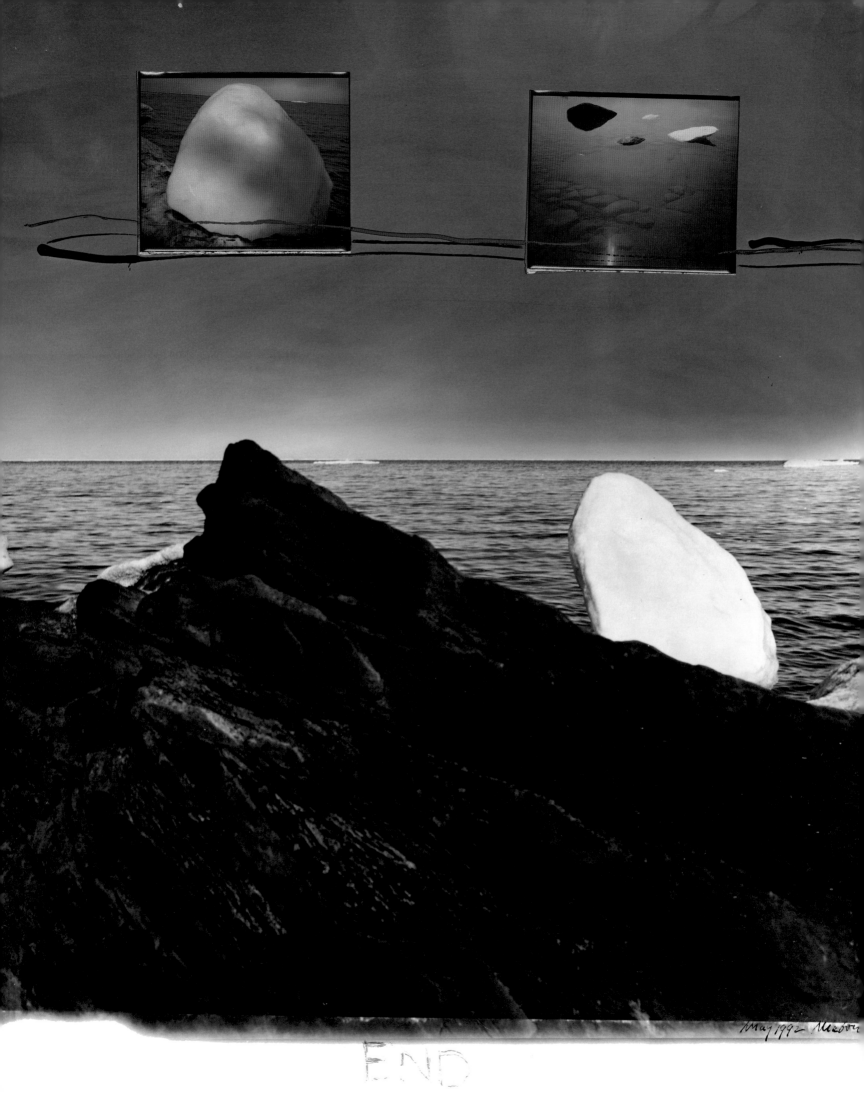

May 1992 Meadows

END

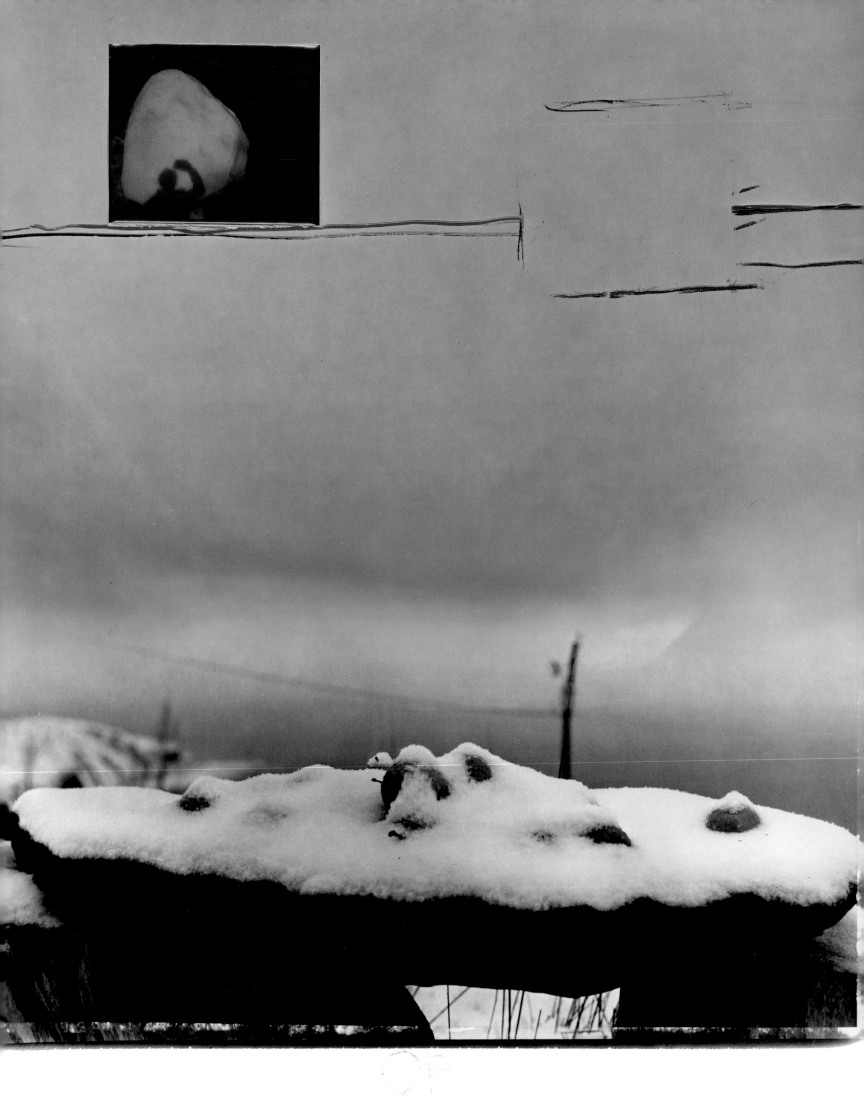

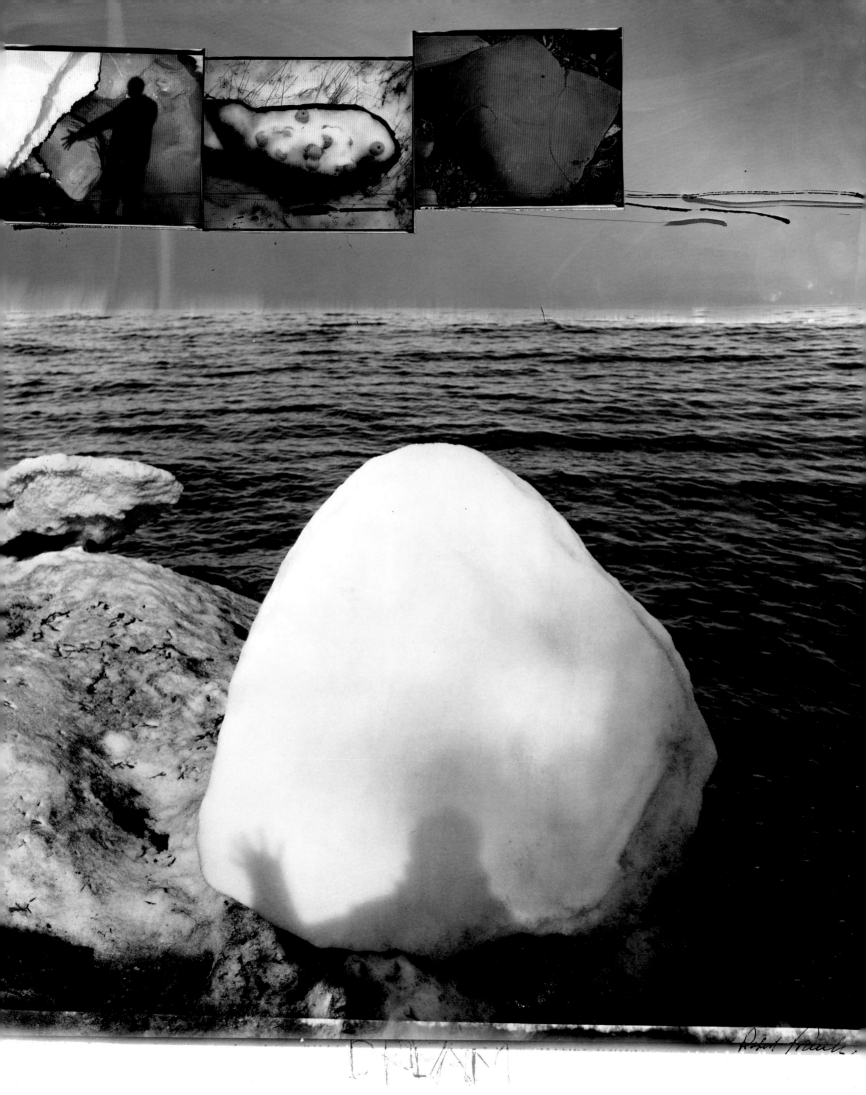

DREAM

Robert Frank

Hold Still—Keep Going
The Later Photographs

In the introduction that he wrote for an American edition of his poems in 1920, D. H. Lawrence espouses a kind of poetry that has since become familiar to all of us.[1] Lawrence argues that traditional poetry has been of two types, what he calls poetry of the future, prophetic and ethereal, and rich, heavily textured poetry of the past. Both are crystalline, complete, finished, and infused with a sense of the eternal; formally exquisite, symmetrical, balanced, densely harmonious, made of "perfected bygone moments [and] perfected moments in the glimmering futurity." Against these, Lawrence advocates a poetry of the present, where there is "no perfection, no consummation, nothing finished." It is a poetry imitative not of a perfect, classic moon shining in a clear sky, but of the moon on the waters, wavering and trembling uncertainly on the tide. Such poetry registers the flashing feeling tones of the moment without regard for the judgment of eternity, and its finest instrument is free verse. Its essence is plasmic, and its passion is for immanence, not transcendence. "It has no satisfying stability," Lawrence says, "satisfying to those who like the immutable."[2]

These remarks extend beyond poetry to include changes that had been taking place in all the arts early in the century. By the time Lawrence's essay had been published, photography had already become the most available medium for catching the quick of the moment. It evolved, however, very much within traditional aesthetic definitions, the same definitions Lawrence was challenging. Beginning with the early experiments of William Henry Fox Talbot and the exalted views of Carleton Watkins, Francis Frith, and other pioneers, photography experienced a kind of fast-forward development out of an ancient matrix; it first had to recover and reprise, in very short time, a poetics of eternity before it could take up the modernist work of making a poetics of process and mutability. Even early brilliant street photography like Eugène Atget's had an aura and charm of the consummate, which was challenged by image makers such as Alfred Stieglitz, Walker Evans, and Dorothea Lange, who helped to introduce new destabilizing impurities into the older poetics of perfection. Robert Frank's first major contribution as a young artist was to make photographs that were the sort of instruments of the present that Lawrence had anticipated. His particular achievement in *The Americans* was to break down the classicizing tendencies of straightforward photography (still visible certainly in the work of Evans) and drain them of the residues of eternity. In formal terms, the moon upon the waters claimed his passion more than the object in the sky. Ironically, by the end of the 1950s he had forged a style that itself would become conventional, with a consummate finish of its own.

In creating a true photography of the present in *The Americans* and the work that preceded it, Frank unintentionally made himself into an exemplar or classic case. For all its non-idealizing intent and its nonchalant disdain for transforming a supreme instant into a beautiful image, his work from the 1950s became a kind of historical shrine. Frank could not have foreseen that cultural circumstances would proclaim him a master for having made images that pulled down conventional notions of mastery. And so he faced a choice: to settle into the achievement, build on its foundation, and perhaps establish himself as a heroic presence like Edward Weston or Minor White; or dismantle it, break down the achieved style, rattle the perfected imperfections.

Frank is a superb still photographer whose instincts have always run somewhat against the grain of the medium. His great passions are motion and change. Immediately after *The Americans,* he completed another project, the bus series. The contact sheets of that series seem to have been made by someone who wants to be making motion pictures but happens to have a 35mm still camera in his hands. The bus is moving, he is moving, the scene before and around him is moving: Frank seems to be hunting that impossible moment when the stilled instant of the frame leaks into the flow of time. Louis Silverstein, art director at *The New York Times,* said that the bus series was as far as anyone could go with still photography "without losing what are supposed to be basic visual…rules," and that the pictures were a deliberate attempt by Frank "to see how far you could go before you've destroyed the canvas."[3] While Frank did not destroy the canvas, he did abandon it. He spent the next fifteen years exclusively making motion pictures.

In the early 1970s he gradually began once again to make photographs that challenged the sweetly melancholic street style of his previous work and which had a pitch and range of feeling not evident earlier. To viewers whose sense of the possibilities of vernacular photography was shaped by *The Americans* (and whose enthusiastic esteem in its very small way conspired to make Frank into the kind of exalted figure he most detested), the images he has made since the early 1970s are the work of an artist reinventing himself, pulling apart the now conventional precedents he himself established and making them over into an art that is denser, less cozy, and more precarious. This gives rise to a general question: When artists reinvent themselves, what of the past should or must be saved, and what brought over into the new definitions? This leads in turn to more local questions: Why is Frank's late work not as inviting as the early work? Why is its tone so jarringly uneven? How has the artist who seemed so unselfconcious in *The Americans* become so roughed-up by raw self-awareness, and how is that kneaded into the plasticity of the new vision?

For artists, the past exists not only as an archive of experience but, also, as a style. The most intense private history is recovered in the formal structures and contents of images. Even the most finished pictures—a café juke box glowing like a radioactive material; a young couple swooning in a bumper car; a 1950s Cadillac offered like a sacrifice upon

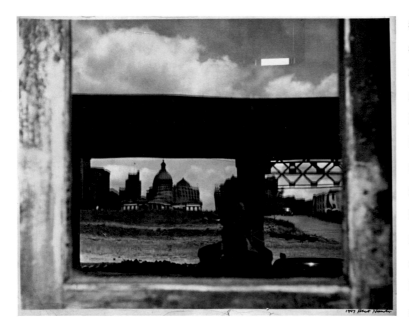

Self-Portrait, St. Louis, 1947

an altar of gleaming concrete—live in an artist's consciousness not as pristine monuments of past glory but as the ordinary materials of daily consciousness. Much of Frank's later work demonstrates how an artist disrupts old formations and restructures them in answer to changed emotional and formal needs. In an early self-portrait made in St. Louis in 1947, we see the photographer, hidden behind his camera, framed and reflected in a window. The city looms behind: a bridge, a dome, a vacant lot, cars and brick buildings. It's a jumpy image, with shadowy definitions, an early example of what critics would later decry as Frank's poor technique. The image is a classic arrangement by the artist, set in relation to his subject, the city, but destabilized, momentarily deranged. Roughly thirty-five years later, after the revisionist style of Frank's books *Black White and Things* and *Peru,* after the controversial investigations of *The Americans* and the subsequent work in film and video, in *Home Improvements* he synthesized his past styles in a self-portrait in which he looks out from behind a videocam, still aloof, but alert, with the passive, predatory attentiveness so crucial to good photographic art. In the 1947 St. Louis image he looks rather like a cubist figure embedded in his surround. In the later self-portrait, he is in a void, without a context, and the image is not jumpy but steamed and fluorescent, the image-maker making himself invisible before our eyes.

That self-portrait is one of five large color panels that comprise *Home Improvements,* 1985, a photograph made from Frank's video of the same title. The matrix has changed from a bleak cityscape in the early picture to a purely subjective self-portrait, in *Home Improvements* (pages 263–265). The later photograph is essentially studio art but it is deployed in relation to the other panels, which are classic by comparison: two portraits of family members, a landscape, an interior. *Home Improvements* is representative of a good deal of Frank's later work in that it dramatizes his own complicity in making images of a life. Two severe panels expose the most important people in his private life, his son Pablo and his wife June Leaf. The other two images expose extremities of place, his two locales: Mabou, Nova Scotia (land's end with its lovely desolation of snow on rocks) and New York City (a subway interior with its alarmed graffiti—"Symptoms It was dark"). The most disturbing is the portrait of Pablo who, we know from the *Home Improvements* video, has been hospitalized. The image, in the grim tones and merciless definition peculiar to video,

is drained of life force. In no way cautionary or cozy (or exhibitionist), it is the clearest image of spiritual agony that Frank has ever made. The extreme foregrounding—Pablo's grand, handsome head turns slightly from us even as it heaves forward in the frame— creates an unsentimental candor that seems, as it sometimes must in photographic art, like cruelty. The enlargement dilates the textures of the video so that the support looks like open-weave canvas. An intimate subject, Pablo is turned into an image pushed nearly to abstraction, to public dissolution, by Frank's desire to achieve a precise level of distress. June's portrait, on the other hand, is annunciatory. She is a heroic presence because she appears so fearlessly available to the travails of experience. (We know from the video that she, too, has been hospitalized.) Both are images that show the way the human face embodies suffering and change. The Mabou and New York panels fill in the configuration, representing the forces of circumstance that affect and sometimes determine that embodi- ment. Frank gives the tenuous nature of the video image a monumental form, but the mon- ument is testimony to private disorder, struggle, and soul-searching.

The way he uses video imagery says much about the ways and means of Frank's later work. After experimenting with video for several years, by the late 1980s he had come to believe it was too personal. "[It] really picks up everything that is there," he says. What he means, perhaps, is that total exposure is not the same as personal or private art and that video, for all its inclusiveness, in its way is too superficially scrupulous and tends to flatten all the elements in a field to a single emotional valence. Video does not really see so much as it vacuums its subjects. Joy seems manic, driven, hysteric; sorrow becomes shamelessly hard-edged and spotless. It makes reality seem floodlit from the inside and records physical activity with crisp precision. It also lends itself very easily to harsh affectlessness (and con- sequently has become the medium of choice for many postmodern artists). In exploring the new technology he was testing for blind spots, soft areas where qualities inherent in video could be destabilized and made to release new expressive energies. Although he has includ- ed video fragments in recent films, including *Hunter,* 1989, and *Last Supper,* 1992, Frank's displeasure with the medium led him to complete only three videos, *Home Improvements,* 1985, and *Moving Pictures,* 1994, and *C'est Vrai! (One Hour),* 1990; but when he makes photographs from video stills, or brings over into his photographic practice the lessons learned from his video experiments, he discovers new dimensions of feeling.

Frank is an artist who takes what is available, finds the chaos in it, then finds a way of using the chaos. Over the past twenty years he has often worked with Polaroids because they let him admit and manipulate disorder in ways that conventional film does not. He says they let him "destroy that image, that perfect image." That is, they free him to pursue in new ways the contrary ambition that has driven him since the early 1950s: to make something that is not a beautiful picture. Frank writes directly on Polaroid negatives, scratching notations and impulses. The picture registers what is outside, the stylus records

what is inside. The entire image thus becomes an opaque membrane on which adversarial pressures imprint their meanings. The words are usually plain, elemental, sometimes to the point of ingenuousness. The writing cracks the composure, disrupting the composition. The results are complex and startling. In 1978, while hospitalized in Halifax, Frank made a series of Polaroids of another patient (page 253). In all but two the sunlight from the window swells into the room, bleaching objects and people. In the penultimate image, we see the patient, Mr. Lawson, in bed. In the final image the bed is empty and the window cannot be seen. On these serial pictures Frank has scratched dates, times, memoranda ("Treatment Therapy"), feelings and tidings ("Goodbye Mr. Lawson"), slanting himself into the story, acknowledging his participation and his own fate. At the bottom appear his own and Mr. Lawson's hospital identification tags, homely signs of mortality.

Frank's excited treatment of Polaroids is also a strategy for working away from, but also out of, the beauty of his early style. One challenge has been to discover other, more unstable forms of countering beauty. With the Polaroid process he has created effects that literally dislodge or blot compositional stabilities and melt or fracture the frame of the image. While pulling the film packet through the rollers—he uses an old Polaroid 195, a much-coveted model among some photographers—he sometimes plays with the negative, twisting and wriggling and hesitating in order to achieve a "wrong" look. As a result, edges and areas of the image appear abraded, raked, or watery. He begins to dismantle the resolved image before it develops, and he does so blindly. The method induces happy errors of disorder and chance, which then become part of his pictorial drama. In the 1950s Frank was criticized for bad technique because of the skewed axis, tilted horizons, irregular focus, and shabby lighting in some of his pictures. These aspects all contributed to a classic American style. In recent years he honors that style by continuing to interrogate conventional composition and tonality.

The pursuit of an alternative beauty continues after the film is pulled from the camera. Frank is notorious for treating his negatives like last week's grocery lists—he handles prints just as casually—so that a negative is "worked," exposed, for a long time after the initial, sanctuary exposure in the camera. He cultivates a damaged beauty in order to bring into a strong compositional structure the decisive random impingements of the world. This is another expression of contrariness, his unwillingness to monumentalize moments or court transcendent effects. One reason he turned to motion pictures was that he wanted their commitment to sequence, process, consequence. His still photographs of recent years are a natural extension (and lesson learned) from that pursuit. The images now are not "taken" but rather carried out, and carried on. And the task has been often occasioned by personal turmoil, by death or the passings of seasons, friends, and places. The actual effects of much of the later work are more quickened and emotionally volatile, also more reflective and ceremonial, than the early work.

Sometimes Frank puts contrary feelings into an image with such aggrieved simplicity that the effects are angular and unsettling. When he writes "I hate you I love you Dont fuck with mother nature," the assertions have a petulant simplicity, but the words fall upon charged images of the changing seasons and of snow-clogged window sills. We should not expect artful words from a photographer any more than we would expect artful photography from a poet. What we get in Frank's pictures are panicked exclamations, news from the front lines, wild slogans, and hilarious platitudes ("Sick of Goodby's" "Curb that lust"). The pictures of the 1950s were also riddled with words—signs, posters, political slogans, tabloid hysterics—but those messages were found already laid into the scene. In the later pictures Frank consciously lays into the grain of the image his own frantic, intimate declarations. It is his way of conversing with the process of forging images, making that exchange the very texture of experience.

The Americans made photography seem a constant pilgrimage to an undetermined but mysteriously critical destination. Every image was a little prayer to the need to stay in motion. Yet, over the years, the artist of the open road has become for the most part a studio artist, though this too has been strategic to undoing a master style and seeking new definitions. We can track Frank's development by following one of his primary subjects, his son, Pablo. In the early pictures we see Pablo mostly among the protective and instructive society of adults, with his mother or at Meyer Schapiro's knee; or studying a newspaper as if play-acting at adulthood. He is free at heart but, the pictures suggest, a child of contingency like us all. His father seems to pick him up casually in the viewfinder, nested in a scene. Later, Pablo appears as a young man in the films *Conversations in Vermont* and *Life Dances On...*, and in the video *Home Improvements*. He is no longer secure in a surrounding scene; he is a subject under scrutiny, a scrutiny that includes the relation between father and son, artist and subject. We witness the disorientation, the strained relation, the struggle to articulate feelings on both their parts, until finally in *Home Improvements* we see Pablo in the Psychiatric Treatment Center in the Bronx where his father visits him. A 1979 portrait shows him holding up books and magazines that declare his interest in UFOs, volcanoes, and meteors. (In those days he was preoccupied with violent interventions in the natural order; there is a moment of tender sympathy in *Life Dances On...* when Pablo's girlfriend draws him out on these subjects.) The portrait is a classic pose, the sitter surrounded by objects suggestive of his nature, like books or weapons in a Renaissance portrait. Pablo's look of bemused defiance speaks to the relation between sitter and photographer. The sober sweetness of the 1950s images gives way to abrasive personal disclosure. Pablo's name and the date appear top and bottom in the image, scrawled on the negative, sometimes printed backward, like mirror-writing blazed on a tree. The figure does not embody motion or growth. He has a sullen intransi-

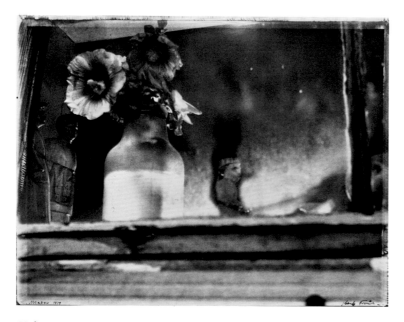

Mabou, 1979

gence, and the image bears no sense of happy past or consoling future. All suggestion of passage, of life on the go, has been suppressed; we see only an emotionally laden present. Frank, however, as usual saves something from the old style. The newsprint images framing Pablo have the blatancy and missionary appeal of the pamphlets, signs, and newspapers that flash out from some of his work in the fifties. The issue, then and now, is deliverance. But deliverance from what and to what? In the early pictures those anonymous messages often expressed some wild, beleaguered hopefulness, and at least a public availability. In Pablo's portrait both are absent: he seems to have sucked into himself all the anxiety and foreboding that accompany the kind of speculation that surrounds him. The words, shrieking cosmic disturbance, are images of an interior which, despite the pictorial force of Pablo's mass of hair and beard blooming darkly against the white background, remains painfully remote and isolated.

Frank's late work is more brutally weathered by personal circumstance, its resolutions more challenged and precarious, than the early images. Some of his most conflicted images, however, are structured on traditional motifs. In a picture of flowers on a window sill (*Mabou,* 1979) one of the blooms is vital and brushed with light, another drooping, half-shut, with gloomy dark textures, and the third is wilted. Behind them, aloof and ceremonious, are small wooden figures, made to outlast the flowers but included in their penumbral light. The objects of nature and culture thus share the same illumination; the motif, shown from below, hovers high in the frame, like a shrine. The relative degrees of perishability represented in flowers and statues are summarized in one irreducible condition of nature, saved from that process by the act of representation. Reproduced in the 1989 edition of *The Lines of My Hand,* this image seems a mere accident of light or phantasmal coincidence, existing at a pitch of visual uncertainty. The picture does not make an issue of that uncertainty but rather absorbs it into its formal language.

Since the death of his daughter Andrea in 1974, Frank has returned to this event many times and used the testimony of personal loss to test the limits of representation. For an artist of public sensibility, the howl of loss needs a ceremonious consistency so that private sorrow may have a public shape and not return to the chaos of its origins. One of the distinctions of Frank's late work, in fact, is the way it has redefined decorum. In a 1980

memorial image, he has printed the words "Pour la Fille" over a field of flowers (page 244). The flowers are shaken and blurred both by the wind and by Frank's deliberate use of a slow shutter speed. Parts of the image are in focus, stilled into a stable bucolic moment; other areas, with their "wrong" look, are tossed and whipped by the passion of remembrance. The image, folding turmoil into quietude, dramatizes the way emotion recollected in tranquility soon tortures the recollective soul. There is a stabbing assertiveness in this and other recent pictures. The garish mournfulness of images associated with Andrea, for instance, display grief but do not invite us into their aura; they offer no welcoming, consoling gestures. This is part of the ceremoniousness of the late work generally, an aloofness that defines more acutely, and with a jagged intensity unequaled by anything in the early work, a disordered spirit and chaotic mood. (The moral intent of the late work is that it shall not be owned emotionally by viewers as readily as *The Americans* was owned.) Frank has always been a poet of happiness, but he has come to make art that answers first and last to the unprincipled disruptors and destroyers of the prospect of joy. We can sometimes feel the force of will trying to overcome the impediments to happiness. One of the ambiguous messages he writes to himself on a photograph is "Look out for hope" (page 245).

Some artists seem to move from style to style, subject to subject, with processional wilfulness. All the disorder of daily life has been absorbed or burned off. What William Butler Yeats called the bundle of accident and incoherence that sits down to breakfast each day has been transformed and compacted into concise, necessary forms. Frank obviously is not such an artist. He is a scrambler, and he delights in subverting his work's most resolute, confident, formal patterns and in putting his most exquisitely achieved effects at risk. He once said that his favorite picture from *The Americans* is the one of a black couple on a San Francisco hillside. What he likes most is the look of anger and insult on the man's face as he looks back at the photographer. That picture embodies the scrambling regard that he has made into a late style. In *Giles Groulx, Mabou, Nova Scotia,* 1978, the domestic ceremony of the visit is bitten all around by the setting, the elements, the roughness of time and circumstance (page 247). As in the pictures of flowers and landscapes, Frank uses contrary elements to tear at the provisional consistencies of the representation—the very surfaces of the *Giles Groulx* imagery seem to create a rough weather of their own. He stirs energy that sometimes runs contrary to his own apparent intent.

Some of Frank's strongest images are of his surroundings. Mabou's extremity makes it a station where nature's intensities shape the life of the spirit. Frank responds by making images of its seasonal moods and the shifting relation between land and sea. Sometimes the permeable and dissolving margins of his images seem like analogues to the marbled frontier between land and sea. In calm weather, the land is a clear margin defining the limits of one element and the beginning of another. At other times, we see the two turbulently mixed,

their limits contested and confounded. (Confounding him as well: in *Home Improvements* June fondly corrects her husband when he mistakes sea foam for ice.) In *Andrea, Mabou, 1977* (page 239), the upper left image shows what seems to be ice (or sea foam?) floating offshore, forming and dissolving; stencilled over the image is "Andrea," talisman of remembrance. The word, so saturated with private agony, is an image of mortal extremity laid upon that other image of extremity. The right-hand panel shows the same seascape, but in thaw. Frank then disrupts the balanced pair of images by flopping and double-printing a snowy scene over the thaw, like a ghostly reminder or augury. In his great poem "Frost at Midnight," Samuel Taylor Coleridge says that the spirit interprets natural objects, their meanings and affects, by its own mood.[4] In several images of Mabou, Frank positions himself as the Romantic in nature, but with all the exasperating (and potentially neutralizing but absolutely indispensable) self-consciousness of a late twentieth-century artist. His spirit becomes arbiter and interpreter of what is out there, and remembrance floods the image with the stark appearance of his daughter's name. But he is also critically self-aware of his own desire to appropriate what he cannot really possess. His sense of this inability is apparent in *Mabou, Nova Scotia,* a picture in which his own early images, or a sign bearing the letters "Words," dangle like forgotten laundry on a clothesline before the sea (pages 128–129). The true reality is in the background: the formless, moody, rhythmic but murderously unpredictable sea, the great chaos out of which the human impulse to make images originates.

Frank's most operatic works of the last twenty years are the companion pieces *Untitled* and *Mute/Blind,* 1989 (pages 287, 289). To make *Untitled,* holes were drilled through a stack of early photographs. In *Home Improvements* we watch Frank give directions to his friend Gunther Moses to perform this task. Frank then bound them in wire like a rag bundle and spiked them to a plywood support. The topmost image is a 1952 *corrida* photograph of a bull with a sword sticking from its back. Beneath this junkyard memorial to his earlier self are displayed faded thermal video stills from *Home Improvements,* among them spectral images of June, Pablo, a sheep, and the landscape outside Frank's house. *Mute/Blind* is composed of out-takes from the 1989 film *Hunter,* mostly images of a blind dog and a statue of a deer, treated so that the deer's eye oozes blue and red dyes. By mutilating his own pictures, Frank is also trying to lay to rest an uncontrollable energy and make it a ruined monument. Frank is driving a stake through a no longer relevant great style, mangling its austere beauty so that its formal, ordered patterns will not deflect the energies of chaos into repetitive (and lucrative) niceties. He is trying to slay certainty. That stack of prints represents an autobiographical structure to which he refuses to be held hostage. The *corrida* image itself is one of enabling violence, by which civilization breaks its enslavement to the minotaur and its tribute of flesh and blood. It is also one of

the many photographs he has made of animals, from the slaughtered horse and sleeping pig of the late 1940s to the penny-picture display of the dog and deer in *Mute/Blind.* The story they tell is that human consciousness, for all its inebriating inclusiveness, tries but fails to recover (or even adequately represent) animal consciousness. Frank's images show how animals continue to be in the world but, so far as our consciousness is concerned, less and less of the world.

The message written across one of Frank's Mabou landscapes describes the gesture of driving a stake in *Untitled* and could serve as a legend for the late work generally: "Hold Still—Keep Going." Frank's brooding on conventional motifs is charged with unrest and discontent. In his photographs he usually sticks close to home, either in Mabou or in his New York studio. We recognize the same views, scenes, and portrait subjects. Within these confines, however, he pushes technique into stranger registers of feeling and invention, from the formal exquisiteness of *Electric Dog,* 1976, to the eerie mockery of portraiture in *Mabou,* 1981, with its Salvador Dalí mask twisting in the sea wind and its rubrics "Blind Love Faith." When we examine the late work we see the present moment at unrest and a kind of anti-stateliness. It is immanence with a vengeance, in an art form that is often the true child of immanence. Over the years, with its self-questionings and apparently abrupt changes, Frank's style has followed evolutionary biases peculiar to its own systemic makeup.

Those biases allow him to be both summative and provisional. In the late "studio" work he plays with materials more liberally than ever before, testing the structural and serial possibilities of multi-panel imagery. He has also crushed the space between himself and his chosen objects, and he treats exposure time as a kind of spatial dimension. He is certainly less concerned with the anecdotal load of the image and more preoccupied with the relations between personal and public meanings. In his way, he has also become a bit more literary, this photographer who so distrusts the adequacy of words. But he also, early and late, made words (or verbal debris) part of the language of a scene. Words actually become the scene in one of his most recent studio works, *Yellow Flower —Like a Dog,* 1992 (pages 136–137). Two side panels show tulips on a table: on the left, the words "Yellow Flower" appear on the image; on the right, the blooms are dead, and scratch marks spell out "Like a Dog." The phrase appears also in the typescript that fills the central panel, and it recalls the closing moment of *The Trial* when Kafka's Joseph K. dies "like a dog." Then we remember that Frank's 1989 film *Hunter* was inspired in part by Kafka's story *The Hunter Gracchus,* in which the hero voices Frank's poetics of the present: "I am here, more than that I do not know, further than that I cannot go." The mandate "Hold Still—Keep Going" translates that statement. The manuscript in *Yellow Flower — Like a Dog* is a rough draft, an image of meaning-making in progress. Phrases in the script—"His feeling like a dog running after Afraid to give up"—have the stabbing immediacy of private counsel but are also efforts to make a complete coherent statement, to make a sentence. The panels'

edges are runny and uncertain, their meanings literally held together, bound by the side panels' clear, still solid frontiers. By each bunch of tulips stands a small, crabby-looking "Old Man Cactus," a witty stand-in for the artist. The tulip petals on the left have a fleshy translucence; their dark stalks are intensely defined. The shadows the petals cast on the wall have a fastness and materiality more stable than that of the material petals themselves. His intent, here and in the other late work, is to give formal expression to his love of the actual, but it is love defined by mature, stark criticism of the actual and of the sensuous present.

Frank made studio pictures throughout the 1970s and 1980s as if to seal off the sort of accident that the work of the late 1940s and 1950s so brilliantly included, but into that controlled environment he sets loose the hyenas of subjectivity. Working on assignment, however, Frank has made images that come directly out of the straightforward public style of *The Americans.* These result from external occasions, not from subjective, self-generated occasions. We might have predicted the subjects that would attract him: politics and overlooked American places. He has not gamely recycled a proven style, he has thickened and intensified it with whatever knowledge and sharpened sense the years have given him. Frank has always been attracted by the festive disarray of politics. His pictures of the 1956 Chicago convention are dyed into our collective imagination. Among the images he made of the 1984 Democratic convention in San Francisco is one of gay demonstrators, arrogant, flirtatious, exhibitionist, and politically assertive. It is a picture that, as a political configuration, pulls us two ways: we see the admirable public self-definition and unity of a group discovering its political identity; we also see the exclusionary self-interest, flamboyantly expressed, that necessarily rips the fabric of consensus-politics and for over a decade has, for

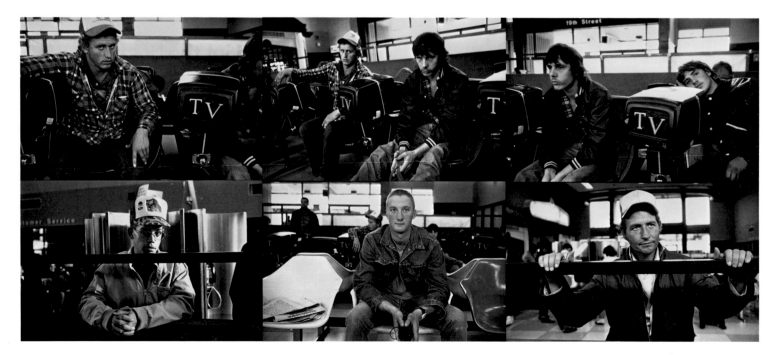

#1 Birmingham, Alabama (detail), 1987

better or worse, weakened the party to which it belongs. The image displays a distinctly post-1960s style of political expression. On assignment in Birmingham, Alabama, in 1987, Frank made images of youths slouched in T.V. seats in a bus terminal that pick up and continue the story of the four photographs from 1955, *In Front of High School, Port Gibson, Mississippi,* where a group of smiling boys taunt the photographer: "He must be a communist. He looks like one. Why don't you go to the other side of town and watch the niggers play?" The men in the bus terminal look disaffected, bored, dazed by the image-dispensing machine attached to their chairs. Out of the Birmingham assignment came another image that shows how a mature artist can take a set of familiar forms, then break them over our heads. A nude black prostitute in a hotel room is flanked on one side by her own hard shadow, on the other by the seedy glow of a woman's face on the television screen. Substance and shadow, reality and representation, flickering forms, flesh and circumstance—this image of the mortal present bears all the thematic force of the later work, though its language is more explicitly taken over from an earlier style. It is also Frank's testimony to himself, of his passion for seizing occasion, external or internal, and trying to make a true, adequate image of the present.

Notes

1/2 *Phoenix: The Posthumous Papers,* 1936. Edward D. McDonald, ed. (New York: Viking Penguin, 1980), 221.

3 From the script of the documentary *Fire in the East: A Portrait of Robert Frank,* Philip and Amy Brookman, 1986, 5.

4 *The Portable Coleridge,* I. A. Richards, ed. (New York: Viking Press, 1967), 128.

Draw the map the voyage made. Yes & No, looking with care in the

beginning, using what I had been taught at school.

Sitting down at my age now — to write. I trust my intuition.

Who am I writing to? To explain my detours. Yes, to keep them

alive. Look the other way — not afraid to make my mistake

and show it. I want to show ambition. I want to show what

it is to be in America. Positive & Negative, I scratch it

thru the surface. Children grow up. Mary is gone. Love turns

to indifference. Always returning to New York — except for Andrea,

Andrea dying in the Air in Guatemala. LIFE DANCES ON...

HOME IMPROVEMENTS... LAST SUPPER... the map makes

itself, I follow, no choice, like exorcising the Darkness come

too early. Please line up the chapters now one two three — too late

to teach about photography. Just accept lost feelings — Shadows in

empty room — Silence on TV. Silence in Canada. Bad Dreams —

Black White & Things, enjoy each minute to the fullest... KEEP BUSY...

The Memory of all. So much of it gone. I wish that the feeling

of that Memory will make a sound of music.

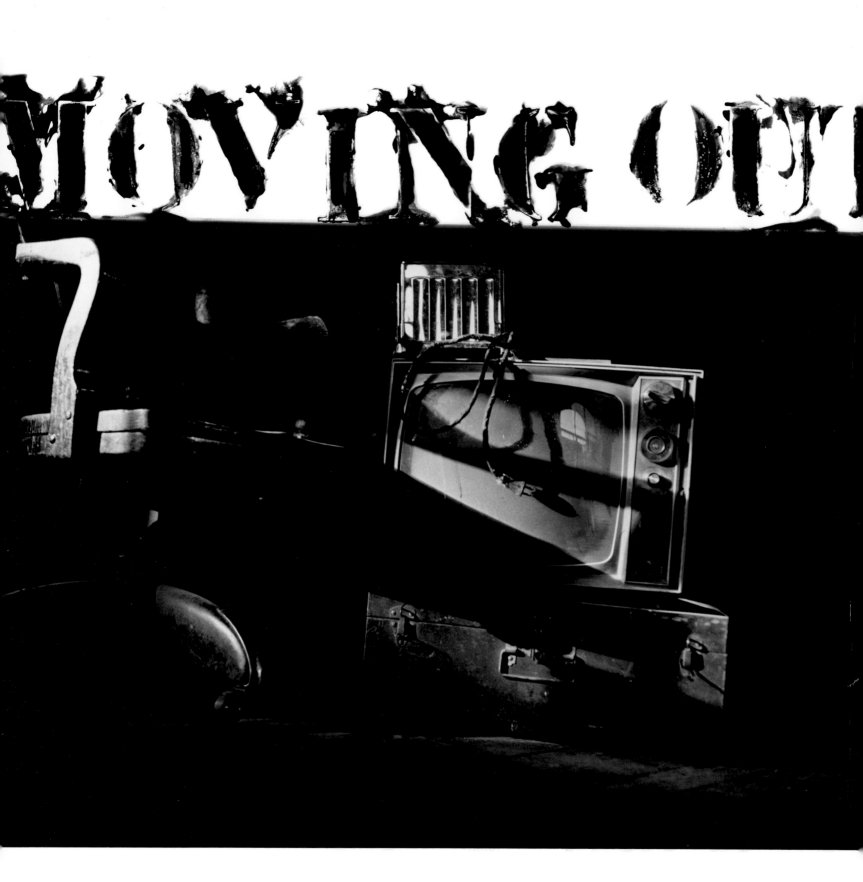

MOVING OUT

FORGOTTEN POSESSIONS IN JOHN TURNERS FINAL ROOM

MOVING OUT

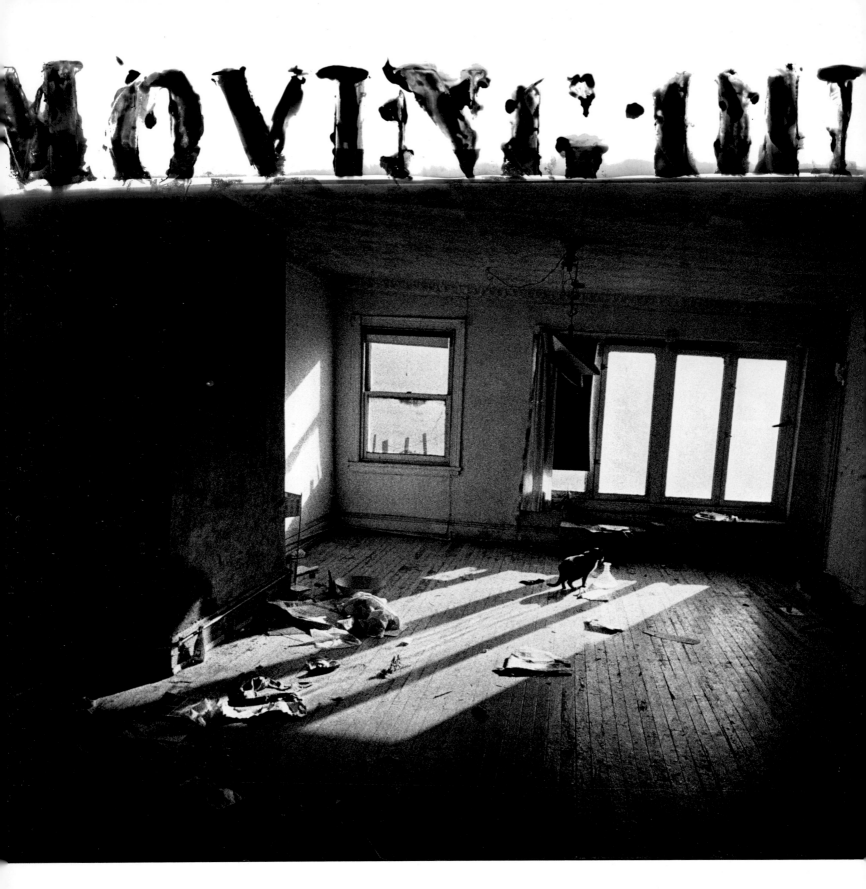

LONG GONE SHADOW OF MARRIAGE ON THIRD AVE LOFT

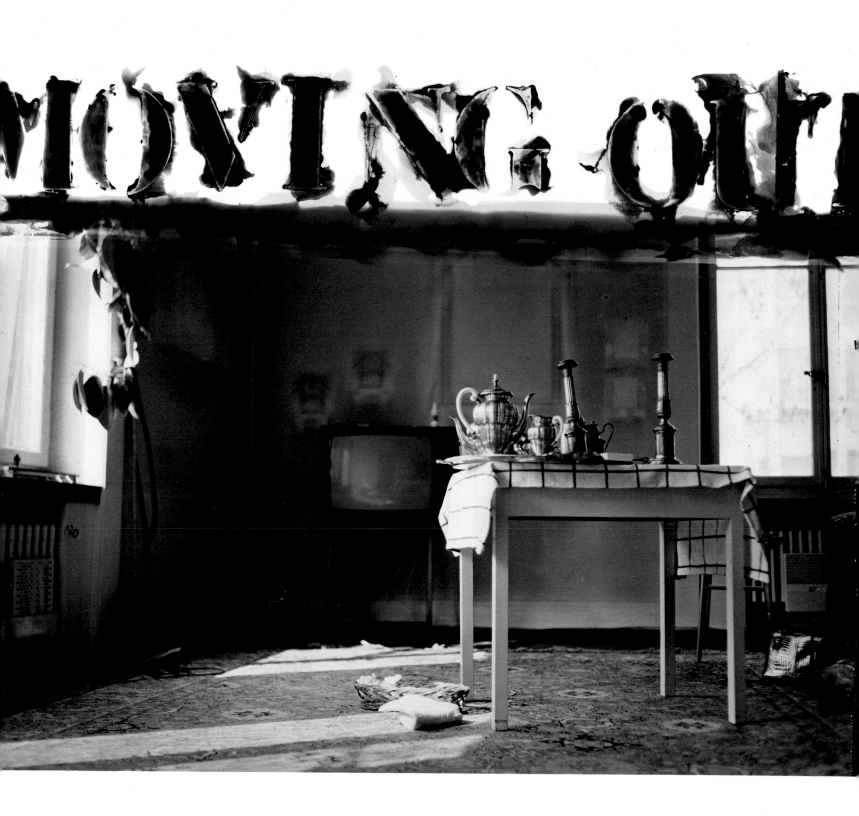

MOVING OUT

AST LOOK AT MY PARENTS WOHNZIMMER IN ZURICH

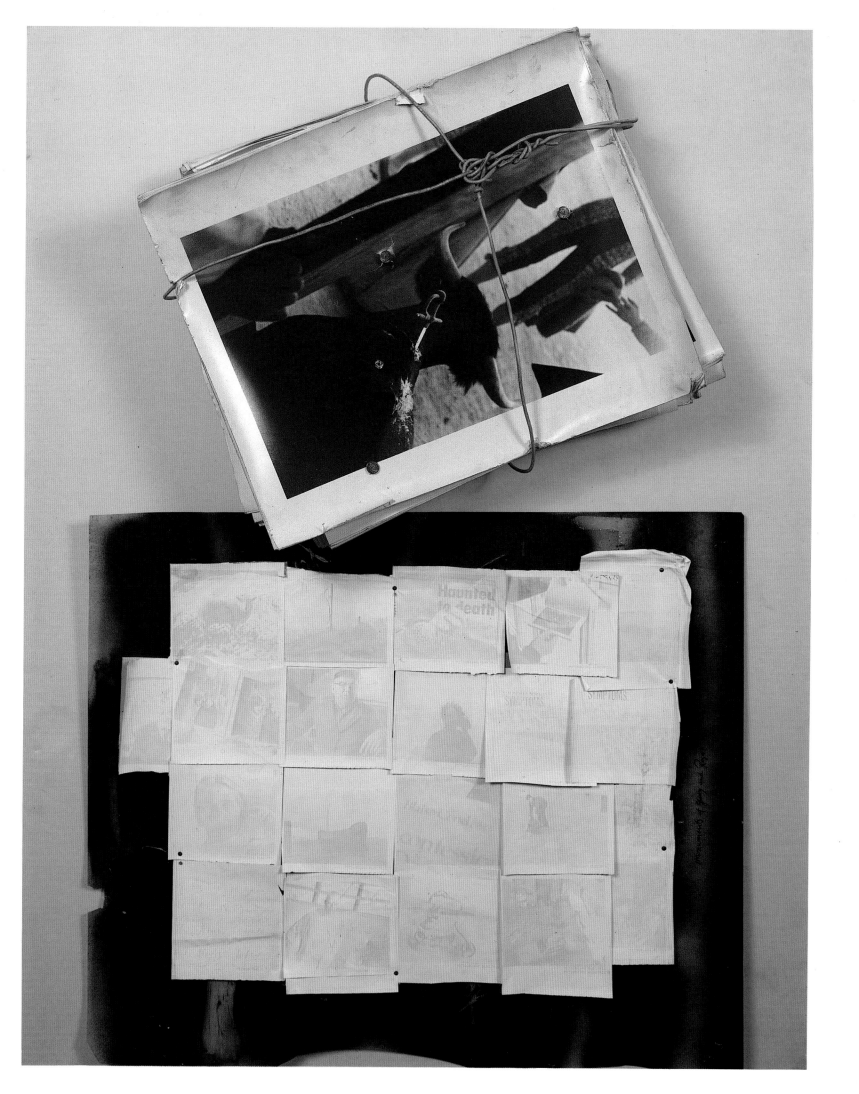

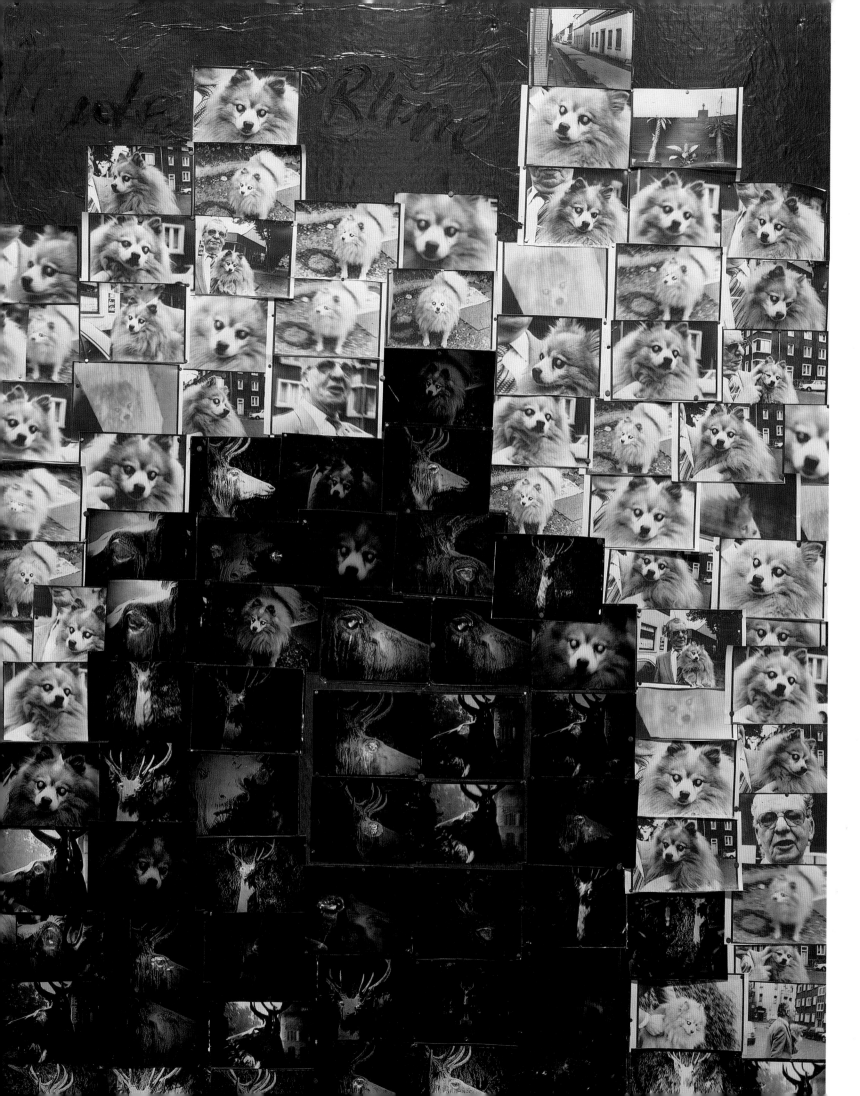

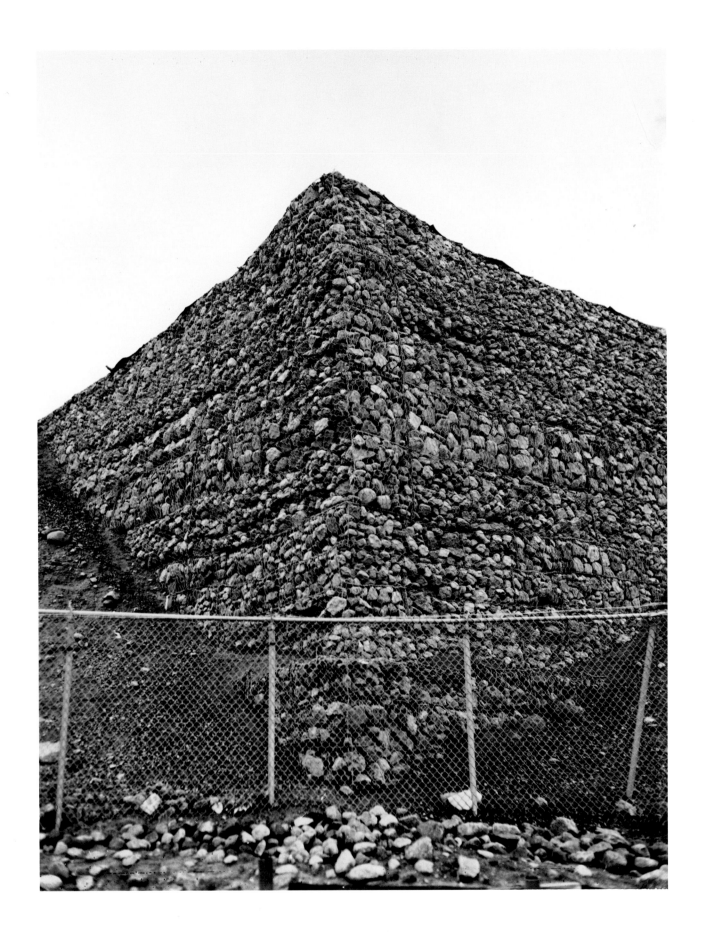

290 Pangnirtung, N.W.T., Runway for Airport, 1992 Pangnirtung, N.W.T., 1992
I Want to Escape, 1993 (pages 292–293)

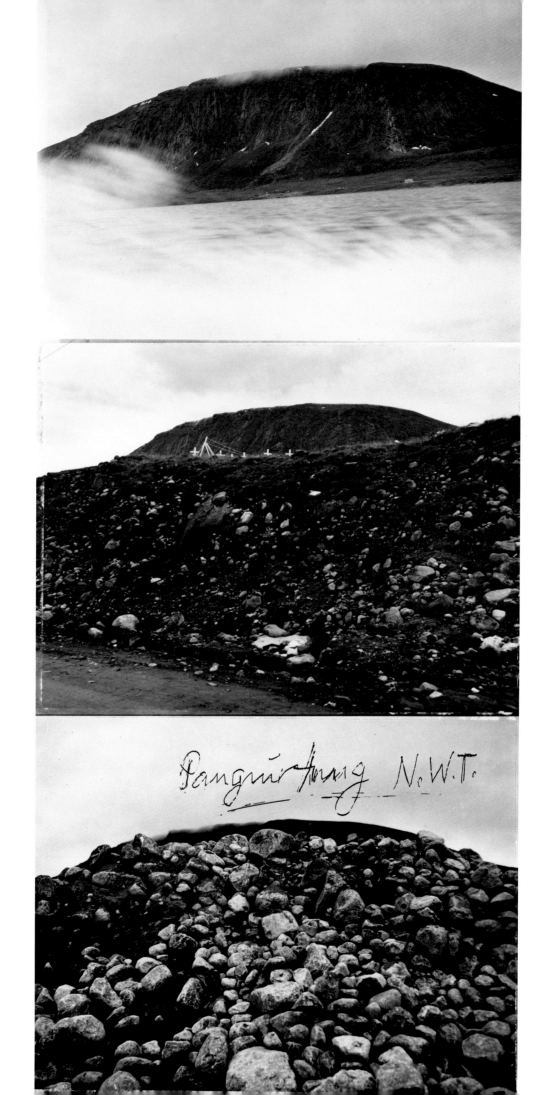

Pangnirtung N.W.T.

the Past

Silence – the Sky turns
Dark – No one lives
here any more
I want to escape

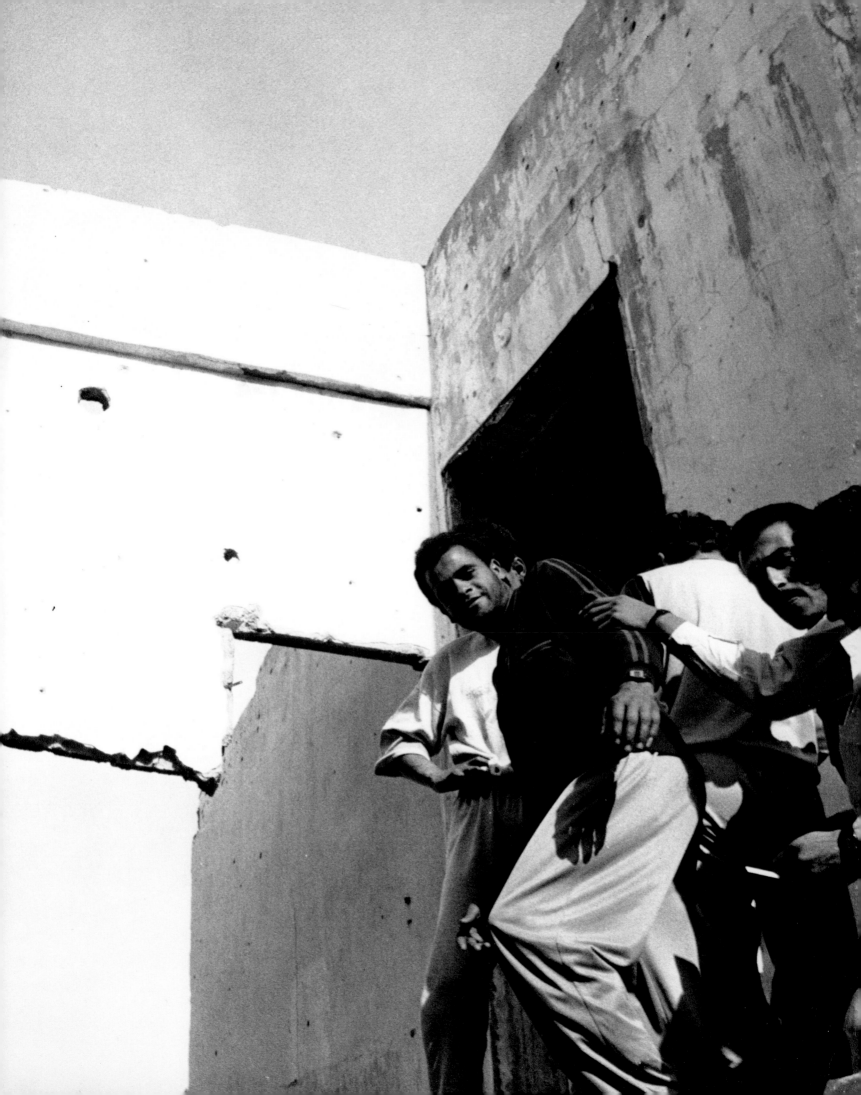

What am I looking for?

To go further... to Beyruth.

The theater is empty—and life goes on.

In Cairo we meet. Dominique, Dina and Robert.

We decide to make a film together.

I ask Dina: who was your best teacher? Mes yeux—my eyes.

Maybe this is the beginning of a friendship beginning of love

beginning of a new story.

CHRONOLOGY

1924 **9 November** Born in Zurich, the second son of Hermann Frank of Frankfurt-am-Main and Regina Zucker of Basel.

1931–1937 Attends the Gabler School, Zurich.

1937–1940 Attends Lavater Secondary School, Zurich.

1940 Studies French at the Institute Jomini in Payerne.

1941 **January** Informal apprenticeship with the photographer and graphic designer Hermann Segesser in Zurich (until March 1942).
September–December Still photographer for the film *Landammann Stauffacher*.
December Hermann Frank applies for Swiss citizenship for Robert and his older brother Manfred.

1942 **May–July** Assistant to the still photographer for the film *Steibruch*.
August Apprentice, later employee in the studio of Michael Wolgensinger in Zurich (until September 1944).

1944 **December** Assistant to Victor Bouverat, Geneva (until June 1945).

1945 **April** Granted Swiss citizenship.
Summer Leaves his position with Bouverat to begin basic military training in Losone, Switzerland.

1946 **May–August** Works for Graphic Atelier H., R. and W. Eidenbenz, Basel.
Makes *40 Fotos*, a book of original photographs. Travels with his father to Milan. Travels to Paris, staying with cousin.

1947 **20 February** Departs Antwerp for New York on S. S. James Bennett Moore.
April Hired by Alexey Brodovitch to take fashion photographs for *Harper's Bazaar* and *Junior Bazaar*. Meets Louis Faurer, a photographer who also works at *Harper's Bazaar*.
September Purchases 35 mm Leica rangefinder camera; until now he has primarily used a 6 x 6 cm twin-lens Rolleiflex.
October Resigns from *Harper's Bazaar*, but continues to contribute as a freelance photographer.

1948 **June–December** Travels and photographs in Peru and Bolivia.

1949 Meets artist Mary Lockspeiser.
Makes two spiral-bound books with thirty-nine photographs from the Peru trip. Gives one to his mother and the other to Brodovitch.
March Sails for Europe; meets the photographer Elliott Erwitt.
April Photographs the Landsgemeinde in Hundwil, Switzerland.
July Meets Robert Delpire in Paris.
August–October Travels to Spain, and, with Erwitt, to Italy and the south of France.
December Makes book for Mary Lockspeiser with seventy-four black-and-white photographs of Paris.

1950 **February** Returns to New York and meets Edward Steichen.
Marries Mary Lockspeiser.

1951 **7 February** Son, Pablo, born in New York.
August Makes photographs for essay titled "People You Don't See," which he enters in *Life's* Young Photographers' Contest. The essay fails to win but Frank does win second prize in the Individual Pictures category.
November Sails for Europe, travels to Paris and London, where he photographs bankers.

1952 **March–August** Travels to Spain where he works on a photographic essay in Valencia about bullfighters.

October In Zurich, introduces Steichen to Swiss photographers for consideration in forthcoming Museum of Modern Art exhibitions, including *Post War European Photography* and *The Family of Man.*
Makes three copies of *Black White and Things,* a book of thirty-four photographs designed by Werner Zryd. Gives one to his mother and one to Steichen.

1953 **March** Photographs a miner, Ben James, who works at the Gee Coal mine in Caerau, Wales.
March Sails from England to New York. Ceases most fashion photography, continues as a freelance magazine photojournalist with occasional advertising assignments. Begins making portraits and illustrating stories for *Life, McCall's, Look, Charm, Vogue,* and *Ladies' Home Journal.*
Meets Walker Evans, photographer and editor at *Fortune.*
Summer The first of many trips to Provincetown, Massachusetts. Meets artists Jan Müller, John Grillo, Lester Johnson, and Miles and Barbara Forst.
December Wins fourth prize in the black-and-white category of *Popular Photography's* 1953 International Pictures Contest.

1954 **February** Makes portraits for feature articles about working women in *Charm* (through 1955).
21 April Daughter, Andrea, is born.
July Travels to a Fourth of July picnic in Jay, New York, and makes the first photograph that he will include in his book *The Americans,* 1958 and 1959.
October Applies for a fellowship from the John Simon Guggenheim Memorial Foundation to support the making of a "broad, voluminous picture record" of the United States. Brodovitch, Evans, Alexander Liberman, Meyer Schapiro, and Steichen serve as references.

1955 **February** Assists Walker Evans with the photographic essay "Beauties of the Common Tool," published in *Fortune,* July.

April Awarded a Guggenheim Fellowship for May 1955 to May 1956.
Travels with Walker Evans to Maine as Evans works on the photographic essay "These Dark Satanic Mills," published in *Fortune,* April 1956.
June–July Photographs in Detroit and environs and in the Ford River Rouge Plant in Dearborn. Photographs commuters on the Congressional train to and from New York and Washington for a picture essay edited by Evans and published in *Fortune,* November.
October–December Leaves New York. Drives to Florida; then to Houston where his family joins him for the trip to Los Angeles. There he develops film.

1956 Applies for and receives renewal of the Guggenheim Fellowship.
March–April The family lives in Orinda, near Oakland, with photographer Wayne Miller, where he develops and edits film.
Mary and the children return to New York. Frank leaves California, traveling eastward through the northern United States, arriving in New York in June.
Family moves to Third Avenue near Tenth Street in New York, near artists Alfred Leslie, Milton Resnick, and Willem de Kooning.
Vacations with family at Provincetown. Travels to Pennsylvania, photographing in Ashland, Shenandoah, and Centralia.
13–17 August Photographs the Democratic National Convention in Chicago. Resumes his commercial photographic assignments, working for *Charm* and other magazines.

1957 **January** Drives to Washington to photograph the inauguration of Dwight Eisenhower and Richard Nixon. Makes the final photograph which will be included in *The Americans.*
June–July Travels to Paris with a maquette of *The Americans* to discuss publication with Robert Delpire.
Meets Jack Kerouac in New York and asks him to write the introduction for *The Americans.*

1958 **January** Begins working for Louis Silverstein of *The New York Times* Promotion Department on a series of advertisements called "New York Is..." and "Where Else but New York?" (through 1963).
April Travels to Florida with Jack Kerouac.
4 July Photographs people sleeping on the beach at Coney Island.
Summer While vacationing in Provincetown, makes an 8mm short film with Mary, Forst, Allen Kaprow, and Richard Bellamy.
Travels on buses throughout New York City, photographing from the bus window.
November *Les Américains* published in France with texts selected by Alain Bosquet. In 1959 published as *The Americans* with an introduction by Jack Kerouac. (See bibliography)

1959 **January–April** Begins work on the film *Pull My Daisy.*
Continues to make photographs through May for *Charm* and later for *Glamour.*
Fall Photographs on the set of the Elia Kazan film *Wild River.*
New York Is published as a book by *The New York Times,* with twenty-four advertisements from 1958 through November 1959, and an essay by Gilbert Millstein.

1960 Films *The Sin of Jesus.*
April *Film Culture,* edited by Jonas Mekas, presents its Second Independent Film Award to *Pull My Daisy.*
September With other independent filmmakers (including Jonas Mekas, Shirley Clarke, Lionel Rogosin, Peter Bogdanovich, and Emile de Antonio), meets at the Producer's Theater in New York to found the New American Cinema Group.

1961 **May–September** Travels to Europe with family.
July Kerouac's narration for *Pull My Daisy* published by Grove Press, New York, with forty-nine frame enlargements from the film and eight photographs of the making of the film by John Cohen.

1963 Directs *O.K. End Here.*
June *The New York Times* publishes *Zero Mostel Reads a Book,* with photographs by Frank.
18 October Becomes U.S. citizen.

1964 **January** Intermittently through April 1966 cinematographer for Conrad Rooks' film *Chappaqua;* travels and films in France, the United States, Mexico, England, India, Ceylon, and Jamaica. Asks Allen Ginsberg to write a screenplay adaptation of his 1958 poem *Kaddish;* screenplay is completed but never produced.

1965–1968 Directs and edits his first feature-length film, *Me and My Brother.*

1968 For use in the editing of *Me and My Brother,* constructs a book combining text, film-frame enlargements, and still photographs.

1969 Works on *Conversations in Vermont,* a film about his children Pablo and Andrea.
Travels to Nashville, as cinematographer for a film about singer Tracy Nelson, directed by Danny Seymour.
Travels to La Luz, New Mexico, where he and assistant Danny Lyon film the First Alloy Conference, a discussion of alternatives to mainstream urban existence.
June–December Writes a column, "Letter from New York," for *Creative Camera* (London).
October Assisted by Danny Lyon, films the documentary *Liferaft Earth* at the "Hunger Show," a group hunger strike organized in Hayward, California, by Stewart Brand and the Portola Institute.
Begins the film *About Me: A Musical;* receives grant in 1970 from the American Film Institute; completed 1971.
Separates from and later divorces Mary Frank.

1970 **October** Buys a house in Mabou, Nova Scotia, with artist June Leaf.

1971 Cinematographer for *Home is Where the Heart is,* a film by Danny Seymour.

Begins to use a Canon Super-8 film camera that June Leaf brings from Japan.
Filmmaking grant from the Creative Artist Public Service Program of New York.
October Teaches a filmmaking class at the Visual Studies Workshop, Rochester, New York, and makes a film with students using 8 mm and Super-8 cameras, titled *About Us* (until February 1972).

1972 *The Lines of My Hand,* a retrospective book made by Frank, is published in a limited edition by Kazuhiko Motomura, Tokyo. Lustrum Press, New York, publishes a different version.
May Makes photographs for cover and sleeves of The Rolling Stones album *Exile on Main Street.* Begins to use a Polaroid Land pack film camera.
June The Rolling Stones commission a film, later titled *Cocksucker Blues,* documenting their North American Tour.

1973 **May** Disappearance and presumed death of friend and colleague Danny Seymour.
Fall Teaches filmmaking at the Nova Scotia College of Art and Design, Halifax.

1974 **28 December** Daughter Andrea dies in an airplane crash near Tikal, Guatemala.

1975 Marries June Leaf.
Teaches filmmaking at the University of California, Davis.
Buys a Lurecamera, an inexpensive camera loaded with 16mm color film, and begins to make collages with text and multiple photographs.
Summer Receives a grant from the Canada Council to make the film *Keep Busy* near his home in Mabou.

1976 **January** Teaches a class at the Newfoundland Independent Filmmaker's Cooperative in St. John's, Newfoundland.
Begins to use a professional Model 195 Polaroid pack film camera with Type 665 Positive / Negative film.

1977 **January** With Sid Kaplan, begins printing multiple Polaroid negatives on one sheet of paper; first is *Mabou,* 1977.
Begins the film *Life Dances On…* (completed in 1980).
Funded by the Corporation for Public Broadcasting, travels with writer Rudy Wurlitzer and filmmaker Gary Hill to Utah to film *Energy and How to Get It.*

1982 **July** Films a documentary titled *This Song for Jack* for the twenty-fifth anniversary celebration of the publication of Jack Kerouac's *On the Road.*

1983 **November** Makes video *Home Improvements* (completed March 1985).

1984 **January** Begins work on a collaborative project, conceived and funded by the Polaroid Corporation, which never materializes, with photographers Robert Heinecken, David Heath and John Wood in Massachusetts.
July Photographs the Democratic National Convention in San Francisco for *California.*

1985 **June** Awarded the Erich Salomon Prize by the Deutsche Gesellschaft für Photographie in Berlin.

1986 **March** On the occasion of a retrospective exhibition at the Museum of Fine Arts, Houston, the documentary *Fire in the East: A Portrait of Robert Frank,* directed by Philip and Amy Brookman is broadcast on public television.
Begins work on film *Candy Mountain* (completed 1987).

1987 **March** Awarded the 1986 Peer Award for "Distinguished Career in Photography" by The Friends of Photography in San Francisco.
December Commissioned by the *Birmingham News* and the Birmingham Museum of Art, photographs in Birmingham, Alabama, as part of a project to document the city.

1988 Commissioned to photograph the Alberto Aspesi shirt collection.

1989 **March** Revised, enlarged edition of *The Lines of My Hand* is published by Parkett/Der Alltag in Zurich.
Makes video *Run* for the band New Order.
September–October Films *Hunter* in the Ruhrgebiet, West Germany.

1990 **April** The Robert Frank Collection established at National Gallery of Art, Washington, with a large gift from Frank of negatives, contact sheets, work prints, and exhibition prints.
26 July Commissioned by the French television station La Sept, makes a one hour video titled *C'est Vrai! (One Hour)* with Michal Rovner. Excerpts are published in 1992 as *One Hour* by Hanuman Press.

1991 **June** Makes a short film for the clothing designer Romeo Gigli in Florence, Italy, assisted by cinematographer Kevin Kerslake.
September–October Films *Last Supper* (completed February 1992).
November Photographs in Beirut, Lebanon, for a project organized by Dominique Eddé.

1993 Travels to Egypt, begins work on a film with Dominique Eddé and Dina Haidar.

1994 **April** Travels to Hokkaido, Japan.

Compiled by Paul Roth

LIST OF SELECTED EXHIBITIONS
OF PHOTOGRAPHS AND FILMS

1950 **2 August–17 September** *51 American Photographers,* The Museum of Modern Art, New York (3 photographs)

1951 **29 April–9 May** *Robert Frank, Ben Schultz, W. Eugene Smith,* Tibor de Nagy Gallery, New York (photographs)

1953 **27 May–2 August** *Post-War European Photography,* The Museum of Modern Art, New York (22 photographs)

1955 **26 January–8 May** *The Family of Man,* The Museum of Modern Art, New York (7 photographs)
 5 March–17 April *Photographie als Ausdruck,* Helmhaus Zurich (photographs)

1961 **28 April–11 June** *Robert Frank, Photographer,* The Art Institute of Chicago (71 photographs)

1962 **29 January–1 April** *Photographs by Harry Callahan and Robert Frank,* The Museum of Modern Art, New York (81 photographs, 1 film)

1964 **25 May–23 August** *The Photographer's Eye,* The Museum of Modern Art, New York (6 photographs)

1966 **28 March–15 April** *Robert Frank,* Hall Memorial Gallery, Murray State College, Murray, Kentucky (organized by George Eastman House, International Museum of Photography, Rochester, New York) (25 photographs; travels through 1980)

1967 **8 January–12 February** *12 Photographers of the American Social Landscape,* Rose Art Museum, Brandeis University, Waltham, Massachusetts (27 photographs)

1969 **26 May–29 June** *Robert Frank,* Philadelphia Museum of Art (86 photographs)

1974 **20 October–5 January 1975** *Photographie in der Schweiz—1840 bis heute,* Kunsthaus Zurich (40 photographs)

1976 **29 February–25 April** *Robert Frank,* Photo-Galerie, Kunsthaus Zurich (52 photographs)

1977 **12 February–12 March** *Appearances,* Marlborough Gallery, New York (6 photographs)
 5–29 October *Robert Frank,* Yajima/Galerie, Montréal (30 photographs)

1978 **20 January–26 March** *Robert Frank,* The Photo Gallery, Still Photography Division, National Film Board of Canada, Ottawa (78 photographs, 1 film)
 15 February–25 March *Robert Frank: Photography and Films, 1945–1977,* Mary Porter Sesnon Art Gallery, University of California, Santa Cruz (85 photographs, 7 films)

1979 **1–24 February** *Robert Frank: The Americans and New York Photographs,* Sidney Janis Gallery, New York (112 photographs)
 25 March–6 May *Robert Frank: Photographer/ Filmmaker, Works from 1945–1979,* Long Beach Museum of Art, Long Beach, California (129 photographs, 6 films)
 16 June–16 September *Robert Frank,* part of *Venezia '79—La Fotografia,* Padiglione Centrale, Venice (150 photographs)
 6 November–8 December *Robert Frank,* Galerie Zabriskie, Paris (70 photographs)

1980 **9 February–8 March** *Robert Frank: Photographs,* Stills Gallery, Edinburgh (48 photographs)

16–28 September *New American Filmmakers Series: Robert Frank,* Whitney Museum of American Art, New York (7 films)

1981 **21 January–15 March** *Walker Evans and Robert Frank: An Essay on Influence,* Yale University Art Gallery, New Haven (25 photographs)
10 April–6 May *Robert Frank,* Blue Sky Gallery, Portland, Oregon (photographs and films)
28 July–5 September *Robert Frank Forward: An Exhibition Tracing the Influence of Robert Frank,* Fraenkel Gallery, San Francisco (photographs)

1984 **18 October–24 November** *Robert Frank: Conventions 1956 and 1984,* Pace/MacGill Gallery, New York (16 photographs)

1985 **19 March–28 April** *Visions of Hope and Despair: Robert Frank's Black-and-White Photographs,* Stanford University Museum of Art (162 photographs)
29 March–10 May *Robert Frank: Fotografias/ Films 1948–1984,* Sala Parpalló, València (150 photographs, 3 films)
15 November–5 January 1986 *Robert Frank and American Politics,* Akron Art Museum (16 photographs)

1986 **15 February–26 April** *Robert Frank: New York to Nova Scotia,* Museum of Fine Arts, Houston (165 photographs, 13 films)
24 April–9 June *Robert Frank: Etats d'urgence,* Centre National de la Photographie, Palais de Tokyo, Paris (photographs and 6 films)
16 October–29 November *Robert Frank,* Pace/MacGill Gallery, New York (38 photographs)

1988 **10 March–4 September** *Birmingham 1988: The Birmingham News Centennial Photographic Collection,* Birmingham Museum of Art (5 photographs)
29 April–2 June *In the Margins of Fiction: The Films of Robert Frank,* American Film Institute, John F. Kennedy Center for the Performing Arts, Washington (organized by the Washington Project for the Arts) (17 films)
13–28 August *42nd Edinburgh International Film Festival,* Filmhouse, Edinburgh (14 films)
5 October–31 December *Dryden Theatre Series,* George Eastman House, International Museum of Photography, Rochester, New York (8 films)
5–20 November *Robert Frank,* Encontros de Fotografia de Coimbra (33 photographs)
16 November–8 January 1989 *The Lines of My Hand,* Museum für Gestaltung Zurich (photographs)

1990 **22–29 September** *Robert Frank, part of Riminicinema,* Mostra Internazionale, Rimini, Italy (photographs and 16 films)

1993 **3 February–12 April** *Beyrouth: Centre Ville,* Centre National de la Photographie, Palais de Tokyo, Paris (photographs)
23 April–1 May *Images 93 Festival of Independent Film and Video,* Euclid Theater, Toronto (films)
10 September–10 October *Robert Frank and the Everyday,* Presentation House and Pacific Cinémathèque, Vancouver (27 photographs, 9 films)

1994 **2 October–31 December** *Robert Frank: Moving Out,* National Gallery of Art, Washington (159 photographs, 21 films and videos).

LIST OF FILMS

Pull My Daisy
G-String Productions, 1959
16mm, black-and-white, 28 minutes
United States
Directed by Robert Frank and
Alfred Leslie
Produced by Walter Gutman
Cinematography by Robert Frank
Edited by Leon Prochnik,
Robert Frank, and Alfred Leslie
Script based on the third act
of the play *The Beat Generation*
by Jack Kerouac
Narration improvised by Jack Kerouac
Principal cast: Richard Bellamy,
Allen Ginsberg, Peter Orlovsky,
Gregory Corso, Larry Rivers,
Delphine Seyrig, David Amram,
Alice Neel, Sally Gross, Denise Parker,
and Pablo Frank

The Sin of Jesus
An Off-Broadway Production, 1961
35mm, black-and-white, 40 minutes
United States
Directed by Robert Frank
Produced by Walter Gutman
Cinematography by Gert Berliner
Edited by Robert Frank and
Ken Collins
Script by Howard Shulman
based on a story by Isaac Babel
Principal cast: Julie Bovasso, John Coe,
Roberts Blossom, St. George Brian,
and Telly Savalas

O.K. End Here
September 20 Productions, 1963
35mm, black-and-white, 30 minutes
United States
Directed by Robert Frank
Produced by Edwin Gregson
Cinematography by Gert Berliner
Edited by Aram Avakian
Script by Marion Magid
Principal cast: Martino La Salle,
Sue Ungaro, Sudie Bond, Anita Ellis,
and Joseph Bird

Me and My Brother
Two Faces Company, 1965–1968
35mm, black-and-white and color,
91 minutes
United States
Directed and cinematography
by Robert Frank
Produced by Helen Silverstein
Edited by Robert Frank,
Helen Silverstein, Bob Easton,
and Lynn Ratener
Script by Robert Frank, Sam Shepard,
Allen Ginsberg
Principal cast: Julius Orlovsky, Joseph
Chaikin, John Coe, Allen Ginsberg,
Peter Orlovsky, Virginia Kiser, Nancy
Fish, Cynthia McAdams, Roscoe Lee
Browne, Christopher Walken, and
Gregory Corso

Conversations in Vermont
Dilexi Foundation, 1969
16mm, black-and-white, 26 minutes
United States
Directed, produced, and script
by Robert Frank
Cinematography by Ralph Gibson
and Robert Frank
Principal cast: Robert, Pablo,
and Andrea Frank

Liferaft Earth
A Sweeney Production, 1969
16mm, color and black-and-white,
37 minutes
United States
Produced, directed, and cinemato-
graphy by Robert Frank,
assisted by Danny Lyon
Edited by Susan Obenhaus
Principal cast: Robert Frank,
Danny Lyon, Hugh Romney, and
Stewart Brand

About Me: A Musical, 1971
16mm, black-and-white, 35 minutes
United States
Directed, produced and script by
Robert Frank
Cinematography by Danny Seymour
and Robert Frank
Principal cast: Lynn Reyner,
Jaime deCarlo Lotts, Robert Schlee,
Sheila Pavlo, Bill Hart, Vera Cochran,
Sid Kaplan, June Leaf, Allen Ginsberg,
and Hugh Romney

Cocksucker Blues
Rolling Stones Presentation, 1972
16mm, black-and-white and color,
90 minutes
United States
Directed by Robert Frank
Produced by Marshall Chess
Cinematography by Robert Frank
and Danny Seymour
Edited by Robert Frank, Paul Justman,
and Susan Steinberg
Principal cast: Mick Jagger,
Keith Richard, and Danny Seymour

Keep Busy, 1975
16mm, black-and-white, 38 minutes
Canada
Directed by Robert Frank and
Rudy Wurlitzer
Produced by Canada Council
Cinematography by Robert Frank
Script by Rudy Wurlitzer
Principal cast: June Leaf, Joan Jonas,
Richard Serra, Joanne Akolitis, and
John Dan MacPherson

Life Dances On..., 1980
16mm, black-and-white and color,
30 minutes
United States
Directed and produced
by Robert Frank
Cinematography by Robert Frank,
Danny Seymour, Gary Hill
Edited by Gary Hill
Principal cast: Pablo Frank,
Sandy Strawbridge, Marty Greenbaum,
Billy, Finley Fryer, and June Leaf

Energy and How to Get It, 1981
16mm, black-and-white, 28 minutes
United States
Directed and produced by
Robert Frank, Rudy Wurlitzer,
and Gary Hill
Cinematography by Robert Frank
and Gary Hill
Edited by Gary Hill
Script by Rudy Wurlitzer
Principal cast: Robert Golka,
Agnes Moon, Rudy Wurlitzer,
William S. Burroughs, John Giorno,
Robert Downey, Lynne Adams, Alan
Moyle, Dr. John, and Libby Titus

This Song for Jack, 1983
16mm, black-and-white, 30 minutes
United States
Directed, produced, and cinemato-
graphy by Robert Frank
Edited by Sam Edwards
Principal cast: Allen Ginsberg,
Gregory Corso, William S. Burroughs,
and David Amram

Home Improvements, 1985
videotape, color, 29 minutes
and 20 seconds
United States
Directed and produced
by Robert Frank
Cinematography by Robert Frank,
June Leaf
Edited by Michael Biachi and
Sam Edwards
Principal cast: Pablo Frank, June Leaf,
and Robert Frank

Candy Mountain
Xanadu Film / Les Films
Plain – Chant / Les Films Vision 4 Inc.,
1987
35mm, color, 91 minutes
Switzerland, France, and Canada
Directed by Robert Frank,
Rudy Wurlitzer
Produced by Ruth Waldburger
Cinematography by Pio Corradi
Edited by Jennifer Auge
Script by Rudy Wurlitzer
Principal cast: Kevin O'Connor,
Harris Yulin, Tom Waits, Bulle Ogier,
Roberts Blossom, Leon Redbone,
Dr. John, Laurie Metcalf,
Rita MacNeil, Joe Strummer,
Arto Lindsay, David Johansen,
and Emile de Antonio

Hunter
Kinemathek im Ruhrgebiet, project of
the Kulturstiftung Ruhr, Essen, 1989
16mm, black-and-white and color,
37 minutes
Germany
Directed by Robert Frank
Produced by Paul Hofmann
Cinematography by
Clemens Steiger, Bernhard Lehner,
and Robert Frank (video)
Edited by Julie Gorchov
Script by Stephan Balint and
Robert Frank
Principal cast: Stephan Balint and
Günter Burchert

C'est Vrai! (One Hour)
LA SEPT, Prony Production,
Paris, 1990
videotape, color, 60 minutes
France
Directed and cinematography
by Robert Frank
Produced by Philippe Grandrieux
Script by Robert Frank,
Michal Rovner
Principal cast: Kevin O'Connor,
Peter Orlovsky, Taylor Mead,
Willoughby Sharp, Bill Rice,
Tom Jarmusch, Zsigmond Kirschen,
Sid Kaplan, Odessa Taft, Sarah Penn,
and Margo Grib

Last Supper
Vega Film, Zurich / World Wide
International Television, 1992
16mm, color, 52 minutes
Switzerland and Great Britain
Directed by Robert Frank,
assisted by Michal Rovner
Produced by Ruth Waldburger,
Martin Rosenbaum
Edited by Jay Rabinow
Cinematography by Kevin Kerslake,
Mustapha Barat (video),
Robert Frank (video)
Script by Sam North, Robert Frank,
Michal Rovner
Principal cast: Zohra Lampert,
Bill Youmans, Bill Rice, Taylor Mead,
John Larkin, and Odessa Taft

Moving Pictures, 1994
videotape, color and black-and-white,
16 minutes and 30 seconds, silent
United States
by Robert Frank
Edited by Laura Israel
Collected footage of Allen Ginsberg,
Raoul Hague, Harry Smith, and
June Leaf, amongst others

LIST OF WORKS EXHIBITED

About Fate, Mabou, Nova Scotia, 1987
mixed media with internal dye
diffusion-transfer (Polaroid) prints
41.9 x 29.8 cm (16¹/₂ x 11³/₄)
Michal Rovner (pages 134–135)

Albisgüetli, Zurich, 1945
silver gelatin developed-out print
38.7 x 36.7 cm (15¹/₄ x 14⁷/₁₆)
Collection of the artist (page 15)

Allen Ginsberg, Peter Orlovsky,
Kansas City, 1966
silver gelatin developed-out print
24.8 x 35.2 cm (9³/₄ x 13⁷/₈)
Collection of the artist (page 213)

Andrea, 1975
mixed media with silver gelatin
developed-out prints
27.9 x 35.4 cm (11 x 13¹⁵/₁₆)
Collection of the artist (page 243)

Andrea and Pablo, 1955–1956
silver gelatin developed-out print
31.9 x 21.2 cm (12⁹/₁₆ x 8³/₈)
Collection of the artist (page 169)

Andrea and Pablo, Hollywood,
1955–1956
silver gelatin developed-out print
11 x 16.3 cm (4⁵/₁₆ x 6⁷/₁₆)
National Gallery of Art, Washington,
Robert Frank Collection, Gift of
Robert Frank (page 212)

Andrea, Mabou, 1977
silver gelatin developed-out print
50.5 x 40.7 cm (19⁷/₈ x 16)
National Gallery of Art, Washington,
Robert Frank Collection,
Anonymous Gift (page 239)

Arequipa, Peru, 1948
silver gelatin developed-out print
21.8 x 33.2 cm (8⁹/₁₆ x 13¹/₁₆)
National Gallery of Art, Washington,
Robert Frank Collection, Gift (Partial
and Promised) of Robert Frank in
Honor of the 50th Anniversary of the
National Gallery of Art (page 56)

Astor Place, New York City, 1949
silver gelatin developed-out print
21.6 x 33 cm (8¹/₂ x 13)
National Gallery of Art, Washington,
Robert Frank Collection, Gift of the
Glen Eagles Foundation (page 38)

Avenue du Maine, Paris, 1949–1950
silver gelatin developed-out print
34 x 22.5 cm (13³/₈ x 8⁷/₈)
National Gallery of Art, Washington,
Robert Frank Collection, Gift of
Mr. and Mrs. Ricard R. Ohrstrom and
the Mars Foundation (page 69)

Bankers/London, 1951
silver gelatin developed-out print
22.4 x 33.3 cm (8¹³/₁₆ x 13¹/₈)
Collection of the artist, Courtesy
Pace/MacGill Gallery, New York
(page 88)

Bar—New York City, 1955
silver gelatin developed-out print
32.1 x 47.8 cm (12⁵/₈ x 18¹³/₁₆)
Philadelphia Museum of Art,
Purchased with Funds Given by
Dorothy Norman (page 185)

Barber Shop through Screen Door—
McClellanville, South Carolina, 1955
silver gelatin developed-out print
27.5 x 41 cm (10¹³/₁₆ x 16¹/₈)
The Museum of Modern Art,
New York, John Spencer Fund
(page 182)

Beaufort, South Carolina, 1955
silver gelatin developed-out print
27.5 x 41.8 cm (10¹³/₁₆ x 16⁷/₁₆)
Eugene M. Schwartz Associates, Inc.
(page 199)

Boston, March 20, 1985, 1985
six dye diffusion-transfer (Polaroid)
prints with mixed media
each: 70.5 x 56.5 cm (27³/₄ x 22¹/₄)
The Museum of Modern Art,
New York, Purchased as the gift of
Polaroid Corporation (pages 260–261)
Exhibited in Washington and
New York City only

Boys/Valencia, 1952
silver gelatin developed-out print
34.8 x 23.5 cm (13¹¹/₁₆ x 9¹/₄)
Collection of the artist (page 92)

Brattleboro, Vermont,
December 25th, 1979, 1979
mixed media with silver gelatin
developed-out prints
27.9 x 34.9 cm (11 x 13³/₄)
National Gallery of Art, Washington,
Robert Frank Collection, Gift of the
Ann and Gordon Getty Foundation
(page 257)

Caerau, Wales, 1953
silver gelatin developed-out print
21.1 x 32.5 cm (8⁵/₁₆ x 12¹³/₁₆)
National Gallery of Art, Washington,
Robert Frank Collection,
Anonymous Gift in Honor of the
50th Anniversary of the National
Gallery of Art (pages 82–83)

Car Accident—U.S. 66, between
Winslow and Flagstaff, Arizona, 1955
silver gelatin developed-out print
22.5 x 33.7 cm (8⁷/₈ x 13¹/₄)
The Art Institute of Chicago, Photo
Gallery Restricted Gift Fund
(page 188)

Central Park South, 1948
silver gelatin developed-out print
33.7 x 26.2 cm (13¹/₄ x 10⁵/₁₆)
National Gallery of Art, Washington,
Robert Frank Collection, Gift of
Robert Frank (page 29)

Charleston, South Carolina, 1955
silver gelatin developed-out print
29.7 x 41.3 cm (11¹¹/₁₆ x 16¹/₄)
Eugene M. Schwartz Associates, Inc.
(page 197)

Chauffeur / London, 1951
silver gelatin developed-out print
22 x 33.1 cm (8¹¹/₁₆ x 13¹/₁₆)
National Gallery of Art, Washington,
Robert Frank Collection, Gift (Partial
and Promised) of Robert Frank, in
Honor of the 50th Anniversary of the
National Gallery of Art (page 94)

City Fathers—Hoboken, New Jersey,
1955
silver gelatin developed-out print
29.9 x 41.6 cm (11³/₄ x 16³/₈)
Eugene M. Schwartz Associates, Inc.
(page 176)

City of London, 1951
silver gelatin developed-out print
23.3 x 15.4 cm (9³/₁₆ x 6¹/₁₆)
National Gallery of Art, Washington,
Robert Frank Collection, Gift of
The Howard Gilman Foundation, in
Honor of the 50th Anniversary of the
National Gallery of Art (page 78)

City of London, 1951
silver gelatin developed-out print
23 x 33.6 cm (9¹/₈ x 13¹/₄)
National Gallery of Art, Washington,
Robert Frank Collection, Gift of
The Howard Gilman Foundation, in
Honor of the 50th Anniversary of the
National Gallery of Art (page 79)

Coney Island, 1947–1951
silver gelatin developed-out print
22.4 x 34.3 cm (8¹³/₁₆ x 13¹/₂)
Collection of the artist (page 36)

Coney Island July 4th 1958, 1958
silver gelatin developed-out print
40.6 x 27.1 cm (16 x 10¹¹/₁₆)
National Gallery of Art, Washington,
Robert Frank Collection, Gift of the
Richard Florsheim Art Fund
(page 202)

Coney Island July 4th 1958, 1958
silver gelatin developed-out print
41.3 x 29.9 cm (16¹/₄ x 11³/₄)
Collection of the artist (page 203)

Contact Sheet #27, 1955
silver gelatin developed-out print
with grease pencil and ink
25.2 x 20.2 cm (9¹⁵/₁₆ x 7¹⁵/₁₆)
National Gallery of Art, Washington,
Robert Frank Collection, Gift of
Robert Frank (page 173)

Contact sheet #340, 1955
silver gelatin developed-out print
with grease pencil
25.4 x 20.5 cm (10 x 8¹/₁₆)
National Gallery of Art, Washington,
Robert Frank Collection, Gift of
Robert Frank (page 172)

Conversations in Vermont, 1969
silver gelatin developed-out print
26.8 x 26.4 cm (10⁹/₁₆ x 10³/₈)
Fotomuseum Winterthur, Switzerland
(page 227)

Couple / Paris, 1952
silver gelatin developed-out print
19.1 x 33.2 cm (7¹/₂ x 13¹/₁₆)
National Gallery of Art, Washington,
Robert Frank Collection, Gift (Partial
and Promised) of Robert Frank, in
Honor of the 50th Anniversary of the
National Gallery of Art (page 89)

Covered Car—Long Beach, California,
1955–1956
silver gelatin developed-out print
19.7 x 29.2 cm (7³/₄ x 11¹/₂)
The Art Institute of Chicago, Photo
Gallery Restricted Gift Fund
(page 187)

Danny Seymour, 1972
silver gelatin developed-out prints,
25.1 x 68.2 cm (9⁷/₈ x 26⁷/₈),
National Gallery of Art, Washington,
Robert Frank Collection,
Anonymous Gift (pages 224–225)

Democratic National Convention, 1956
silver gelatin developed-out print
49.4 x 33.3 cm (19⁷/₁₆ x 13¹/₈)
Collection of Pace/MacGill Gallery,
New York (page 180)

Democratic National Convention,
Chicago, 1956
silver gelatin developed-out print
34 x 23.2 cm (13³/₈ x 9¹/₈)
The Art Institute of Chicago, Photo
Gallery Restricted Gift Fund
(page 180)

Detroit, 1955
silver gelatin developed-out print
32.9 x 21.6 cm (12¹⁵/₁₆ x 8¹/₂)
National Gallery of Art, Washington,
Robert Frank Collection,
Anonymous Gift (page 168)

Doll, New York, 1949
silver gelatin developed-out print
34.8 x 21.3 cm (13¹¹/₁₆ x 8³/₈)
Collection of the artist (page 34)

Egypt, 1992
silver gelatin developed-out print
25.4 x 31.3 cm (10 x 12⁵/₁₆)
Collection of the artist (page 299)

Egypt, 1992
silver gelatin developed-out print
23.5 x 31.1 cm (9¹/₄ x 12¹/₄)
Collection of the artist (page 299)

Elevator—Miami Beach, 1955
silver gelatin developed-out print
29.5 x 43.5 cm (11⁵/₈ x 17¹/₈)
National Gallery of Art, Washington,
Robert Frank Collection, Gift of Lois
and Georges de Ménil and Amy Rose
(page 191)

11th Street and Broadway, 1951
silver gelatin developed-out print
32.5 x 26.7 cm (12¹³/₁₆ x 10¹/₂)
National Gallery of Art, Washington,
Robert Frank Collection, Gift of
Robert Frank (page 32)

Elizabethtown, North Carolina, 1955
silver gelatin developed-out print
34.1 x 23.3 cm (13⁷/₁₆ x 9³/₁₆)
Collection of the artist (page 178)

End of Dream, 1992
silver gelatin developed-out prints with
internal dye diffusion-transfer Polaroid
prints and enamel-type paint
49.7 x 121.4 cm (19⁹/₁₆ x 47¹³/₁₆)
Collection of the artist
(pages 267–269)

Fear—No Fear, 1988
silver gelatin developed-out prints
114.6 x 50.5 cm (45¹/₈ x 19⁷/₈)
Collection of the artist, Courtesy
Pace/MacGill Gallery, New York
(page 139)

Ford Plant, 1955
silver gelatin developed-out print
35.2 x 23.2 cm (13⁷/₈ x 9¹/₈)
National Gallery of Art, Washington,
Robert Frank Collection, Gift of
Lois and Georges de Ménil (page 190)

14th Street White Tower,
New York City, 1948
silver gelatin developed-out print
22.6 x 34.1 cm (8⁷/₈ x 13³/₈)
National Gallery of Art, Washington,
Robert Frank Collection, Gift of the
Glen Eagles Foundation (page 33)

Fourth of July—Jay, New York, 1954
silver gelatin developed-out print
33.7 x 22.2 cm (13¹/₄ x 8³/₄)
The Art Institute of Chicago, Photo
Gallery Restricted Gift Fund
(page 183)

From the Bus, New York, 1958
silver gelatin developed-out print
35.4 x 33.7 cm (13¹⁵/₁₆ x 13¹/₄)
National Gallery of Art, Washington,
Robert Frank Collection,
Anonymous Gift (page 205)

From the Bus, New York, 1958
silver gelatin developed-out print
35.2 x 27.5 cm (13⁷/₈ x 10¹³/₁₆)
National Gallery of Art, Washington,
Robert Frank Collection,
Anonymous Gift (page 206)

From the Bus, New York, 1958
silver gelatin developed-out print
35.2 x 27.3 cm (13⁷/₈ x 10³/₄)
National Gallery of Art, Washington,
Robert Frank Collection,
Anonymous Gift (page 206)

From the Bus, New York, 1958
silver gelatin developed-out print
35.4 x 27.3 cm (13 ¹⁵/₁₆ x 10 ³/₄)
National Gallery of Art, Washington,
Robert Frank Collection,
Anonymous Gift (page 207)

From the Bus, New York, 1958
silver gelatin developed-out print
35.2 x 27.2 cm (13 ⁷/₈ x 10 ¹¹/₁₆)
National Gallery of Art, Washington,
Robert Frank Collection,
Anonymous Gift (page 207)

Funeral / Paris, 1951–1952
silver gelatin developed-out print
22.1 x 33.3 cm (8 ¹¹/₁₆ x 13 ¹/₈)
Collection of the artist, Courtesy
Pace / MacGill Gallery, New York
(page 94)

Funeral—St. Helena, South Carolina,
1955
silver gelatin developed-out print
31.1 x 47.6 cm (12 ¹/₄ x 18 ³/₄)
Philadelphia Museum of Art,
Purchased with Funds Given by
Dorothy Norman (page 178)

Gallup Motel, 1955
silver gelatin developed-out print
14.9 x 42.2 cm (5 ⁷/₈ x 16 ⁵/₈)
Collection of the artist
(pages 170–171)

Giles Groulx, Mabou, Nova Scotia, 1978
mixed media with chromogenic prints
and silver gelatin developed-out print
50.6 x 40.8 cm (19 ¹⁵/₁₆ x 16 ¹/₁₆)
National Gallery of Art, Washington,
Robert Frank Collection, Gift of
Robert Frank (page 247)

*Goodbye Mr. Brodovitch I'm Leaving
New York, December 23rd, 1971 OK?,*
1971
silver gelatin developed-out print
40.9 x 50.6 cm (16 ¹/₈ x 19 ¹⁵/₁₆)
National Gallery of Art, Washington,
Robert Frank Collection, Gift of
Robert Frank (pages 228–229)

Halifax Infirmary, 1978
silver gelatin developed-out print
with oil-type paint
50.5 x 40.6 cm (19 ⁷/₈ x 16)
National Gallery of Art, Washington,
Robert Frank Collection,
Anonymous Gift (page 253)

Hoboken, New Jersey, 1955
silver gelatin developed-out print
39.1 x 58.4 cm (15 ³/₈ x 23)
Collection of the artist (title page)

Hold Still—Keep Going, 1989
silver gelatin developed-out print
with acrylic paint
50.3 x 40.3 cm (19 ¹³/₁₆ x 15 ⁷/₈)
National Gallery of Art, Washington,
Robert Frank Collection, Gift of the
Collectors Committee (page 141)

Hollywood, 1958
silver gelatin developed-out print
34.3 x 23.7 cm (13 ¹/₂ x 9 ⁵/₁₆)
Collection of the artist, Courtesy
Pace / MacGill Gallery, New York
(page 167)

Home Improvements, 1985
five dye diffusion-transfer (Polaroid)
prints with mixed media
each: 56.5 x 66 cm (22 ¹/₄ x 26)
Museum of Fine Arts, Houston
(pages 263–265)

Hoover Dam, Nevada, 1955
silver gelatin developed-out print
46.2 x 30.9 cm (18 ³/₁₆ x 12 ³/₁₆)
National Gallery of Art, Washington,
Robert Frank Collection, Gift of the
Evelyn and Walter Haas, Jr. Fund
(page 168)

I Want to Escape, 1993
silver gelatin developed-out prints
50.3 x 80.2 cm (19 ¹³/₁₆ x 31 ⁹/₁₆)
Collection of Pace / MacGill Gallery,
New York (pages 292–293)

*In Mabou—Wonderful Time—With
June,* 1977
mixed media with chromogenic prints
40.8 x 48.7 cm (16 ¹/₁₆ x 19 ³/₁₆)
Collection of the artist, Courtesy
Pace / MacGill Gallery, New York
(pages 248–249)

*In Switzerland, 1944–46 —> to
America, 1947,* 1941–1947
silver gelatin developed-out print
31.6 x 31.3 cm (12 ⁷/₁₆ x 12 ⁵/₁₆)
National Gallery of Art, Washington,
Robert Frank Collection, Gift of the
Glen Eagles Foundation (page 14)

Indianapolis, 1956
silver gelatin developed-out print
28.4 x 40.8 cm (11 ³/₁₆ x 16 ¹/₁₆)
Eugene M. Schwartz Associates, Inc.
(page 195)

Iuka, Mississippi, 1955
silver gelatin developed-out print
21.6 x 31.9 cm (8 ¹/₂ x 12 ⁹/₁₆)
Collection of the artist (page 192)

Jack Kerouac, 1958
silver gelatin developed-out print
22.1 x 33.3 cm (8$^{11}/_{16}$ x 13$^1/_8$)
Collection of the artist, Courtesy
Pace/MacGill Gallery, New York
(page 212)

Landscape/Peru, 1948
silver gelatin developed-out print
21.9 x 33.2 cm (8$^5/_8$ x 13$^1/_{16}$)
National Gallery of Art, Washington,
Robert Frank Collection, Gift (Partial
and Promised) of Robert Frank, in
Honor of the 50th Anniversary of the
National Gallery of Art (page 95)

Lebanon, 1991
silver gelatin developed-out print
21.4 x 33 cm (8$^7/_{16}$ x 13)
Collection of the artist
(pages 294–295)

Lebanon, 1991
silver gelatin developed-out print
33.6 x 22.6 cm (13$^1/_4$ x 8$^7/_8$)
Collection of the artist (page 296)

Lebanon, 1991
silver gelatin developed-out print
29.5 x 22.5 cm (11$^5/_8$ x 8$^7/_8$)
Collection of the artist (page 297)

London, 1951
silver gelatin developed-out print
34.6 x 23.3 cm (13$^5/_8$ x 9$^1/_8$)
National Gallery of Art, Washington,
Robert Frank Collection,
Anonymous Gift (page 130)

London, 1952–1953
silver gelatin developed-out print
22.9 x 34 cm (9 x 13$^3/_8$)
Collection of Pace/MacGill Gallery,
New York (page 77)

London, 1952–1953
silver gelatin developed-out print
27.3 x 39.9 cm (10$^3/_4$ x 15$^{11}/_{16}$)
National Gallery of Art, Washington,
Robert Frank Collection, Gift of
Robert Frank (page 81)

London, 1952–1953
silver gelatin developed-out print
32.9 x 21.6 cm (12$^{15}/_{16}$ x 8$^1/_2$)
Collection of the artist (page 82)

Look Out For Hope,
Mabou—New York City, 1979
silver gelatin developed-out print
with ink
60.7 x 50.6 cm (23$^7/_8$ x 19$^{15}/_{16}$)
National Gallery of Art, Washington,
Robert Frank Collection, Gift of the
Evelyn and Walter Haas, Jr. Fund
(page 245)

Los Angeles, 1955–1956
silver gelatin developed-out print
33 x 21.9 cm (13 x 8$^5/_8$)
The Museum of Modern Art,
New York, Purchase (page 193)

Los Angeles—February 4th—I Wake
Up—Turn On TV, 1979
silver gelatin developed-out print
50.5 x 36.4 cm (19$^7/_8$ x 14$^5/_{16}$)
National Gallery of Art, Washington,
Robert Frank Collection,
Anonymous Gift (page 254)

Lucien and Sheila, 1978
silver gelatin developed-out print
17.5 x 41.4 cm (6$^7/_8$ x 16$^5/_{16}$)
Collection of the artist
(pages 214–215)

Mabou, 1971
silver gelatin developed-out prints
with masking tape and ink
39 x 58.2 cm (15$^3/_8$ x 22$^{15}/_{16}$)
Canadian Museum of Contemporary
Photography, Ottawa (pages 230–231)

Mabou, c. 1976
mixed media with chromogenic prints
43.8 x 37.8 x .6 cm (17$^1/_4$ x 14$^7/_8$ x $^1/_4$)
Collection of the artist (page 246)

Mabou, 1977
silver gelatin developed-out prints
with marker
50.3 x 80.2 cm (19$^{13}/_{16}$ x 31$^9/_{16}$)
National Gallery of Art, Washington,
Robert Frank Collection, Gift of
Robert Frank (pages 240–241)

Mabou, 1979
silver gelatin developed-out print
with acrylic paint
51.1 x 60.6 cm (20$^1/_8$ x 23$^7/_8$)
National Gallery of Art, Washington,
Robert Frank Collection, Gift of
the Collectors Committee
(pages 258–259)

Mabou, 1991
silver gelatin developed-out print
42.4 x 55.4 cm (16$^{11}/_{16}$ x 21$^{13}/_{16}$)
Collection of the artist (page 131)

Mabou Mines, 1971–1972
silver gelatin developed-out prints with
enamel-type paint and grease pencil
44.1 x 70.2 cm (17$^3/_8$ x 27$^5/_8$)
Collection of Pace/MacGill Gallery,
New York (pages 22–23)

Mabou, Nova Scotia, 1977
silver gelatin developed-out print
31.4 x 47 cm (12³/₈ x 18¹/₂)
National Gallery of Art, Washington,
Robert Frank Collection, Gift of the
Collectors Committee (pages 128–129)

Mabou Winter Footage, 1977
silver gelatin developed-out print
50.4 x 39.4 cm (19¹³/₁₆ x 15¹/₂)
Collection of the artist (page 13)

Mallorca, Spain, 1952
silver gelatin developed-out print
21.5 x 32.1 cm (8⁷/₁₆ x 12⁵/₈)
National Gallery of Art, Washington,
Robert Frank Collection,
Anonymous Gift in Honor of the
50th Anniversary of the National
Gallery of Art (page 72)

Mary, 1959
silver gelatin developed-out print
21.9 x 33 cm (8⁵/₈ x 13)
Collection of the artist, Courtesy
Pace/MacGill Gallery, New York
(page 211)

Mary and Pablo NYC, 1951
silver gelatin developed-out print
22.1 x 33.3 cm (8¹¹/₁₆ x 13¹/₈)
Collection of the artist (page 55)

Folio from *Mary's Book*, 1949–1950
silver gelatin developed-out prints
22.9 x 35.6 cm (9 x 14)
Mary Frank (pages 62–63)

Folio from *Mary's Book*, 1949–1950
silver gelatin developed-out prints
22.9 x 35.6 cm (9 x 14)
Mary Frank (pages 64–65)

Me and My Brother, 1965–1968
bound volume with silver gelatin
developed-out prints and
typewritten text
31.8 x 24.8 x 2.9 cm (12¹/₂ x 9³/₄ x 1¹/₈)
Collection of the artist
(pages 222–223)

Medals, New York, 1951
silver gelatin developed-out print
35.1 x 23.5 cm (13¹³/₁₆ x 9¹/₄)
National Gallery of Art, Washington,
Robert Frank Collection, Gift (Partial
and Promised) of Robert Frank, in
Honor of the 50th Anniversary of the
National Gallery of Art (page 35)

Men of Air, New York, 1947
silver gelatin developed-out print
35.1 x 23.6 cm (13¹³/₁₆ x 9⁵/₁₆)
National Gallery of Art, Washington,
Robert Frank Collection, Gift (Partial
and Promised) of Robert Frank, in
Honor of the 50th Anniversary of the
National Gallery of Art (page 30)

*Mississippi River, Baton Rouge,
Louisiana*, 1955
silver gelatin developed-out print
27.3 x 42.2 cm (10³/₄ x 16⁵/₈)
Eugene M. Schwartz Associates, Inc.
(page 200)

Moving Out, 1984
silver gelatin developed-out prints
with acrylic paint
50.6 x 121.4 cm (19¹⁵/₁₆ x 47¹³/₁₆)
National Gallery of Art, Washington,
Robert Frank Collection,
Anonymous Gift (pages 283–285)

Moving Pictures, 1994
videotape, silent
sixteen minutes and thirty seconds
Collection of the artist

Mute/Blind, 1989
mixed media with chromogenic prints
and thermal transfer prints
104.5 x 81.3 x 5.1 cm (41¹/₈ x 32 x 2)
National Gallery of Art, Washington,
Robert Frank Collection, Gift of Isabel
and Fernando Garzoni, Switzerland, in
Honor of the 50th Anniversary of the
National Gallery of Art (page 289)

Near Victoria Station, London, 1951
silver gelatin developed-out print
33 x 22.1 cm (13 x 8¹¹/₁₆)
National Gallery of Art, Washington,
Robert Frank Collection, Gift of
The Herbert and Nannette Rothschild
Memorial Fund in memory of
Judith Rothschild (page 76)

New Jersey, 1954–1955
silver gelatin developed-out print
21.1 x 30.2 cm (8⁵/₁₆ x 11⁷/₈)
San Francisco Museum of Modern Art,
Gift of Dr. and Mrs. Barry S. Ramer
(page 201)

New York City, 1947
silver gelatin developed-out print
23.3 x 19.1 cm (9³/₁₆ x 7¹/₂)
Collection of the artist (page 27)

New York City, 1947–1951
silver gelatin developed-out print
34.9 x 25.4 cm (13³/₄ x 10)
Collection of Pace/MacGill Gallery,
New York (page 37)

New York City, 1955
silver gelatin developed-out print
41 x 29.9 cm (16¹/₈ x 11³/₄)
Eugene M. Schwartz Associates, Inc.
(page 179)

NYC for A.B., 1947
silver gelatin developed-out print
31.3 x 14.1 cm (12⁵/₁₆ x 5⁹/₁₆)
National Gallery of Art, Washington,
Robert Frank Collection, Gift of the
Glen Eagles Foundation (page 28)

*New York City, 7 Bleecker Street,
September,* 1993
silver gelatin developed-out print
28.6 x 36.4 cm (11⁵/₁₆ x 14³/₈)
National Gallery of Art, Washington,
Robert Frank Collection, Gift of
Robert Frank (cover)

New York Subway, 1953
silver gelatin developed-out print
34.3 x 22.1 cm (13¹/₂ x 8¹¹/₁₆)
Collection of the artist (page 39)

Old Woman/Barcelona, 1952
silver gelatin developed-out print
34.8 x 21.6 cm (13¹¹/₁₆ x 8¹/₂)
Collection of the artist (page 90)

On the Boat to the USA, 1947
silver gelatin developed-out print
33.2 x 26 cm (13¹/₈ x 10¹/₄)
National Gallery of Art, Washington,
Robert Frank Collection, Gift of the
Glen Eagles Foundation (page 21)

Pablo and Sandy, Life Dances On...,
1979
silver gelatin developed-out print
25.4 x 35.1 cm (10 x 13¹³/₁₆)
National Gallery of Art, Washington,
Robert Frank Collection,
Anonymous Gift (page 255)

Pablo in Valencia, 1952
silver gelatin developed-out print
17.4 x 26.2 cm (6⁷/₈ x 10⁵/₁₆)
National Gallery of Art, Washington,
Robert Frank Collection,
Anonymous Gift in Honor of the
50th Anniversary of the National
Gallery of Art (page 73)

Pangnirtung, N.W.T., 1992
silver gelatin developed-out print
58.4 x 25.9 cm (23 x 10³/₁₆)
Collection of the artist (page 291)

*Pangnirtung, N.W.T., Runway for
Airport,* 1992
silver gelatin developed-out print
29.5 x 22.5 cm (11⁵/₈ x 8⁷/₈)
Collection of the artist, Courtesy
Pace/MacGill Gallery, New York
(page 290)

Parade—Hoboken, New Jersey, 1955
silver gelatin developed-out print
31.3 x 47.6 cm (12⁵/₁₆ x 18³/₄)
Philadelphia Museum of Art,
Purchased with Funds Given by
Dorothy Norman (page 175)

Parade/Valencia, 1952
silver gelatin developed-out print
23 x 33.3 cm (9¹/₁₆ x 13¹/₈)
Collection of the artist, Courtesy
Pace/MacGill Gallery, New York
(page 87)

Paris, 1949
silver gelatin developed-out print
21.5 x 32.4 cm (8⁷/₁₆ x 12³/₄)
National Gallery of Art, Washington,
Robert Frank Collection, Gift of the
Prince Charitable Trusts (page 11)

Paris, 1951–1952
silver gelatin developed-out print
21.4 x 32.9 cm (8⁷/₁₆ x 12¹⁵/₁₆)
National Gallery of Art, Washington,
Robert Frank Collection,
Anonymous Gift (page 67)

Paris, 14ème, 1951–1952
silver gelatin developed-out print
23.6 x 15.5 cm (9⁵/₁₆ x 6¹/₈)
Collection of the artist (page 68)

Peru, 1948
silver gelatin developed-out print
23.2 x 35.1 cm (9¹/₈ x 13¹³/₁₆)
Collection of the artist (page 56)

Peru, 1948
silver gelatin developed-out print
23.7 x 33.7 cm (9⁵/₁₆ x 13¹/₄)
Andrew Szegedy-Maszak and
Elizabeth Bobrick (page 57)

Peru, 1948
silver gelatin developed-out print
11 x 34.3 cm (4⁵/₁₆ x 13¹/₂)
National Gallery of Art, Washington,
Robert Frank Collection, Gift of
Robert Frank (pages 58–59)

Peru, 1948
spiral-bound book with silver gelatin
developed-out prints
20 x 26 x 1.6 cm (7⁷/₈ x 10¹/₄ x ⁵/₈)
Collection of the artist (pages 60–61)

Place de l'Etoile, 1951–1952
silver gelatin developed-out print
23.8 x 34.1 cm (9³/₈ x 13⁷/₁₆)
National Gallery of Art, Washington,
Robert Frank Collection, Gift of
Robert Frank (page 66)

Political Rally, Chicago, 1956
silver gelatin developed-out print
47.6 x 31.1 cm (18³/₄ x 12¹/₄)
Philadelphia Museum of Art,
Purchased with Funds Given by
Dorothy Norman (page 177)

Porte Clignancourt, Paris, 1952
silver gelatin developed-out print
20 x 33 cm (7⁷/₈ x 13)
National Gallery of Art, Washington,
Robert Frank Collection, Gift (Partial
and Promised) of Robert Frank, in
Honor of the 50th Anniversary of the
National Gallery of Art (page 71)

Procession/Valencia, 1952
silver gelatin developed-out print
21.9 x 33.2 cm (8⁵/₈ x 13¹/₁₆)
National Gallery of Art, Washington,
Robert Frank Collection, Gift (Partial
and Promised) of Robert Frank, in
Honor of the 50th Anniversary of the
National Gallery of Art (page 88)

Profile/Venice, 1951
silver gelatin developed-out print
23.2 x 33.2 cm (9¹/₈ x 13¹/₁₆)
Collection of the artist (page 93)

Pull My Daisy, 1959
silver gelatin developed-out prints
with grease pencil on paper
31.1 x 24 cm (12¹/₄ x 9⁷/₁₆)
Collection of the artist (page 219)

Pull My Daisy, 1959
silver gelatin developed-out print
42.9 x 29.7 cm (16⁷/₈ x 11¹¹/₁₆)
National Gallery of Art, Washington,
Robert Frank Collection, Gift of
Evelyn Stefansson Nef (page 221)

Raoul Hague, Woodstock, New York,
1962
silver gelatin developed-out print
27.9 x 42.1 cm (11 x 16⁹/₁₆)
Collection of the artist (page 211)

*Restaurant—U.S. 1 Leaving Columbia,
South Carolina*, 1955
silver gelatin developed-out print
22.7 x 33.8 cm (8¹⁵/₁₆ x 13⁵/₁₆)
Eugene M. Schwartz Associates, Inc.
(page 194)

River Rouge Plant, Detroit, 1955
silver gelatin developed-out print
31.4 x 47.6 cm (12³/₈ x 18³/₄)
Collection of the artist (page 189)

*Sagamore Cafeteria,
New York City*, 1955
silver gelatin developed-out print
21.9 x 32.9 cm (8⁵/₈ x 12¹⁵/₁₆)
National Gallery of Art, Washington,
Robert Frank Collection,
Anonymous Gift (pages 132–133)

St. Nicholas Arena, Billie Holiday, 1959
silver gelatin developed-out print
29.2 x 19.1 cm (11¹/₂ x 7¹/₂)
Andrew Szegedy-Maszak and
Elizabeth Bobrick (page 184)

St. Rita's Hospital, Sidney, Nova Scotia,
1991
silver gelatin developed-out print
50 x 57.9 cm (19¹¹/₁₆ x 22¹³/₁₆)
Collection of the artist, Courtesy
Pace/MacGill Gallery, New York
(page 138)

Santa Fe, New Mexico, 1955
silver gelatin developed-out print
23.2 x 34 cm (9¹/₈ x 13³/₈)
Eugene M. Schwartz Associates, Inc.
(page 198)

Sick of Goodby's, 1978
silver gelatin developed-out print
48.3 x 33 cm (19 x 13)
National Gallery of Art, Washington,
Robert Frank Collection, Gift of the
Collectors Committee (page 251)

Spain, 1952
silver gelatin developed-out print
34.1 x 23.5 cm (13⁷/₁₆ x 9¹/₄)
National Gallery of Art, Washington,
Robert Frank Collection,
Anonymous Gift in Honor of the
50th Anniversary of the National
Gallery of Art (page 75)

Spain, 1952
silver gelatin developed-out print
21.4 x 32 cm (8⁷/₁₆ x 12⁵/₈)
Collection of the artist (page 72)

Street Line, New York, 1951
silver gelatin developed-out print
35.1 x 22.9 cm (13¹³/₁₆ x 9)
National Gallery of Art, Washington,
Robert Frank Collection, Gift (Partial
and Promised) of Robert Frank, in
Honor of the 50th Anniversary of the
National Gallery of Art (page 31)

Table, Mallorca, 1952
silver gelatin developed-out print
35.1 x 22.9 cm (13¹³/₁₆ x 9)
National Gallery of Art, Washington,
Robert Frank Collection, Gift (Partial
and Promised) of Robert Frank, in
Honor of the 50th Anniversary of the
National Gallery of Art (page 74)

10th St. Painters, 1985
mixed media with silver gelatin
developed-out prints
72.9 x 91.9 cm (28 $^{11}/_{16}$ x 36 $^{3}/_{16}$)
Collection of the artist, Courtesy
Pace/MacGill Gallery, New York
(pages 208–209)

Tickertape/New York, 1951
silver gelatin developed-out print
35.1 x 25.4 cm (13 $^{13}/_{16}$ x 10)
National Gallery of Art, Washington,
Robert Frank Collection, Gift (Partial
and Promised) of Robert Frank, in
Honor of the 50th Anniversary of the
National Gallery of Art (page 91)

Trolley—New Orleans, 1955
silver gelatin developed-out print
87.7 x 127.5 cm (34 $^{1}/_{2}$ x 50 $^{3}/_{16}$)
Richard and Ronay Menschel
(page 196)

Untitled, 1989
mixed media with silver gelatin
developed-out prints and thermal
transfer prints
101.9 x 76.5 x 16.8 cm
(40 $^{1}/_{8}$ x 30 $^{1}/_{8}$ x 6 $^{5}/_{8}$)
National Gallery of Art, Washington,
Robert Frank Collection, Gift of Isabel
and Fernando Garzoni, Switzerland,
in Honor of the 50th Anniversary of
the National Gallery of Art (page 287)

Untitled, 1993
silver gelatin transfer (Polaroid) prints
27.9 x 43.2 cm (11 x 17)
Collection of the artist
(pages 300–301)

U.S. 91, Leaving Blackfoot, Idaho, 1956
silver gelatin developed-out print
28.9 x 42.2 cm (11 $^{3}/_{8}$ x 16 $^{5}/_{8}$)
Eugene M. Schwartz Associates, Inc.
(page 186)

*View from Hotel Window—Butte,
Montana,* 1956
silver gelatin developed-out print
21.7 x 32.8 cm (8 $^{9}/_{16}$ x 12 $^{15}/_{16}$)
Gilman Paper Company Collection
(page 188)

Washington, D.C., 1957
silver gelatin developed-out print
40.8 x 27.5 cm (16 $^{1}/_{16}$ x 10 $^{13}/_{16}$)
Collection of the artist (page 181)

Washington D.C. Inauguration Day,
1957
silver gelatin developed-out print
30.6 x 45.6 cm (12 $^{1}/_{16}$ x 17 $^{15}/_{16}$)
National Gallery of Art, Washington,
Robert Frank Collection,
Anonymous Gift (pages 216–217)

Welsh Miners, 1953
silver gelatin developed-out print
34.9 x 23.3 cm (13 $^{3}/_{4}$ x 9 $^{3}/_{16}$)
National Gallery of Art, Washington,
Robert Frank Collection,
Anonymous Gift in Honor of
the 50th Anniversary of the National
Gallery of Art (page 85)

Willem de Kooning, 1961
silver gelatin developed-out print
34 x 22.4 cm (13 $^{3}/_{8}$ x 8 $^{13}/_{16}$)
Collection of the artist (page 210)

Woman/Paris, 1952
silver gelatin developed-out print
35.2 x 22 cm (13 $^{7}/_{8}$ x 8 $^{11}/_{16}$)
National Gallery of Art, Washington,
Robert Frank Collection, Gift (Partial
and Promised) of Robert Frank, in
Honor of the 50th Anniversary of the
National Gallery of Art (page 90)

Yellow Flower—Like a Dog, 1992
silver gelatin developed-out prints
31.1 x 118.9 cm (12 $^{1}/_{4}$ x 46 $^{13}/_{16}$)
Collection of the artist, Courtesy
Pace/MacGill Gallery, New York
(pages 136–137)

Zoe, Juin 21, 1980, 1980
silver gelatin developed-out print
41 x 50.8 cm (16 $^{1}/_{8}$ x 20)
National Gallery of Art, Washington,
Robert Frank Collection, Gift of the
Collectors Committee (page 244)

Zurich, 1945
silver gelatin developed-out prints
6.2 x 30.5 cm (2 $^{7}/_{16}$ x 12)
National Gallery of Art, Washington,
Robert Frank Collection, Gift of
Robert Frank (pages 16–17)

Zurich, 1945
silver gelatin developed-out print
19.7 x 18.1 cm (7 $^{3}/_{4}$ x 7 $^{1}/_{8}$)
National Gallery of Art, Washington,
Robert Frank Collection, Gift of
Robert Frank (page 18)

ACKNOWLEDGMENTS

Robert Frank has inspired a passionate following among photographers, artists, writers, critics, and historians, many of whom have been enormously helpful as we have organized the Robert Frank Collection at the National Gallery, the exhibition *Robert Frank: Moving Out,* and the accompanying book. At the Gallery, Paul Roth has been involved in all aspects of this undertaking, and his considerable expertise has proved indispensable. We are particularly indebted to Peter MacGill, of Pace/MacGill Gallery, New York, for his support and invaluable counsel; and to his assistants Margaret Kelly and Kevin Kaplan for their efficient and unflagging contributions. Anne Tucker of the Museum of Fine Arts, Houston, and Andrew Szegedy-Maszak of Wesleyan University read the essays in this publication, offered perceptive criticisms, and shared their keen appreciation of Frank's work, for which we are extremely grateful. In addition, Stuart Alexander, Ed Grazda, Sid Kaplan, and Kazuhiko Motomura answered numerous questions and clarified critical issues relating to Frank's technique and chronology, thus significantly enriching this endeavor.

The National Gallery has been able to purchase the photographs in the 1989 edition of Frank's retrospective survey, *The Lines of My Hand,* thanks to the support of several individuals and foundations: Richard and Ronay Menschel, Robert and Joyce Menschel, and the Horace W. Goldsmith Foundation; Howard Gilman and The Howard Gilman Foundation; the Collectors Committee of the National Gallery of Art; George and Betsy K. Frampton and the Glen Eagles Foundation; Fernando and Isabel Garzoni; Evelyn and Walter Haas, Jr.; Ann and Gordon P. Getty; Lois and Georges de Ménil; Frederick and Diana Prince and the Prince Charitable Trusts; Evelyn Stefansson Nef; Harvey S. Shipley Miller and The Herbert and Nannette Rothschild Memorial Fund; the Richard Florsheim Art Fund; the Mars Foundation; Amy Rose; Gay Block; Allen and Ricard R. Ohrstrom; James H. Lemon, Jr.; Ann L. Ugelow; and several anonymous donors.

Our principal collaborator and copublisher in this venture, Walter Keller of SCALO, has provided enthusiastic support and unwavering faith in the merits of the publication. Hans Werner Holzwarth created the sensitive design of the catalogue, which so accurately reflects the complex and often contradictory nature of Frank's art. Robert Hennessey was given the formidable task of making the tritone negatives, and through his superb skill and great devotion he has succeeded brilliantly in reproducing Frank's intricate prints. Miriam Wiesel of SCALO has been responsible for the graceful translations of all the essays into German.

Many individuals at the National Gallery have been crucial to the realization of this complex undertaking. All of the essays in the catalogue have been enhanced by the astute editorial judgment of Mary Yakush, and the book has benefited tremendously from her capable management of the production process. Frances P. Smyth, Chris Vogel, and Lisa Khoury of the editors office also provided expert advice and assistance in publishing the catalogue. The development office has played a central role, and we are extremely grateful to Laura Fisher and Melissa McCracken for their enthusiastic efforts on behalf of this project. We extend sincere thanks to Lauren Cluverius, Michelle Fondas, and Ellen Evangelista of the registrars office, who orchestrated the complicated shipping arrangements for the photographs; to D. Dodge Thompson, Trish Waters, Ann B. Robertson, and Stephanie Fick for their careful oversight of administrative details; to Gaillard Ravenel, Mark Leithauser, and John Olson for their thoughtful design and installation of the exhibition; to Connie McCabe and Deborah Derby for their informative advice and skillful attention to the conservation of Frank's photographs; to Hugh Phibbs, Jenny Ritchie, and Jamie Stout for their handling of the intricate issues relating to the matting and framing of these works; to

Christopher With for his translation of one of the essays from German into English; to Elizabeth A.C. Perry and Katherine Clark Hudgens from the office of corporate relations; to Neal Turtell, Anna Rachwald, Ted Dalziel, and Tom McGill from the library; and to the department of imaging and visual services. In addition, a special word of thanks is due Peggy Parsons for her organization of the accompanying program of Frank films; Tom Valentine from audiovisual services; and Susan Arensberg of the education department.

In the division of graphic arts we wish to thank Andrew Robison, Mireille Cronin, Tom Parette, and Eleanor Thomas for their ongoing support and assistance. In the department of photographs several interns have contributed work essential to this project, including Toby Jurovics, Rachael Arauz, Carrie Suhr, Amy Freedman, and Mikka Gee. And we wish also to express our deep gratitude to Julia Thompson, Mary Suzor, Ann McNary, and Martha Blakeslee, who, with great good humor, have given countless hours to the organization of the large Robert Frank Collection.

In the last four years we have called upon many friends and colleagues, and at every turn we found individuals ready to share knowledge, time, and expertise. We wish particularly to thank:

Taro Amano	Nicole Friedler	Baroness Marion Lambert	Martin Schaub
Pierre Apraxine	Lucinda Furlong	Walter Läubli	Annamarie Schuh
Walter Binder	Peter Galassi	Marian Luntz	Emil Schulthess
Kurt Blum	Allen Ginsberg	Lisa Lyons	Eugene Schwartz
Claude Brunschwig	Brian Graham	Guido Magnaguagno	Ann Shumard
Roger Brunschwig	Jonathan Green	Jay Manis	Louis and
Peter C. Bunnell	Roland Gretler	Jonas Mekas	Helen Silverstein
Bill Burke	René Groebli	Wayne Miller	Christian Staub
Martha Chahroudi	Willy Guggenheim	Mitsuru Nikaido	David Streiff
John Cohen	Robert Haller	Christian Peterson	Barbara Tannenbaum
Jno Cook	Martha Hanna	Lisa Phillips	David Travis
Jack Cowart	Kathleen Hart	Sandra Phillips	Hripsimé Visser
Robert Delpire	Carroll Hartwell	Pieter Dirk van der Poel	Karin Wegmann
Byron Dobell	John Hill	George Reinhart	Colin Westerbeck
Willi Eidenbenz	William Johnson	Jock Reynolds	John Wetenhall
Friedrich Engesser	Ellen Kaufmann	Nan Rosenthal	Luzzi Wolgensinger
Manfred Frank	Shino Kuraishi	Nicole Rousmaniere	Sylvia Wolf
Mary Frank	Sue Lagasi	Michal Rovner	Werner Zryd

The curators wish to thank their families and friends, whose support, advice, and patience have aided us in ways that are impossible to acknowledge adequately in words. And we would like to thank June Leaf and Robert Frank. For the last four years, while they have been moving forward, we have been asking questions and raising issues they thought were long since resolved. For their generosity, trust, and most of all their friendship, we are profoundly grateful.

Sarah Greenough and Philip Brookman

Alexander, Stuart. *Robert Frank: A Bibliography, Filmography and Exhibition Chronology 1946–1985.* Tucson: Center for Creative Photography, University of Arizona, in association with the Museum of Fine Arts, Houston, 1986.

Allan, Blaine. "The Making (and Unmaking) of *Pull My Daisy.*" *Film History* 2:3 (1988), 185–205.

Art for the Nation: Gifts In Honor of the Fiftieth Anniversary of the National Gallery of Art. Exh. cat. National Gallery of Art. Washington, 1991, 402–409, 516–519.

Baier, Leslie. "Visions of Fascination and Despair: The Relationship Between Walker Evans and Robert Frank." *Art Journal* 41:1 (Spring 1981), 55–63.

Bennett, Edna. "Black and White are the Colors of Robert Frank." *Aperture* 9:1 (1961), 20–22.

"Books: An Off-Beat View of the U.S.A.: *Popular Photography's* Editors Comment on a Controversial New Book". (Review of *The Americans*). *Popular Photography* 46:5 (May 1960), 104–106.

Brand, Stewart. "Robert Frank Returns To Still Photography," *CoEvolution Quarterly* 29 (Spring 1981), 2.

Brookman, Philip. *Robert Frank: An Exhibition of Photography and Films, 1945–1977.* Exh. cat. Mary Porter Sesnon Art Gallery, University of California at Santa Cruz, 1978.

——. *Robert Frank: Photographer/Filmmaker, Works from 1945–1979.* Exh. cat. Long Beach Museum of Art. Long Beach, California, 1979.

Brumfield, John. "'The Americans' and the Americans." *Afterimage* 8:1/2 (Summer 1980), 8–15.

Bunnell, Peter C. "Certain of Robert Frank's Photographs…." *The Print Collector's News Letter* 7:3 (July/August 1976), 81.

Cassell, James. "Robert Frank's *The Americans:* An Original Vision Despite Tod Papageorge's Challenge." *The New Art Examiner* 8:10 (Summer 1981), 1, 8.

Caulfield, Patricia. "New Photo Books: The Americans." (Review of *The Americans*.) *Modern Photography* 24:6 (June 1960), 32–33.

Claass, Arnaud. "Robert Frank et les Avant–Gardes." *Contrejour* [Paris] 13 (October/November 1977), 22–25.

Cook, Jno. "Photography: Robert Frank's Parody." *Nit & Wit: Chicago's Arts Magazine* 6:3 (May/June 1984), 40–43.

——. "Robert Frank's America." *Afterimage* 9:8 (March 1982), 9–14.

——. "Robert Frank: Dissecting the American Image." *Exposure* 24:1 (Spring 1986), 31–41.

——. *The Robert Frank Coloring Book.* School of The Art Institute of Chicago, 1983.

Cosgrove, Gillian. "The Rolling Stones On Tour— The Film That Can't Be Shown." *The Montréal Star* (10 September 1977, sec. D, 1, 6 and 12 September 1977, sec. C, 2).

Cotkin, George. "The Photographer in the Beat-Hipster Idiom: Robert Frank's *The Americans.*" *American Studies* 26:1 (Spring 1985), 19–33.

Cousineau, Penny. "Robert Frank's Postcards from Everywhere." *Afterimage* 5:8 (February 1978), 6–8.

Deschin, Jacob. "Project Awards: Guggenheim Fellowships for Frank and Webb." *The New York Times* (1 May 1955), sec. 2, 17.

———. "Two-Man Exhibit: Photographs by Callahan and Frank at Museum of Modern Art." *The New York Times* (4 February 1962), sec. 2, 21.

Di Piero, W. S. "Not a Beautiful Picture: On Robert Frank." *TriQuarterly* 76 (Fall 1989), 146–165.

[Dobell, Byron]. "Robert Frank: Swiss Mister." *Photo Arts* [New York] 1:10 (December 1951), 594–599.

Dugan, Thomas. *Photography Between Covers: Interviews With Photo-Bookmakers.* Rochester, New York: Light Impressions Corp., 1979.

Eddé, Dominique. *Beyrouth: Centre Ville.* Paris: Les Éditions du Cyprès, 1992, 138–167.

Ennis, Michael. "The Roadside Eye." *Texas Monthly* 11:11 (November 1983), 180–183.

Evans, Walker. "Robert Frank," *U. S. Camera 1958.* Edited by Tom Maloney. New York, 1957, 90.

"Feature Pictures: Robert Frank…The Photographer as Poet." Edited by Byron Dobell. *U. S. Camera* 17:9 (September 1954), 77–84.

Floyd, Tony. "*Pull My Daisy:* The Critical Reaction." *Moody Street Irregulars: a Jack Kerouac Newsletter: The Film Issue* 22&23 (Winter 1989–1990), 11–14.

Fresnault-Deruelle, Pierre. "*Les Américains* de Robert Frank." *Revue Française d'Études Américaines* 39, February 1989, 63–70.

Frizot, Michel. "Robert Frank, ailleurs et maintenant." *Clichés* [Brussels] 25 (April 1986), 48–53.

Garel, Alain. "Robert Frank: Entretien: Images en Mouvement." (Interview with Frank.) *La Revue du Cinéma* [Paris] 435 (February 1988), 49–52.

Gehrig, Christian. "Frozen Moments." (Interview with Frank.) *Schweizer Illustrierte* (17 April 1989), 57–62.

Glicksman, Marlaine. "Highway 61 Revisited." (Interview with Frank.) *Film Comment* 23:4 (July/August 1987), 32–39.

Green, Jonathan. "*The Americans:* Politics and Alienation," *American Photography: A Critical History 1945 to the Present.* New York: Harry N. Abrams, 1984, 80–93.

Guimond, James. "The Great American Wasteland," in *American Photography and the American Dream.* Chapel Hill: The University of North Carolina Press, 1991, 207–244.

Gutierrez, Donald. "Books: The Unhappy Many." (Review of *The Americans.*) *Dissent* 8:4 (Autumn 1961), 515–516.

Hachigian, Nina and Tod Papageorge. "Interview with Robert Frank." (Interview with Frank.) *Black and White: The Yale Undergraduate Photography Review.* Edited by Nina Hachigian, 1989, 2–7.

Hagen, Charles. "Candid Camera." *Artforum* 24:10 (Summer 1986), 23, 116–119.

———. "Robert Frank: Seeing Through the Pain." (Review of *The Lines of My Hand.*) *Afterimage* 1:5 (February 1973), 1, 4–5.

Hill, Gary. "Energy and How to Get It: Proposal By Gary Hill for a Film by Robert Frank, Gary Hill, and Rudy Wurlitzer." *CoEvolution Quarterly* 29 (Spring 1981), 16–19.

Hinderaker, Mark. "*The Family of Man* and *The Americans.*" *Photographer's Forum* 2:4 (September 1980), 22–28.

Hyland, Douglas K. S. *Birmingham 1988: The Birmingham News Centennial Photographic Collection.* Exh. cat. Birmingham Museum of Art and *The Birmingham News,* Birmingham, Alabama, 1988.

Jeffrey, Ian. "Robert Frank: Photographs From London and Wales, 1951," 10–36. *Creative Camera International Year Book 1975.* Edited by Colin Osman and Peter Turner. London: Coo Press, Ltd., 1974, 10–36.

Jobey, Liz. "The UnAmerican." *The Independent on Sunday: The Sunday Review.* 29 March 1992, 8–10.

Johnson, William. "Public Statements/Private Views: Shifting the Ground in the 1950s." *Observations: Essays on Documentary Photography, Untitled,* No. 35 (1984), 81–92.

Katz, Paul. *Robert Frank: The Americans and New York Photographs.* Exh. cat. Sidney Janis Gallery. New York: Sidney Janis Gallery, 1979.

——. "Robert Frank," *Photography/Venice '79,* Exh. cat. Municipality of Venice and the International Center of Photography, Milan and New York: Gruppo Editoriale Electra and Rizzoli International Publications, 1979, 311–326.

Kernan, Sean. "Uneasy Words While Waiting: Robert Frank." (Interview with Frank.) *U. S. Camera/Camera 35 Annual: America: Photographic Statements.* Edited by Jim Hughes. New York, 1972, 139–145.

Lambeth, Michel. "Books Reviewed: The Americans." *Canadian Forum* 40:475 (August 1960), 120.

L[äubli, Walter]. "Robert Frank." *Camera* 28:12 (December 1949), 358–371.

Leslie, Alfred. "'Daisy': 10 Years Later." *Village Voice* 14:7 (28 November 1968), 54.

Lhamon, W. T. Jr., *Deliberate Speed: The Origins of a Cultural Style in the American 1950s.* Washington: Smithsonian Institution Press, 1990, 124–135.

"*Life* Announces the Winners of the Young Photographers' Contest." *Life* 31:22 (26 November 1951), 15–24, 30, 32.

Lifson, Ben. "Robert Frank and the Realm of Method." *Village Voice* 24:8, 19 February 1979, 75.

Macdonald, Dwight. "Films: Amateurs and Pros." (Review of *Pull My Daisy.*) *Esquire* 53:4 (April 1960), 26, 28, 32.

Mann, Margery. "West: The Americans Revisited." *Camera 35* 18:10 (January 1975), 14, 74–75.

Mekas, Jonas. "Cinema of the New Generation." *Film Culture* 21 (Summer 1960), 1–20.

——. "Movie Journal." *Village Voice* 5:4 (18 November 1959), 8, 12.

Millstein, Gilbert. "In Each A Self–Portrait." (Review of *The Americans.*) *The New York Times Book Review* (17 January 1960), 7.

Nesterenko, Alexander & C. Zoe Smith. "Contemporary Interpretations of Robert Frank's *The Americans.*" *Journalism Quarterly* 61:3 (Autumn 1984), 567–577.

Newhall, Beaumont. *The History of Photography: From 1839 to the Present Day.* 4th revised and enlarged edition. New York: The Museum of Modern Art, 1964.

Papageorge, Tod. *Walker Evans and Robert Frank: An Essay on Influence.* Exh. cat. Yale University Art Gallery. New Haven, 1981.

"Photographs by Robert Frank." *Choice: A Magazine For Poetry and Photography* 2 (1962), 97–112.

Photography in Switzerland: 1840 to Today. Edited by Hugo Loetscher, Walter Binder, Rosellina Burri–Bischof, and Peter Killer. Exh. cat. Foundation for Photography. Teufen, Switzerland: Arthur Niggli, 1974.

Photography Within the Humanities. (Interview with Frank.) Edited by Eugenia Parry Janis and Wendy MacNeil. Danbury, New Hampshire: Addison House Publishers, 1977, 52–65.

"The Pictures are a Necessity: Robert Frank in Rochester, NY November 1988." (Interviews with Frank.) Edited by William S. Johnson. *Rochester Film and Photo Consortium Occasional Papers* no. 2 (January 1989).

Porter, Allan. "Robert Frank: A Bus Ride through New York." *Camera* 45:1 (January 1966), 32–35.

"Portraits: The Photographs of Robert Frank." *Art Voices* 5:3 (Summer 1966), 57–60.

Revault d'Allones, Fabrice. "Un Américain à Paris." (Interview with Frank.) *Photomagazine* 88 (December 1987/January 1988), 26–28.

Rice, Shelley. "Some Reflections On Time and Change in the Work of Robert Frank." *Photo Review* 13:2 (Spring 1990), 1–9.

Richard, Paul. "The Artist's Gift of a Lifetime: Photographer Robert Frank Donates Works to National Gallery." *The Washington Post* (7 September 1990), B1, B2.

———. "The Unwavering Vision of Robert Frank." *The Washington Post* (20 April 1986), G1, G5.

"Robert Frank." *Aperture* 9:1 (1961), 4–19.

"Robert Frank." *Aperture* 19:1 (1974), 120–123. Reprinted as *The Snapshot.* Edited with an introduction by Jonathan Green. Millerton, New York: Aperture, 1974.

Robert Frank. Exh. cat. Mostra Internazionale. Rimini, Italy: Riminicinema, September 22–29, 1990.

"Robert Frank." (Interview with Frank.) *Camera Austria* 22 (1987), 17–23.

"Robert Frank." (Interview with Frank.) *Switch* [Tokyo] 10:4 (September 1992), 12–91.

Robert Frank. Introduction by Rudolph Wurlitzer. Millerton, New York: Aperture, 1976.

"Robert Frank." *The Massachusetts Review* 19:4 (December 1978), 766–773.

"Robert Frank: la photographie, enfin." *Les Cahiers de la Photographie* 11/12 and numéro spécial 3 (1983), 1–125.

Robert Frank: Sobre Valencia 1950. Exh. cat. Sala Parpalló/Institució Alfons el Magnànim. Valencia, 1985.

"Robert Frank." *U. S. Camera 1958.* Edited by Tom Maloney. New York: U. S. Camera, 1957, 91–114.

Roegiers, Patrick. "Robert Frank ou les mystères de la chambre noire." (Interview with Frank.) *Le Monde Aujourd'hui,* supplément au no. 12840 du *Le Monde* (11–12 May 1986), VI–VII.

Rotzler, Willy. "Robert Frank." *du* 22:1 (January 1962), 1–32.

Rubinfien, Leo. "Photography: Robert Frank in Ottawa." *Art in America* 66:3 (May/June 1978), 52–55.

Schaub, Martin. "FotoFilmFotoFilm: Eine Spirale: Robert Franks Suche nach den Augenblicken der wahren Empfindung." (Interview with Frank.) *Cinema: unabhängige Schweizer Filmzeitschrift* [Zurich] 30 (1984), 75–94.

———. "Postkarten von überall und innere Narben: Ein Porträt des sechzigjährigen Fotografen und Filmemachers Robert Frank, der vor 37 Jahren die zufriedene Heimat verliess." *Tages Anzeiger Magazin* 44 (3 November 1984), 8–13, 15–16.

Schiffman, Amy M. "Politics as Unusual: Robert Frank." *American Photographer* 13:5 (November 1984), 52–57.

Schmid, Joachim. "Ein Interview mit Robert Frank." (Interview with Frank.) *Fotokritik* [Berlin] 14 (June 1985), 16–21.

Schuh, Gotthard. "Robert Frank." *Camera* 36:8 (August 1957), 339–356.

Scully, Julia, and Andy Grundberg. "Currents: American Photography Today: Robert Frank's Iconoclastic, Outsider's View of America." *Modern Photography* 42:10 (October 1978), 94–97, 196, 198, 200.

Searle, Leroy. "Symposium: Poems, Pictures and Conceptions of 'Language.'" *Afterimage* 3:1/2 (May/June 1975), 33–39.

Shainberg, Lawrence. "Notes From the Underground." *Evergreen Review* 50 (December 1967), 22–25, 105–112.

Silberman, Robert. "Outside Report: Robert Frank." *Art in America* 75:2 (February 1987), 130–139.

Skorecki, Louis. "Robert Frank: L'Arlesien." (Interview with Frank.) *Libération* 2521 (2 July 1989), 19–33.

Stott, William. "Walker Evans, Robert Frank and the Landscape of Dissociation." *Artscanada* 192/193/194/195 (December 1974), 83–89.

Sullivan, Constance, and Peter Schjeldahl. *Legacy of Light.* New York: Alfred A. Knopf, 1987, 54–55, 127–135.

Swanberg, Lasse. "Robert Frank." (Interview with Frank.) *Fotografisk Årsbok 1968.* Stockholm: Nordisk Rotogravyrs Förlag / P. A. Norstedt & Söner, 1967, 56–61.

Takata, Ken. "Toward an Elegance of Movement — Walker Evans and Robert Frank Revisited." *Journal of American Culture* 12 (Spring 1989), 55–64.

Talese, Gay. "42nd Street — How it Got that Way." *Show* 1:3 (December 1961), 62–71.

Tannenbaum, Barbara, and David B. Cooper. *Robert Frank and American Politics.* Exh. cat. Akron Art Museum. Akron, 1985.

Thétard, Henry. "Magie du Cirque." *Neuf* [Paris] 7 (September 1952), 14–23.

Todoli, Vicent, Jno Cook, and Martin Schaub. *Robert Frank: Fotografias/Films 1948/1984.* Exh. cat.

Sala Parpalló / Institució Alfons el Magnànim. Valencia, 1985.

Tucker, Anne Wilkes, and Philip Brookman. *Robert Frank: New York to Nova Scotia.* Exh. cat. Museum of Fine Arts Houston. Boston: Little, Brown and Company, 1986.

Tyler, Parker. "For 'Shadows,' Against 'Pull My Daisy.'" *Film Culture* 24 (Spring 1962), 28–33.

"The Venice Film Festival." *Show* 2:5 (May 1962), 60–65.

"Walker Evans on Robert Frank: Robert Frank on Walker Evans." (Interview with Frank.) *Still* / 3. New Haven: Yale University, 1971, 2–6.

Wheeler, Dennis. "Robert Frank Interviewed." (Interview with Frank.) *Criteria* 3:2 (June 1977), 1, 4–7, 24.

[White, Minor]. "Book Review: *Les Américains.*" *Aperture* 7:3 (1959), 127.

Frank, Robert. *Alberto Aspesi: Shirts.* Milan: Alberto Aspesi, 1989.

——. *Les Américains.* Text selected and edited by Alain Bosquet. Paris: Robert Delpire, 1958. Reprinted as *Gli Americani,* with text selected and edited by Alain Bosquet and Raffaele Crovi, Milan: Il Saggiatore, 1959. Reprinted as *The Americans,* with introduction by Jack Kerouac, New York: Grove Press, 1959. Revised and enlarged edition, New York: An Aperture Book, The Museum of Modern Art Edition, 1968. Revised edition, Millerton, New York: An Aperture Monograph, 1978. Reprinted, New York: Pantheon Press, 1986. Reprinted, Zurich: SCALO, in association with the National Gallery of Art, Washington, 1993.

——. "Ben James: Story of a Welsh Miner," in *U. S. Camera 1955.* Edited by Tom Maloney. New York, 1954, 82–93.

——. *Black White and Things.* Washington and Zurich: National Gallery of Art and SCALO, 1994.

——. "Coney Island: Robert Frank." *Camera* 50:3 (March 1971), 18–25.

——. "The Congressional," edited by Walker Evans. *Fortune* 52:5 (November 1955), 118–122.

——. "Edgar Varèse, Willem de Kooning." *Harper's Bazaar* 3012 (November 1962), 166–169.

——. "The Fashion Independent: Inside East Europe." *Harper's Bazaar* 3021 (August 1963), 82–91.

——. "Films: Entertainment Shacked Up With Art." *Artsmagazine* 41:5 (March 1967), 23.

——. *Flower Is….* Tokyo: Yugensha/Kazuhiko Motomura, 1987.

——. "from *One Hour.*" *Grand Street* 10:4 (1991), 32–48.

——. "A Hard Look at the New Hollywood." *Esquire* 51:3 (March 1959), 51–65.

——. "Indiens des Hauts–Plateaux," with text by Georges Arnaud. *Neuf* [Paris] 8 (December 1952), 1–36.

——. [Introduction] in *Appointment Calendar,* 1969, with photographs by Ralph Gibson. Los Angeles: American Civil Liberties Union of Southern California, Published and distributed by Ward Ritchie Press, 1968.

——. "J'aimerais Faire un Film…" in *Robert Frank.* Paris: Centre National de la Photographie, 1983.

——. "Letter From New York." *Creative Camera* 60 (June 1969), 202–203.

——. "Letter From New York." *Creative Camera* 61 (July 1969), 234–235.

——. "Letter From New York." *Creative Camera* 62 (August 1969), 272.

——. "Letter From New York." *Creative Camera* 64 (October 1969), 340.

——. "Letter From New York." *Creative Camera* 66 (December 1969), 414.

. [Letter to Albano da Silva Pereira] in *Robert Frank.* (Interview with Frank.) Edited by Albano da Silva Pereira and Paulo Mora. Exh. cat. Centro de Estudos da Fotografia de Associacao Academica de Coimbra, Coimbra, Portugal, 1988.

——. [Letter to Danny Seymour], in *A Loud Song* by Danny Seymour. New York: Lustrum Press, 1971, 55.

——. [Letter to Gotthard Schuh], in "Gotthard Schuh: The Irretrievable Instant." *Camera* 47:3 (March 1968), 4.

——. [Letter to Ralph Gibson], in *Young American Photography: Volume 1.* Edited by Gary Wolfson. New York: Lustrum Press, 1974.

——. [Letters], in "Car Photographs Tokyo," by Nobuyoshi Araki, *Switch* [Tokyo] 10:4 (September 1992), 156–168.

——. [Letters to Daniel Price], in *Shots: A Journal About the Art of Photography* 24 (December 1990), 30–35.

——. *The Lines of My Hand.* Tokyo: Yugensha, Kazuhiko Motomura, 1972. Revised edition, New York: Lustrum Press, 1972. Revised edition, Zurich: Parkett / Der Alltag, 1989.

——. *New York Is.* Introduction by Gilbert Millstein. New York: New York Times [1959].

——. "October 31, 1989," in *The Jack Kerouac Collection.* Rhino Records. Santa Monica, 1990, 20.

——. *One Hour.* New York and Madras: Hanuman Books, 1992.

——. "A Pageant Portfolio: One Man's U.S.A." *Pageant* 13:10 (April 1958), 24–35.

——. "Portfolio by Robert Frank, July 16–19, 1984." *California* 9:9 (September 1984), 123–133.

——. "Portfolio: Robert Frank: 5 Photographs." *The Second Coming Magazine* 1:6 (January 1965), 57–62.

——. "Speaking of Pictures: A Photographer in Paris Finds Chairs Everywhere." *Life* 30:21 (21 May 1951), 26–28.

——. [Statement], in "The Cinema Delimina-Films From the Underground," by Stan Vanderbeek. *Film Quarterly* 14:4 (Summer 1961), 5–15.

——. "A Statement…," in *U. S. Camera 1958.* Edited by Tom Maloney. New York, 1957, 115.

——. "Three Groups of Photographs Taken 1955/56 on a Trip Across the USA." *C Magazine* [Toronto] 3 (Fall 1984), 66–70.

——. [Tribute], in *Best Minds: A Tribute to Allen Ginsberg,* by Bill Morgan and Bob Rosenthal. New York: Lospecchio Press, 1986, 112.

——. [Untitled], in *Charles Pratt: Photographs.* Edited by John Gossage. Estate of Charles Pratt, Millerton, New York, 1982, 9.

——. *Zero Mostel Reads A Book.* New York: New York Times, Inc., 1963.

—— and Alfred Leslie. *Pull My Daisy.* Text by Jack Kerouac. Introduction by Jerry Tallmer. New York: Grove Press, 1961.

—— and Jack Kerouac. "On the Road to Florida." *Evergreen Review 74* (January 1970), 42–47, 64.

—— and Lee Friedlander. *The Sculpture of Raoul Hague: Photographs by Robert Frank and Lee Friedlander.* New York: The Eakins Press Foundation, 1978.

—— and Werner Bischof and Pierre Verger. *Indiens Pas Morts,* with text by Georges Arnaud. Paris: Robert Delpire, 1956.

PHOTOGRAPHIC CREDITS

Produced by the editors office, National Gallery of Art.
Editor-in-chief, Frances Smyth. Senior editor, Mary Yakush.
Production manager, Chris Vogel.
Tritone negatives by Robert Hennessey, Middletown, Connecticut.
Typeset in Adobe Garamond and Futura by Design pur, Berlin.
Printed on Gleneagle by Litho Specialties, Inc., Saint Paul, Minnesota.
Designed by Hans Werner Holzwarth, Design pur, Berlin.

Cover: *New York City, 7 Bleecker Street, September,* 1993
Frontispiece: pages II–V: Detail of pp. 263–265
page VI: *Hoboken, New Jersey,* 1955

Library of Congress Cataloging-in-Publication Data
Greenough, Sarah, 1951–
Robert Frank: moving out / Sarah Greenough and Philip Brookman;
with contributions by Martin Gasser, W. S. Di Piero, John Hanhardt.
p. cm.
Catalog of a traveling exhibition opening at
the National Gallery of Art, Oct. 2, 1994.
Includes bibliographical references (pp. 327–333)
ISBN 1-881616-26-6
1. Photography, Artistic—Exhibitions.
2. Frank, Robert—Exhibitions.
I. Frank, Robert. II. Brookman, Philip.
III. National Gallery of Art (U.S.). IV. Title. V. Title: Moving Out.
TR647.F74 1994b 94-20187
779.092—dc20 CIP